EROTIC THEATRE

Erotic Theatre

John Elsom

Introduction by John Trevelyan CBE

TAPLINGER PUBLISHING CO., INC.
NEW YORK

First published in the United States in 1974 by
Taplinger Publishing Co., Inc.
New York, New York

Library of Congress Catalog Card Number: 73-15277

ISBN 0-8008-24652

Printed in Great Britain

To Sally

Contents

List of Illustrations

Acknowledgements

I would like to extend my thanks to Norman Plaskett for helping with the photographs, and to the many directors, actors, actresses and producers who have so generously given their time for interviews; and to Ginette Ashkenasi, for carrying so much of the burden of my French. Extracts of this book have already appeared in *London Magazine*, and I would like to thank the editor, Alan Ross, for allowing me to reprint them.

The author and publishers thank the following for permission to reproduce photographs: the Enthoven Collection in the Victoria & Albert Museum (1, 2, 3, 4, 5, 6, 7, 8, 10, 11, 12, 14); the Raymond Mander and Joe Mitchenson Theatre Collection (9, 13, 21); Donald Cooper (15, 16, 23, 24, 25); Kayaert of Brussels and the Béjart Ballet, director Maurice Béjart (17); Sirkka-Liisa Konttinen (18, 35); Paul Raymond (19, 32, 33); John Timbers (20); Douglas H. Jeffery (22); Roger Perry (26); François Bertin of Lausanne (27); Alex Agor (28); Keystone Press Agency Ltd (29); John Haynes (30, 36, 37); Sally Fraser (Report, London) (31); André Nisak of Paris (34); Friedman-Abeles of New York (38); Dominic (39, 40, 41).

Introduction

by John Trevelyan CBE

This book has made me think. It has taught me things that I did not know before, and it has challenged some assumptions that I have been too ready to accept – assumptions about human beings and about the societies that they have constructed for their security and well-being. While its main subject is theatre, and in particular erotic theatre, it is also a study of changing social attitudes. I am now largely unfamiliar with the world of theatre through lack of time in recent years, but the world of films, with which I am familiar, has presented its direct parallels in the present century. While, unlike the stage play, the film is still controlled by censorship, I like to think that in recent years the creative artists have not found this unreasonably restrictive nor an intolerable burden. I now believe that the time has come to free the film-maker as well as the playwright: after reading this book I am increasingly inclined to this view.

John Elsom has contrasted the social sexual attitudes of 1890 to 1910 with those of 1950 to 1972 as reflected in the plays and other similar entertainments of the time. We can perhaps assess the first period in a reasonable perspective, but we have the disadvantage of not having lived through this time and are therefore without subjective impressions. We have lived through the second period, but all these personal memories may lessen our objectivity. As Sir Arthur Bryant once wrote, it is difficult for a man who travels over a range of mountains to determine which is the highest peak until he is some distance away. We cannot expect perfection in our judgement either way, but we can always learn and try to understand.

We can start by trying to understand ourselves and our own sexual attitudes. As John Elsom says, "Our sexual behaviour is a

thread in a pattern. The pattern is ourselves." For a study in
depth we shall need the help of an analyst, but we can at least try
to find honest answers to the questions, What are my sexual
inclinations? What are my social sexual attitudes? What are my
sexual moralities? As this book points out, much of the contem-
porary debate on censorship and "permissiveness" is confused
because of the failure to distinguish between these three things.
We are all searching for truth, and we can at least start by searching
for the truth about ourselves.

What can we learn from our sexual fantasies? We are told in this
book that in order to lessen our guilt feelings we like our sexual
fantasies to be at a distance in space or time and not too closely
related to our own lives – does this explain the phenomenal success
of Hefner's *Playboy* with its untouchable girls? – but why do we
have guilt feelings at all? Can we justifiably blame Victorian
rigidity when a hundred years ago every sexual taste was catered
for, although less openly than it is today? Can we justifiably blame
the anti-sexual moralities of Christianity or blame St Paul for
creating sexual inhibitions in every generation of our ancestors?

Why does guilt about masturbation seem to persist with every
new generation when the young today are not frightened, as my
generation were, by absurd lies about its effects? We can joke
about it now – as in *Oh! Calcutta!*, or where Michael in *The Boys in
The Band* says that the great thing about masturbation is that you
do not have to look your best! – but few people would like to be
seen doing it. Pornographic theatre is an aid to masturbation for, as
John Elsom tells us, we can retain the image of the physical act
until we get home – to use the memory of what we have seen to
provide any necessary sexual stimulation.

Must we continuously be seeking new sexual thrills as a second-
hand experience or even now as a first-hand experience through
"audience participation"? If so are there enough permutations to
provide for this indefinitely? New freedoms have been both used
and abused, and it is perhaps significant that in an age when the
young paint on walls the words "PEACE" and "LOVE" and anti-war
slogans, the real world is full of violence and this is reflected in
entertainment. The violence itself can be caused by sexual as well
as by political or economic frustration and can, of course, be
aphrodisiac. Copulation should be an expression of love, but it
can also be interpreted as an act of aggression. The basic differences
in the philosophies of Sartre and Genet, so well explained this
book, are important in this context.

There has always been a tendency to accept anything new as significant whether it has any value or not, and there are self-conscious pseudo-intellectuals who will accept something without question because it is new. When Yoko Ono, who I believe to be sincere, filmed 365 human bottoms, the film had a sound-track of tape-recorded comments during the filming – one man said: "I believe this is a new 'break through' in art. I would describe it as meaningful, meaningless, if you know what I mean." I do not know what he meant, and nor did he. It is this kind of person who would not, like John Elsom and me, regard *Oh! Calcutta!* as "a disaster", or regard this and other similar entertainments as the price that the theatre has had to pay for the new freedom gained in 1968 by the abolition of censorship.

Yet it is a price worth paying because, as Parliament saw at the time, there is little that law or censorship can do that is worth doing other than protecting children and immature minds, and much that law and censorship can do that is both unjust and harmful. Obscenity laws create a profitable black market, and there are always ways of evading controls. The answer may lie in education, but this is inevitably a long-term answer, longer than it need be while so much of the educational process is devoted to examination pressures forced on schools and universities by grow-ing economic competition. How little time can be devoted to the acquisition of culture, which A. N. Whitehead defined as "activity of thought and receptiveness to beauty and humane feeling". If more people acquired culture the theatre and other forms of entertainment would reflect it, and would benefit.

This is not to say that erotic theatre would die, or even that it should die, but I believe that it would have a new quality. People need, and will continue to need, erotic stimulation, and if this makes their lives happier the world will be a happier place. Such words as "obscenity" and "pornography" could well become archaic and I believe that nobody would be the worse for it. The theatre can teach us something about life and about human problems, and if it can make us understand more about the human condition it can help us all in our search for the truth.

1

The Two-way Mirror

Western societies have acquired a curious habit. They gaze into the two-way distorting glass of their theatres and ask the question, "Who is the most sexually decadent of them all?", confident that the mirror will reply, "Thou art, oh Queen" – or King as the case may be. "Have art forms ever before been so drenched and impregnated with erotic obsessions," asked Malcolm Muggeridge, one of the BBC's religious correspondents, at the 1969 Edinburgh Festival, "so insanely pre-occupied with our animal nature and its appetites?" In 1931, the British Board of Film Censors deplored the number of films which depended upon "that unpleasant aspect which is best described as 'sex appeal'", and Bernard Shaw was convinced that the theatre of the 1900s was singularly erotic. In 1874, the critic of the *Penny Paper* was appalled by the French influence on British theatre – "the evil is spreading . . . with the most lascivious gestures . . . wanton wriggling which panders to the brute in man"– while Jeremy Collier in 1698 condemned the whole acting profession as "whoring, cursing, filthy atheists". Sooner or later, they were all convinced, the pendulum must swing back to more acceptable standards – otherwise, in the words of Edward J. Mishan (*Encounter*, 1972), mankind will be swept down into the "pornographic maelstrom" which insidiously distracts and lures "the fast-scurrying members of the affluent society to the impending holocaust of the human species".

Nor is this a peculiarly Anglo-Saxon form of self-abuse. The common complaint against the theatre for centuries throughout Europe has been that it is both lascivious in itself and the cause of lechery in others. "I am utterly dismayed," said the Empress Maria-Theresa of Austria, who shaved the heads of the prostitutes in the Tiefen Graben and made them sweep the streets, "by the problem of the theatres." Her fears were echoed by the less severe Goncourt

brothers in Paris during the Second Empire, and by the Puritans in every country – from Cromwell, who closed the theatres in Britain in 1642, to Mrs Ormiston Chant, the American reformer in the 1890s. Others, of course, interpreted the signs differently. One man's decadence is another man's sexual enlightenment. But the liberals and the Puritans tend to hold certain assumptions in common – that drama is a mirror to the age and that therefore any change in sexual behaviour which we notice on the stage or screen represents a unique development in human affairs. The theatre has become a focal point for the complicated emotions of sexual shame and self-approval.

Unfortunately, if the theatre is a reflection of the times at all, it is a treacherous mirror, for where does the image we see relate to the lives we live? Have we chosen, to begin with, the correct angle of vision? If we stand in front of a mirror, we are looking at an apparently accurate picture of ourselves – but with every detail reversed. But if we stand behind a two-way mirror, we watch other people moving around in a deceptive blur. What shocks us (if we are shocked) when we go to the theatre? The sudden sight of our own hidden natures, brought (as it were) from the decent obscurity of the left side of our minds into prominence on the right? Or are we appalled by the lives other people appear to be leading? Furthermore, the very medium, glass or drama, is one which is composed of minute flaws, distortions which are most misleading when they are least obvious. Comedies in everyday life do not exactly *end* with a marriage, as Byron pointed out. Any book on erotic theatre starts with a forbidding dilemma: that while it is universally acknowledged that the theatre is a product of its times, it is almost impossible to decide who is producing what and why.

This is not the only problem. The language we use causes further difficulties. "To define pornography or obscenity precisely," wrote Alma Birk, chairman of the British Health Education Council, "has proved beyond the wit of man. Maybe we should stop trying." But perhaps pornography and obscenity are particularly difficult words: banners tattered by too many moral campaigns. Pornography has a built-in sense of wrongdoing, although I shall attempt a non-moral definition later on. What we consider wrong varies from person to person. But what about "erotic"? The *Concise Oxford Dictionary* defines the word like this – "of love, amatory". Another dictionary adds: "of sexual passion". The Greek roots emphasized the sexual nature of love, and during the nineteenth century in Britain, when sexual passions were

generally considered to be shameful, the word caught up the grime of debasement – *animal* love, *mere* eroticism. Nowadays we would clean off some of the grime and with it as well the connotations of love. Erotic entertainment at the Raymond Revuebar in London does not mean a filthy, debased spectacle – nor does it imply a Theatre of Love. The word has come to mean "sexually stimulating".

But again, what is meant by "sexually stimulating"? "If I knew exactly what turns the public on," a strip-club proprietor told me, leaning against his Rolls Royce, "I'd be a rich man." Should we use the word erotic to mean the full range of stimulation – from the fluttering of a Japanese fan to a Mata Hari seduction? Or should we limit it only to the more extreme stimulations? And again, what do we mean by extreme? Those stimulations which lead to an orgasm? But what about those passing moments of sexual pleasure which are not orgasmic? The real problem of finding clear, correct and generally acceptable words lies in the nature of sexual behaviour, which cannot be limited to an act or series of acts. Our sexual behaviour is a thread in a pattern. The pattern is ourselves. When we pick at this thread, when we want to make it seem more prominent or try to pluck it out altogether, we may seem to be solely concerned with the thread. In fact we are altering the whole design. A Christian said to me, "Stimulation which leads to marriage is courtship. All the rest is just eroticism. Extreme eroticism is obscenity." The words have been placed within a total context, an image of society and man. But even if we leave aside those contexts which depend upon religious faith, our definitions still drag along the weight of our background philosophies. If we insist that sex is just a function of the body and that the whole pyramid of custom and taboo has been built to house the dead king God, we are still by implication expressing an opinion as to how man ought to behave. Free love, like free verse, is an abstraction. In practice, it usually means either an attempt to limit the relationship to the few moments of sexual contact, a transaction which is almost ascetic in its restriction, or a general desire to let the relationship develop as its own impetus may dictate – "No strings, eh baby?" In both these cases what may be called "free love" is really nothing of the kind. They are simply two attempts to re-define the transactions which conventionally accompany fucking. They do not do away with transactions altogether. Behind our efforts to clarify sexual language lies a wider struggle to define what man is – that he is solitary, or gregarious, or created in the

image of God, or whatever. To one person, eroticism means the promise of a good sexual meal, and anything else is cant; to another, it implies random stimulation which should be directed towards marriage or "a deeply worth-while relationship". Anything else is indecent.

We cannot ignore these background philosophies, for they influence so directly what we consider to be erotic. Striptease in another context is just an illustrated lecture in anatomy. Nor can we ignore the social nuances which surround our sexual language. I used the word fuck in the preceding paragraph, but did so self-consciously, not because these four letters still retain for me the threat of half-forgotten taboos, but because "fuck" has rolled down so many slopes over the past few years that it is smothered with moss. American theatre communes have invested it with extreme aggression ("mother-fucking bourgeois intellectuals!") or undue reverence ("the holiness of fuck"), while in London, it has acquired a strange social distinction, either of the student underground or of a bland enlightenment which chats about fellatio over sherry. A geography of London could be compiled based upon sexual language and its social nuances. Fucking is the Hampstead word for *copulation* which is the Putney word for what we in Ealing would have called *intercourse* which in Hornchurch is paraphrased euphemistically as *making love* to avoid the Romford vulgarity, *fucking*. In the nineteenth century, fuck, cock, cunt and prick were words to be used by the lower classes when drunk. They represented the ultimate in class degradation. The rehabilitation of these words was not only a belated attempt to release the English language from a pall of prissiness, but it also revealed an eagerness to cut across class barriers. Both these crusades were (to my mind) admirable ones, but if pursued too energetically left the warrior with an odour of sanctity harder to wash off than the ordinary dust of battle.

Even simple sexual words therefore cast long shadows. In our traditionally dualistic image of man – soul and mind on one side, body on the other – our sexual behaviour seems to occupy an uncomfortable pivotal position, being neither obviously physical (like toothache or warm feet) nor mental (like mathematics). For this reason sexual language has a tendency to spread, to get out of control, to absorb areas of experience which (from another stand-point) might seem not to be sexual at all. In that marvellously straight-faced spoof of all sexual surveys (so straight-faced that many libraries still list it as a sociological study), *The Obscenity*

Report – Pornography and Obscenity in America Today, written by two anonymous Washington lawyers and submitted to President Nixon, there are many passages which reveal all too clearly this tendency towards diffusion:

> The stark truth is that the greater the infusion of obscenity into a given community, the less real love in that community. Not surprisingly the very physical characteristics of homes in communities with obscenity problems are sex-orientated. In many, bidets have been added to bathrooms; in others, double-sized baths; in others, red satin sheets hug provocatively sized and suggestively shaped beds. Can children ignore all this?

The Obscenity Report is deliberately preposterous, but its satirical intentions are easily overlooked when placed beside so many other equally silly statements which have been made with the owl-faced solemnity normally reserved for race riots and Vietnam. "Filthy literature," stated the late J. Edgar Hoover, former director of the FBI, "is creating criminals faster than jails can be built," or – from the other side of the argument – "To touch the truth is to touch your genitals!" which was a Reichian headline in the British underground entertainment guide, *Time Out*. Those skirmishes with British theatre censorship in the early 1960s about "fuck" and what constitutes an obscene gesture: now that the dust has settled, what was the fuss about? The road to sexual freedom is littered with non-events. The first step towards clearing away this bluster is the clarification of terms – a task doubly necessary for a book on the theatre, for drama is a complex language in that many forms of expression, other than words, are used.

I use the word theatre widely to mean the live performance of any form of drama, including dance, straight plays, musicals, music hall and pantomime before an audience. I do not intend to venture (except for the sake of comparison) into the fields of film or television. By "erotic" I mean "sexually stimulating", despite the many questions which this definition begs. Something which stimulates me might not interest anyone else.

> One exceedingly peculiar feature of human sexuality from a biological standpoint is its instability of object, and the fact that unless the anxiety-loaded phase of development is satisfactorily overcome, there may be a partial or complete diversion of sexual interest, especially in the male, away from its normal target to biologically inappropriate objects – a part of the body, an article of clothing, or a member of the same sex.
>
> (Dr Alex Comfort, *Sex and Society*, 1962)

Our sexual inclinations have been influenced, if not rigidly moulded, by childhoods which nobody else can share. I use the phrase, erotic theatre, to mean those stage productions where there seems to be a conscious attempt to stimulate the audience sexually. The emphasis is on the word conscious. The director and the cast intend the audience to be stimulated. A director may present an image normally considered erotic – a pretty, naked actress – in a context which deliberately sets out to avoid stimulation. I would not call such a production erotic. Or an actress may inadvertently stimulate notorious lechers, but I would not for that reason describe her performance as erotic. There has to be a conscious attempt to stimulate, but since our individual inclinations subtly differ, the director has to decide on generalized erotic effects. The theatre nearly always presents *consensus* sex. The director chooses either "normal" sexual objects – biologically appropriate ones, to use Alex Comfort's phrase – or "inappropriate" ones which are likely to appeal to a large section of the public. But what is considered normal and appropriate – and abnormal and inappropriate – differs from age to age, from culture to culture. To quote Dr Comfort again:

> If a culture encourages or values a form of sex expression – be it homosexuality or excessive prudery – all those will show it who can: in a culture which discourages it, only those will show it who must.

Erotic theatre therefore relates not only to those sexual inclinations which are actually felt by members of the audience, but also to those social attitudes which determine what ought to be felt. A director may set out to present the sexiest show in town, but in doing so he is likely to reveal a range of political and social attitudes which have nothing to do with his apparent aim. The Raymond Revuebar in London, "the international centre for erotic entertainment", is one of the most middle-class theatres I have visited, from the huge chandelier in the foyer to the strippers themselves, who convey the impression that all women are gilded temptresses on the prowl for successful men-about-town.

Some productions aim solely and singlemindedly to stimulate the audience, all other effects are incidental or suppressed. I call this genre *pornographic* theatre, using the word in a clinical rather than moral sense. Pornography is an aphrodisiac: it is the presentation of a situation or image which is intended to stimulate an orgasm. This sense of the word pornographic may seem to have a limited application for the theatre. It is hard and extremely

uncomfortable to have an orgasm in the best upholstered stalls. But it is possible to store up pornographic images (as a squirrel does with nuts) for use later on. But how do we distinguish between pornographic theatre and those erotic moments in straight drama which may also seem stimulating when we go to bed? The emblem is in the form. Pornographic theatre, like pornographic books, seeks to present images which encourage the viewer towards a sexual climax. All images irrelevant to this purpose – all non-erotic material – are omitted. Once the climax has been reached, the episode is over and the story (if one exists) limps on to the next exploratory stimulation, leading on to the next climax. The form of the work is conditioned by the nature of physical orgasms, and the clearest examples would probably be those from the brothel theatres of the eighteenth and nineteenth century, where madames such as Charlotte Hayes, Louisa Turner and Miss Falkland would stage tableaux and dances to display their girls favourably and stimulate their clients. I would also include most striptease in this category, together with such plays as the London production of *Pyjama Tops*, where the story is just a framework for scenes which differ little from striptease. Full-length pornographic plays are rare, although they exist. Rochester's *Sodom* (1684) might be an example, and so too would the Victorian mock-pantomime, *Harlequin Prince Cherrytop and the Demon Masturbation* (1879). There are stage directions in both plays which suggest that neither were produced:

> . . . in the middle of the garden is a woman representing
> a fountain, on her head and pissing bolt upright . . .

The private aristocratic theatres in France during the eighteenth century – of Prince Philippe d'Orléans and the Duc d'Hénin – staged pornographic plays, although few of the manuscripts have survived. I would be wary, however, of describing Andy Warhol's *Pork* as pornographic, despite the scenes of sexual behaviour which were more extreme than any others presented in a public theatre in Britain. These episodes – of troilism, of a girl seeking new orifices in which to stick her range of battery-run dildos, of cunnilingus and fellatio – were shown within an atmosphere of cool detachment, emphasized by the chattering, inconsequential and wildly funny dialogue. The tone of the production prevented the range of sexual behaviour from seeming to stimulate: it was almost anti-erotic.

My definition of pornography would not be accepted by everyone, precisely because it lacks a sense of outrage. Trevor

Huddlestone, the Bishop of Stepney in London, has defined porno-
graphy as "the commercial exploitation of sex". I have rejected this
definition because I do not know what it means. If it simply means
that sex is being used to secure an economic advantage for someone,
then some marriages could be considered pornographic. If the key
word is not commercial but exploitation, I am still bemused. Many
people exploit sex, particularly sexual guilts and fears, to gain
power or psychological advantage, without providing anything
which is commonly recognized as pornography. Selling sexual
images to stimulate people is only exploitation (and therefore
wicked) if we believe (*i*) that all stimulation is wicked, or (*ii*) that
sexual stimulation should be kept out of the market-place. I am not
sure how this last alternative could be achieved, apart from supply-
ing state-subsidized aphrodisiacs. Or is exploitation a matter of
degree? Is selling a stimulating book at 50p legitimate – at £5
exploitation? Is pornography a matter of cost? Perhaps – but I am
sure that this is not what Bishop Huddlestone meant. He may be
trying to distinguish between artificial and "natural" stimulation.
But it is hard to make this distinction. Stimulation is a necessary
part of the sexual act: the way we talk, the books we read, the
clothes we wear, make-up, fashion and music all contribute some-
times to an atmosphere conducive to making love. This is not to
suggest that pornography can never be harmful, but that it is not
necessarily so. If a man chooses not to become involved with a girl
whom he finds attractive, he may decide to masturbate to relieve
the pressure of his desire. This choice is not necessarily harmful or
immoral – it could be wise. Masturbation works better than a cold
shower. In other situations, masturbation can become an intense,
self-absorbed habit which cuts across human relationships. But to
condemn masturbation because it can be harmful and to ignore
those occasions where it is helpful seems to me a form of supersti-
tion, linked to the old belief that the spilling of seed is tantamount
to the destruction of life. Without an explicit condemnation of
masturbation, it seems illogical to condemn aids to masturbation –
pornography.

Pornographic theatre has a limited form and a clear-cut useful-
ness. But few productions are so single-mindedly erotic. Many
plays include erotic scenes without serving the function of porno-
graphy. I use the phrase, erotic drama, to cover those forms of
theatre where the audience is deliberately stimulated to feel sexual
emotions, but where these emotions are part of the overall impact
of a production which includes other feelings and may not, as a

whole, be erotic at all. *Troilus and Cressida* (particularly in John Barton's production for the Royal Shakespeare Company) is within this category. The audience was supposed to feel sexually stimulated when Helen Mirren as Cressida scampered naked into the wings. We were supposed to feel the longing of Troilus. Without this eroticism, the production would have made less sense. But neither the production nor the play inclined towards the pornographic because these images occurred within a wider logic – that trivial emotionalism leads to anarchy and war.

There is one further category, which I term the theatre of sexual transactions, where the erotic element is present but suppressed, and where the attention of the audience is directed towards the bargains surrounding sexual behaviour. There are two sorts of transactions which I have in mind – those of social custom, and those of private agreements and taboos. I would include in this category the marital drama of the nineteenth century – the transactions of marriage, divorce, the rights of women and men, the social concern aroused by the problems of disease and prostitution. Within the relationships governed by social custom, there are personal transactions, on a less formal and sometimes less conscious level. The taboos which exist, say, within a family to protect a direct clash between a son and his father, can be hidden transactions ("you will obey my authority until you're eighteen"; "I will accept your authority in this matter, but not in that"). The plays of transactions may not be erotic at all. There may be no deliberate intention to stimulate the audience. Indeed the Naturalistic plays in the 1890s which were pre-occupied by the unfair treatment of women were firmly anti-erotic. It may seem unwise to include this vast category in a book concerned with erotic theatre. I have done so for various reasons. I have already suggested that what we consider to be erotic derives not just from our sexual inclinations but also from our social attitudes in general – to which the drama of sexual transactions provides an excellent key. Furthermore, a glance at theatre history reveals that these plays of transactions were often received with an emotional response quite out of keeping apparently with the cool, non-erotic tone of the works themselves. Those plays, such as Ibsen's *Ghosts* or Brieux' *Damaged Goods*, which dared to describe the effects of VD, were hysterically denounced. The theatre was considered not to be the place for such matters to be discussed – before mixed audiences, some of whom might not be married and therefore presumed ignorant of sexual matters.

There was an intense social struggle to improve standards of sexual behaviour, but how could this be achieved? Some considered that the theatre's duty was to present only images of sweetness and light, of happy marriages, virtuous women and honourable men, and to ignore the darker episodes. To present the black side, however unfavourably, was to publicize it. When Brieux expressed the medical view that VD was curable in time but that to marry uncured was a crime against humanity, many felt that this approach lessened the superstitious terror of VD – hence weakening the taboos surrounding intercourse outside marriage. The rational approach lessened the superstitious awe which was considered to hold marriage in place. It was a concealed attack on marriage itself. For a mixed audience to watch this covert attack was to invite the disintegration of the Christian family system. And so *Damaged Goods*, a severely austere thesis play, was banned by the British censor and considered dangerously immoral in France – to our minds a startling judgement. To concentrate on erotic drama and pornographic theatre and to ignore the theatre of transactions would distort the perspective of understanding. Changing the transactions surrounding sexual behaviour was a slow process which was in itself charged with erotic tension. In the 1890s, if a woman rebelled against the marriage laws, she was often considered either to be a *spinster* – that is, someone unlikely ever to have the opportunity to benefit from marriage – or a nymphomaniac who would find marriage restricting. Someone like Agnes in Pinero's *The Notorious Mrs Ebbsmith* (1895), was either fair warning or fair game.

Nearly every society which contains theatre at all – in other words, nearly every society – can offer examples of all three categories. But the proportions and emphases differ greatly, together with what is considered erotic. It is sometimes stated that Paul Derval at the Folies Bergère in 1918 was the first modern Western director to use nakedness as a theatrical effect. After him – the deluge. But this is the sort of fact on which wider opinions totter. The Folies Bergère set a style for spectacular revues in which naked dancers appeared, at first rather statuesquely, supporting huge head-dresses which limited movement, and then, during the 1930s, in acrobatic dances. But throughout the nineteenth century in London, despite censorship and the licensing laws, there were music-hall spectacles known as "poses plastiques", "tableaux vivants" or "Living Statuary", in which girls in revealing tights

posed in scenes depicting *Nymphs Bathing* or *Diana the Huntress*. These music-hall acts, together with the Folies Bergère, were the forerunners of the static nude scenes in the Windmill Theatre revues in London during the 1940s and 1950s, and the touring strip revues of the 1950s which bore titles like *Paris After Dark* or *Strip Strip Hooray*. A young man in London during the 1860s and 1870s who chose not to visit the brothel clubs but wanted to see a woman naked, not in tights, would probably have visited one of Dr Kahn's Anatomy Lectures, which were advertised in music-hall programmes. If we suppose that stage nakedness was suddenly invented as a theatrical effect in Paris in 1918, we are limiting our conception of theatre to boulevard productions. What really changed was the context – from the furtive and masculine to the open and popular, from the private experience to the public.

Different social situations, in short, produce different forms of erotic theatre. It is obviously impossible in any one book to consider all examples of erotic theatre and to relate them to their historical background. The subject is uncontrollably vast. I am limiting my scope to Western theatre over the past 150 years, and am concentrating on topics drawn from two short strips of time hacked from this long cloth, from 1890 to 1910 – and from 1950 to 1972. These two periods present an interesting contrast. Sexual attitudes were rapidly changing in both, but in different directions. Europe, particularly Britain, and the United States would seem by current standards to have been intolerably strait-laced at the turn of the century – despite the echoes of La Belle Epoque during the Naughty Nineties. Today there is a mood of sexual tolerance, although the Kraken of puritanism still stirs. Popular "serious" thought in the 1890s tended to be essentialist in outlook – now it is existentialist. In both periods, substantial efforts were made to improve the lot of women, but in the 1890s the emphasis lay on the vote and legal rights within marriage, whereas today there is an attempt to alter the submissive image of women, to secure complete social and psychological parity for the "second sex".

This contrast is reflected in the theatre. Both periods can be considered as ones of considerable theatrical achievement. The years at the turn of the century saw the rise, and decline, of the naturalistic movement in drama – the last art form to be affected by this aspect of romanticism. In 1889 there was the first British production of Ibsen's *A Doll's House*. Ibsen was at the height of his powers and the swell of his influence, still to write *Hedda*

Gabler (1890), *John Gabriel Borkman* (1896) and *When We Dead Awaken* (1899). On 20 October 1889, Hauptmann's social drama, *Vor Sonnenaufgang* (Before Sunrise), was first performed at a literary matinée of the Freie Bühne, an occasion which "is generally regarded as marking the birth of naturalistic drama in Germany". The Freie Bühne was following the example of Antoine and the Théâtre Libre in Paris (1887–1893) which did much to establish the cause of naturalistic theatre in France and was imitated in turn by J. T. Grein's Independent Theatre in London. These three separate – though inspirationally linked – theatres and companies contributed a new "no-nonsense" approach to questions of marriage, propriety and sexual problems. They were popularly associated with what Beerbohm Tree termed, in a phrase of unpleasant loftiness, "obstetric drama". Each of them presented productions which were considered "shocking" or "daring", and they all suffered from censorship which they opposed with a brilliant articulateness. Nowadays the drama produced by this movement has acquired something of the unfortunate prestige of "classic" drama. It is considered too literary, too formal. The very qualities which allowed Ibsen's plays – and Shaw's – to be read with equal pleasure in the study as to be seen on the stage, are now considered "untheatrical". Drama has to be total, not merely verbal.

We are more inclined perhaps to praise other movements which began in the 1890s. In 1896, Jarry's *Ubu Roi* shocked Paris from its first word, "Shit", onwards. The schoolboy irreverence, anal humour and cheerful anarchy developed later into the mock Academy of Pataphysics, foreshadowed Dadaism, surrealism and the Theatre of the Absurd. "After us," said Yeats gloomily, who saw *Ubu Roi*, "... the Dark Gods". Frank Wedekind, sometimes ranked with D. H. Lawrence for his influence on twentieth-century sexual attitudes, wrote *Frühlings Erwachen* (Spring Awakening), that brilliant and tender study of adolescent sexual behaviour, in 1891: and in 1895 and 1904, he completed the two Lulu plays, *Der Erdgeist* (Earth Spirit) and *Die Büchse der Pandora* (Pandora's Box). It was the age of Strindberg and Chekhov, of Sudermann, Schnitzler, Maeterlinck, Donnay, Bataille, Porto-Riche, Galsworthy, Pinero and Granville Barker; when society drama was in vogue and social drama was trying to push its way through; when George Edwardes was changing old-style burlesque into the new musical comedy, and musical comedy itself was changing under the influence of New York; when the small café theatres in Paris, following the example of the earlier Le Chat Noir and Moulin

Rouge, were becoming a major tourist industry, catering to British and American tourists on uncertain sprees; when the modern repertory movement in Britain began and the Actors' Association in Germany hammered the establishment to improve the lowly status of actors; when the powers of the Lord Chamberlain in London to censor plays were first seriously held in question and when, in Paris, censorship broke its back on the rocklike sincerity of Brieux' plays; when so many attitudes towards drama which we would now call our own were beginning to form – and others (diametrically opposed) were starting to be considered old-fashioned.

These two periods are separated by wider gulfs than mere time, and yet on occasions the chasm narrows, forming uncertain bridges. The general contrast between them is enough to suggest that other questions can be posed. Are there any attitudes towards eroticism in general and erotic theatre in particular which have remained obstinately the same? And if there are, what does this constancy among the variables reveal? The persistence of our prejudices? Or is there a much-needed sun against which the revolution of the years can be measured? If this sun exists and can be observed through however dark a glass, it may yet provide a focal point against which the changing angles of taste can be gauged. The meaningless controversies over "permissiveness" in contemporary theatre arrive at their foreseeable deadlocks precisely because there is too little common understanding as to what has happened and what has not. The basic language is missing in which the debate can be fruitfully conducted. The search for this language is fundamental to this book.

2

The Insolent Mistress

In one respect the theatre during the nineteenth century was more erotic than our own. The whole profession carried with it an air of raffishness and scandal. This notoriety had little to do with actual plays and productions which, when they did shock, more often provided the excuse for a prejudice than the cause of it. The theatre rubbed respectability up the wrong way not for what it did but for what it seemed to be: without status, inherently useless, falsely alluring, ostentatious and, above all, licentious. It was the obvious profession for Wedekind's Lulu, for Zola's Nana, for the demi-mondaine on her way to security as the kept woman of a count. Nor were only actresses disreputable. Mary Brodribb, Henry Irving's mother, would have nothing to do with her son from the moment when, at the age of eighteen, he decided to go on the stage. Later, when Irving became famous and had married Florence O'Callaghan, his wife would attend his first nights and inquire on the way home, "Are you going on making a fool of yourself like that for the rest of your life?"

But from this unprepossessing image, the theatre eventually derived an unexpected strength. By being the very opposite of what middle-class society was supposed to admire, the theatre came to represent an alternative to bourgeois standards, less violent and dangerous than outright criminality, more acceptable than revolution and always apt to be borne aloft by a fashionable wind of change. Rebellious sons, bored husbands and frustrated wives turned to the theatre to kick against the traces. Baron von Essen divorced Siri, who later married Strindberg, not because of her lovers, but because she chose to go on the stage. Attraction to the theatre was a warning signal that some member of the family was sliding away from domesticity. Every actor and actress – but particularly the managers among them – had to adjust to this

surrounding notoriety: either by emphasizing his or her personal respectability, or by riding the scandal elegantly like a red horse. And when the standards of respectability themselves came under attack (as they did in the late nineteenth century and have been ever since), the reputation of the theatre improved by contrast. "The artist, the criminal and the confidence trickster," wrote Thomas Mann, "have very similar minds," but the alternative was to be bourgeois, which was usually taken to mean someone solidly complacent of his surroundings, blandly accepting all the hypocrisies and social restrictions, blind to blatant evils.

This notoriety differed little from country to country and was caused by a combination of factors: the social and economic insecurity of the theatre, a certain lofty attitude towards the idea of "game", a belief that the "falseness" of the theatre contradicted the search for truth, and an awareness that the "glamour" onstage sharply contrasted with the tattiness off. In Germany, the theatre was most respectable. The glorious memory of Goethe and Schiller sustained a concern for drama among serious writers at a time when elsewhere in Europe plays were considered a literary medium far inferior to novels and lyric poetry. The organization of the nineteenth-century German theatre most nearly resembled the modern repertory movement. The various court theatres, "Hoftheater", rivalled each other in the splendour of their productions; and so did the town or municipal theatres, "Stadttheater", who would often find that councils would be prepared to increase their subsidies rather than see the standards slide. There was also a variably thriving commercial theatre, but the touring theatre companies, the staple source of employment in Britain and France, suffered badly in competition with the Hoftheater and Stadttheater. They visited small towns without established theatres, often playing in cafés, squares or halls with makeshift stages. By the turn of the century, there were 15,000 actors and actresses in Germany playing in established theatres, and the touring companies were not counted. But the situation of actors and actresses within these companies was miserable: the wages were low – equivalent to £10 a month – and they were considered to be domestic servants. The same laws governing the relationship between masters and servants applied to them. They suffered from the vulnerabilities of maids and chauffeurs; actresses were at the mercy of their employers. In France, there was a sharp distinction in respectability between members of the two national companies, the Théâtre-Française (Comédie-Française) and the Odéon, which

ruled themselves according to the most severely bureaucratic principles, and the other theatres – the boulevard and café theatres. The provinces were supplied almost entirely by touring companies, supposedly emanating from Paris. In Britain, actors were regarded as little better than vagabonds. They were treated with the same mixture of envy and suspicion given at one time to gipsies and later to commercial travellers. It was a prejudice enshrined in law. Walpole's Act of 1737 (which provided the legal precedent for most later laws relating to stage censorship) is called "An Act for reforming the laws relating to rogues, vagabonds and sturdy beggars, and vagrants, and sending them whither they ought to be sent, as relates to the common players of interludes." In Pinero's *Trelawny of the Wells* (1898), which is set in the theatre world of the 1860s, Sir William Gower, representing polite society, refers to all actors as "gipsies", his only concession to theatrical achievement being that some actors are "splendid gipsies".

With the exception of Germany, therefore, most acting companies suffered from a social exclusion which was largely the result of their economic circumstances. In Britain, this travelling was mitigated in the eighteenth century by the protection of local landlords and the presence of settled provincial circuits: but it was not until the mid-nineteenth century that companies other than the lucky few could settle down in a large town and bank their nightly take. Because they were wanderers, actors avoided some of the restrictions of a settled community, but could enjoy few of its benefits either. An actress might be able to take a lover without shocking her family: but she had not much defence against the young man who might leave her with child. Indeed such was the reputation of actresses, the sympathy of the courts might well lie with the young man and his family. Bills had to be paid in advance, except where tradesmen and landladies were known to be sympathetic. In towns belonging to some touring circuit, small theatrical communities might develop – not dissimilar to the Red Room community in Stockholm which Strindberg described – which were sometimes rather carefree places, little Bohemias, but more often tatty and inward-looking, regarded with suspicion by the rest of the town and retorting with a defensive disdain. These uneasinesses were permeated with sexual tensions. Actresses were regarded often as smarter-than-average whores, but unlike ordinary prostitutes, where you paid your money and took your chance, actresses were cunning and devious, luring the young man into a

hall of mirrors where the transactions of the outside world were reflected and distorted, not resting until they had robbed a youth of his patrimony, and then off – to another town.

The semi-documentary fiction of the period – such as Heinrich Mann's *Die Kleine Stadt* (The Little Town, 1909) or Strindberg's *Röda Rummet* (The Red Room, 1897), both of which deal with the impact of theatre companies on small towns – contain stories which follow this general pattern. A young man falls in love with the heroine of a melodrama – an actress young and protectable who is terrorized (in the play) by the villain and (in real life) by the manager of her company. He is introduced to her and they meet secretly: Romeo and Juliet, torn between the warring factions of his bourgeois family and her domineering employer. He gives her presents and dresses – and together they plan to elope. But he discovers at the last moment that she is not really a virgin about to be eaten by a dragon: she has had lots of lovers and she is married to the manager. She has been playing the courtship game, helped by the manager, simply to get as much as she can from him. His Sir Galahad rôle has been wasted. She disappears overnight with the rest of the company who leave debts behind them, and he returns home a sadder, wiser and much poorer man. Stories like this had another effect apart from warning young men – they also toughened the cynicism with which actresses were treated. Strindberg and Heinrich Mann were both sympathetic to the bohemians: if they conned the bourgeoisie, it was because these timid, puritanical, pampered sons of shopkeepers deserved to be conned. But elsewhere in fiction, the lesson was taught that actresses were artists in sexual duplicity, and deserved to be treated roughly. In life, this lesson was practised. William IV abandoned Dorothy Bland ("Mrs Jordan") after she had borne him 10 children and they had been lovers for 20 years. She died destitute in France in 1815. Affairs with actresses were battles in the sexual war, free from the moderating influence of social custom.

In times of stress, actors had to live by their wits or their bodies. "Can you starve?" Kean asked an aspiring young actor, inquiring about his talents. "I am an actress," said Nina in Chekhov's *The Seagull* (1896). "Tomorrow morning early I must leave for Eltz by train in a third-class carriage, with a lot of peasants, and at Eltz the educated tradesmen will pursue me with compliments. It is a rough life." Nina was de-classed, a vulnerable situation in a rigidly class-structured society. She belonged nowhere. Nowadays

we might be tempted to sentimentalize her state of almost existen-
tial freedom. Away from bourgeois restrictions, she could choose
her own destiny. If we do adopt this attitude, we have the dubious
comfort of knowing that it was also shared by the Victorians.
Together with the cynicism towards actresses, there was also
considerable envy. The popular image of the actress in the nine-
teenth century was of someone whose beauty enabled her to
ignore conventional marriage transactions, unless she wished to
use them for her own purpose. Examples from real life to support
this image were never lacking. Many of the courtesans in Paris
during the Second Empire began their careers on the stage,
attracted wealthy and aristocratic lovers and acquired fortunes
which enabled them to live in a style of unparalleled magnificence:

> In the last five years of the Second Empire, from 1865 to 1870, Cora
> (Pearl) reached her dazzling zenith. She was so rich that her jewels
> alone were worth a million francs, she had two or three houses fur-
> nished quite regardless of expense, and she showed the lavishness of
> all the *grandes cocottes*, choosing some of her clothes at Worth's,
> giving stupendous entertainments, grand dinners, masked balls and
> impromptu suppers (at which the peaches and grapes did not rest on
> the usual vine leaves, but on fifteen hundred francs' worth of Parma
> violets). She threw herself into the febrile life of the Second Empire.
> Early in 1866 she appeared as Eve at a fancy-dress ball at the Restau-
> rant des Trois Frères Provençaux. She looked very well, reported an
> English journalist, "and her form and figure were not concealed by
> any more garments than were worn by the original apple-eater". On
> 26 January 1867, she appeared at the Théâtre des Bouffes-Parisiens,
> as Cupid in Offenbach's comic opera *Orphée aux Enfers*.
>
> (Joanna Richardson, *The Courtesans*, 1967)

The great days of the *grandes cocottes* ended with the defeat of the
French at Sedan in 1870, and the journalists in Paris during the
1880s noted their decline:

> The courtesan of our day has gone democratic like everything else.
> Under the Empire, she belonged to a few; today she belongs to
> everyone.
>
> (Albert Wolff, *Mémoires d'un Parisien*, 1888)

But the legend of the courtesans did not fade away. They had,
after all, encouraged Alexandre Dumas (*fils*) to coin a new word –
demi-monde. Plays and novels were written about them, notably
Dumas' *La Dame Aux Camélias*, which was based on the life of
Marie Duplessis, and Zola's *Nana* (inspired by Blanche d'Antigny).

La Dame Aux Camélias (1852) was considered thoroughly immoral in Britain, for it presented a sympathetic portrait of the demi-mondaine – as a victim of society. It was banned by the censor, although it was staged in a modified form as *Heartsease* and in Verdi's opera, *La Traviata*. *Nana* (1880) was considered totally degraded, for here the demi-mondaine is portrayed as a revenging agent of class hatred. The actress-courtesan, as Joanna Richardson has pointed out, helped to produce a minor social revolution:

> In the days of Louis Philippe (1830–1848), the courtesans did not appear in broad daylight; they did not have their civil status and their place in the sun. But during the Second Empire, the mondaines and demi-mondaines had begun to crush shoulders with each other at charity balls and races. At first sight they were identical women, dressed by the same couturiers with the subtle difference that the demi-mondaines had more *chic* than the mondaines (indeed it was then that the word *chic* came into fashion among women).

The courtesans blurred the distinction between beautiful women of low birth and those of high, but to be successful they usually required the shop-window of the theatre.

This image of the actress demi-mondaine was widespread throughout Europe. She appears as a stock character in Schnitzler's plays (set in Vienna), in the plays of Bataille and Porto-Riche (in Paris) and has slowly become transmuted into the Hollywood Movie Star. The Gaiety Girls in London during the 1890s who married into the aristocracy were objects of admiration, wonderment and much unmerited scandal. Despite their social successes, they still inhabited a half-world towards the turn of the century – neither within society nor totally without. In 1881, the Prince of Wales persuaded Ferdinand de Rothschild to hold a midnight supper party for his mistress, Sarah Bernhardt, but the occasion was a disaster. None of the fashionable wives would speak to her – but could she, who occupied a place so close to the heart of society, lower herself to mingle with mere parvenus and merchants? Seymour Hicks, the Edwardian actor-manager, kept wives and demi-mondaines in separate mental compartments: demi-mondaines were "fickle, elusive and as unreliable as they are beautiful ... good fellows of a few months." They suffered, even during the moments of their triumphs, from a profound social exclusion.

This exclusion however was not without its own rewards. An affair with an actress demi-mondaine represented an alternative to Christian marriage, although it was not, of course, an alternative which many could afford. The system – both for men and women –

had many advantages. It was not necessary to enter into complicated family bargains to have an affair with an actress, although it
was a matter of mutual pride to see that she was well-dressed and
protected. In marriage, wives were presumed dutiful and virtuous;
demi-mondaines were presumed otherwise – and this distinction
was of importance at a time when William Acton's *Treatise on the
Functions and Disorders of the Reproductive Organs* (1857) was still
a popular textbook on sex, an eighth edition being published in
1894. In it Acton asserts:

> . . . the majority of women (happily for them) are not much troubled
> with sexual feeling of any kind . . . I admit, of course, the existence of
> sexual excitement terminating in nymphomania, a form of insanity
> which those accustomed to visit lunatic asylums must be fully con
> versant with; but with these sad exceptions, there can be no doubt
> that sexual feeling in the female is in the majority of cases in abey
> ance . . . Many men, and particularly young men, form their ideas of
> women's feelings from what they notice early in life among loose, or
> at least, low and vulgar women . . . Any susceptible boy is easily led
> to believe, whether he is altogether overcome by the syren or not,
> that she, and therefore all women, must have at least as strong
> passions as himself. Such women however give a very false idea of the
> condition of female sexual feeling in general.

And so any woman who enjoyed sex must either be half-way
towards nymphomania or low and vulgar, in other words not
suitable for marriage. But these considerations did not apply to the
demi-mondaine. The demi-mondaines felt free to admit their
sexual enjoyments and men were aware of a heightened pleasure
which comes from the satisfaction of knowing that his partner is
not merely being dutiful. In Donnay's *Amants* (1895), the retired
actress heroine, Claudine Rozay, initially states categorically that
she prefers to be a demi-mondaine rather than a wife. She has
freedom, she is not a prostitute, she is supported by two lovers,
and should either of them become jealous or possessive, she can
return to her professional career on the stage. Actresses, because
they had a career, could assume some parity with men. They were
not necessarily dependent on their lovers. The problems came, of
course, when there were children, but even then, Donnay leads us
to believe, the solutions were not uncivilized. The demi-mondaines
clubbed together to look after the children when their mothers
were working. If their lovers were generous they could afford maids
and governesses. The great merit of the demi-mondaine system
was that it offered sex outside the cumbersome, property-minded

transactions of marriage and without blatant class exploitation. One of the most unpleasant aspects of *My Secret Life*, the Victorian diary of extra-mural sex, is the assumption of the author that any maid or factory girl could be bought for half a crown – simply because the wages were low and the practical needs so enormous. With an actress demi-mondaine, a lover was expected to be attentive: she was considered more independent and less easy to exploit.

Only the more glamorous actresses, however, could aspire to the ranks of the demi-monde. If run-of-the-mill actresses were classed at all during the nineteenth century, it was with the higher echelons of prostitution. An uneasy relationship had existed between the stage and prostitution which dated back to the time when actresses first started to replace young male actors impersonating women on the public stage. Queen Anne passed a law forbidding members of the public to go backstage during the course of performances – it was feared that the green room was being used for orgies in the interval. Macready in the 1830s imposed severe social restrictions on his actresses and had a struggle to drive the prostitutes from the auditoriums of Covent Garden and Drury Lane. The King's Theatre, Haymarket, was known then as Fops Alley. "Of all places," ran a contemporary account, "for downright lasciviousness and intemperate intrigue, there is nothing in London to equal the King's Theatre. Amost all the ladies in their turn fall victim to the Venus-like atmosphere." This was where Louisa Turner danced, who afterwards became a famous whore and madame. The Argylle Rooms in London during the 1860s was described by Henry Mayhew in *London Life and London Poor* as a centre for prostitution. The music hall emerged from the brothel. D. J. Kirwan, the London correspondent for the *New York Times*, evoked the scene in language both vivid and disapproving:

> Women, dressed in costly silks and satins and velvets, the majority of them wearing rich jewels and gold ornaments, are lounging on the plush sofas in a free and easy way, conversing with men . . . While we are standing (looking at them) the room is darkened and a chemical light coloured flame irradiates the room like twilight at sea, and the entire female population rush below to join in the last, wild, mad shadow-dance of the night. Around and around they go in each other's arms, whirling in the dim uncertain graveyard light, these unclean things of the darkness, shouting and shrieking, totally lost to all shame – their gestures as wanton as the movements of an Egyptian Almee and as mad as the capers of a dancing dervish.

The café music halls during the 1880s and 1890s exerted the same complicated attraction – the mixture of shame and fascination – for the Parisian (the "dim, uncertain, graveyard light" can be seen in the paintings of Lautrec). At the turn of the century in London, the Alhambra and Empire Theatres in Leicester Square were famous not only for their spectacular international variety, but also for the promenades at the back of the circle. They provided, according to A. E. Wilson, "a gilded rendezvous for the man about town and moneyed seeker after pleasure". "The auditorium of a theatre," wrote Shaw in 1909, "with its brilliant lighting and luxurious decorations makes an effective shelter and background for the display of fine dresses and pretty faces. Consequently theatres have been used for centuries as markets by prostitutes." The Argylle Rooms in the 1860s and the Alhambra and Empire Theatres in the 1900s were expensive, elegant places: the women were fashionable – the men were rich. Other theatres lacked the same glamour. Shaw described them:

> Some of the variety theatres [in London] still derive a revenue by selling admissions to women who do not go to look at the perform- ances and men who go to purchase or admire the women. And in the provinces this state of affairs is by no means confined to the variety theatres. The real attraction is sometimes not the performance at all. The theatre is not really a theatre. It is a drink shop and a prostitu- tion market: and the last shred of its disguise is stripped by the virtually indiscriminate issue of free tickets to men. Access to the stage is easily obtained: and the plays preferred by the management are those in which the stage is filled by young women who are not in any serious technical sense of the word actresses at all . . . it is an intolerable evil that respectable managers should have to fight against the free tickets and disorderly housekeeping of unscrupulous competitors.

At the turn of the century, as Shaw pointed out, a whore picked up by the police would probably have given her profession as "actress".

Nor was this term entirely misleading, for nineteenth-century brothels often staged productions which differed little from those provided by some strip clubs today. In the eighteenth century, the organizers of the shows at the Almack's Club went in for oriental pomp, sometimes with aquatic spectacles featuring water nymphs. In Amsterdam, Mrs Prendergast invited her clients to *Billiards at Half Past Nine* – an invitation which could be safely shown to one's wife, for it did not specify that the cues would be handled by twelve

young Dutch girls, naked and able to interpret the rules of the
game with imagination. Charlotte Hayes once sent around a notice
to her regulars which read:

> Mrs Hayes commends herself respectfully to Lord — and takes the
> liberty of reminding him that this evening at 7.00 precisely 12
> beautiful nymphs, spotless virgins, will carry out the famous feast of
> Venus, as it is celebrated in Tahiti, under the instruction and leader-
> ship of Queen Oberea.

The feast was based on an account from the memoirs of Hawksworth,
one of Captain Cook's travelling companions, and the girls were
eventually ceremonially fucked by the clients who wanted to
do so and also by some sailors imported for the occasion. Twenty-
three clients attended, five from the House of Commons. There
were many similar places. Miss Falkland, another madame, owned
three – the Temple of Mysteries, the Temple of Flora and the
Temple of Aurora. These brothel clubs differed little from those
which can be found today – in Japan, Europe and the States –
except perhaps that the voyeuristic element is stronger today and
participation less commonplace. This is probably because these
countries have stronger laws against brothels than they do against
strip clubs. In the nineteenth century, this distinction was not
made. The girls of the brothel clubs could regard themselves as
"actresses" in various ways. They took part in staged erotic
pageants – such as the feast of Venus. Often, too, their private
sessions with clients were watched by spectators from whom the
madame would derive an extra income. Mrs Berkeley had special
viewing windows above the "punishment room" in her establish-
ment, where spectators could watch her clients being horsed over
an easel to be flogged – or sometimes lying on a naked girl to be
beaten and brought to orgasm at the same time. She also employed
girls, such as Big Bertha, who liked to be beaten – and was slightly
more careful with their health during a flogging than some manage-
ments are today in Japan, where the sadism of these spectacles can
sometimes reach frightening proportions. Also, of course, girls were
"actresses" in truly private sessions – in that they would dress up
as maids, governesses, ballerinas and so on, to suit the client's
inclinations. "Theatrical Wardrobe for Sale" is still a call-girl's sign
in newsagents' windows.

Not only, therefore, were theatres used as markets by prostitutes,
but also brothels turned themselves temporarily into theatres.
Even polite theatres – from whose auditoriums the prostitutes had

been driven and whose managements imposed severe restrictions on the social lives of actresses—were not entirely free from this guilt by association. Theatres in the nineteenth century often stood physically in the red-light districts, side by side with brothels in a notorious street. The theatre was a sort of pilot fish to the sharks and whales of the other world. The Palais Royal in Paris before the Revolution was one such area, the Tiefen Graben in Vienna was another, and so too in eighteenth-century London were Covent Garden, Goodman's Fields and Drury Lane. Today there is a similar association in Soho, parts of Copenhagen and Hamburg, but nowadays we would make a sharp mental distinction between those reputable theatres on Shaftesbury Avenue and the less reputable ones on the backstreets not a hundred yards away. At other times, such geographical distinctions have been harder to make, or when drawn have carried connotations of class and expense rather than respectability. It was sometimes necessary to emphasize the worthiness of the theatre in contrast to its surroundings. The manager, John Hollingshead, described Cranbourne Street near Leicester Square (where Daly's Theatre opened in 1891) as a place where "the sweepings of the Low Countries own the right of way and its proper name is not Cranbourne Street, but Moll Flanders' Parade." But the theatre was built for a highly respectable American actor-manager, Augustin Daly, and its design was "discreet and dignified", like a "solid dining or banqueting apartment".

Thus the theatre in the nineteenth century swam in a whole sea of sexual associations from which it only gradually towards the end of the century began to crawl. If a theatre was not obviously dry, it was assumed to be wet. There were several dry theatres in the 1890s in London: Her Majesty's under the management of Beerbohm Tree, the Lyceum with Sir Henry Irving, St James's with George Alexander; some dampish: the Gaiety and Daly's, both managed by George Edwardes; others elegantly wet and gleaming: the Alhambra and the Empire; still more, cheerfully soaked and dishevelled: the Standard, Shoreditch, and the Britannia, Hoxton; others, aquatic or drowning. There were also some amphibious theatres, changing from management to management, but this was a dangerous situation, for genteel audiences would be alienated by an untimely touch of bawdry and primness was the common target of comedians in music halls. The only way to ensure that the product of a theatre would find the right audience was to develop, often slowly, by trial and error, a certain image for the place itself,

which meant in particular controlling its class and sexual associations. This involved a struggle for managements which they fought with a grim determination – for if the theatre had been allowed to assume completely its mantle of notoriety, if it had remained perpetually in the state of half-ostracism, the security of the profession would permanently be at stake. Queen Victoria herself was criticized for visiting a production of Boucicault's *The Corsican Brothers* (1852). The dramatist Henry Arthur Jones in 1906, on a visit to Harvard, denounced "the insane rage of Puritanism that would see nothing in the theatre but a horrible unholy thing to be crushed and stamped out of existence". Managers were determined, if their theatres had any pretensions towards respectability, to throw no meat of scandal towards the eagerly snapping teeth.

But the raffish image of the theatre was not a total disadvantage to the profession. On the contrary it provided a built-in appeal for the product. At a time when mere play was held in disfavour, the sexual associations of the theatre provided a strong, super-rational attraction for the product. At the turn of the century, an attractive girl could acquire the double-edged fame of a demi-mondaine simply by walking across the boards of a stage, and the man who bought her a drink afterwards would feel himself a daredevil. We handed to the theatre a mystique composed of hidden and socially unrealizable desires. This fascination was often elevated into an unreal glamour, but was also susceptible to arch paternalism – such as that revealed by censorship – or downright disapproval. The art form was like a mountain surrounded by rosy-pink, sickly clouds. The naturalists tried to blow them away, but they can still be seen on sullen evenings in Paris or London, hovering just beyond the statue of Eros, somewhere above, among the lights which flicker and fuse.

"The novel," Chekhov once wrote, "is the writer's legitimate wife, the stage is a noisy, flashy and insolent mistress." Such metaphors are not chosen by accident. They reveal more than the impatience of a dramatist with his insecure profession or Shaw's fascinated disapproval of auditoriums haunted by prostitutes. Rather they reveal the mixture of longing and repulsion felt by the outsider towards a world where success had to be ostentatious because failure was pathetic and without excuse, where there was no plateau of normality where one could live without anxiety, where men and women existed like children by pleasing others and were forced to change manners, appearance and opinions to the mood of

the market, where ordinary dignity had to be stressed until it seemed ridiculous, where constant relationships were considered almost impossible and transitory ones too cliché-ridden to be interesting – very like an unhappy affair. Like mistresses, the theatre offered the double attraction of sex unrestricted by normal social conventions, but this freedom brought with it an isolation and insecurity. "Theatres," wrote Chekhov, ". . . are the evil disease of our towns." Shaw said much the same, and so too did Strindberg. In Porto-Riche's play, *Amoureuse*, the wife Germaine is astonished that an actress she knows does not behave like a whore. Even in the 1950s, we would add the phrase, "As the actress said to the bishop . . ." to some trivial remark and watch the sentence flower into bawdry.

From this muddle of unreal glamour and social insecurity, the modern repertory movement was eventually born – with its emphasis on balanced companies (no stars), mixed programmes (each play good of its kind) and social integration with the community. In the late nineteenth century, repertory companies were still gleams in the eyes of professionals such as Frank Benson. Most managements were trying to select from the confusion a settled image for daring or good taste, which could then be marketed to a particular section of the public. If we go to a theatre today expecting it to be sleazy, a comedian can turn a sentence into innuendo with a slight emphasis; in another theatre, in a different environment, the audience would miss the point – or find it unbearably vulgar. Similarly an actress in one theatre can convey with a light smile all the possibilities of a week in Brighton; elsewhere the smile might be misinterpreted as charm. Our expectations condition our response – and the modern repertory movement cultivates a bland non-committal image simply to prevent the company programmes from being too stereotyped by audience expectation. But Edwardian theatres pulled in the opposite direction and most managements emphasized the image which they wanted to acquire. If we look back at those postcards of actresses, which were sold in their thousands to the young men who collected them, much as pin-ups were later and porn is today, we are aware that they carried around with them the weight of their context. Because this girl had appeared at the Gaiety or the Alhambra, her photograph was fair game for our fantasies: and the significance of these photographs is that they subtly controlled the fantasies, hinting at possibilities in one direction or another. A haughty expression and a large hat, wild eyes and crinkled untidy hair, masculine neatness

and a riding crop – when eroticism is assumed the deviations need not be stressed.

On reading memoirs of the period, playbills and contemporary reviews, one is struck by the sheer burden of sexual fantasy which actors and actresses were doomed to drag around. Miss Bessie Bellwood was "the barmaid who only gives the public what they want". Less blatantly – and in a different area of the class spectrum– Julia Neilsen was "a romp, a delicious hoyden", "a joyous creature abounding in life"; Marie Tempest was "a dainty rogue in porcelain" (the critic A. B. Walkley coined the phrase "roguey poguey" for her); Constance Collier was "goddess-like"; J. T. Grein, that solidly intelligent manager, praised the "winsome womanliness" of Ellen Terry; Mrs Patrick Campbell had "nothing commonplace in her emotional make-up – [she played] highly strung women, women of splendour, magnificence – extravagant creatures who were all nerves and fascination." To praise actresses in these terms – which are to my mind both excessive and oddly inhuman – became almost the occupational disease of theatre critics, who would apply them to any woman who had stepped a little beyond the régime of children, church and cooking. Max Beerbohm described a court appearance of Christabel Pankhurst (of all people) like this:

> ... put the wood nymph in the dock of a police court and her effect is quite wonderful ... no, that is a misleading image. The wood nymph would be shy, uncomfortable: whereas Miss Pankhurst in her barred pen seemed as comfortable and self-possessed as Mr Curtis Bennett on the bench. And as she stood there, with her head inclined merrily to one side, trilling her questions to the Chancellor of the Exchequer, she was like nothing so much as a little singing bird born in captivity.

It was easy for an actress – or a suffragette portrayed through the eyes of a theatre critic – to be called a wood nymph, a creature, a goddess, a hoyden or whatever; hard, much harder, for her to be accepted as an intelligent woman. They were, in short, male sex objects – and while it is fun for either a woman or a man to be considered on occasions as a sex object, it is a rôle which becomes tedious if one cannot escape from it. If we find Shaw's heroines rather tiresome with their down-to-earth commonsense and debating skill, it is partly because we do not see them against this background. And if we half-close our eyes when looking at this exotic parade, the figures become vaguely familiar. From contem-

porary publicity stills? Partly – but also perhaps from Genet's *The Balcony* and Warhol's New Hollywood. Few actresses carry around with them today the sort of sexual grand piano which Mrs Patrick Campbell could play at any party. They can still play the piano, but it is not built into their image as a deformity. Helen Mirren and Billie Whitelaw? No. Elizabeth Taylor? Perhaps – but for the screen not the stage. The best example perhaps would be the British drag comedian, Danny la Rue. If we compare two contemporary portraits of actresses – one from the *Guardian* about Diana Rigg and the other from *Penthouse* about Lynn Partington who is considering taking up the stage as a career – it is the *Penthouse* description which most nearly resembles the sort of praise customary in Edwardian criticism. And *Penthouse* is, of course, a magazine for men and the blurb on Lynn Partington was the prelude to a gatefold of tempting pictures:

> At 33, Miss Rigg is a serious woman who has little time for pleasantries or flippancy when there is work to be done. She had arrived in a restaurant from the National Theatre, where she is rehearsing Tom Stoppard's new play *Jumpers*, sat down, lit a cigar, and having rejected the menu, snapped out an order to the head waiter for just an "omelette aux fines herbes – baveuse".
>
> (*Guardian*, 14 January 1972)

> Once upon a time in a grey and wintry kingdom hard by the river Thames, there lived a young lady whose fairness of face and loftiness of principle so impressed the presiding chronicles of such things that they wafted her away to an enchanted castle far to the south. There, amid the first downy days of autumn, they distilled her comeliness in portraiture of peerless craft and infinite refinement.
>
> (*Penthouse*, December 1971)

The *Guardian* portrait is possibly too self-consciously nonglamorous – to counteract perhaps Miss Rigg's reputation as the black-leather, karate-chopping Miss Peel, her rôle in the television *The Avengers* series. The other is self-consciously exotic – as if to emphasize that such women are rare, pearls beyond price.

Nor were actors exempt from the Edwardian exoticism. George Alexander played "the typical well-groomed Englishman: he carefully eliminates all trace of vulgar humanity from his acting. He behaves on the stage as any perfect gentlemen would off it." Charles Hawtrey was a "well-bred, well-groomed, well-fed man of

the world of the utmost glib charm who would blandly lie himself
in and out of trouble". The perfect gentleman and the perfect cad –
two sexual stereotypes. The actor's search for a sexual image which
was distinct and marketable and yet would be capable of adjust-
ment from play to play, also affected casting. In Paris during the
1860s, M. Ricour, the manager at the Ecole Lyrique, would line
up his new actresses – nez-retroussés on his right, the Greek and
Roman noses on his left – and make them pronounce two invented
words "éléganté" and "superbatandur". From these simple tests,
he would decide, "You, my child, are a tragédienne – you are an
ingénue," – and dispose of their careers accordingly. This rather
external approach to the problems of casting – as a glance at the
captions in *Spotlight* confirms – is not entirely dead: but it is
gradually being considered old-fashioned. Few actors and actresses
would wish to be condemned to play sexual stereotypes – although
often they are. It would bore them and also be considered vaguely
insulting to the arts of acting. They would prefer to work within a
major repertory company – such as the Royal Shakespeare Com-
pany – where the directors are keen to maintain a suppleness of
approach by giving them various types of parts. Most provincial
repertory theatres in Britain try to show "mixed" programmes,
ranging from music hall to Shakespeare, in which the likelihood of
any one actor being condemned to play endlessly the dandy, the
cad or the juvenile lead, is remote. Actresses do not have to make
this awkward break from being an ingénue (before 30) to a char
(after 30). In the nineteenth century, to possess a strong sexual
image was one way of ensuring continuity of employment. Today
an actress who possessed such an image, might well find that her
opportunities were restricted.

This is, however, the favourable side to the story, for in the less
successful regions of the profession the erotic image of the theatre
led to an intolerable exploitation – by managers, casting directors,
theatre proprietors and stage-door Johnnies. To avoid being
treated as a whore, an actress always had to be on her guard.
Ballet-dancers in particular were notorious and therefore fair
game. In England, the fame of the Venetian courtesan was spread
through the many small and needy Italian ballet companies: but
from the first ballet production imported from France, *Pygmalion
and Galathea* (1734) in which the girls wore tights beneath short
skirts and dresses, dancing was considered to be little more than a
way of attracting army officers. The glories of the Romantic
Ballet in Paris were imported into London in the 1820s, but

without altering – indeed they exaggerated – the general reputa-
tion. French, Italian and German ballet-dancers were particularly
popular with the young bucks who frequented the Kings Theatre,
Haymarket, in the 1830s. English girls were badly paid even in the
backstage transactions – and with good reason, for the allure of the
costumes, skimpy and revealing by the standards of the times, the
movement and glamour of the stage attracted girls to the *corps de
ballet* who were not dancers at all. Some worked in factories by
day: others were prostitutes.

The "innocent" ballet girl occupied a peculiar place in Victorian
fiction, which probably reflected similar attitudes in daily life. She
is often represented as a fragile waif, drawn towards glamour and
destroyed by it:

> The three old ladies gave each a little scream.
> "A ballet-dancer!" cried the eldest.
> "With such short petticoats, Mabel!" said Miss Lilian reproachfully.
> "Dancing in public on one toe!" exclaimed Miss Priscilla, holding
> up her hands . . .
>
> "We are sorry, Mabel Preston," began Miss Wentworth, "we are
> sorry for you, but you must get work elsewhere. We cannot have our
> nephew, Captain John Wentworth's shirts made by a ballet-dancer.
> It would be setting the young man far too bad an example."
>
> (*Chambers Edinburgh Journal*, 1853)

It was a myth which had some terrible consequences. Ballet-
dancers in the nineteenth century would wear loose-fitting skirts
and petticoats with the hem just below the knee. The Lord
Chamberlain in the 1870s decreed that the length of the skirts
should not be less than thirty inches. These muslin skirts were
highly inflammable, and the stages were lit until the 1890s mainly
by gas-lamps and burning torches. Often a skirt would drift
against a lamp and burst into flame, burning the girl perhaps to
death before the fire could be extinguished. Accounts of such
deaths – of Julia McEwan, Fanny Smith and others – appeared
with unpleasant frequency in the press from the early nineteenth
century to the 1880s, at least fifty years. "Hardly a month passed,"
wrote Ivor Guest in *The Victorian Ballet Girl*, "without some-
where another victim being added to what one journal termed 'the
holocaust of ballet girls'." The dangers struck the *corps de ballet*
and the stars alike: Clara Webster, the hope of English ballet, was
burnt. Emma Livry, the first ballerina of France, died in flames.

All these accidents could have been avoided. Ways were known to fireproof material, and in any case, managers could have kept the dancers away from the flames. The lamps could have been protected by wire guards. The prompter, as the *Illustrated London News* suggested, could have carried fire blankets. But these elementary precautions were never taken. Dancers preferred not to sully their dresses with a solution of alum and managers surrounded their dancers with flame. "The very first time," explained Mr Crummles in *Nicholas Nickleby*, "I saw that admirable woman, she stood upon her head on the butt end of a spear, surrounded by blazing fireworks." It is hard to resist the conclusion that burning ballet-dancers were good for trade and that the obvious danger added an extra spice to the entertainment, as tightrope walkers working without a safety net. But tightrope walkers are highly trained acrobats, whereas ballet-dancers often had little training. Fanny Smith worked by day as a steel-pen grinder. To us it is perfectly appalling that these tragedies should have happened at all – and so unnecessarily. But what is perhaps more distasteful is the cynical lachrymose relish with which they were greeted. One nameless poet – with a style reminiscent of McGonagall – described the dangers of fire:

> . . . the greatest risk who run
> Are lightly costumed Ballerinas – escape for them there's none –
> A spark upon the muslin dry, then instantly it lights,
> Into a flame, like lightning flash, at sea on summer nights
> A blazing mass of agony, all maddened, quick they fly,
> Yet fly not from the enemy that dooms them thus to die,
> That shrivels up the glowings limbs and face and form, alas!
> Leaving of female loveliness a charred and calcined mass.
> Ah, happy if they die at once and from life's stage retire
> Than linger on in torment from the all remorseless fire.

Clara Webster lingered on in torment for a few days, and then died. The descriptions of her funeral provided lugubrious publicity for the theatre:

> The body presented a melancholy spectacle. It is a matter of surprise to us all that the deceased could have been so greatly disfigured in so short a time. The body is so much burnt that when it was put into the coffin, the flesh in some parts came off in the hands of the persons who were lifting it, and on the same account it could not be dressed.
>
> (*Court Journal*)

She was appearing, when the accident occurred, in a ballet, *The Revolt of the Harem* (1844), as Zelika the Royal Slave, supposedly gambolling around a bath and splashing water on other slaves:

> Lovely butterfly of the passing hour, she attracted the gaze of the gay votaries of fashion and pleasure, and like the doomed moth, fluttering in the flame, consumed her ephemeral existence! Who will not dwell on the agony of that dread hour, when Clara, enacting the part of the sportive nymph, in the bath of the sérail felt the devouring flame encircle her graceful form, yet – oh, bitter mockery! – not a drop of *real* water near!

The Victorians were therefore also shocked – but their reaction seems to have been mingled with the sort of melancholy relish which prevented them from taking steps to stop such accidents happening again. Their dismay was tempered by the general conception of ballet-dancers – that, at worst, they were whores and, at best, out to improve their status by capturing the heart of an army officer. There seemed a greater appropriateness in the thought that moths drawn to the flame of social success should sometimes be physically burnt.

Bizarre – disgusting – but is it not perhaps an example of the war which still exists between our sexual moralities, attitudes and inclinations, a battle in which there are too many human sacrifices? Clara Webster was the victim of a moral disapproval which simply ostracized a profession from serious thought and concern. The ballet was not squashed to extinction by the notoriety: it simply flourished in an atmosphere of seediness, danger, squalor and exploitation. And might not perhaps the same arguments be applied today to prostitution – which is tolerated in most large Western towns, but so censoriously that the girls are offered few physical or legal protections. It is often argued that to improve the physical conditions in which prostitutes work would attract more girls into prostitution: the same arguments were applied to ballet in the nineteenth century. This may happen – but few people (I would guess) would prefer arbitrary paid sex to longer-lasting relationships. In other words, we are again confusing attitudes, moralities and inclinations. And in this confusion, we allow inhuman conditions to exist, even perhaps to the extent of relishing the squalor.

It was inevitable that the notoriety of the acting profession should feed back into plays and productions, so that the theatre itself began

to perpetuate its own erotic legends. The stage portrait of the actor is someone who plays around with life, refusing to settle down until it is too late. The myth of the actress is of someone who extends adolescent sexual display firstly into a technique, then to a way of life and finally into a prolonged self-deception about her age. These legends are remarkably widespread, popular within the profession and without, surviving even today when the social conditions surrounding the theatre have significantly changed. The students and schoolmasters in Chekhov's plays are markedly different from those, say, in *Goodbye, Mr Chips*, but his actresses are much more familiar. Irina Arkadina in *The Seagull* has much in common with the actress in Schnitzler's *La Ronde* or *Anatole*, Judith Bliss in Coward's *Hay Fever* or the star in almost any show-business musical. They are always harking back to their past successes, quoting huge chunks from their best rôles. They are affected in their speech. They are attracted to much younger men, while remaining weakly dependent on older ones. They love flattery and ooze a self-conscious charm, which quickly switches to bitchery when they are confronted with rivals. They seem incapable of sustaining ordinary adult-to-adult relationships. No sooner has Trigorin in *The Seagull* succumbed to Irina's remarkable display of emotion – "I am not ashamed of my love! My jewel! My despair!" – than she grows bored with him, says contentedly to herself, "Now he is mine!" and decides to go away on her own. Judith Bliss is a more affectionate portrait of an actress, but similar features prevail. When she is kissed by Richard Greatham, she assumes a proposal of marriage and starts (to Richard's horror) planning her own divorce. When she discovers Sorel and Sandy hugging in the library, when she interrupts her husband David embracing Myra who uses "sex as a sort of shrimping net", or is told that Simon her son has kissed Jackie, she starts to plan so many alternative futures that the poor outsiders are driven away and scarcely noticed in their going. A stage actress – as recognizable a type as a stage Irishman and more frequently seen – is someone who seems to regard the ordinary transactions surrounding a marriage or an affair as a game which she plays with such startling virtuosity that it would seem almost insulting to limit her skill to one match. Journalists, catching the habit, sometimes write with surprise about sturdy long-lasting marriages in the profession, as if one slide on the helter-skelter had miraculously gone straight. Actresses in turn-of-the-century plays are usually presented as demi-mondaines, but when they do teeter towards marriage they send up the whole

system, professing wild histrionic loyalties which their actions
deny.

These are of course only myths, but so commonplace that one is
tempted to believe that there may after all be some truth to them.
It has been suggested that there is some natural law attracting the
emotionally deprived towards the theatre where, if they are lucky,
their hunger for love can be fed by applause, and if not, their fears
of rejection can be properly matched by an empty or unsympathetic
house. Or, alternatively, that those who are uncertain of themselves,
who can find no inner consistency to their feelings, seek out the
stage where they can play a variety of rôles and commit themselves
to nothing. Whether such laws exist or not, successive generations
of actors and dramatists have sought to perpetuate the image –
and sometimes to contradict it rather too forcibly, pleading their
own high motives and the honour of their profession (thus adding,
one would have thought, the vulgarities of rectitude to the list of
self-deceptions). Dickens, Thackeray, Shaw, Chekhov, Brecht,
Pirandello, Anouilh, Coward, Osborne and O'Neill have all from
time to time guyed the poor barnstormer with his noble gestures
and rolling gait, his high-flown remarks contradicted by the smell
of Scotch. Against a tawdry background, dignity has little chance.
"When the curtain rises on that little three-walled room," said
Treplieff, the young would-be dramatist in *The Seagull*, "when
those geniuses, those high-priests of art show us people in the act
of eating, drinking, loving, walking and wearing their coats, and
attempt to extract a moral from their insipid talk, when the play-
wrights give us under a thousand different guises the same, same
old stuff, then I simply have to run from it, as Maupassant ran
from the Eiffel Tower which was about to crush him by its vul-
garity."

The theatre, through its own self-portraits as well as through its
social insecurities, has represented in our society a distillation of
unreliability, the essence of emotional chaos. Actors and actresses
have acquired the reputation of being vain and foolish, selfishly
generous and autocratically dependent, neurotic, prone to suicidal
jealousies, forever acting and rarely living. Together these various
images represent the exact opposite of the bourgeois virtues. But
by the turn of the century, the bourgeois customs, particularly
bourgeois marriage, came under attack. Faced by the popular
image of the housewife, who would not secretly prefer to be an
actress? Confronted by the drab routine of office or factory, who

would not envy the actor? We have become chronically sceptical of middle-class pretensions, particularly those of us who are middle class. And beyond this scepticism, we have a different view of man. People, Dr Eric Berne tells us, play games: but some do so consciously with actors, can therefore adjust to circumstances and retain an element of self-doubt – and others do not. As middle-class moralities, particularly on sexual matters, became tarnished with uncertain self-criticism, the image of the stage – and of demi-mondaines – shone brighter as a sort of alternative. As an existential approach to life gradually began to replace the old essentialism, the activity of acting gained a new importance. It was a way of trying out different situations before finally committing ourselves in action. Hence the old insecurities of the theatre, and its supposed freedom on sexual matters, re-emerged as virtues. Literature provides few better examples of what Aristotle called "reversal of events" – for what do we dislike now most about turn-of-the-century plays? *Lady Windermere's Fan, The Notorious Mrs Ebbsmith, The Second Mrs Tanqueray*? Possibly its complacent acceptance of middle-class values – its bourgeois familiarity What we do not appreciate is the very necessary efforts which the profession made to be bourgeois – to avoid a worse state of affairs. Henry Irving's knighthood in 1895 was a triumphant symbol that the theatre had at last received a certain respectability. The profession was elated – but now we look back at society drama and imagine a betrayal of the social freedom which the theatre ought to uphold. If we possess some of this freedom now, it is only because the battle for status is no longer such an urgent one.

We can thank the actor-managers of the 1890s and 1900s for winning this battle for us.

3

Marketing Virtue in London

Throughout the nineteenth century in London, the theatre had marketing problems. Its potential public was large but ill-defined, its product variable in appeal, its image, as we have seen, inclined to be raffish. Many of these problems were caused by the Industrial Revolution. In the eighteenth century, companies played in medium-sized playhouses, and a manager could tell, simply by glancing around the auditorium, what class groups were present, the balance between them, and therefore what entertainment would appeal. In the early nineteenth century, huge new town theatres were built to cater to the rapidly rising industrial populations. The seating capacities of Drury Lane and Covent Garden (rebuilt respectively in 1809 and 1812) were over three thousand. The Standard, Shoreditch (rebuilt in 1867), was reputed to have an average *weekly* attendance of 50,000 during the pantomime season. This is equivalent to the Albert Hall being filled once a day for a week. The theatre could have been considered almost a mass medium. The two or three tiers of the Georgian playhouse became four or five tiers. These huge new audiences also belonged to less easily identifiable class groups, and therefore it was harder to gauge in advance the reception of a production. Managers responded at first by staging long programmes, four or five hours in length, providing something for everyone who was prepared to wait. At Drury Lane in 1817, one programme included *Othello*, a pastoral ballet *Patrick's Return*, *The Follies of the Day* and Holcroft's *Marriage of Figaro*. The emphasis then – as in advertising today and "mid-Atlantic" films – was on mainly generalized effects – much spectacle and no controversy, and among these effects was the rather tame erotic interest of the pastoral ballet, with shepherds and shepherdesses gambolling in a springtime world. To avoid any possible confusion between the erotic content of

ballets and daily life in Britain, managements during the course of
the century chose ballets which were set in increasingly remote
milieux – harems, Chinese palaces, castles in the Alps – places
where the set seductive dances, *pas de fascination*, could conceivably
be imagined to happen.

> The "tableau of the Venetian Orgy" in the third act with its host of
> bacchantes and lazy revellers stretched upon the ground, is volupt-
> uously beautiful, a delicious effect having been thrown over the group
> by the pale blue light reflected from the shining moon behind. The
> character of this ensemble is lovely in the extreme. There is a
> Boccaccio-like air over the whole scene – an Italian summer's evening,
> a loving languor, Epicurean inactivity and "the breath of gentle
> music".

This passage comes from a review of a ballet, *The Beauty of Ghent*
(1844), which was replaced by another ballet, *Lady Henrietta,* set
in England. *Lady Henrietta* was not a success. Somehow a hunt
ball did not seem to offer the same balletic possibilities as a slave-
market scene – or the Epicurean luxury of medieval Italy – or later
the underworld of Offenbach.

These long programmes and huge theatres were unwieldy.
Audiences were rowdy in scenes which bored them, and since the
programmes were so varied, a scene was always liable to bore one
section of the audience or another. And disgruntlement led to
violence. When Kemble raised the price of admission to the pit in
the rebuilt Covent Garden (from 3*s.* 6*d.* to 4*s.*), there were riots
for sixty-seven nights – until Kemble lowered the prices again and
apologized into the bargain. A similar situation occurred in the
1880s, over sixty years later, when the Bancrofts took over the
Haymarket and tried to replace the old pit benches with stalls. The
Bancrofts were able to overcome the disturbances as Kemble was
not: but the incidents serve to remind us that the docile audiences
of today have not always been the norm. The fear of violent public
reactions was one of the arguments put forward to support stage
censorship. At the censorship inquiry of 1909, the critic A. B.
Walkley, together with G. K. Chesterton and others, expressed his
concern at the danger of crowds:

> . . . a crowd is a new entity, different in mind and will from the
> individuals who compose it: just as if you mix up two chemical
> elements you get a new compound . . . the intellectual pitch of a
> crowd is lowered and its emotional pitch is raised. It takes on some-
> thing of the characteristics of a hypnotised subject . . . It tends to be
> excitable, irrational, lacking in self-control. You get innumerable

instances of that in history – for example in the French Revolution, where men in crowds committed horrible excesses which they could not account for afterwards . . .

This was a good argument for banning all political meetings, and behind these words is the sort of panic which blurs the distinction between theatre audiences and French revolutionaries. All crowds are the same: workers crowding the gates, suffragettes, the disturbances in India – the cracks in the marble which could spread. Was Mr Walkley's real fear that the new revolution would be preached from the stage? He continued:

> . . . to read something obscene may do you as a private individual reader a certain amount of harm: it will do you much more harm, I submit, if you listen to those indecent words being uttered in the company of some hundreds of other human beings. The thing then becomes a scandal. My own sense of shame would be very greatly increased. I might blush at something I read privately: but I should be confounded with the greatest possible shame if I had to listen to those very words in the miscellaneous company of hundreds of theatre-goers.

This conclusion runs dangerously close to bathos. Having built up a generalized fear of crowds, Mr Walkley's *theatrical* example is one of personal embarrassment. But this quotation reveals that sex, together with political agitation and blasphemy, was considered a force which could inflame the populace. This belief itself helps to explain some of the taboos current in nineteenth-century public theatre – no nakedness, no copulation, no "bad" language. The word "miscellaneous" in the last quoted sentence is interesting. Mr Walkley, with many theatre managers, disliked – and perhaps feared – the heterogeneity of the theatre, the lack of class apartheid. Playgoers did not belong to all the same age, class or gender groups, and therefore certain middle-of-the-road standards had to be applied to the theatre to avoid giving offence or the arousal of violent passions – which might lead to riot. These standards were administered as restrictions on the theatre through various authorities – the local licensing authorities, the police in cases of prosecutable obscenity, and through the Lord Chamberlain's Department and prior-to-production censorship of plays. In practice this meant that certain middle-class standards of conduct were imposed on the theatre – with the general co-operation of theatre managers, who were just as eager to avoid punch-ups in the auditoriums. Apart from the absolute taboos already mentioned, there was also extreme

reticence in the handling of certain sexual subjects and in language. But this reticence was not absolute. It relied on the variable discretions of watch committees and the Lord Chamberlain's Examiner of Plays, who would almost instinctively take into account the tone of the production and the audiences it would be likely to attract.

Within these restrictions, managers still had to struggle with the unwieldy potential of mass audiences. They learnt to direct their product to particular sections of the market. The large rowdy audiences of the early nineteenth century alienated the more sophisticated playgoers – particularly those who had been to Paris and admired the delights of Romantic ballet and the tightly knit, ingenious scripts of Scribe. Some managers struggled to attract back these clients by emphasizing the gentility of their theatres. It was a battle which affected every aspect of theatre – from the architecture of the buildings, the programmes offered, to the standards of conduct backstage and in the streets. The new West End theatres were designed palatially – as if to remind audiences that they were now in the Queen's Theatre or the Alhambra, where they had to behave. The Bancrofts reduced the long, ill-rehearsed potpourri programmes to a single elegant production. Irving at the Lyceum darkened the auditorium to enhance the significance of the stage, and in doing so, restricted the activities of those who regarded going to the theatre as an excuse for other transactions. Gilbert at the Savoy brought back the matinée which the working classes were unlikely to attend. Hare at the Court Theatre provided tea and coffee in the intervals, instead of stronger drink. All these organizational details in the 1870s and 1880s were designed to restrict the appeal of these theatres to the reputable middle classes.

This tendency also affected the manner, behaviour and dress of actresses. George Edwardes replaced the tights and flouncy petticoat-ridden skirts of the burlesque actresses at the old Gaiety with the more demure dresses of the slimmer, younger chorus girls of musical comedy. Managers sometimes made actresses sign contracts (itself a means of stabilizing the profession) with clauses to the effect that they would accept no gifts whatsoever from stage-door Johnnies or, a stranger detail, would not board a train (when on tour with the company) carrying brown paper parcels. When John O'Toole took over the Folly Theatre in 1879, he pinned a list of regulations in the dressing-rooms, including the rule: "No stranger to be admitted behind the scenes under any circumstances,

or to be in any dressing-room with permission." A stranger was anyone who was not a member of the company. The regulations sometimes extended to dress and behaviour outside the theatre. According to Macqueen Pope, George Alexander once met Henry Ainley and Lilian Braithwaite, two members of his company, in Bond Street. They were dressed informally – Henry Ainley was wearing a soft hat, tweeds and a sports coat. George Alexander, on the other hand, wore a silk hat, a morning coat and formal accessories. He stopped them and said, "I am pleased that two young members of my company should be friendly. It is what I desire, what I like. But I would ask you to remember that this is Bond Street and that you are members of St James's Theatre company. That requires social obligations in dress. I am sure I need not say more."

To belong to a respectable theatre company was rather like living in a convent without the same opportunities to lay up treasure in heaven. But despite this urge towards gentility, it was customary for actresses not to admit that they were married or had children. A delicate balance had to be maintained between conveying the impression that actresses were available demi-mondaines and at the same time guarding against offence to the normal proprieties.

While some managements sought out the respectable audiences, others did the reverse. Victorian and Edwardian music halls grew from two main roots: the burlesque comedies of H. J. Byron and others, and the supper-clubs of the first half of the nineteenth century. The supper-rooms of the 1830s, which developed into the pub music halls of the 1850s and 1860s, catered to male audiences. Dickens and Thackeray (in *The Newcombes*) wrote about them with fascination. Here where the chairman was flanked by two professional singers and the public was invited to join the choruses, there would sometimes be staged wild caricatures of divorce cases, featuring some Lord or other, inverting the heroic pretensions of the aristocracy in the emotional (if not the formal) tradition of *The Beggars' Opera*. Renton Nicholson (who died in 1861) ran a touring Judge and Jury Club, over which he presided as Lord Chief Baron. He would call "female" witnesses – usually comedians in drag – to give evidence: and they would explain in considerable detail how "so-and-so attacked me and what he did". Renton Nicholson presided at the Coal Hole in the Strand, the Cyder Cellar in Maiden Lane, Offley's in Henrietta Street and the Dr Johnson in the Strand.

Behind the salaciousness of the stories, there was considerable class aggression: the lords were pompous hypocritical fools, the judge was an old lecher. And when the trial was over, the platform would be cleared for an exhibition of "Poses Plastiques". Evans, who ran one of the first supper-rooms, also published in the 1860s a forty-page booklet which contained advertisements for Dr Kahn's *Physiology of Reproduction* courses, which were illustrated by female models. Emma Lyon (later Lady Hamilton) once toured as a model for similar exhibitions.

The class aggression of the supper-rooms, together with the "Living Pictures" or "Poses Plastiques", were afterwards incorporated into the music halls, where however the resentments were expressed more good-humouredly. The caricatures of the Masher, Swell and Toff were keenly observed but mild in tone – T. W. Barrett sang of John the Masher in 1880:

> I am the sort of fellow you will meet with every day,
> I captivate each pretty girl that comes across my way,
> I always wear the very best of thirty shilling suits,
> You'll find I always wear a pair of gaiters o'er my boots.

> I'm known by all the Totties and the Lotties in the Town,
> They know my name, but they prefer to call me Captain Brown,
> My chain's the latest pattern, there's none that can surpass,
> It's warranted to be all solid eighteen carat brass.

Vesta Tilley's dashing male impersonations, together with the songs "Burlington Bertie", "Captain Gingah" and countless others from the 1890s and 1900s were in the same vein. These caricatures concentrated on different class styles, which included different sexual emphases – the lower classes, easy-going, without side, casual and "honest"; the middle classes, constrained, concerned with fashion and propriety, but always on the "look-out" . . .

> My gal's an out-and-outer,
> That is she's not a muff,
> There's no two ways about her,
> She's a proper bit of stuff.
> When on Sunday dress'd all in her best,
> She's flash but she's discreet,
> She's as straight as any sausage,
> And a dozen times more sweet.

The middle-class proprieties, so scrupulously observed at the St James's Theatre, were often objects of fun in the music hall.

This broad contrast in the style of the product also affected the social atmosphere of the auditoriums. A première at the St James's Theatre was "a social event of the first importance". The attendants spoke quietly and were not permitted to receive tips. Any barracking from the gallery was mild and restrained. But at, say, the Standard, Shoreditch, such decorum was rare. One poor singer suffered badly from the rowdiness. "Shut up," called a voice from the gallery, "Give the poor bitch a chance!" "Thank you, sir," the singer called back nearly in tears, "I'm glad to see there's one gentleman in the house." These two extremes were also marked by gradations in innuendo: the hints of impropriety in society drama – the broad double meanings of music hall. If we now take these differences for granted, together with the spectrum of nuances which divided the two extremes, we have to remember that during the nineteenth century managers had to discover them through a process of trial and error. Their livelihoods depended on their discovery of a commercially viable image.

Class consciousness in the nineteenth century was not simply a negative reflection of economic circumstances. It had a positive side. It was one way of re-structuring a society which had lost shape and cohesion. Eighteenth-century towns were small enough for status to retain a human shape. A tenant farmer looked like Jim, a blacksmith was Bob. Class distinction in the nineteenth century had often a frightening aspect: masses of people all belonging to the working class – all clerks, all domestic servants. The professional classes could blandly describe the behaviour of the workers in these words from *Lancet* (April, 1869): "the natural predominance of the animal life in the illiterate renders the control of animal lusts difficult or impossible." With such an outlook, who could blame the author of *My Secret Life* for having as many factory girls and domestics behind the shed as he could afford? And who could blame the young man and woman aspiring to be middle class for imposing the most rigid restraints on their behaviour? There is a temptation nowadays to characterize the Victorian age as one of massive official prudery combined with an equally unpleasant underground licence: Ouïda and William Acton on the one hand, the author of *My Secret Life* on the other. But the picture has more than two colours. Within each class group, there were acceptable and unacceptable deviations from the norm: ways of keeping a

mistress if one could afford to do so, proper times and places if one could not. But drifting up or downwards through the different atmospheres of class, one quickly lost reserves of sexual breath. The real Victorian prudery or licentiousness – different forms of sexual rigidity – came when there was an attempt to cross from one class group to another. Marie Lloyd toned down the bawdy content of her act when playing to audiences in the East End, she heightened it for the middle-class audiences who relished this spectacle of Cockney uninhibitedness:

> You see I wear the Rational Dress.
> Well, how do you like me, boys?
> It fits me nicely more or less –
> A little bit tasty, eh boys?
> (From *Salute My Bicycle*)

This was the sort of stuff which pleased James Agate: "Marie Lloyd sang as Rabelais wrote, for good Pantagruelists and no others . . . She employed [an armoury of] shrugs and leers and to reveal every cranny of the mind utilized each articulation of the body. . . . She was most saltily British." But in the East End, her most popular song was the one which made her famous, "The Boy I Love is Up in The Gallery" – sung straight. Marie Lloyd's particular gift was to seem demure when she wanted to – bawdy when she did not. In 1896, Miss Carina Reed, one of Mrs Ormiston Chant's supporters, opposed the renewal of the licence of the Empire Theatre because the promenade was being used by "gay women" and also because the audience was being inflamed and titillated by a Marie Lloyd song, "Johnny Jones":

> What's that for, eh? Oh, tell me Ma!
> If you won't tell me, I'll ask Pa!
> But Ma said, "Oh, it's nothing, shut your row!"
> Well, I've asked Johnny Jones, see, so I know now.

Miss Reed complained that at this point the women in the audience started to look at the men. "They laughed very much. But then I saw men and women accosting each other, and go off together." The licensing committee invited Marie Lloyd to perform the song so that they could judge for themselves its obscene tendency:

She sang the offending number absolutely straight without a flicker of expression – and the members of the committee were stunned. After a brief discussion, they told her they could find nothing wrong. It was then that her temper flared and she made them listen to one

of the respectable songs which their wives might sing in their own homes – "Come Into The Garden, Maud". She gave it every possible lewd gesture, wink and innuendo, she pawed the ground like a stallion, and rubbed her pearls across her teeth, and she made it obscene. "You see?" she concluded, tapping her forehead, "it's all in the mind!"

(D. Farson, *Guardian*, 20 May 1972)

But it was not in the mind: the suggestiveness was conveyed non-verbally through the gestures and intonations. One consequence of the Victorian restriction of sexual language was that to convey sexual meaning, inappropriate words had to be distorted for the purpose. There was a divorce between the apparent meaning of a word and the sexual content it could be made to carry. The theatre has been cursed by an easy reliance on innuendo: but innuendo only becomes necessary through the restriction of language. Dame Edith Evans once gave Maggie Smith this advice: "If you don't know how to say a line, make it sound dirty." When no language exists to express so important an area of human experience, the emotions have to be conveyed by other means. But sometimes the disparity between the words and the sexual content led to the opposite of suggestiveness. Many Edwardian drawing-room songs had an obvious sexual content which was ignored in the singing. Dame Clara Butt, contralto to the Empire, used to sing the "Indian Love Lyrics", one of which began:

Less than the dust beneath thy chariot wheels . . .

and was a sort of hymn to the delights of female slave masochism. But she sang it with a resounding determination which made one fear for the chariot wheels.

By the turn of the century, the spectrum of class and sexual associations of the theatre had divided into separate shades: it was no longer the confused and muddy mixture of colours which afflicted mid-century theatre in Britain. The working classes had been siphoned towards the music hall, with its pub humour and community spirit. Lower-middle-class audiences would visit the pantomimes, and sometimes the better music halls and melo-dramas. W. S. Gilbert at the Savoy and later George Edwardes at the Gaiety and Dalys, catered to the fashionable younger set with light musicals which contained a slightly irreverent attitude towards authority and a flirtatious one towards sex. At the Court Theatre in the 1880s and later at St James's, there was society

drama. At Her Majesty's, Beerbohm Tree bore the standard of Shakespeare and "high drama" aloft. The Alhambra and the Empire supplied "tired business man" entertainment, influenced by Offenbach, the spectacular revues from Paris, the Can Can and the Riperelle. The Vaudeville and Avenue Theatres relied largely on French farces, adapted "from the original" and often omitting episodes which were considered too daring.

The spectrum therefore provided considerable variety, within the limits of taboos and middle-class reticences which were some-times enforceable through law, but more often observed by managers of their own accord. But apart from these taboos, there were also some telling omissions. Nowhere – except rarely among the writers of the new naturalistic drama, who attacked the unfair treatment of women in marriage – is there the expression of a considered opinion that Christian marriage might not be a good thing. Society drama, French farces and melodrama alike supported marriage, though with different emphases. In one sense this is surprising, for an alteration to the normal family structure was one of the chief social consequences of the Industrial Revolution. In the eighteenth-century country towns and villages, a child could usually rely on the extended, as opposed to the nuclear, family unit. His protection was guaranteed not just by his parents, but by grandparents, cousins, aunts and uncles. As individual couples drifted towards the industrial towns, these extended family units were broken up, with the result that new responsibilities – and heavy ones – were laid on the parents. If the parents died or separated, little social organization existed to protect the orphans. There was little attempt to replace the extended family by the formation of town communes. In the theatre, although marriage and its problems were endlessly discussed, few plays called into question the system itself and most plays (at least in the plot moralities) insisted on a tougher observance of the system. "Fashionable drama," wrote Shaw, " . . . concerns itself almost exclusively with adultery" – but he failed to add that the opinions of adultery were generally unfavourable, that the concept of marriage was never attacked and that the system as a whole was defended with an almost unnatural violence.

The degree of the dogmatism varied according to the shades of the spectrum: but from a suitable distance, and with his eyes half-shut, a wandering Martian might well have assumed that British theatres were indeed temples, devoted to a cult marriage, whose origins were shrouded in mystery, whose legends structured daily

life and with an iconography whose subtle differences could only be appreciated by the initiated. What the Martian would have missed was the "estrangement" effect provided by the reputation of the theatre: it was an improper medium imitating and propagating the standards of propriety. Nor would he have appreciated the almost colonial struggle which the theatre suffered to be accepted by society. Just as British-educated Indians and West Indians sometimes out-Eton Eton, so actor-managers like Sir George Alexander and Sir Gerald du Maurier were more proper than they needed to have been. A large section of the theatre was devoted to upholding the standards of propriety but without ever managing to cast off the taint of its heritage.

Propriety was a battlemented town, surrounded by a forest, a desert and a contaminated beach. By day, the citizens would sometimes casually, apparently so, climb the walls of the town on their way to work, to gaze over towards the Forest of Sexual Passion, admire the exotic flowers which bloomed in the tangled undergrowth and listen to the soft bird calls and harsher cries from its mysterious depth. But they could not without danger cross over into this jungle – for there monsters lurked, overpowering passions which drove men to murder and girls to suicide. And having once ventured into this territory, they would find it hard to return. The townsmen would not let them in, or if they did, the wanderers would still hear the cries from the forest and become restless, unpredictable in their behaviour, considered mad. Just beyond the walls of the town were the shacks and suburbs of the wanderers, the demi-mondaines and spendthrift youths, waiting for the moment when the narrow doors to the town were left unguarded and unlocked, hoping to sneak back under some disguise. Seymour Hicks, the actor-manager, described the homes of demi-mondaines with a snobbish pity:

> The maisonettes (they nearly all live in maisonettes) are generally as alike as the model cottages in a Garden City. They have the narrow hall, lit by an imitation onyx bulb, held in the hand of a nude figure peeping through bulrushes of tin or copper. Drawing-rooms, conspicuous for the absence of the pictures of their relatives, but adorned by the photographs of youthful soldiers in uniform they have met twice, on which are written Christian names only, even if the donor is a Hebrew in the Marines.

Some rich or daredevil adventurers (such as Seymour Hicks) returned without difficulty, by bribing or charming the guards.

And their stories – of Montmartre and Leicester Square – entered
the mythology of the townspeople, who on their journeys to the
battlements would point out the glamorous sections of the forest
to each other and pretend an intimate knowledge of them. Others –
like Oscar Wilde – were less fortunate. These wanderers, despairing
of re-admittance to the town and fearful of returning to the jungle,
would wander farther and deeper into the Desert of Social
Exclusion. (Sir George Alexander removed Oscar Wilde's name
from the playbills of *The Importance of Being Earnest*.) They lived,
if they were lucky, on food parcels sent from the town, or found a
little oasis in Yorkshire where they could settle down monastically
with a friend. But the unlucky ones, desperate for food, would
discover the beach where there seemed to be food and company:
but found to their cost that the ground itself was polluted by the
excrement from the town, that friendship itself was disease-ridden
and the food was poisoned. There was no return from the beach.
Some young girls, vengeful and desperate, would stand outside the
walls of the town, beckoning to the men to join them. Some men
concealing their momentary spells of faintness and the pain in their
groins would return to the town, settle down for a few years to
watch their children grow deformed and their wives sick: and
eventually all would drift back to the beach, beyond which was only
the black sea.

But to the town itself – in the dead centre of Propriety sat the
"housewife", or "Hausfrau", or "maitresse de maison" – for in this
respect the nuances differed little from country to country. She
was guarded on one flank, by her mother or mother-in-law in her
high Mandarin chair whose sharp features and cold eyes were the
best guarantees of virtue by making vice a formidable challenge –
and on the other, by priests dispensing comfort. The housewife
was the timid monster who, according to the American critic,
J. B. Matthews, had to be protected from Dumas (fils) and *La
Dame Aux Camélias*, who according to Horace Mayhew's *Wonder-
ful People* was "proficient in pies" and had "a deep knowledge of
puddings", who would not on principle belong to a circulating
library and would fall asleep over a novel if it accidentally slipped
into her hands, who would preserve her "wedding dress with a
girlish reverence" and was unwilling to waltz "even with an
officer" because it made her feel giddy. It is the Hausfrau in
Wedekind's *Spring Awakening* who is simply too shy to tell her
daughter Wendla the facts of life and thus is indirectly responsible

for Wendla's miserable fate – an unwanted pregnancy, a fatal abortion and a gravestone with the pious inscription, "Blessed are the Pure in Heart". The housewife was fed by the good husband who would maintain the façade of the home and maintain the strength of the town walls: but the bad husband would spend rather too long on the battlements, beyond the line of duty, and would sometimes be suspected of helping to maintain the suburbs.

This then was the town of Propriety. Nowadays motorways have been driven across the old boundaries into the heart of the jungle. The old monsters have been photographed, tamed and pinned on walls. The desert is covered with motels: and even the beach, though still contaminated, is thought capable of cleansing. But it would be a mistake to assume that even at the turn of the century, the citadel seemed the same in all lights. The basic features were there, but sometimes the shadows were heavy and black, the town walls monstrously high, the gates closed inexorably with the dismal clang of a Gothic castle. At other seasons, the town would seem elegant in its proportions, supplied like Harrogate with a permanent autumnal glow and sometimes (such were the extremes) the architecture would seem unreal and fairy-like, an enchanted place where all its restrictions could be overcome by wishing them different. In melodrama, society drama and French farces – the three main treadmills of nineteenth-century marital drama in London – similar stock characters and situations appear: the innocent girl, the fallen woman, the demi-mondaine, the rake, the dandy, the cad, the upright husband, the mother-in-law, the housewife, the priest and the lawyer. But the colouring changed, together with the depth of characterization and the violence of the dilemmas.

In melodrama, the town was Gothic. Hideous fates awaited all who strayed, innocently or intentionally, beyond the battlements: the monsters were seductive and treacherous, or hideous and cruel, and their victims pleaded with them in vain. It was a genre popular throughout Europe from the Théâtre du Grand Guignol in Paris – where the plays were short, sensational and bloody – to the Standard, Shoreditch. During the early 1900s, Bernard Shaw, Oscar Wilde and Walter Melville were the only English-speaking authors popularly known in Germany. Walter Melville? He wrote melodramas – *The Girl Who Wrecked His Home, A Disgrace to her Sex* and *That Wretch of a Woman*. The melodramas at the Standard, Shoreditch, were adventure stories, in which the heroine had

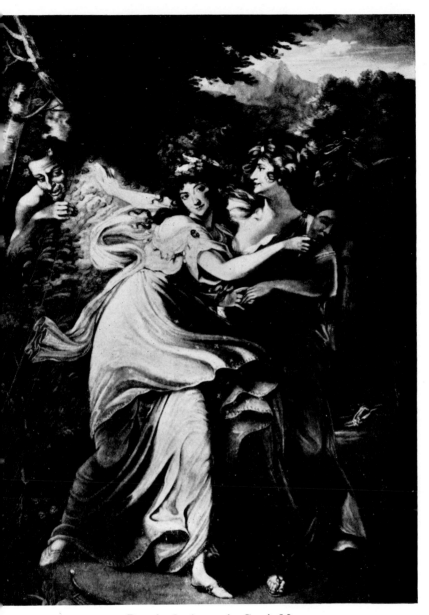

1 Dorothy Jordan as the Comic Muse

3 Marie Tempest as Becky Sharp in *Vanity Fair*
(1896)

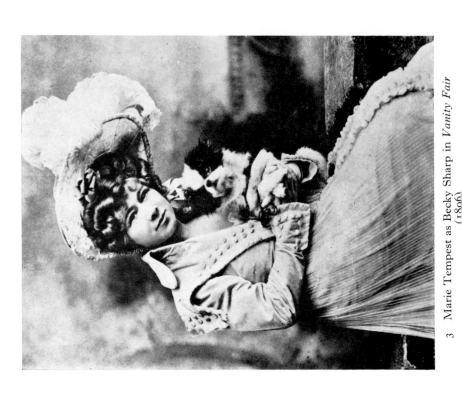

2 Clara Webster as Zulieka in the ballet *Revolt of the
Harem*, the rôle in which she was burnt on stage

4 Vesta Tilley 5 Vesta Tilley

VICTORIAN POSTCARDS

Mrs Patrick Campbell as Militza
in *For The Crown* at The
Lyceum (1896) 7 Marie Lloyd

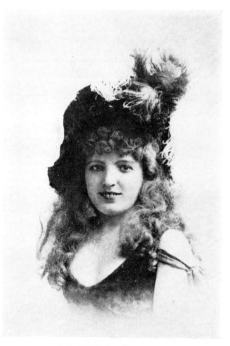

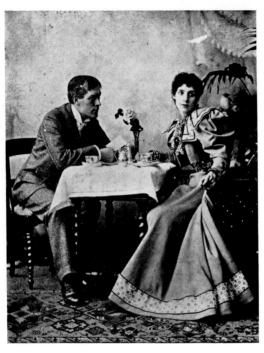

8 Sir George Alexander and Mrs Patrick Campbell in *The Second Mrs Tanqueray* (1893)

9 Miss Janet Achurch as Nora in the first British production of *A Doll's House* (1889)

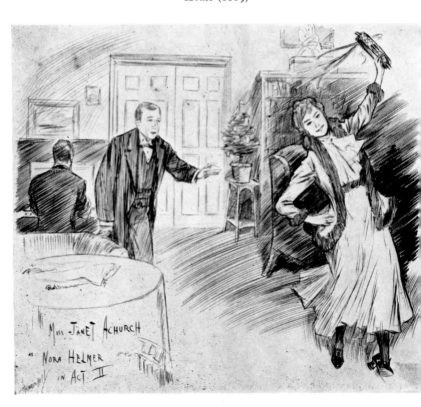

10 Miss Muriel Beaumont as
 Agnes and Mr Charles
 Hawtrey as Charlie Ingleton
 in *Dear Old Charlie* (1908)

11 Granville Barker as Frank and
 Madge McIntosh as Vivie in
 Mrs Warren's Profession (1902)

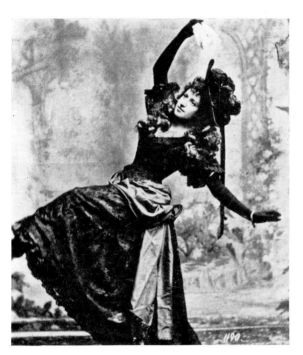

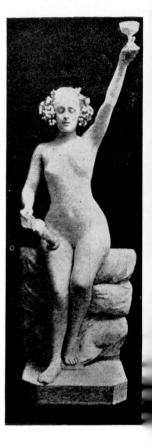

12 Lottie Collins in her song-and-dance number "Ta Ra Ra Boom de Ay"

13 La Milo as the *Bacchante*, an example of living statuary (1906)

14 Maud Allan as Salome

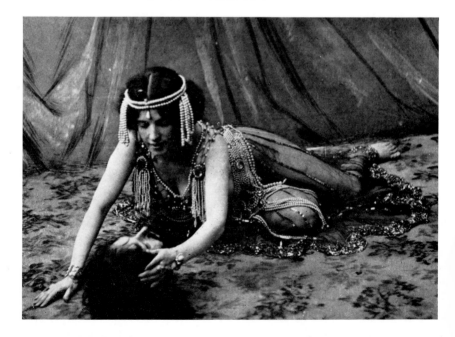

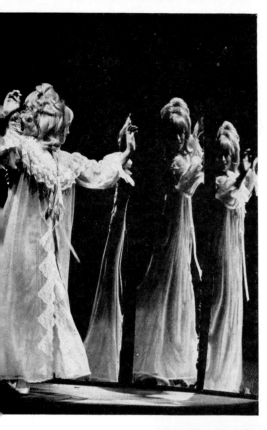

15 Julia Foster as Lulu in the
Nottingham Playhouse
production (1970) at the
Royal Court Theatre,
London

Julia Foster with John
Justin as Prince Escerny
in *Lulu* at the Royal Court
Theatre, London

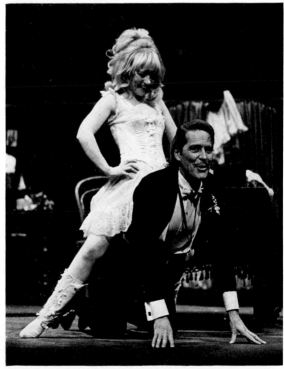

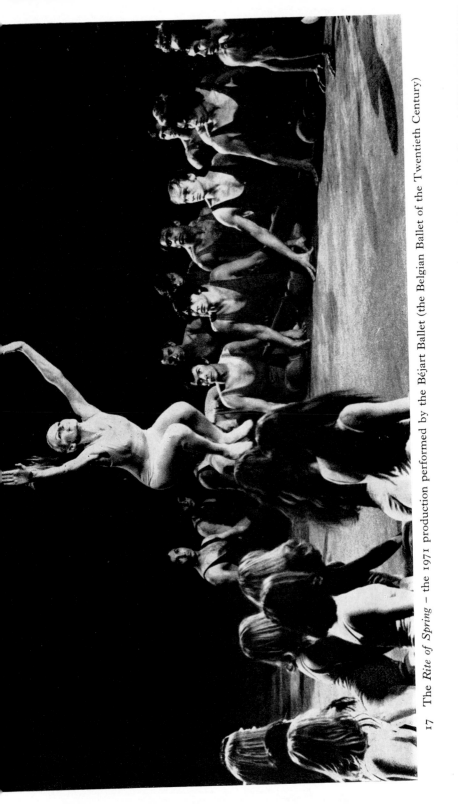

17 The *Rite of Spring* – the 1971 production performed by the Béjart Ballet (the Belgian Ballet of the Twentieth Century)

to contend with the sort of problems which afterwards faced Pearl White:

> Miss Amy Steinberg as the heroine in the madhouse scene [hung] by her wrists on the wall . . . When the heroine to avoid persecuting got into the car of a balloon and cut the rope, I was dumfoundered and when she afterwards chawed the knuckles of the sportsman who was clinging to the car, I gasped.
>
> (Concerning *The Ruling Passion*, 1883)

The scenes in which the heroine was persecuted – or perhaps not the heroine, but some unfortunate pawn in the villains' game – were bloodthirsty. One set-piece scene of cruelty occurred in the various productions of *Oliver Twist*:

> Nancy was always dragged round the stage by her hair, and after this effort, Sikes looked up defiantly towards the gallery, as he was doubtless told to do in the marked prompt copy. He was always answered by one loud and fearful curse, yelled by the whole mass like a Handel Festival chorus. The curse was answered by Sikes dragging Nancy twice round the stage, and then like Ajax, defying the lightning. The simultaneous yell then became louder and more blasphemous. Finally when Sikes, working up to a well-rehearsed climax, smeared Nancy with red ochre and taking her by the hair . . . seemed to dash her brains out on the stage, no explosion of dynamite, no language ever dreamt of in Bedlam could equal the outburst.

The productions at the Théâtre du Grand Guignol were particularly spectacular, so that the name came to describe a genre of extreme melodrama: the heroine's head in one production was caught in a printer's vice, so that apparently the blood and brains squirted across the stage as the curtain slowly came down. Flogging scenes were popular, and more excruciating forms of torture: the rack, the Iron Maiden. The melodramas at the Standard, Shoreditch, were more moral and sentimental in tone, in that the worst tortures were reserved for the villains and the heroines usually escaped to live happily ever after. Walter Melville's *The Girl Who Took A Wrong Turning* (1906) was a great success. The story concerned a wicked adventuress, Vesta la Clere, who lured a village maiden, Sophie, to the bright lights and the gay life of London. Sophie has a sailor boy-friend who follows her to the dens of evil in Leicester Square, and finds her transformed into a "woman of the world" with fine dresses and airs to match. Sophie refuses to return with him to the village, but she accidentally meets her

uncorrupted sister selling flowers. Her heart is touched and she
returns to the village, saved by the bell from the fate of a fallen
woman. Vesta la Clere is shot and dies in agony. The sheer
spectacle of the melodramas – Leicester Square, ballooning,
burning buildings, train wrecks and ships sinking at sea – was one
cause of their popularity, but another was undoubtedly the sado-
masochism, which in a sense replaced the otherwise inhibited love
scenes.

Shaw once called the plot morality of a similar melodrama (*The
Conquerors*, staged surprisingly and unsuccessfully by George
Alexander in 1898) about as convincing as "a deathbed repent-
ance", and he blamed the Lord Chamberlain for the convention
that the virginity of the heroine had to be protected at all costs. A
whole act could be spent in attempted rape with "prayers for
mercy, screams for help and bloodcurdling hysteria", but if the
hero, often a sailor, came along in the nick of time or (as in *The
Conquerors*) the heroine fainted and the villain had a change of
heart, it was acceptable. It was not acceptable to show the actual
deed, however decorously. The heroines were always passive victim
of men's lust. Only wicked women were forward. If a woman showed
signs of liking sex, or worse still "fell", she had to repent very
quickly or she would share the fate of Vesta la Clere. The morality
lulled the conscience against brutality: a complicated and familiar
paradox. During a recent television discussion on the film *Straw
Dogs* (1971), in which a girl is repeatedly raped, one woman pointed
out that the girl had had a lover before marriage, and so this was
more or less what she could expect.

We should never perhaps assume a direct cause and effect
between what we see on the stage and what we do in life, but a
man who steeped himself uncritically in the conventions of melo-
drama might be tempted to conclude that (1) a man even in
marriage had to be the sexual aggressor because his wife would be
unlikely to share his interests; (2) if she did share them, she was
probably degraded and unworthy to be his wife; and (3) no fate
was too horrible for a fallen woman. This combination of stimula-
tion and a sexually illiterate morality would, if the public had been
too gullible, have provided an excellent finishing school for Jack
the Ripper. Shaw's objection to melodrama was slightly different.
He felt that by not showing the likely consequences of "immorality"
on stage – realistic rape, abortion, unwanted pregnancy and VD –
the stimulation was unrelated to the real dangers (which might
indeed have deterred) and associated instead with violent and

unlikely threats which would not have been taken seriously. In a sense, the consequences were glamorized, for it is more attractively horrible to be slaughtered by Jack than to rot from VD. It was rather like a parent telling a child, "You play with fire and the bogeyman will get you" – and not "You'll get burnt."

In society drama, the walls of Propriety glowed with a softer light. The struggles in the forest and the cries from the beach were heard at a distance. There were no rapes on stage – rarely even an embrace. Society drama rarely contained scenes which could be described as erotic. The plays presented, say, at the St James's Theatre during the régime of George Alexander belonged (in my terminology) to the theatre of transactions – *Lady Windermere's Fan, The Second Mrs Tanqueray, Mid-Channel*. The fallen woman would still be likely to die – but she would commit suicide nobly and die off stage. The settings were elegant interiors, and the characters were distinguished by a greater insight into their dilemmas, which did not contradict the fundamental tenets of Propriety, but added an air of reasonableness. The fallen woman was an object of pity, rather than fear or contempt. She had been perhaps betrayed by a wicked man – like Mrs Arbuthnot in Wilde's *A Woman of No Importance*, who

> drags a chain like a guilty thing. The fire cannot purify her. The waters cannot heal her anguish. Nothing can heal her! No anodyne can give her sleep! No poppies forgetfulness! She is a lost soul!

– which was bad enough. Or she could have been someone like Paula Tanqueray in Pinero's *The Second Mrs Tanqueray* who tries to reform but cannot. When Aubrey Tanqueray marries Paula Reay, a fallen woman, he wants to prove that "it's possible to rear a life of happiness, of good repute, on a – miserable foundation". Paula, just before their marriage, hands him a letter (which he refuses to read) containing an account of all her past misdemeanours and offers him a chance to escape from actual marriage. But he is resolute in his philanthropy and nobly marries her, and gradually the social isolation, Paula's sense of guilt and Aubrey's tactless desire to protect his "innocent" daughter of a former marriage from the surrounding scandal, eats into their happiness. When Paula discovers that Aubrey's daughter, Ellen, wants to marry one of her former lovers, Captain Ardale, she feels that her presence will be of general embarrassment and commits suicide. *The Second Mrs Tanqueray* is, of all the society drama genre, the play which

seems still the most open-minded, least willing to jump to conclu-
sions and most sympathetic. Paula was perhaps right – she should
have remained a demi-mondaine, and Aubrey was wrong to marry
her without being prepared in his heart to accept her past, not
simply to ignore it. It is a play which was distinguished by Pinero's
own particular interpretation of Christian charity and, in its time,
it was regarded as advanced, daring and even immoral. George
Alexander was relieved when it was passed by the censor, and
Clement Scott, the *Daily Telegraph* critic, was vicious in his
attacks on it, even implying that Pinero had borrowed the idea
from someone else, having neither the wit nor the decadence to
think of it himself. The fallen woman could also have been someone
like Mrs Ebbsmith (in Pinero's *The Notorious Mrs Ebbsmith*), a
former suffragette who falls in love with Lucas Cleeve, a brilliant
young politician now separated from his wife. Lucas's family
intervene, in the person of the cynical Duke of St Olpherts, and
try to restore the marriage, by suggesting a solution *à la mode*:
Lucas Cleeve should live with his wife (though in different quarters
of the house) while Agnes Ebbsmith resides in a suburban
villa with a "little garden, a couple of discreet servants – every-
thing à la mode". Mrs Ebbsmith considers the situation seriously
enough to throw a Bible on the fire – but repents and runs
away to a secluded country house to think "of the woman I have
wronged – your wife!" She chose in other words the Desert of
Social Exclusion, where she would have dwelt in discomfort but
good company – with Mrs Arbuthnot, Lady Windermere's
mother, and Sir George and Lady Orreyed, Paula Tanqueray's
friends.

In Paris, society drama was much more sympathetic to the prob-
lems of the demi-mondaine. In London, too much sympathy
would have been banned by the Lord Chamberlain. In Donnay's
Amants, the heroine, Claudine Rozay, a retired actress, lives a
comfortable life as the kept woman of a Count (whom she even-
tually marries) and has a passionate affair as well, which she out-
grows. In Brieux' *Les Hannetons*, a woman confesses to being a
fallen creature when she is not, in order to secure her status as a
kept woman, rather than a wife – because a demi-mondaine had
certain advantages over a wife: she kept her independence. British
and American critics, with the notable exception of Shaw, regarded
French society drama as another indication of the decadence of the
French race. They disliked in particular the outspokenness of the
dialogue. Porto-Riche was considered an outright sensualist be-

cause the heroine, Germaine, in his play, *Amoureuse*, freely declared her passionate love for her husband, Etienne, using in conversation the intimate "tu" and not the more formal "vous". The language of love in British society drama was fraught with difficulties. Max Beerbohm described the problems of the dramatist:

> I think I see him, at his desk, biting the tip of his pen gloomily. At length, after a long mental struggle, he sets his pen to paper, and writes:
> HAROLD: *Mildred*!
> MILDRED:
> He paces up and down his room for a few minutes and then, with a shrug of his shoulders, inserts "*Harold*!" More pacing up and down and presently is added:
> HAROLD: My darling!
> MILDRED: My darling!
> (They embrace.)
> He nerves himself with a cigarette and writes boldly, blindly:
> HAROLD: The very first time I saw you – you remember? It was in the orchard. (She presses his hand.) The apple-blossoms?
> He deletes the apple-blossoms and hurries on to:
> Well, at the moment of seeing you, I knew – even then – that I loved you.
> MILDRED:
> After some hesitation the dramatist rises, puts on his hat, and goes out for a long brisk walk. On his return, he is delivered as follows:
> And I too, Harold, knew that I loved you.
> HAROLD: Dear one!
> MILDRED: Dearest!

In Edward Garnett's *The Breaking Point* (which was banned by the Lord Chamberlain), Garnett has considerable difficulty in mentioning that his heroine is pregnant. In his introduction, Garnett refers to her as being *enceinte* for since the French were always improper, they could use the word without being thought additionally so. In the dialogue, he tiptoes around the subject with the clumsy concern of Bertie Wooster, surrounded by upsettable coffee tables:

> SHERRINGTON: I love her to distraction and she me. She's given herself to me – she's given me her future – her family know nothing. Do you see? And now it's necessary that she should come to me.

MANSELL: (staring) Necessary? Are you sure it's necessary?
SHERRINGTON: I'm not absolutely sure, but I believe the *thing* has
 happened.
MANSELL: Good God! What a position!
SHERRINGTON: Yes, I'm – *hideously* to blame.

Such reticence amounted to a bad stammer: and it could be
argued that the walls of Propriety in Britain were largely main-
tained by the Orwellian process of language restriction. The formal
and informal taboos extended to nearly all words which were too
explicitly physical:

> Speaking of some kind of food, "It is very good," says the Captain,
> "for the stom – " and . . . apologizes profusely. "Ah," says the vicar's
> daughter to the curate who was in love with her, "I was a little girl
> then – all elbows and knees," whereat the curate utters an exclama-
> tion of pained surprise.
> (Max Beerbohm, on *Lady Huntworth's Experiment*)

Society drama did not usually represent an ultra-conservative
point of view. Clement Scott disapproved of all the works of Oscar
Wilde. He disliked Pinero's comparatively sympathetic portraits of
the demi-mondaine, and particularly the dandies of Wilde's plays,
whom (Wilde said) would take over the world. Who were the
dandies? It was a word, of course, particularly associated with
Wilde, and it fell out of favour after his pathetic trial. Generally, in
George Alexander's productions, they were middle-aged cosmo-
politan Englishmen renowned for their wit and cynicism, whose
very presence cast the serious marriage transactions around them
into confusion. Lord Illingworth in Wilde's *A Woman of No
Importance* was one such character, the Duke of St Olpherts was
another. Many society dramas can be considered as a sort of tennis
match between the dandies and the prudes, with the fallen woman
as the ball. The dandies were usually confounded in the last act,
having set the style of the first.

In French farces, the town of Propriety was little more than a stage
set, with walls which could be pushed over and propped up again.
If Lady Windermere had been discovered in Lord Darlington's
flat, she would have been ruined. She would have become a fallen
woman. In French farces, she would have lied her way out of
trouble. The bedroom scene was the last ditch of compromise in
society drama: a maze of opportunity in French farce. The dandy

of society drama was the attractive cad of French farce, who could always wheedle his way through, with Charles Hawtrey's lazy charm. The tone of French farces was one of hedonism. The girls enjoyed sex as well as the men, and the dire consequences of misbehaviour became domestic misunderstandings which a clever man could smooth over. Society drama always set an example: French farce did not pretend to.

The genre dominated European boulevard theatre from the emergence of Scribe in the 1820s, to Labiche in the 1850s, Sardou in the 1880s and Feydeau at the turn of the century. Each generation brought variations to the familiar: a punch-card, piano-roll theatre. Few dramatists could resist the temptation to wring out one more melody – not Ibsen, not Pinero, not even Shaw who dismissed the genre as Sardoodlum. And throughout the nineteenth century, the genre was considered *risqué* in Paris, immoral in London and decadent in Germany. Not only did the form survive, but also the air of naughtiness. From our lofty position in the twentieth century, much Scribean comedy must seem a triumph of convention over curiosity: and indeed this may be so – but are we perhaps underrating the value of formalism which has the effect of concentrating the attention on minor, significant shifts of emphasis? Perhaps we should read "well-made" comedies and French farces as Soviet correspondents for Western newspapers read *Pravda* – noting the telling omissions from a party conference and deducing from them a major shift in policy. Scribe's success lay partly in the fact that he brought together stock "comic" characters who were also perennial symbols of changing custom. The symbols marked the boundaries of Propriety, which were always being slightly adjusted. In one year, the maid could flirt with the master – the next, kiss him – the next, be slapped on the bottom – and so on. The tone of the plays were light and amusing, and so the walls of Propriety were neither so formidable nor so rigid. "Let's get a divorce" – well, we can, but we would probably re-discover our wives and husbands in the process, which is roughly the conclusion of Sardou's play, *Divorçons*. Nor was the eroticism held so firmly at a distance. Some branches from the jungle could overhang the walls of the city. The springs of the bed could be heard to creak and gasps of pleasure were not inaudible, or always off-stage. In one farce, as Shaw noted with disapproval, an actress changed her underclothes on stage. In *Dear Old Charlie* (which Charles Brookfield, later to become censor, translated from a Labiche farce), a man seduced two wives of friends, without

coming to any great harm or spreading havoc in the marriages. It was considered a highly distasteful and immoral play, but the Lord Chamberlain's Examiner of Plays passed it, because he was generally lenient on plays "from the French". It was almost part of the *entente cordiale*.

Nineteenth-century audiences were bombarded by questions of marriage and propriety, much as we are lambasted today by–sex?– well, at least advertising. These three genres – melodrama, society drama, and French farce – were directed to different sections of the market, and would probably have been staged in different theatres. When George Alexander tried out a melodrama, it was a notable (and for him rare) disaster. These three genres were linked by a common acceptance – not just of the basic pair-mating situation which might loosely be termed marriage, but of a much wider system, involving man's relationship to his own body, his language, his relatives and those with whom he allowed himself to associate. Marital drama in the nineteenth century and early twentieth century endlessly tried to re-define the boundaries as to what could be permitted and what could not. Nowadays if we meet someone who keeps finding himself in the same unfortunate pre- dicaments – say, a kleptomaniac or accident-prone man – we would turn analysts from force of habit. Obviously, we would say to ourselves, this man is manoeuvring himself into situations which reflect his unconscious needs or fears. His accidents are not really accidental at all – they are symbolic expressions of hidden traumas. Can we perhaps extend this argument to the theatre? Does the repetitiveness of marital drama reflect similar underlying tensions which audiences and the profession alike were unwilling to face too directly? In a way, it must, for otherwise the public would have grown bored and more theatres would have closed. But the difference between the man with problems and the formal, public theatre lies in the fact that drama is always a conscious, controlled activity, never an instinctive response to hidden needs. A woman may snatch a baby from a pram outside a supermarket: she is not at that moment bothering about what other people will think of her or what the morality of the act will be. She suppresses that side of her nature. But the dramatist and director can never entirely do this. They always have to worry what other people will think of them. Even in staging the most obviously pornographic shows, they still have to select the context carefully, so that their clients will be able to relax into the stimulation – without feeling that they

will be ostracized or attacked for doing so. The Anatomy lectures of Dr Kahn were given a mock scientific context: the French farces came from France. Therefore, the repetitiveness of marital drama came not just from an overpowering inclination to act as voyeurs on other people's marriages, but from a desire to reconcile the blatant disparities between the sexual moralities current, the social attitudes and the hidden inclinations. Everyone knew that these disparities existed, but this general awareness did not bring the problems closer to solution. The dilemmas were caused either by lack of knowledge, or the wrong knowledge, or by a slow ethical and social transition, a process which, with the most powerful general will, could not have been hurried – and still perhaps cannot. And so – year in, year out – the same problems were considered, the same conclusions were reached and the drama lay in nuances. The tongue kept nagging the hole in the tooth without sucking away the decay.

If we look at these disparities more closely, we are forced to the realization that Christian sexual morality was responsible for many of them. I say "forced" – not because I am in any sense wishing to be a Christian apologist – but because Christian sexual morality has been so beaten around in recent years, that I am reluctant to add to the attack. "The fact of having made sex into a 'problem'," wrote Alex Comfort, "is the major negative achievement of Christianity" – which is a slightly harsh assessment perhaps. Christ had little to say on the subject and not all the early Christians shared the fanatically prudish views of St Jerome, his sadistic violence (familiar from melodramas) in denouncing lust. Some were much friendlier figures, such as Pelagius. Nor were the churches solely responsible for the sexual attitudes which gradually became associated with them. The harshest condemnations of sexuality were those expressed by the Manichean heretics, who believed that since existence in the world was harsh and painful, an ante-chamber to the Realm of Light, complete with torture instruments, procreation itself was evil. The Manicheans had much influence on medieval Christian thought, but most Christian teaching, while emphasizing the moral superiority of celibacy, has nevertheless tolerated intercourse for the purposes of procreation within marriage. This was the rather dismissive Christian view of sexuality at the turn of the century, although it has since been modified.

While it would be unfair to blame Christianity for the excesses of the Manicheans, it is not unfair to point out, as Sherwin Bailey does

in *The Man–Woman Relationship in Christian Thought*, not an anti-Christian work, that Christian sexual teaching was largely based on mistaken views about the biological process of sex. There was a superstitious reverence for semen, which was considered to contain the whole embryo – the woman was merely the nurse to the male seed. From this assumption (which pre-dates Christianity – it can be found in the *Oresteia*) other consequences ensued. Women were considered inferior to men because they did not directly contribute to the procreative process. They were simply living test-tubes in which the seed could grow. Male masturbation and homosexuality were violently attacked, because life itself was being wasted. Female masturbation and lesbianism were less urgent targets. Onan was a man. Secondly, it was believed that the moral danger of sexuality came with the stimulation, with the sexual excitement. In the nineteenth century, there were speculations that, with the advance of science, procreation could be achieved without stimulation at all – without intercourse even. The ascetic dislike of all forms of eroticism, within marriage or without, is an attitude which can be found in nearly all Christian teaching – from St Augustine to St Aquinas, who believed that the morality of human behaviour was dependent on the conscious will, guided by faith and reason, which erotic stimulation undermined. If it were possible to procreate without feeling the physical pleasure of procreation, it would be all to the good, and (if Christian pamphlets and biographies are to be believed) many people went to extreme lengths to avoid feeling this pleasure or (failing that) to avoid giving this pleasure to others. It is only quite recently that the Anglican Church has accepted that physical excitation is necessary and desirable within procreation – let alone as a means of greater intimacy within a relationship – or that the woman is more than a nurse to the male seed. "Advances in scientific knowledge," Sherwin Bailey rather blandly remarks, "have rendered untenable a view of physical sexuality which has obsessed the mind of the Church for more than fifteen centuries and has profoundly and adversely influenced the sexual attitudes of the West."

Christian sexual morality dominated nineteenth-century con-sciences – which is not to suggest that everyone agreed with it, but that those who were brave enough publicly to disagree, were forced into extreme statements of opposition. Since the Christians asserted that sexual stimulation was always harmful except for the purposes of procreation, someone like Wedekind was almost bound to come along to state equally categorically that "the pursuit

of sensual pleasure" was man's highest aim. The ethic produced the anti-ethic. There were also other consequences. Since (from a Christian point of view) intercourse was only permitted within marriage and for the procreation of children, the idea of contraception was considered disgraceful, together with all forms of extra-marital sex. Even the Archbishop of Canterbury today (in an interview published in the *Observer*, 23 January 1972) seems to associate sex outside marriage with promiscuity, which the dictionary defines as indiscriminate sex:

> You might have a couple not of the Christian faith who would say, "We don't believe in Christianity, we don't believe what you tell us about natural law and we think it right just to be promiscuous."

But sex outside marriage need not be indiscriminate at all, except from the very narrow outlook of the committed, traditionally minded Christian. There is a great difference between someone who must have a different partner every night, and the person who is trying to discover a partner with whom to settle. There is a difference between "rat-in-the-trap" extra-marital sexual behaviour and "experimental" sex. Two people may live together for some time and then decide for various reasons the relationship is not going to work. Others may decide to crowd in as many lovers and mistresses as they can into their youths. Christianity fatally blurred these various distinctions and therefore in nineteenth-century marital drama, one finds that Vesta la Clere, Paula Tanqueray, and Zoë Blundell (in Pinero's *Mid-Channel*, 1909) are considered almost equally worthy of terrible fates. Christianity, in short, is a promiscuous morality, indiscriminating in a very literal sense. The married state is blessed, sex outside marriage is doomed. Nowadays many Christians would wish to modify this rigid outlook, but at the turn of the century, all the churches were equally uncompromising. In 1908, the Lambeth Conference violently attacked birth control as "an evil which jeopardizes" the purity of married life. In the 1930s, this attack was modified, and in 1958, the conference published a paper, *The Family in Contemporary Society*, which was intended to give a fuller weight to the "personal value of coitus" in marriage and tolerated the use of contraceptives. But this new toleration of sex within marriage does not generally extend to sex outside it. This means a numbing of human sympathy, which at the turn of the century was particularly expressed in two ways: characters within a play were defined largely by their sexual rôles, and secondly, once the taboos surrounding

sex outside marriage had been broken, there was a sort of conscienceless free-for-all. We have already described how the ballet girls, because they were considered promiscuous as a type, were subject to all sorts of dangers, including burning, and the fallen women who expiated their sins by violent death. But there was also this almost hysterical longing for "illicit" forbidden sex – the gaudy, depraved, abandoned delights of Montmartre and Leicester Square, the infinite danger, the heady delights. The idea that sex outside marriage can be as boring as sex within it, was expressed by Pinero and Seymour Hicks, but few other writers. The naturalists, Shaw, Brieux and Ibsen, rebelled against the glamorization of illicit sex – but nevertheless the glamour remained. In Britain, since the censor permitted no attack on the institution of marriage as such, the desire for extra-marital sex was expressed in endless ballets and spectacles about sex life in other countries. How many people were tempted into colonial escapades simply to escape the sexual restrictions at home? These restrictions were particularly expressed in the sexual rôles allotted to characters in plays and, one supposes, to people in daily life. Once a woman married, she adopted the rôle of wife, which meant that in uncountable ways her life was structured. Her life was also strictly patterned if she became a demi-mondaine and lived in a discreet suburban house with a couple of tactful servants. As Jill Tweedie pointed out, however, in the *Guardian* (13 December 1971):

> Inside my body there is a small being of indeterminate shape and no sex at all . . . at times it looks down at the body to which it is attached with a distinct feeling of surprise at the odd protuberances. It has forgotten that it lives inside a female.
> Mary Stott, in her chapter of the book *Woman on Woman*, says "menstruating, gestating, giving birth, suckling are exclusively female experiences. Eating, drinking, sleeping, touching, tasting, smelling are not. Is it conceivable that the femaleness of my body, the fact that it is structured for childbearing means that my senses transmit their messages to female brain cells which somehow dictate female responses? Do I perceive as a woman? . . . It is hard to believe so." She illustrates the division in most of us, not between sex and sex, but between sex and no sex, and most of our activities and emotions fall into the no-sex category.

Plays at the turn of the century largely ignored that side of womanhood which did not belong to the assigned sexual rôle: from the moment an actress entered the stage, the audience would know that

she was intended to be a demi-mondaine, a wife or a mother-in-law, and adjust their expectations accordingly. And so rarely in the theatre could one watch that most interesting aspect of sexuality: the processes by which one assimilates one's sexual inclinations into the rest of one's being. Sexuality was a rôle, a fixed state, a premise from which the logic of the stories were drawn.

Nor did the curse of Christian sexual teaching end with this sort of over-simplification. Pathetic stories from brothels reveal that many men visited prostitutes not to fuck them, but to act out childhood situations where stimulation occurred, coupled with severe restrictions, shame and punishment. The girls "allowed" their clients to watch them dressing and undressing, but whipped them at the first signs of an erection. These whippings were not exactly aids to orgasms, since the orgasms were often prevented from happening by, say, placing small rings around the relaxed penis. The devices invented to stop boys masturbating became in later life incorporated into non-orgasmic sexual rituals. In these instances, therefore, Wilhelm Reich's valuable insight in *The Function of the Orgasm* that whippings encourage the inhibited person to "burst" out of his socially conditioned, anti-sexual "armouring", is not entirely valid. The punishments took place without the release. The men were paying for sexual nostalgia. On other occasions, of course, whippings did lead to orgasms and were intended to do so: there is a lugubrious account of one of these sessions in *My Secret Life*. Brothel games had to reconcile the warring pressures of desire and guilt, and sometimes the delicate balance between them could not allow anything so disruptive as an orgasm.

Such extremes were not exactly *caused* by Christian sexual teaching – but the morality contributed to the mixture of shame and desire, which could only be expressed in violently anti-sexual games. The ritual beatings-up of virgins who refused to co-operate in melodramas, and of fallen women who co-operated too eagerly, were one manifestation. Another occurred more good-humouredly, in the slapstick school sketches of pantomime and revues, and in music-hall songs:

> Hold your hand out, you naughty boy!
> Hold your hand out, you naughty boy!
> Last night, in the pale moonlight,
> I saw you – I saw you –
> With a nice girl in your arms,

You were whisp'ring words of joy,
And you told her you never kissed a girl before –
Hold your hand out, you naughty boy!

This is good fun: and much Edwardian theatre reminds one of the truth of Montaigne's dictum, that vice is the lack of due proportion. The best marital dramas at the turn of the century, such as *The Second Mrs Tanqueray*, managed to reconcile the various disparities within an atmosphere of human understanding and tolerance. But the less good ones succeeded only in expressing a narrow form of sexual propaganda, committing what in a different context would have been considered as the treason of the clerks.

This assessment is, however, both too kind to the dramatists and managers at the turn of the century – and too harsh. Too harsh, because I have deliberately concentrated in this chapter on popular drama, on marketing to large audiences, leaving aside the more challenging work of the Naturalists (who did not believe that Propriety had to be defended at all costs and who saw some of the evils of the system) and of others, such as Wedekind and Jarry, who believed that Propriety had to be attacked. Their work will be considered later. But I may have been kind to suggest that the theatre inevitably reflected the slowly changing pattern of custom. This process may have had to be slow in life, but the theatre is not real life. It provides a game area, where we can try out alternatives. The theatre in the nineteenth century was uncertain of its status in society and could not therefore relax into make-believe. It was tortured with the desire to please, to say the right things – to placate. Its imagination was therefore constricted, and those moments of sexual passion which took place as part of the story were shorn of the opportunities which could have given them life – the opportunities of rich precise language, of physically alert playing, of surprise and insight. In a sense, the theatre sold its soul by marketing virtue – in the belief that it could only survive by seeming good. The theatre survived, it even prospered – but "this treason of the clerks" damned the theatre into an awkward gawkish conformity from which marital drama particularly suffered. Neither the pumice of the naturalists nor the limpid waters of Chekhov's plays could properly cleanse the theatre from this grime of assumed holiness.

4

Nora, Flora and Laura

> But most thro' midnight streets I hear
> How the youthful Harlot's curse
> Blasts the new-born Infant's tear,
> And blights with plagues the Marriage hearse.

A hundred years after William Blake wrote those lines, the town of Propriety still stood with its midnight streets – battlemented with superstition, fortified by custom and so secure apparently that it was hard to tell where the natural landscape ended and the man-made bricks and mortar began. Many believed that this citadel was part of the supplied universe: a God-given haven against the worse terrors outside. They were not unduly troubled by the cries of the excluded. Sin, they reflected, brought suffering and the sins of the father would be visited upon his children and grand-children. It was part of the moral order, for what else deterred man from sin but suffering? To deny punishment would also be to deny reward, and by implication to doubt that a benevolent God existed, who was concerned for the moral well-being of his flock. In the late nineteenth century, however, there was a new breed of scientists and sociologists, carrying around Darwin in their rucksacks, who heard the cries differently. The harlots, in their view, were victims of a social order whose origins were no more divine than mere defence of property. The diseased children were not suffering from the divine wrath of God – they were paying the penalty for the superstitious ignorance which refused to discuss rationally the problem of venereal disease. It was time, they felt, for the town to be surveyed objectively, with reason and the foot ruler: a time-and-motion survey had to be conducted on custom. Were even housewives, for whose protection the citadel had been erected, guarded by the system? Or were they prisoners, denied the

elementary freedoms belonging to them as human beings? These
questioning reformers were preoccupied with the injustices of sexual
custom, and they influenced the theatre through the genre of
naturalistic drama. Unfortunately, sexual behaviour is a hard sub-
ject to tackle with dispassionate objectivity. The naturalists were
determined to be rational and scientific in their approach to
marriage and other sexual problems: but in doing so, they supplied
alternative myths which proved almost as hard to treat with a
proper disrespect as those of Propriety itself.

Naturalistic drama, the genre, needs to be distinguished from
naturalism itself. The theatre was edging towards naturalism, in the
matter of doorknobs and real doors, for much of the nineteenth
century. It was the last literary medium to be scathed by the prin-
ciples expressed in Wordsworth's *Preface to the Lyrical Ballads*:
that art should imitate life, and not vice versa. Naturalism did not
affect the plays themselves, or the technique and approach of the
dramatist, until Zola turned his attention to the theatre in the late
1870s. This is when the genre, naturalistic drama, can most
accurately be said to have begun: although Ibsen's early naturalistic
plays, including *A Doll's House*, were also written in the late 1870s
Zola lent his prestige as a novelist to the new genre, supplied it with
a manifesto and a set of principles, to distinguish it firmly from
boulevard and popular theatre. Zola wanted to present a human
situation with as much fidelity as he could muster in order to
demonstrate how it had occurred. He compared his task as a writer
to that of the experimental scientist. In a laboratory we can build a
test-tank to demonstrate the effect of waves on a sea-wall. In the
theatre (so the argument ran) we can provide closely observed
imitations of events from life, near replicas, which would demon-
strate "the cause and effect of human behaviour".

These aims – which obviously overrate both the controllability of
the stage and the objectivity of the scientific approach – provided
a *raison d'être* for the theatre. Serious writers, who were attracted
in general towards the stage but not to the boulevard variety,
found in the principles of naturalism an ideal to inspire them. But
to approach this ideal, completely new techniques – of acting,
writing and directing – had to be found, together with new
audiences, new sources of money to cover the time before the
genre was appreciated by the box-office and new ways of dodging
the censor. The full impact of naturalistic drama, therefore, was
delayed until the appearance in the late 1880s of small theatre
clubs, where actors and dramatists could experiment in comparative

freedom and without losing too much money. But the nature of these clubs added another colour to the pattern. They were small, impoverished, transitory places, orientated more towards the writer than the professional theatre man: homes for intellectuals and other subversives. In October 1887, André Antoine, an employee of the gas company, started the Théâtre Libre in a converted room situated in the Passage de l'Elysée des Beaux-Arts, "a doubtful looking alley". The audiences were expected to be hidden observers to the action, a fourth wall, and the actors, instead of appealing to the audiences in gestures and asides, pretended to ignore them. This style encouraged the belief that the audiences too shared the dispassionate objectivity of the dramatists. The example of the Théâtre Libre in Paris was followed by the Freie Bühne at the Deutsches Theater in Berlin in 1889, and by J. T. Grein's Independent Theatre in London. The *Free* Theatre, the *Independent* Theatre, the very names are polemic. These theatres would, it seemed, do and dare anything, sustained only by an intellectual highmindedness and a concern for man the animal. People were what their circumstances and their heredity made them. The task of the dramatist was to analyse the circumstances and that of the public was to listen to the analysis, to understand it and act accordingly. The work of the theatre clubs anticipated the Moscow Arts Theatre of the 1900s and the Actors' Studio in New York in the 1950s, as well as many small theatre clubs and communes of today whose names reflect the origins of the movement – Les Tréteaux Libres, the Living Theatre. A dissociation began then which survives today – between the *avant-garde* and the popular establishment. One could not tolerate the other. Shaw sneered at Irving. The Théâtre Libre loathed the theatre of Sardou and Feydeau. Chekhov hated the popular stage. From the other side of the fence, Beerbohm Tree dismissed the genre as "obstetric drama" and the censor censored. The separation between these two theatrical worlds impoverished both outlooks. The Naturalists kept a certain integrity by steering clear of the commercial temptations, but also lost, perhaps, a buoyancy of vision, the middle-class determination to make the best of a bad job, the hopeful adjustment to circumstances, ordinary *joie de vivre*. The impoverishment of the boulevard theatre need not be stressed: the mindlessness and complacency is still with us.

It is hard nowadays fully to appreciate the reactions of shock and dismay which greeted the early work of the Naturalists –

particularly Zola's *Nana* (1880), Ibsen's *A Doll's House* (1879) and
Ghosts (1881) and Shaw's *Mrs Warren's Profession* (1893). They
were widely considered to be immoral, subversive, preoccupied
with sex, morbid and decadent. J. B. Matthews, an American critic
who sturdily supported everything that is holy and beautiful in life.
found *Nana* so painfully unpleasant that he was sure it had been
written to cater to the depraved curiosity of man. Shaw was more
inclined to give Zola the benefit of the doubt: "[Zola] found a
generation whose literary notion of Parisian cocotterie was founded
upon Marguerite Gautier [from *La Dame Aux Camélias*] ... [and] felt
it his duty to shew them Nana." But even Shaw dismissed Zola as
a crime reporter and compared him to the cartoonist whose studies
of cancer so affected his art that his whole technique became
"cancerous". Strong, shooting talk – and yet few genres now seem
more austere, more elevated in thought and intention than late
nineteenth-century naturalistic drama. Perhaps that was the
problem. An atmosphere of non-religious puritanism surrounded
the genre – the determination of a young social worker who will not
avert his eyes from the degradation of the world and will not be
contaminated by it either. The love scenes were so conscientiously
non-erotic that only fools and animals seemed likely to enjoy sex at
all. The styles of acting and staging avoided the glamour of society
drama: the gorgeous dresses, the plunging necklines, the scenes of
eye-flashing passion. When Brignac in Brieux' play, *Maternity*
(1903), orders his wife Lucie into the bedroom, there is no lingering
on the delights of masculine brutality as there would have been
(say) in melodrama. Shaw complained that when *Mrs Warren's
Profession* was banned by the British censor, audiences in the States
went to see the play for all the wrong reasons. Britain was to
America what France was to Britain: a country of scandal and
permissiveness. Any play banned in Britain must be lascivious in
the extreme. From the shocked comments of many critics and the
disapproval of the censor, who banned more naturalistic plays than
those of any other genre, an outsider would have been led to believe
that naturalistic drama verged on the pornographic. "Revoltingly
suggestive and blasphemous", was one description of *Ghosts*. But
what was suggestive about it? There are no creaking beds in
Ghosts (as there were in French farces), no rape scenes or prolonged
seductions (as there were in melodramas), no scenes which even
veer towards the sexually stimulating. Why was this austere debate-
play received so intemperately in Britain? "Absolutely loathsome

and fetid" – "as foul and filthy a concoction as has ever been allowed to disgrace the boards of an English theatre".

The answer to this question is a complicated one, for it reflects the many ingredients which composed the opposition to naturalistic drama. The shock was partly caused by the subject matter – by the sheer fact that the problems of VD, the rights of women and the desirability of preserving marriages were being discussed on the stage at all, and in an atmosphere free from the shibboleths of Propriety. But it was not just the subject-matter. The whole argument of the play seemed to undermine the basis of Christian marriage. Mrs Alving in *Ghosts* has carefully maintained the semblance of a correct marriage – despite the fact that her husband, Captain Alving, is a notorious rake. When young, she wanted to elope with the man she loved, Pastor Manders, but they decided that such an action would be against the laws of God. And so Mrs Alving remains zealously married – even preserving the "good" name of her husband after his death by building an orphanage to his memory. The ghosts of the past cannot, however, be so easily suppressed. Oswald, the Alvings' only legitimate son, has inherited a venereal disease from his father, which results in a slow softening of the brain. By trying to preserve her respectable marriage, Mrs Alving has ruined her own life and borne a son whose life was equally cursed. In the last tragic moments of the play, she watches her son turn mad. *Ghosts* was "blasphemous" because it questioned the sanctity of marriage, it was "immoral" because the elopement seemed a missed opportunity, not a tempting sin avoided, and it was "suggestive" because it referred to the secret life of Captain Alving, the sub-stratum of dark indulgences which most Victorians were content to leave hidden.

Was there also perhaps a deeper response, less conscious and less easily explained, amounting almost to a fear? One which affected the very heart of the relationships between men and women? Mrs Alving had much in common with the other heroines of Ibsen's plays – particularly Nora in *A Doll's House* and Hedda Gabler. She resented the status allotted to her by society. Her personality transcended her sexual rôle. Society drama encouraged audiences to believe that women were what their sexual rôles had destined them to be. They were housewives, demi-mondaines or domestic servants. Any sliding between these rôles (as in the case of Paula Tanqueray) was doomed to disaster. Naturalistic drama encouraged the opposite belief – that such fates were grotesque restrictions of human freedom. Male audiences, conditioned to believe that

marriage sanctioned sexual relationships, were confronted by the unpleasant thought that it did nothing of the kind. The man who imposed his will on his partner, inside marriage or without, was still a tyrant. Women were not *"Machines:* male gratification, for the use of . . .", they were individuals with an equal right to determine their emotional lives. A fair-minded observation apparently – but if this equal right were conceded, would women be willing ever to gratify male sexual needs? Probably not – for the belief persisted in naturalistic drama as it did in society drama, that well-brought-up women felt no erotic pleasure. And women – who were accustomed to conceal their feelings lest they be thought ill-bred – were not offered the excuse of duty to submit to men. Within a general aura of sexual shame, it was more difficult to make love to an individual with an independent critical sense, who was encouraged to say "Yes" or "No" of her own free will, than to someone whose declared sexual rôle in marriage was to be an object of male desire. There is a parallel in the eighteenth-century comedy, *She Stoops to Conquer.* Marlowe, the hero, is adept at seducing serving-girls, but tongue-tied and impotent when confronted by eligible girls of his own class. Some of the same inhibitions afflicted those men who were faced by "emancipated" women.

The emancipated woman was supposed to be someone who could earn her own living and was therefore not forced to sell her sexual favours in return for economic security. Many naturalistic dramatists assumed, with Shaw and Brieux, that female sexual needs were purely maternal. The emancipated woman only mated when she wanted children. If a man insisted upon sex for the purpose of sensual gratification, a pleasure which women were supposed not to feel, he was a bully or a caveman. He was even transgressing the natural laws – for women, according to the Naturalists, decide the future of the human race by selecting their partners with care to secure the best genetic and environmental circumstances in which to breed children. Men bestially want to fuck, while women desire in an elemental way to perpetuate the species.

These double standards shocked Strindberg, who called Ibsen "that Norwegian bluestocking". Strindberg was convinced that the male writers of the naturalistic movement had ratted to the other side in the sex war. He was particularly incensed by *A Doll's House,* in which Nora, previously kept in a state of childish dependence on her husband Torvald, finally rebels against him and slams the door on her adult nursery. He wrote a retort, *The Wife of Herr Bengt,* in which a woman's rôle is shown to lie in a

dutiful submission to her husband. He was convinced that the whole debate about women's rights was misconceived. He would quote Nietszche, his personal friend, approvingly: "Der Liebe ist der Krieg, der Todhass der Geschlechter" (Love is war, the mortal hatred of the sexes). In this war, women were always trying to castrate men, just as men wanted to gain possession over women. But men tend to be more foolishly idealistic than women and approach the battle with delicate consciences which women do not possess. Laura (in Strindberg's play *The Father*) destroys her husband's sanity, power and dignity with the help of other men: she ties him up in a strait-jacket. Men through their own sense of justice bring about the downfall of other men. Ibsen, Shaw and Brieux were traitors, not exonerated from their treachery by good intentions. Other writers who did not share Strindberg's obsessive concern for male virility, also felt that by attacking the customs of Propriety, the Naturalists were in danger of leaving the sex war devoid of rules. Henry Arthur Jones re-wrote *A Doll's House* and called it *Breaking a Butterfly*. There were some other changes too. Nora is re-named Flora (or Flossie) and Torvald – Humphrey Goddard; and in the last act, where Nora slams the door, Flora confesses her foolishness and begs Humphrey to forgive her. Emancipation meant sexual anarchy, the mere exploitation of one sex by another. The tone of naturalistic drama was considered to be cold and clinical, pitiless in its exposure of useful hypocrisies – greyly heralding an age of passionless procreation.

No better tribute can be paid to the sheer persuasiveness of the naturalistic dramatists than to point out that these attacks lost much of their vigour within thirty years. But was the opposition blunted by the truthfulness of the plays – or by a social climate which accepted these plays as truthful – or even perhaps by the decline of the naturalistic movement which began at the very moment of its success? In the 1890s, the ideals of naturalism, as expressed by Zola, were understood to be impractical. Zola realized as much. The dramatist cannot observe human behaviour with the impartiality of a camera nor analyse his data with the precision of a self-programming computer. He is one of the machines which he is supposed to be taking apart. This inner lack of logic assisted the disintegration of the first, most idealistic wave of naturalistic drama. By the mid-1890s, the genre had become "established" – and had lost its original impetus. Ibsen and Strindberg both turned towards symbolism, and the Théâtre Libre closed in 1894. In this short time, from 1880 – 1894, the

movement bred a generation of imitators, some of whom followed
Shaw and Brieux into "thesis" drama, where the realistic portrayal
of life was simplified into social argument and polemic, while
others followed Chekhov and the Moscow Arts Theatre into the
theatrical equivalent of impressionism. During the decline of
naturalistic drama, the original ideals were simplified drastically.
The later Naturalists assumed that man was a product of two fac-
tors, *environment* and *heredity* – two headings which sound plau-
sible enough, scientific almost, implying various mechanistic and
non-human forces which condition human behaviour. The condi-
tioning factors attributed to heredity ranged from inherited
diseases (such as VD and alcoholism) to racial and class characteris-
tics – and to the forces of evolution whereby a woman would
instinctively select a healthy male with whom to mate rather than
a sickly one. The environmental factors primarily meant money –
the economic structure of society, the laws of marriage and the
division of property, together with the customs of Propriety which
were often held to have economic origins.

Analysing human behaviour in these terms had certain advan-
tages – one was that the Naturalists broke free from the jargon of
the churches – but also caused considerable problems. Nobody
was quite sure which effect to ascribe to which fundamental cause.
Curel, for example, was one of those dramatists who believed that
class characteristics were inherited. His play, *Les Fossiles* (pro-
duced by the Théâtre Libre in 1892) concerned a family, the
Chantemelles, who regarded the perpetuation of their line as
the highest, most imperative human duty – for the aristocrats are
the natural leaders of the human race, whose nobility lies in endless
self-sacrifice, mollified only by wealth and hunting. Curel adopts
an ambivalent attitude towards the Chantemelles: they are
incapable of change, and yet they need to adapt themselves or die.
To other Naturalists, class was an inevitable product of natural
selection. The lower classes would improve their lot or starve, the
decadent inbred aristocracy would fade away into asylums, leaving
only the stronger, more intelligent members of the middle classes,
themselves in particular, who would evolve to a higher race.
Shaw wrote *Pygmalion* to stress that the class system was the pro-
duct of environmental factors, not inherited ones. Class was not
built into the biology of the human race as a permanent obstacle
course. But it was really a toss of the coin as to which line of logic
one chose. The social implications of such arbitrary decisions –
which were of course masquerading as "scientific" or "objective"

– could have been profound. If one assumed that class differences were part of the evolutionary process, the idea of improving the lot of the poor was positively harmful, for it delayed the arrival of the superior race. If one believed too literally in the survival of the fittest, any attempts to weaken the impact of ordinary commercial aggression were counter-productive.

The writers of the Théâtre Libre sometimes gave intellectual respectability to Parisian anti-Semitism. One published a dialogue (not in itself anti-Semitic) which set out to prove that racial inter-marriage between Jews and the French would always lead to disaster. The racial characteristics were too opposed. In Hauptmann's *Vor Sonnenaufgang* (Before Sunrise, 1889), the doctor hero decides not to marry the girl he loves. Her parents are alcoholics. He fears that she may have inherited their alcoholism – although he has no evidence to suppose that she has. We would now regard his agonizing dilemma as unnecessarily apprehensive, but all such problems developed because the two terms, heredity and environment, were vague and extendable like elastic. There was too easy a progression from provable assertions to unprovable ones. They were corsets, holding in a vast unruly stomach of undigested thought.

One consequence of this confusion was that the image of women profoundly changed. Originally the Naturalists championed those causes which the Suffragette movement considered important. But they did not stop at the vote or even at an economic equality of opportunity. Women, they argued, were the leaders in an evolutionary parade towards paradise: the function of men was to give them children and moral support. If the male will was superimposed upon the female, evolution itself was delayed. This argument inflamed still further the running sore of male sexual guilt, so painful a feature of nineteenth-century culture. For the next forty years, British drama moved away from the tradition of the hero cad, so popular in the 1890s. It was afflicted instead by the timid male hero and the sexually aggressive heroine, men who would blush and clutch their knees when sitting on the sofa with a desirable blonde. Were Strindberg's fears confirmed? Who was left behind in the doll's house after Nora had slammed the door? Was it her husband Torvald? And who held the keys to this new nursery? Was it that avenging demon of honourable men, the perfidious Laura?

Shaw and Brieux both made valiant efforts to reverse the male
chauvinism of their societies, but they did not accompany their
strictures with a matching appreciation of sexuality. In one sense
they made matters worse by providing an apparently rational, but
altogether misleading account of the different sexual needs of men
and women. Nora's revolt against Torvald symbolized for the next
generation the rebellion of women against environmental chau-
vinism, as opposed to the instinctual variety in bed. But not many
women could afford this defiance. Eugène Brieux concentrated on
the problems of lower-middle-class women, for whom every step
towards freedom is threatened by concealed economic pits. In his
early play, *Blanchette*, he considers the problem of an innkeeper's
daughter who has been well educated and won her diploma as a
teacher. Her father Rousset is proud of her, but when she returns
home, he expects her to serve behind the bar. Her degree is only
something to add to her "dot" to raise the marriage stakes. When
Blanchette refuses to spend her life as her father's barmaid,
Rousset turns her out of the house as a miserable layabout, and she
is forced to wander the streets of Paris, another *déclassée* forced to
sell herself for bread. Blanchette's problem was simply to find a
job in a world which denied economic independence to women.
Nora's defiance is all very well if one has a private income: but
Blanchette had not. The French Naturalists, such as Brieux and
Emile Fabre, hammered home this argument to the point of
exhaustion. Family relationships (they insisted) were conditioned
by economic considerations: *La Famille, C'est l'Argent* – the
title of a play by Fabre staged at the Théâtre Libre. The
economic system gave men all the advantages. Brieux' *The Three
Daughters of M. Dupont* (1897) was written to prove that all
the meagre alternatives open to a daughter of a middle-class
family were equally designed to support male power at the expense
of women.

 M. Dupont has three daughters, Caroline, Angèle and Julie. He
succeeds in marrying Julie to Antonin, the son of M. and Mme
Mairaut who own a bank. He is happy with the arrangement, for
his own printing business is not prosperous. The bank is not doing
too well either, and the Mairauts are glad to receive Julie's "dot"
of 30,000 francs together with a country house prone to flooding.
The Duponts know that the Mairauts are going through difficult
times, but they assume that Antonin's rich uncle will die and leave
him a fortune, an assumption which the Mairauts do much to
foster. When the uncle turns out to be as poor as the rest of them,

the Duponts accuse the Mairauts of treachery and try to obtain a divorce. Julie is merely a pawn in this battle, and her haplessness is further increased by the fact that her husband, Antonin, for whom she feels no great affection, denies her the child which she craves. Her two sisters, both unmarried, are equally unfortunate. Julie's step-sister, Caroline, receives a legacy from her aunt, which she partly gives away to Courtezon, an honest, hard-working man whom she expects to marry her. But Courtezon has been living with a woman for years – outside marriage: a situation of which Caroline is unaware. She has been swindled and faces the future with no prospects of marriage – nor a job beyond needlework – nor a decent income. The third sister, Angèle, is a fallen woman. At the age of seventeen, she was seduced and left with child. Her father drove her from the parental home, and was only prepared to receive her back, when Angèle too received her share of the aunt's legacy. Angèle lives as a demi-mondaine in Paris, apparently wealthy and happy, a popular night-club singer. But behind that glittering façade lies a life of despair, isolation and degradation. She smiles because she is paid to do so, and without that professional smile, her child would not eat. Julie confronted by these alternative life-styles resigns herself to the rigours of an unhappy marriage. The daughters are all without choice or opportunities. Money conditions everything – the relationships within the family, the status in society, the education and prospects of the children.

The British tended to regard the bourgeois marriage markets of France as the sort of behaviour to be expected from Frenchmen. "Paris," wrote Shaw, firmly to squash affectionate memories of La Belle Epoque, "is easily the most prejudiced, old-fashioned, obsolete-minded capital in the West of Europe." His own estimate of the economic opportunities for women was marginally more optimistic. Mrs Warren may have been driven into her profession as a madame from economic need, but she learns to enjoy her job and piles up enough money to provide her daughter, Vivie, with a good education. Vivie becomes a solicitor's clerk, having insisted on her right as an independent woman to do something useful with her life. She refuses to live off her mother's immoral earnings indefinitely. She, like Nora, has closed the door on the doll's house. But behind this admirable self-assertion is another form of deprivation, for it is hard to imagine Vivie actually enjoying a sexual relationship with a man. Her mild affair with Frank is conducted in baby talk:

FRANK: The babes in the wood: Vivie and little Frank.
(He slips his arm round her waist and nestles against her like a weary child.)
Let's go and get covered up with leaves.
VIVIE: (rhythmically, rocking him like a nurse.) Fast asleep, hand in hand, under the trees.
FRANK: The wise little girl with her silly little boy.
VIVIE: The dear little boy with his dowdy little girl.

When she came to a woman's estate, Vivie put behind her childish things, including Frank. Independent career women, such as Vivie, are habitually treated in British naturalistic drama either as blue-stockings or born spinsters or (as in Shaw) attractive women who are above that sort of thing. Many writers were prepared to applaud Nora, Vivie and other women who broke away from domesticity, but they were not willing to follow up this praise by allowing them sexual freedom. A woman was therefore faced with the uncomfortable choice of marriage, children and economic dependence, or independence, a career and celibacy. Sexual passion was an obstacle to a girl who wanted to assert herself in a man's world. Shaw is careful to point out (in his Preface to *St Joan*) that Joan dresses up in men's clothes and rides with the troops for perfectly rational reasons, not because she likes consorting with soldiers nor (heaven forbid!) from any hidden urge towards lesbianism.

Shaw assumed that the loss of sexual pleasure was not a great sacrifice for the emancipated woman to make. It only became important when a woman had become conditioned (like Mrs Warren) to sell her sexual services. A woman who was independent would not seek this pleasure at all; she would have no reason to. Women's sexual pleasures came not with copulation, but with procreation. "Experience shows," he wrote in his Preface to *Getting Married*, "that women do not object to polygyny when it is customary: on the contrary they are its most ardent supporters." He continued:

The reason is obvious. The question as it presents itself in practice to a woman is whether to have, say, a whole share in a tenth-rate man or a tenth share in a first-rate man. Substitute the word income for the word Man and you will have the question as it presents itself economically to the dependent woman. The woman whose instincts are maternal, who desires superior children more than anything else, never hesitates. She would rather take a thousandth share, if necessary, in a husband who was a man in a thousand, rather than a com-

parative weakling all to herself. It is the comparative weakling, left mateless by polygyny, who objects. Thus it was not the women of Salt Lake City nor even of America who attacked Mormon polygyny. It was the men. And very naturally.

This speculation rests on the assumption that women require good fathers for their children, rather than companions and lovers. The style of the argument is representative both of its age and of Shaw's contribution to Edwardian debate. The proposition is developed with mock mathematics – "a whole share in a tenth-rate man or a tenth share in a first-rate man" – and mock examples – "Experience shows . . .", "the women of Salt Lake City". Shaw, writing in 1908, was arguing a sensible case for the liberalization of the divorce laws, but the brusque, no-nonsense style seems almost intended to arouse opposition. It is aggressive rather than persuasive. Indeed the assertiveness damages the argument, for Shaw is tempted into wild generalities which the experience of his audiences must have contradicted. Women inherited instincts which were an integral part of the evolutionary process. They ensured the survival of the species by selecting strong and healthy partners rather than weaklings. Women were the ones in whom the life force beat most strongly. Shaw developed this argument in *Man and Superman*. Don Juan (John Tanner) was not a seducer of women. On the contrary, he used all his energy and strength to escape from them. But because he was strong and intelligent, Anna recognized him to be a proper father for her children – and hunted him down. There was nothing he could do about it. Her need was paramount. Women are ruled by higher laws than mere choice, reason or preference. It was in the interest of the human species that they should not be victimized by law or harassed by the arbitrariness of men. The Naturalists sometimes seem to have replaced the strictures and conditions of the Church with two other abstracts – the life force and the laws of economics – which also had the effect of limiting human choice. It may have been sinful for a Christian to lust after a woman even in his heart, but it was also dangerous nonsense for the rational socialist to use birth control.

Shaw and Brieux alike interpreted the use of birth control to mean that male lusts were being satisfied at the expense of the female need to procreate. The possibility that women too might need to be satisfied sexually without the burden of more child-bearing did not occur to them, or if it had, would have been

dismissed as male propaganda. "Childless marriages," grumbled Shaw, "have become the excuse for male voluptuaries" – not (you will notice) female ones. Quite apart from all the legal and economic restrictions placed upon women in marriage, there was also this nasty submission to men in bed:

> The vulgar and consequently the official view of marriage is that it hallows all the sexual relations of the parties to it. That it may mask all the vices of coarsest libertinage with added elements of slavery and cruelty has always been true to some extent: but during the past forty years it has become so serious a matter that conscientious dramatists have to vivisect legal unions as ruthlessly as illegal ones.
>
> (Shaw, Preface to *Three Plays of Brieux*)

Libertinage, according to Shaw and Brieux, is something which men do to women – not the other way round. Brignac in *Maternity* is a caveman when he hauls Lucie to bed, but Anna in *Man and Superman* was not being a cavewoman when she forced John Tanner to marry her against his apparent will. "Give women the vote," said Shaw jocularly, "and in five years they'll be taxing bachelors." Of course it can be argued that John Tanner was not really protesting at all – only sounding grumpy to conceal his attraction for Anna. But if this were so, the life-force idea, which occupies so much of the play, the preface and the interlude *Don Juan In Hell*, would be irrelevant.

These double standards, of course, must be placed within the context of male chauvinism – the social bias in favour of men which Shaw and Brieux were trying to reverse. They did not invent this chauvinism nor did it die away after the First World War. Lucie in Brieux' *Maternity* does not want to go to bed with her husband, because he is an alcoholic and her children are already showing signs of having inherited this alcoholism: sex without further procreation, of course, disgusts her. Henriette in Brieux' *Damaged Goods* is equally apprehensive of her husband's VD. How sympathetic would the establishment have been to their natural rebellion? It is hard to define the establishment, but at least one section of it, the Roman Catholic Church, would have disapproved. Even in 1950, Albert Ellis discovered in his research for *The Folklore of Sex* that American Roman Catholics were being formally advised to continue normal marital relations after the discovery of the husband's sickness, should the *husband* desire it. Women were encouraged to leave the possibility of contamination to the discretion of God. If a woman had slept with a venereally diseased

man – discovering later his sickness – she was advised to marry him:

> All the physical afflictions that can ensue from the marriage of a diseased person, both to the unhealthy consort and to the offspring, are an immeasurably lesser evil than one mortal sin which marriage could avert.
>
> (Father Connell, *American Freedom and Catholic Power*, 1950)

Therefore Henrietta and Lucie, who feared for the health of their children as well as their own, were nevertheless expected to do their marital duty. Shaw and Brieux pointed out that this was unfair – and compiled a formidable battery of arguments to support what seems a self-evident case. Brieux mentions an extraordinary statistic – that venereally diseased wet-nurses were more in demand in Paris than the healthy sort. A nurse who caught VD from an unhealthy child could sue the parents. And so parents with doubts about their health would prefer to employ someone who could not sue to someone who could. In arguing their case with such cogency and force, Shaw and Brieux furthered the view that women were passive victims of male lust. They endured this crucifixion for the good of mankind. The corollary of Shaw's statement that legal and illegal unions can equally mask the "coarsest libertinage" is that no status can elevate lust. True, of course – again self-evident, since laws do not penetrate the surface of a relationship, but since the lust was always shown to be male, this truism merely added to the burden of shame which conscientious men were expected to carry. This lofty view of male guilt was shared by many detached, urbane men of letters. "Marriage as we see it today," wrote Auguste Filon, "defaced and corrupted by modern life seems to me almost as contemptible as adultery." But it is hard for any fairly normal man, one who has chosen "biologically appropriate" objects, to have sexual relationships at all without falling into one of these two categories.

The Naturalists over-simplified the nature of sexual experience: it was a consequence of their quasi-scientific approach. Women were mothers, and men, at best, were childlike supplicants and at worst, brutish bosses. Even John Tanner, Shaw's *alter ego*, who is stoutly determined to maintain his masculine independence through the rigours of a wedding, is eventually tamed by Anna's amused maternal affection:

> TANNER: . . . The wedding will take place three days after our return to England, by special licence, at the office of the district super-

intendent registrar, in the presence of my solicitor and his clerk,
who, like his clients, will be in ordinary walking dress –
VIOLET: (with intense conviction.) You are a brute, Jack.
ANNA: (looking at him with fond pride and caressing his arm.) Never
mind her, dear. Go on talking.
TANNER: Talking!
(Universal laughter)

From such an outlook, could those sexual conversations develop,
which are perhaps an inseparable feature of erotic love? For men
and women, it is intolerable *always* to be treated as a child,
although it may *occasionally* be fun. A well-balanced man (if such a
paragon exists) wishes to please the woman he is with and to be
pleased by her. If we ignore the pleasures and wishes of others, if
we fail to listen with our bodies as we may try to attend with our
minds, our relationships suffer and we grow gradually into a state
of frustrated loneliness. A short cut to this suffering comes when
we fail to adjust to the different moods of our partners. Dr Eric
Berne, in *Games People Play*, put forward an amusing hypothesis
concerning the origins of sexual quarrels. In his view, men and
women of all ages have three separate rôles – as a parent, as an
adult and as a child. These rôles exist side by side in the per-
sonality. They are distinguished sometimes by language – or
behaviour – or even intonations of the voice. Thus a husband may
say to his wife, "You *may* take the car" – giving his parental per-
mission. Or he may say, "Do you need the car?" – asking an adult
question of an adult. Or he may say, "*Please* don't take the car!" –
implying either "Mummy, stay at home with me!" or "Mummy,
be careful!" If the wife adjusts to these rôles, answering with a
complementary rôle, there is no problem. If she replies to the
parental husband with childlike deference, "Oh thank you, dear!
I'll be very careful!" or if she answers the adult husband in an
adult tone, "I need the car this afternoon," or if she replies to the
childlike husband with a reassuring maternalism, "I won't be long,
darling!" no quarrels need be expected. The sparks fly when the
rôles do not match – when a wife replies to a paternal husband in
an adult tone of voice: "You *may* take the car!" "Well, it's *our*
car!" These illustrations suggest that the woman is reacting to the
man, but the situation can equally be reversed. Dr Berne suggests
that most of us play these different rôles and that if we refuse to
play one of them, this may indicate a certain rigidity in our per-
sonalities. I may, for example, be a parent in my study. I concede
to nobody else an equal right to be there. But if I always insist on

being a parent, in every other room of the house, then I am some-
one who is incapable of taking other rôles. If someone insists on
always being an adult, then no spheres of influence within any
situation can be marked out. Every minor detail has to be dis-
cussed "rationally" between equal partners, because no authority
in any sphere has been conceded – a lengthy and tedious process.

The Naturalists retorted to the father–daughter relationship of
male chauvinism by asserting that the mother–son relationship
was more in accordance with laws of nature. Nowadays both of
these behaviour patterns would be regarded as equally limiting.
Mutual satisfaction is the passport to modern marriage, as any
magazine supplement would affirm. The universally applauded
triumph of mutual satisfaction, the simultaneous orgasm, would
be hard to envisage (let alone achieve) in the biological system
dreamt up by Shaw and those Naturalists who shared his point of
view.

The later Naturalists also lost one valuable insight which the early
romantics possessed to a fault and Ibsen expressed with brilliant
force: the sheer human resentment of blind conditioning. The
early romantics expressed this in Promethean terms: the aspiring
will of man grappling with the inexorable laws of God, Byron
wrestling with sexual guilt on a high mountain. Change the phrase
"laws of God" and substitute "bourgeois conventions and bio-
logical needs" and we find the situation of Hedda Gabler. Hedda
has chosen a good father for her children, George Tesman: he is
also malleable enough for her to mother, should she wish to do so.
She is pregnant as she should be after six months of honeymoon.
Why is she unhappy? There are many possible reasons, none of
them easily explained by the Shavian lines of reasoning. Hedda is
unhappy because she is a woman and not a man, because her life
stretches before her in an unending commonplaceness, because
she has lost her most exciting potential lover, Eilert Lövborg, and
acquired a threatening one, Judge Brack, because her estimation of
herself cannot be matched by any rôle which she is likely to be
asked to play, not as a mother, mistress or wife and because, quite
simply, she is pinned down by circumstances. She suffers from
"divine discontent". Nor is this suffering confined to Ibsen's
heroines. His heroes, from Brand to John Gabriel Borkman, are
similarly afflicted. Indeed one of Ibsen's first lyric poems summa-
rizes the anguish in an anecdote about a bear. A bear has been
captured in the high mountains by hunters – who sell it in chains

to a fairground proprietor. The showman places the bear in a cage, with a metal floor heated by a boiler. As the floor gets hot, the bear lumbers in pain from one burnt foot to the other while the showman plays a tune on his flute, "Life is beautiful – life is gay." The bear has apparently learnt to dance.

We might call this state of spiritual rebellion "alienation" and bring to bear on its definition a host of other examples: of Marxist alienation in which man is dissatisfied with his unjust society; of Thomas Mann's Felix Krull, the confidence trickster who is not too certain who he is but is confident of his ability to seem what others want him to be; of Pirandello and the seven characters who resist the simplifications of the stage; of Max Frisch's *Andorra* and the young boy who endorses his Jewishness only when he discovers that he is not a Jew; and inevitably – of the theories of Freud. Ibsen anticipated Freud remarkably, to the details of the Electra complex and penis envy. Or perhaps we should say that they both interpreted the sexual anxiety at the turn of the century in a similar way – as a struggle between the Superego and the Id, the Mountain and the Valley in Ibsen's *When We Dead Awaken*. Freud described the alienation of man from his supposed sexual needs like this:

> However strange it may sound, I think the possibility must be considered that something in the nature of the sexual instinct itself is unfavourable to the achievement of absolute gratification ... The erotic instincts are hard to mould: training of them achieves now too much, now too little. What culture tries to make of them seems attainable only at the cost of a sensible loss of pleasure: the persistence of the impulses that are not enrolled in adult sexual activity makes itself felt in an absence of satisfaction.

He goes on to argue that man's dissatisfaction with his sexual behaviour contributes to his urge for betterment:

> For what motives would induce man to put his sexual energy to other uses if by any disposal of it he could obtain fully satisfying sexual pleasure? He would never let go of his pleasure and would make no further progress.
>
> (Freud, *The Most Prevalent Form of Degradation in Erotic Life*)

Those Naturalists who believed that man was a product of blind mechanical forces, mainly evolutionary and benevolent, were saying in effect that man could only submit to his destiny. Any

attempts to the contrary, such as birth control or the sexual emancipation of women to match the economic, were almost by definition reactionary and doomed to failure. Ibsen, on the other hand, argued that there was a tension between what a man or woman physically was and what he or she wanted to be. He could endorse his sexual nature by assenting to it in marriage, adultery or any other form of sexual behaviour, or he could withhold his spiritual acceptance. Sexuality was therefore a means of self-expression. Within the limits imposed on us by sheer survival we chose our destinies – to ascend the high mountains or visit the valleys. And even beyond these limits, we could choose with Hedda not to live at all, rather than to survive in a debased form. Almost alone among the Naturalists, Ibsen celebrates the torment of free will.

But were not the Naturalists taking too negative an approach towards *custom* and speculating about it too freely? Is custom really a cage to torture and tame the bear? Obviously it can be a cage – but it may also be a quick way to sum up a situation. Men and women need to find circumstances in which it seems appropriate to make love. These circumstances may differ from age to age, but the search for appropriateness goes on. Without a feeling that the situation is right, it is difficult for a man to erect or for a woman to respond to his excitement, and therefore there is a conscious or unconscious re-arrangement of circumstances to acquire this suitability. If a man feels ashamed to fuck – or interprets fucking as an aggressive act – he may need to comfort himself with the thought that women are degraded anyway, they get what is coming to them. Consider again young Marlowe's unfortunate dilemma in *She Stoops to Conquer* (1773): he was stimulated not just by a pretty girl – but by a pretty girl within a social context. The context confused his conscience – stimulating his sense of class rebellion and lulling his moral sensibilities at the same time. He was too ashamed of his sex to make love any other way. When Miss Hardcastle discovers accidentally that he is shy with his social equals but a devil with the maids, she plays along with his fantasies. She loves him and therefore dresses as a maid. Both of them re-arrange the circumstances of their lives to find a situation which seems appropriate. This appropriateness is a fusion of social attitudes, moralities and sexual inclinations. Thus, Marlowe feels sexually attracted to maids because he assumes that (*a*) all maids have nothing to lose – none of them are virgins and they do not expect to make good marriages; (*b*) he can pay for their services

lavishly – which will improve their prospects, and (*c*) he wants to fuck a pretty girl.

> MARLOWE: We all know the honour of a barmaid of an inn! I don't intend to rob her, take my word for it, there's nothing in this house I don't intend to pay for!

Marlowe is of course a snob, a male chauvinist and a feudal exploiter of the poor, but these are our estimates of his behaviour – not his own. We are, however, all Marlowes in the sense that we try to reconcile the various aspects of our personalities within the sexual act. If a man is determined not to be a male chauvinist, he may find a submissive child, maid or mistress equally unstimulating.

Custom provides a consensus guide as to what is considered appropriate. It may be grotesquely unfair or quite out of contact with the realities of living. Nineteenth-century law assumed that husbands were responsible for the behaviour of their wives – but the law is an ass. Despite these absurdities, custom may still serve a useful purpose – by providing situations where it seems temporarily appropriate for men and women to make love, rather like initiation ceremonies. The fantasies which custom provides are often necessary to overcome the uncertainties of adolescence. "How do I know that she likes me?" "Ask her to dance." "But will she want to live with me?" "Propose to her." Neither the dance nor the marriage is of any importance in itself. The custom is not the relationship: it is a socially defined entrance to the complicated maze of living with a partner. Having passed this doorway, the problems of mutual understanding begin.

The trouble with custom is that it is sometimes taken too seriously: men start to assume that women must be maids or the second sex because their adolescent fantasies require them to be so. When this happens, custom quickly hardens into oppression and male or female chauvinism is born. But to change a chauvinistic custom is often more difficult than it seems. The causes which the Naturalists championed have largely been won: women have the vote and, while they may not have achieved full economic parity with men, women are now able to earn their livings – whereas Blanchette could not. But in winning these battles, the Naturalists altered what was considered appropriate in courtship. An age of sexual hesitancy began. The same problem today occurs with the successors to the Suffragettes, Women's Liberation. The writers of the Women's Lib. movement rightly insist on psychological and

sexual parity with men. Unfortunately, this justice cannot be achieved through an alteration in custom. A fair-minded acceptance of another person can only be achieved through a relationship. An attack on sexual custom may be perfectly justified: but it may also delay the start of relationships and hamper the conquest of shyness.

The Naturalists were self-righteous revolutionaries. They argued the case against Propriety from the standpoint of the respectable. Edward Garnett in his Preface to *The Breaking Point* is at great pains to point out how moral his play is, although his heroine is *enceinte*. Shaw emphasized that *conscientious* dramatists vivisect marriage. J. T. Grein, André Antoine and Otto Brahm all insisted that *their* theatres were not like other theatres. They would never stage anything which was, say, as trivial as the mock-classical bawdry of Offenbach, as salacious as a Feydeau farce, as offensive as a music-hall burlesque. Does not this assertion of personal virtue present a living example of the alienation which Ibsen and Freud described? Can we perhaps detect a hidden and (should it be so) crushing irony – that by insisting so heavily on the mechanistic origins of human behaviour, the Naturalists were proving by their example that they were above such blind laws? Was this the inner intention? If we admit, say, that we are compulsive liars, we are trying to prove our honesty in the very admission. Was this the case with the Naturalists? Perhaps so. But Frank Wedekind chose a simpler line of attack. He described the scientism of the Naturalists and the conventions of propriety in one expressive word – *Lebensangst* – the anxious fear of life. In the early 1890s, enraged by Hauptmann's satirical portrait of his own family in *Das Friedensfest*, he accused Hauptmann of leeching on to other men's lives and then went on to insist that the Naturalists had tried to keep sexuality at a distance, fobbing Eros and the Bacchae off with mock rationalism. The disdain of the Naturalists for the popular theatre was a symptom of this inhibited superciliousness. Wedekind wanted to challenge Nora, Flora and Laura with a feminine symbol who would represent the exact opposite. And so from the depths of *Sturm und Drang*, Grand Guignol, panto and circus, not to mention Nietszchean philosophy, he dragged up Lulu.

5

Lulu Dancing

Lulu was the arch destroyer of men and marriages, the purest of agnostics who concentrated her attention on what Wedekind regarded as man's highest pursuit, that of sensual pleasure. She could only be tamed to one man's will by brute force – the Ringmaster's whip or Jack the Ripper's knife – thus illustrating the maxim of Nietzsche, that love is war, the mortal hatred of the sexes. Ordinary daily loyalties, the stuff of domesticity, were either beyond her or beneath her, acccording to one's interpretation. It is usually the weak in Wedekind's plays, with their anxiety of life, *Lebensangst*, who cling to the routines and the conventions in a vain attempt to escape the sexual battle. When Mrs Bergmann in *Spring Awakening* is asked by her fourteen-year-old daughter Wendla to explain the facts of life, she covers herself with confusion.

MRS BERGMANN: . . . But it doesn't come . . . I can't be responsible . . . I deserve prison – to have you taken away.
WENDLA: . . . Be brave, Mamma.
MRS BERGMANN: So listen . . .
WENDLA (trembling): Oh God, God.
MRS BERGMANN: To have a child . . . Can you hear me, Wendla?
WENDLA: Please be quick – I can't bear it . . .
MRS BERGMANN: To have a child – the husband – the man one is married to – you have to . . . love him, love him – the way you can only love a man. You have to love him so completely – with your whole heart – so much that it can't be spoken. You have to love him, Wendla, the way you're still too young to love . . .
WENDLA: God in heaven.
MRS BERGMANN: So now you know what difficult tests lie ahead.
WENDLA: And that's all?
MRS BERGMANN: As God has told me.

Her timidity has a cruel result, for Wendla in her ignorance becomes pregnant and (since Mrs Bergmann cannot face the prospect of her daughter mothering an illegitimate child) dies from an abortion. Nor is *Lebensangst* limited to fussy mothers. Moritz, an adolescent boy, also suffers from it. He is inexhaustibly curious about sex, but when his friend Melchior tries to explain it to him, he is too upset to listen.

> MORITZ: I can't chat about reproduction, Melchior. No . . . no . . . couldn't you write it all out, everything you know – clear, unambiguous – stick it in one of my books during break and I'll take it home without knowing. One day it'll just turn up. So I'll have to look through it however much work there is piling up. And if it's absolutely essential – you could put a few diagrams in the margin.

Melchior does so, but when Moritz commits suicide after failing his exams, these drawings are seized as proof that Melchior has been corrupting Moritz. Melchior is sent to a boy's reformatory. *Spring Awakening* is a play about the awfulness of growing up, in a society which denies adolescents the most basic form of knowledge, that of their own bodies. Why was this knowledge denied? To protect the bourgeois marriage market. If Wedekind's vision of the uninhibited pursuit of sexual pleasure seems almost inhuman in its disdain for home comforts, we have to remember that he was reacting against Propriety, *Feudalismus der Liebe*, a feudalism of love against which all must rebel. It was not enough to open a few doors in the hothouse – laughing at marriage with M. Sardou, observing it clinically with Zola, sentimentalizing the misfit with Dumas (fils). It had to be attacked, as it were, frontally – with the very opposite. Lulu was that opposite.

Wedekind was inspired to write the first draft of *Lulu* after seeing a pantomime *Lulu* in Paris, copies of which do not seem to have survived, although we can perhaps guess at the style of the original. Wedekind's first version was in the form of a single play which tells the story of a street girl who is "rescued" from poverty by a rich newspaper proprietor, Dr Schön. Schön makes her his mistress, but when she starts to interfere with his family life, he marries her off firstly to the hideous Dr Goll who dominates her, and then (after Goll's death) to the insipid anxious artist, Schwartz. But Lulu is in love with Schön, and he, against his better judgement, dotes on her. A marriage between them would violate all the codes of

Propriety. Lulu is no Pygmalion – she cannot be made respectable by a few vowel sounds. Her real father is Schigolch, a disgusting old tramp, "a phantom born", as Alex Natan puts it, "from Mephistophelian slime". When Schwartz dies – committing suicide following the discovery of Lulu's infidelity – Lulu goes on the stage briefly as a dancer in one of Alwa's ballets before finally forcing Dr Schön to marry her. She has won the war between the sexes and, like a true conqueror, she does not respect the wishes of her victim, except perhaps in bed. She brings Schön's home into disrepute, stocking every parlour cupboard with canned lovers – Roderigo Quast the strong man from a circus, Hugenburg a schoolboy, a gamekeeper, Alwa, and the lesbian Countess Geschwitz. Tormented by jealousy and shame, Schön threatens to kill them all, begs Lulu to commit suicide like a good penitent adulteress, and when she does not, he threatens to shoot her himself. In the struggle, Schön's revolver twists out of his hands and into Lulu's. Lulu shoots him, Schön dies and Lulu is arrested by the police.

These events occupy the first three acts of the original *Lulu*, which were followed by two further acts, in which Lulu, having escaped from prison, flees to Paris and then to the slums of London where she dies, now a common prostitute, at the hands of Jack the Ripper. But the last act caused censorship problems, and so the original version was never performed. Wedekind then expanded the first three acts into a single play, *Earth Spirit*, which was performed in Leipzig in 1898 to great acclaim. He then re-wrote the last two acts as a sequel, *Pandora's Box*, adding a new first act in which Countess Geschwitz saves Lulu from prison. This new play was performed privately in 1904 and 1905, again with great success. Wedekind appeared in all these productions, playing the Ringmaster, Dr Schön and Jack the Ripper. But still censorship interfered with the public production of *Pandora's Box* and in any case, Wedekind was not happy with the division of the Lulu plays into two separate stories. He therefore wrote yet another version, omitting the last scene, but bringing together *Earth Spirit* and *Pandora's Box* once again into a single play, *Lulu*. Wedekind wrote and re-wrote the Lulu plays from 1891 to his death in 1918, and the story acquired layers of meaning as his personal life unfolded. He even married the actress, Tilly Newes, who played Lulu in 1905. Nor did the story of the Lulu plays end with Wedekind's death – for Alban Berg, the composer of *Wozzeck*, saw and admired the first production of *Pandora's Box*. Berg

tackled an operatic version which was unfinished at his death in
1936. There have been several films and in 1970, Peter Barnes
adapted *Earth Spirit* and *Pandora's Box* into a single play, *Lulu*,
for the Nottingham Playhouse. The production transferred success-
fully to London. And so the story and its central character has
haunted not only Wedekind, but Reinhardt, Berg, Peter Barnes
and many other writers and directors during the course of the
century. It is a theme which occupies an important – perhaps a
central – place in our culture to rank with, say, Mother Courage
and the good soldier Schweik, for Lulu represents a distilled
sexuality which is both victimized by society and preys upon it.

With the different versions of *Lulu*, the styles and interpreta-
tions vary. Berg's music for *Lulu* is thick-textured, jagged and
doom-laden. The tragedy of Lulu's fate in the slums is foreshadowed
in the early scenes, so that the story moves inexorably to the last
swift and horrible stabs of the knife. Peter Barnes, on the other
hand, sharpens the dialogue of the original, making the juxta-
positions between farce and horror all the more evident. Some-
times, he replaces the original image with one more suited to a
permissive age. In *Pandora's Box*, Schigolch, swearing by "all
that's holy", lays his hand on Lulu's ankle. In Barnes' *Lulu*, he
swears on her vagina. Barnes drastically cuts the Ringmaster pro-
logue in which Lulu is presented to the audience as a wild animal.
These changes imply slightly more than editing, for Wedekind
evidently saw the story of Lulu as an allegory – the title, *Earth
Spirit*, suggests as much – and to explain the symbols, to place
them in the context of the current discussions about marriage, he
used long explanatory speeches, such as the Prologue:

> Proud Gentlemen and Ladies who are gay
> Step right inside to look around the zoo
> With burning pleasure, icy shudders too,
> Here where the soul-less brute creations play.
> The show is just beginning, come and see
> How to each pair a child's admitted – free.
> Roll up! Roll up! Ladies and Gentlemen, and see.

The translation (by Stephen Spender) does not conceal the heavy
didacticism and laborious jokes – cynical academic-showman, in
the style of a music-hall chairman. This peculiarly heavy style
contrasts with the lightness of the scenes to follow and belongs to
a certain mock-classical vein in German drama, to be found both
in Büchner in the 1830s and Brecht in the 1920s. It was partly an

affectionate send-up of *Sturm und Drang*, much as the *Beggars'*
Opera burlesqued Italian Opera. Peter Barnes' version of the
Prologue cuts out the "unnecessary" words and with it the bur-
lesque and didacticism:

> Roll up! Roll up. Ladies and Gentleman, and see
> the wild animals! Excitement! Thrills! Danger!
> The greatest show on Earth! Roll up! Roll up!

Wedekind's prologue extends for 120 lines, Peter Barnes' for
about 16. We know from the various accounts of Wedekind's
acting, that he favoured a direct harangue to the audience –
working somewhat in the tradition of melodrama. As a director, he
emphasized that the speeches should be clear, well-pointed,
larger than life: no nuances of naturalistic acting which he hated.
Brecht saw and admired his acting:

> He was not a particularly good actor . . . but as Marquis von Keith he
> put the professionals in the shade. He filled every corner with his
> personality. There he stood, ugly, brutal, dangerous, with close-
> cropped red hair, his hands in his trouser pockets, and one felt that
> the devil himself couldn't shift him. He came before the curtain as
> ringmaster in a red tail coat, carrying whip and revolver, and no one
> could forget that hard, dry, metallic voice, that brazen faun's head
> with eyes "like a gloomy owl" set in immobile features.

Wedekind played the ringmaster in the first production of *Earth*
Spirit and we can imagine the effect: the harangue, the tough,
brutish presence. Wedekind's Ringmaster met the prejudices of
the audience in head-on collision, and the shock prepared the way
for other shocks – that custom equals timidity, that religious faith
is bunk, that love is war and that sensuality is the only pleasure
worth pursuing.

Peter Barnes cut back on the heavy, some might call it Teutonic,
rhetoric, and in doing so lost – or at any rate underplayed – the
original argument. But perhaps the argument was lost already for
we live in a different world. Lulu was created to combat the
"Hausfrau" monster, who is now slowly sinking in a sea of cus-
tard, whereas her rival, some fear, is trampling all over the place,
stamping our domestic fields into a mudpatch of condoms and
foeti. Lulu may have been a relevant and necessary symbol in 1900,
but has not she become the prurient cliché of the 1970s? Lulus
stare down at us from half the cinemas in London, from bookstalls

even in Canterbury. In 1962, Rolf Thiele, the German film director, tackling yet another screen version of *Lulu*, said:

> The girls of today are all Lulus. They do not know themselves, do not question themselves and are therefore pardonable like Lulu.

This is a nonsensical piece of pre-publicity, which nevertheless contained the hidden warning that this particular shoal in the sea of experience was in danger of being over-fished. Peter Barnes faced other problems as well. How is it possible to re-capture nowadays that moral fervour which (on the simplest level) could retort to anxious stories about adulteresses who were abandoned and slain, with the cry, "Yes, but isn't an ecstatic death better than a slow death in the chains of marriage?" Wedekind was, as Burkhardt has said, a *simplifacteur*, and beset by all these other simplifications of the erotic, it is hard to distinguish the clarion call from the muzac stimulation. To an audience today, the quasi-mystical rhetoric of the 1890s, the bogeymen turned redeemers, the anti-religion to exorcize the faith must all seem equally perverse. When Lulu in the Nottingham Playhouse production begged Jack to stay with her, what did we see! An earth spirit meeting her sub-blime though terrible destiny? No – a lonely woman made desperate by circumstances. The weird exultation cannot be attempted. We, in other words, require the psychological motivation for which Wedekind had a contempt. Wedekind wanted his characters to be symbolic, stressing their allegorical importance at the expense of their credibility. We are pulling in the opposite direction. We are familiar with the symbol which we are now trying to humanize.

All, however, was not entirely lost with the Nottingham Playhouse revival – for the story can be interpreted on many levels. It was not good Wedekind, but it was engrossing drama. Peter Barnes simplified the story into two acts – the first based on *Earth Spirit* and the second on *Pandora's Box*. The bare story of *Earth Spirit* follows the well-known and loved pattern of the Electra complex, complete with a lofty guardian/father, Schön, and a degraded one, Schigolch. We do not have to bother with the Earth Spirit idea if we do not want to. The psychological motivation which we require is therefore present (though buried) in the plot which Wedekind supplied: and it overwhelmed the allegory of Vice Triumphant from the original script. We may still jib at the Ringmaster Prologue, preferring to tame mixed-up girls with analysis rather than the whip – if such a distinction can be made.

We may find the end of the first scene too long drawn out – where
Schwartz questions Lulu about her beliefs and she answers, "I do
not know." For Wedekind, this was an important statement,
particularly after the death of Dr Goll, indicating that the pursuit
of sensual pleasure cuts across daily faiths. Today this agnosticism
is the mark of an ordinary sincerity, and the repetitions of the
script merely slow down the scene. Without the allegorical over-
tones, the first act worked well enough on the level of a Schnitzler
tragic farce, ridiculing bourgeois morality, ironically observing the
effects of erotic love and, through a succession of contrasting
scenes, moving towards a grand climax of lovers, ogres and pistol
shots. There is not the tight construction of a Schnitzler play, say
La Ronde, nor the easy Viennese sophistication, but the characters
are more colourful. The production had a tough modernity to it,
an admirable achievement by Stuart Burge: the sensuality of
Julia Foster with her neat innocence – the kinky scenes stated with
a gourmet's instinct to savour the taste without being too greedy.

 The real problems occurred in the second act, based on *Pan-
dora's Box*, where Lulu goes on the rampage throughout Europe.
The relationship in *Pandora's Box* between Geschwitz and Lulu
balances that between Schön and Lulu in the first act – as a
theatrical bridge under which the other events flow. But here the
comparison ends, for the Geschwitz/Lulu affair does not possess
the same psychological validity, but holds instead a higher moral
fervour. Wedekind saw the Countess Geschwitz as "someone
burdened with the curse of abnormality" who has "to summon up
all her spiritual resources to conquer [her] spiritual destiny". She
catches cholera to take Lulu's place in prison, she helps to murder
Roderigo who threatens to squeal on Lulu in Paris, she carries
around Schwartz's portrait of Lulu with a fetishistic reverence and
eventually is slain with Lulu in London. Geschwitz is distin-
guished by a dog-like devotion which Lulu continually needs – yet
spurns. Before we assume too quickly that the masochism of
Geschwitz is simply her way of getting kicks, we have to bear in
mind that conquest and submission are central to Wedekind's
conception of the sexual war. Effie, the "Lulu" of Wedekind's
Castle Wetterstein (1910), drinks the poison destined for her last
lover, Luckner. Elfriede (in his *Death and the Devil*) is a champion
of woman's rights, a Nora or Vivie, but she becomes converted to
a different philosophy after a visit to a brothel. She then realizes
that her destiny as a woman is to find "death in sensual pleasures",
"to be slaughtered on the sacrificial altar of sensual love". On one

level, Wedekind inverts the customary warnings by stressing the
passion which leads to a gory sacrifice: a woman has not lived until
she's been slaughtered. On another, complete domination and
total submission are seen as the natural consequence of erotic love.
The self-destructive power of erotic love is precisely the theme of
Wedekind's play: and it is precisely at this point that a modern
audience is likely to quibble and prevaricate. "Our emotional life,"
states Rudiger in *Castle Wetterstein*, "consists in our over-rating
the importance of human relationships." Lulu seduces Schwartz
the artist, while her first husband Goll is still cooling on the floor
after a heart attack. "No one," says Rudiger, "is irreplaceable."
We find this vision today somewhat watered down in the black
comedies of Joe Orton, or in the vein of Gothic savagery in George
MacBeth's poems – or in the dead-pan cannibalistic humour of
Bond's *Early Morning*. It is not unfamiliar to us. But we do not
quite take it seriously – it is an affectation, an amusing style. But
Wedekind was speaking to audiences conditioned by the churches
and custom to believe that sexuality brought with it a diabolic
unreason, an anarchy of superhuman force. He embraced this idea
with delight: "of course, it's destructive – that is its purpose."
Lulu, the embodiment of this principle, was not a grand seduc-
tress. Wedekind described her as "childlike, natural, unself-
conscious, and possessed of a certain lightness". She had a hot
line to her animal nature and the earth spirit did the rest. The
world which Wedekind's Lulu inhabited was still one of a medieval
dualism – the spirit versus the flesh, Pentheus versus the Bacchae.
Wedekind, after watching the naturalists appealing to reason,
cheered on the other side.

Lulu was intended to be the embodiment of the female sexual
impulse, whatever that may be, and if it seems strange that the
same historical age could produce so many different extreme
pictures of femininity, from the "Hausfrau" to Nora and Laura to
Lulu, we have to remember firstly that these are all portraits of
women seen through the eyes of men, and secondly, that these
images form part of a European dialectic, where one advocate
would retort to the arguments of another with flat assertions to the
contrary. Wedekind did not exactly have to "invent" Lulu – for
the image was already there. He merely tried to reverse the moral
assessment of her. In every Western capital, there were women
whom moralists called "abandoned" – but who were neither
prostitutes, nor demi-mondaines living in prim suburban villas,

nor courtesans in the eighteenth-century sense – but sexual
adventuresses who took advantage of the fluid and confused out-
look of the time, sometimes exploiting the protection of marriage,
sometimes the freedom of the streets and the obscurity of hotels,
and above all, "abandoning" themselves to passions which the
timid and restrained might deplore but secretly envy. Wedekind is
at pains to point out that the pursuit of the erotic retains its own
form of purity. When Alwa accuses Lulu of being "a most design-
ing bitch", she retorts naïvely, "I only wish I were." She simply
acts (as Martin Esslin pointed out) "with total sincerity in follow-
ing her own nature." When Casti-Piani in *Pandora's Box* tries to
blackmail her into a brothel, she retorts indignantly:

> I can tell in the pitch dark at a distance of a hundred feet whether a
> man is made for me or not. And if I sin against my knowledge of
> myself, I feel soiled in body and soul, and it takes me weeks to over-
> come the self-disgust.

In the midst of a morass of lovers, husbands and intrigues, Lulu
retains a certain innocence: and this delight in her own sensuality
is expressed above all in her dancing.

We do not see Lulu dancing in any version of Wedekind's Lulu
plays, although she does dance in some later adaptations (not in
Peter Barnes' one). This seems to be surprising, for the story
mentions how she danced the can-can for Schwartz and one scene
is staged in her dressing-room at the theatre, where she is starring
in a ballet-revue staged by Alwa. She describes her own passion
for dancing and she has apparently a sensational impact on others.
"I've never seen an audience so enthusiastic," exclaims Alwa in
delight at his first triumph. "When she dances," explains Prince
Escerny, "she becomes intoxicated by her own beauty." "I don't
see anybody when I'm dancing," explains Lulu, "If I miss just
one evening I dream all night I've been dancing. And next morning
I wake up exhausted." Her dancing is self-absorbed: alone with
her beauty and her fantasies, she abandons herself to an inner
reverie from which (nearly) all outside distractions are excluded.
She only becomes aware of the audience in one bitter moment –
when she sees Schön sitting with his fiancée in the audience. Then
she feels as if she has been beaten all over and refuses to dance.
Lulu's abandonment in dancing is not something which is directed
towards an audience; she is not even trying to seduce Schön
from a distance. Abandonment comes when the body takes over

from the mind, when one ceases to be aware of others or of one's mind directing the limbs.

But why does not Wedekind actually show her dancing? He was not a literary purist. He did not share the naturalists' disdain for the popular theatre. On the contrary, he loved Grand Guignol, circuses, the music hall, the spectacular revues and burlesques of Paris. He disliked London, a "grey" city, because too few theatres presented the revue spectaculars which he loved, and those that did were (by Parisian standards) inhibited. Wedekind's vision of the ideal theatre, according to Leon Feuchtwanger, was "a combination of colour, music, word and gesture" – which was more likely to be realized in the popular theatre of Paris than in the naturalistic plays of the Deutsches Theater or the Théâtre Libre, or in the society drama at the St James's. But he did not even try to exploit dancing and music in *Lulu*. There are two explanations for his reticence. One is that this image of Lulu dancing was simply impractical to create: it had to be a distillation of the sensual, an ideal, and any false step by the dancer/actress, any smile slightly too fixed, would have destroyed an illusion central to the meaning of the play. The other reason was that he did not have to run this risk. His audiences already knew – or could guess at – what an abandoned dance was like. There were plenty of dancers and small troupes around Europe which specialized in a particular sort of frenzy, and apart from them, there were many slower, more statuesque ballets in which the beauty of the body was celebrated without athletic sweat. From these examples, the audience could compound their own version of Lulu dancing, without being distracted by a single limited routine concocted by an actress or a director on stage. Wedekind ducked the opportunity of presenting this distillation because he felt that to do so would have been both risky and unnecessary The extreme pursuit of sensual pleasure is an abstraction, easy to talk about but hard to realize in practice, even if it is possible to do so. If he had shown Lulu dancing, might not the audience have sensed that the argument of his play was based on false premises?

Lulu as an image caught the imagination. The sight of Lulu dancing might have destroyed the illusion. And so Wedekind left this test to the imagination, relying on the fantasies of his audiences to carry him through. If *Lulu* had been presented in London during the 1900s (the first modified version was not staged until 1927), what would audiences in the grey capital have imagined? Perhaps the essence of Lottie Collins, who rose to fame with one

song which epitomized the classlessness and fury of the adventuress. The verse was deliberately demure:

> A smart and stylish girl you see,
> The belle of high society;
> Fond of fun as fond could be
> When it's on the strict QT,
> Not too young and not too old,
> Not too timid, not too bold,
> But just the very thing, I'm told,
> That in your arms you'd like to hold.

Then she would place her hands on her hips, barmaid style, kick up her legs through the broken petals of her petticoats and sing:

> Ta-ra-ra *Boom*-de-ay . . .

"She sang and danced," wrote Macqueen-Pope in awe, "with wild Bacchanalian abandon, her extremely high kicks coinciding with drum and cymbal crashes in a display of wild, untamed savagery which nobody watched unmoved." She sang this one song – from theatre to theatre – hired by impresarios to present this moment of abandon as part of the packaging of other shows during the interval – until she was exhausted by the three-times nightly frenzy. Long after the craze was over and her energy drained away, the memory as it were lingered on. Dancers were imitating Lottie Collins even during the 1940s and 1950s: her gestures, her high kicks, her quick sideways thrust of the bottom. A Second World War song, "Hands, Knees and Boomps-a-daisy", recalled the original. Lottie Collins fascinated audiences partly by the abrupt contrast between the surface gentility and the *rosserie* beneath. *Rosserie* was a word in vogue in Paris during the 1890s. *Rosse* meant a tart or prostitute: *rosserie* meant a vicious sort of ingenuousness, a Schweikian approach to life and authority. There was a cult of underworld theatre in both Paris and London – the middle classes discovered the joys of slumming. In London, East End music halls were fashionable for audiences from the West End. In Paris, *comédies rosses*, following the fashion set by Henry Becque's *La Parisienne*, filled the commercial theatres: and *chansons rosses* were sung in the nightclubs and café theatres. In the twenties, *rosserie* became incorporated into the early Brecht-Weill musicals, such as *The Threepenny Opera*, where there is a sinister delight that the middle-class pigeons are coming home to roost.

But perhaps the audiences of the 1900s would have preferred to associate Lulu with the more "classical", softer and more sensuous approach of Maud Allan, whose Salome dance in 1908 caused a minor scandal, for nobody could decide what she wore, if anything, beneath the seventh veil. Or did they recall Isadora Duncan, who had already provoked several scandals with her free interpretations of Greek dancing? But Lulu, they might have reflected, was originally a Parisienne, although Wedekind transposed the setting of the original *Lulu* pantomime from Paris to Berlin. But he did not lose the quality of her Parisian abandonment, which possessed a special quality for the rest of Europe. She started dancing in the streets, begging for her father Schigolch. Was she then a *grisette*? "All the intelligence, the devotion, the pity of a woman are to be read in her wonderful eyes, but below there is the nose and mouth of a sensual little creature, a vicious almost vulgar smile, lips pouted for a kiss, but with a lingering, or dawning, suggestion of irony ... exactly the reigning type, the type one meets constantly on the Paris pavements." This is a description of Mlle Réjane, a leading actress in Paris during the 1890s, who was particularly at home in the orgy scenes, such as those staged in Donnay's *Lysistrata*, an Offenbachian version of the original story where Lysistrata gets her own way, not just by encouraging the women to withhold their favours from men, but by knowing herself when this abstinence is likely to be counter-productive. Mlle Réjane appeared in *Lysistrata* wearing transparent muslin before her lover Agathos (played by Lucien Guitry) who trembles with anticipation. She complains petulantly: "Men! They're all the same! Just because I'm dressed like a dancer, I seem to him a hundred times more desirable!" Mlle Réjane was an athletic actress – as well as a beautiful one, her acrobatic dances were as well known as her distinctive face and her sly suggestive voice.

Lulu was rescued from the pavements, but if Schön had not noticed her, where would she have gone? Possibly into the café theatres, to dance the Parisian Quadrille or can-can. The can-can was the abandoned dance of the nineteenth century whose origins were surrounded in Spanish mystery, but became firmly associated with Montmartre and the left bank. It was the dance of the underworld: Offenbach used it as such. The high kicks supposedly began in a game with the authorities, who at one time posted public morality inspectors in bars and cafés to see that nothing untoward occurred. When the inspectors turned their backs, the girls rivalled each other to kick the hats off members of the

audience – an experience which gave the men a chance to see
the long legs, from ankle to crotch, the frilly decorated drawers and
knickers on which La Goulue stitched a red heart and La Maca-
rona, sequins. The first can-can was danced in London in 1868
and, in October 1870, the police opposed the renewal of Strange's
licence at the Alhambra, because the Collona Troupe had danced
the can-can and one of the performers, Sarah Wright (Wiry Sal),
had "raised her foot higher than her head several times towards the
public", an action which had been "much applauded". In 1874,
there was a badly rehearsed and otherwise disastrous comedy with
music, *Vert Vert*, at the St James's Theatre in London (of all
places! though this was fifteen years before George Alexander took
charge) – a production which saved the management from bank-
ruptcy, however, because it featured the Orpheon Troupe from
Paris, dancing the Riperelle, a version of the can-can. The dresses
were short and, as one shocked witness during the ensuing court
case complained, the girls wore underneath them only "swimming
drawers". The court case against *Vert Vert* failed, but a similar one
in New York succeeded. The police, before the case against them
had been heard (let alone proved), marched the dancers in their
scanty costumes through the winter streets and locked them in
jails. In the 1870s, 1880s and 1890s, the can-can represented the
height of immodesty – and added a nuance or so to knicker fetishism.
Jane Avril, Lautrec was delighted to observe, wore underclothes
in which black, green, lilac, blue and orange were "exquisite-
ly juxtaposed". The other dancers, including La Goulue, wore
white. Would the Paris Lulu have been Jane Avril, whose air of
"depraved virginity" Arthur Symons so much admired?

But Lulu did not only dance the can-can. Alwa, Dr Schön's son,
is a writer and theatre director, Wedekind's ironic self-portrait,
for Alwa (according to *Pandora's Box*) wrote a successful play,
Earth Spirit, which was staged before a Sultan – with naked
dancers. Alwa tends to be spiritual about sex. In the first scene of
Earth Spirit, he tempts Dr Goll away from the studio where
Lulu's portrait is being painted by Schwartz, by inviting him to a
rehearsal of his ballet-play, *The Dalai Lama*, a work which he
anticipates will "put Buddhism back on its feet". "You'll like the
third act," he tells Goll, "the Dalai Lama surrounded by her
monks. You'll see the monkeys, our Brahmins and our little
girls ... the Daughters of Nirvana shivering in their tights!"
"*Tights!*" exclaims Goll, rising hurriedly, "I'll be back in five
minutes!" Schön is not very impressed by his son's achievements.

"Only you could let a dancer appear through two whole acts in a raincoat!" – but there is method behind Alwa's restraint, as well as an instinct for raincoats. "I've planned it so she has six solo appearances, each one more daring than the last. But she'll dissipate the whole effect if she reveals too much of herself too soon." Lulu is admired at every twist of her body, at each drop of a glove, within raincoats and without – but what, as a booking agent might ask, is her speciality? Perhaps a quality to which we have already referred – her self-absorption. Time and again, in descriptions of the can-can, of the dance of the seven veils, of the harem ballets so popular at the Alhambra in London, we read that the dancers have become "intoxicated" with the rhythm, have "lost themselves" in the music, are not restrained by the presence of others, have become in a word "abandoned". The frenzy is self-stimulated, a form of masturbation, which the audience watch as voyeurs. Lulu's frenzy owes nothing to the admiration of others, only to the stimulation of herself. In a sense, her art was a lonely one – just as her disdain for the transactions surrounding a relationship also might supply the recipe for isolation. Lulu's frenzy is a form of detachment – the reverse of the idea expressed by Shaw that a determined girl can leave sex aside until she's got a good job and the vote. Wedekind solves the separation between mind and body by stating simply that the mind, super-ego, rights of women or what you will can be left aside until the dance is over: until death.

Lulu always remains detached from the concerns of others – and her own comfort and security – by burying herself in dance, but on this level, she is not entirely alone – for her instinctive carnality enables her to respond to the buried needs of others. Schwartz wants a virgin wife, and so she pretends with some conviction that she is one. She wears boots for Geschwitz, and rowels for Escerny; she mothers Hugenburg and torments Schön. Wedekind anticipated Pirandello by allowing Lulu to adopt many different and apparently self-contradictory rôles. She can bully and be submissive, a mother and an erring daughter, a Lesbian with Geschwitz, a tightrope-walker with Roderigo. Unlike Pirandello, who regarded rôle-playing as a means of self-protection, Wedekind presents this variety in a more positive light. Lulu simply enjoys sex in all its forms. She does not pretend to be a good housewife to keep Schön satisfied. She does not try to hold the *status quo* to avoid the anarchy which might follow. This sort of pretence would bore her:

> Can you answer truthfully?
> I don't know.
> Do you believe in God?
> I don't know.
> Is there anything you can swear by?
> I don't know.
> Have you ever been in love?
> I don't know.

These questions belong to a world of transactions with which Lulu is unfamiliar. She is only an earth spirit.

In an essay, *The Democratization of Art* (1968), the American critic Robert Brustein isolates a confusion. He was reviewing a production by the Performing Group, *Dionysus in 69*, directed by Richard Schechner, which involved some audience participation.

> . . . a string of sexual exercises in which the more intrepid are invited to join (one or two do occasionally, very passively and self-consciously). None of this gets past the petting stage, but it is clearly meant to suggest an orgy whose justification is to be found in the myth: Schechner sees the Dionysian impulse as primarily a libidinal affair. This interpretation would undoubtedly have surprised the Greeks, who looked upon Aphrodite, not Dionysus, as the embodiment of the erotic instinct – Dionysus was considered the source of drunken frenzy, hallucination, and irrationality, with sex as a possible result but hardly a motivating drive.

This confusion is an important one, for it is not even between compatibles, but almost between opposites. In Euripides' play, *The Bacchae*, the followers of Dionysus, led by Argauë, leave the town of Thebes to celebrate Bacchic rites in the hills. They are women; no men are permitted to watch the celebrations, which involve drugged intoxication (through eating mushrooms) and hypnotized rhythmic dancing. In this frenzied state, Argauë discovers a "mountain lion", which she tears apart with her bare hands, and carries the head back in triumph to Thebes. But the "lion" is really her son, Pentheus, the over-rational ruler of Thebes, who has ventured into the hills to watch the Bacchic rites. Argauë slowly realizes with horror what she has done, and the destruction of Pentheus remained an awful testament to the powers of Dionysus. Aphrodite, on the other hand, represented the love of beauty and the love of art. By conferring her girdle on anyone or anything, she transformed it into an object of longing and wonder-

ment. Erotic love – Eros was her son – had nothing to do with Bacchic orgies: it was a gentler principle altogether, expressing desire and fulfilment, though perhaps treachery and jealousy as well.

The sexual act is not one which is conducive to abandoned frenzy. To begin with, all the known positions are too limiting. Even Weckerle, an enthusiastic PT instructor, who in 1907 published a work in which he stated that "too much sex never wore out anyone except a weakling who is out of training," ran out of alternatives after the first hundred positions – after considering sex on the parallel bars and the trampoline. Nor were any of these athletic variations exactly abandoned: the basic discipline required in bed is also needed on the trampoline – in other words, a knee in the wrong place or a swift accidental karate chop and desire evaporates as snows do in spring. The rhythms of intercourse, varied though they may be, impose a certain non-frenzied order to the movements. A Bacchic orgy can last for days, an erotic orgy is more spasmodic. Someone under the influence of drink or drugs, does not necessarily bother about the person he is with. Masturbation, however, may be fun but it is a substitute for satisfactory fucking. It is just not as good. One has to imagine a sexual partner. You do not have to imagine a partner to get drunk. Erotic desire may rule out other considerations – such as money, family ties and Propriety – but it has a purpose and a specific gratification. It is not anarchic passion, blind and directionless.

In the nineteenth century, this confusion between Dionysus and Aphrodite was remarkably widespread. A. B. Walkley believed that indecency on the stage could lead to mass riots. Something of a myth developed, which remains today, that if the intellectual control over sexual behaviour weakened there would be a terrible outburst of sexual energy – devastating, brutal and destructive. When politicians today oppose the liberalization of the obscenity laws, they sometimes warn us against "opening the floodgates" – as if sexuality were a dark and muddy tidal stream which will bear us all to disaster. From the other side of the argument it is often suggested that the formal, conventional restraint of sexuality leads to consequences which are equally dire. It is like trying to trap the sun in a wooden box: the box will burn and the suddenly released force of the sun will be a thousand times more dangerous and explosive. If man were sexually satisfied, he would not need to prove his masculinity by inventing weapons of mass destruction. On another level, in our strip clubs and blue films, there often runs

a bizarrely inflated commentary, which grates against the images provided. Thus:

> COMMENTARY: We were seized by a frenzy of desire, of torment and lust, which was beyond our control . . .
> IMAGE: (The man loosens his tie. The woman unbuttons her blouse.)
> COMMENTARY: We flung ourselves into each other's arms and there began a night of abandoned passion . . .
> IMAGE: (They sit on a bed.)

And so on, until . . .

> COMMENTARY: Ooh – ah – it's crazy – it's wild – it's too much . . .
> IMAGE: (The man climbs on top of the woman, and starts to fuck her carefully, with an eye to the camera angle)

This emphasis on sexual frenzy can cause some problems. Some people feel that there is something wrong if their orgasms are not world-shattering and mind-blowing. The disparity between the ecstatic expectations and the limited experience sometimes makes intercourse seem ridiculous. Furthermore, by concentrating on this state of self-intoxication, one can ignore the more genuine pleasures of intercourse – the sexual conversations which develop between the partners. It becomes an act similar to masturbation, in that – eyes tightly shut, fantasies running riot – each partner is only concerned with their extremities of his or her own passions.

I would not have spent so much time in stating the obvious, if all these confusions did not in some way relate to the image of Lulu. The very title of Wedekind's second play, *Pandora's Box*, suggests the release of sexuality as an anarchic and destructive force upon the world. Although Wedekind was on the side of this force – and opposed to the *Lebensangst* – he nevertheless presents such a frightening picture of sexuality that somehow the anxieties seem reasonable. Lulu dancing becomes deaf to the world, abandoned, intoxicated by her own beauty; she has become, in other words, like the masturbators in a blue film. But even dancing, though less restricted in movement than fucking, can rarely be quite so abandoned. Those modern Lulus, the strippers, have to calculate their effects very carefully; the frenzy must not last too long, beyond their eight minutes. Serena Wilson, of the starring double act Serena and Milovan, explained the problems to me:

> We are developing this act where we use two whips instead of one. We used to have this scene where he whips me and then I wrench the

whip from him and start to whip him back. It was all right, but it did not make sense that I should be strong enough to beat him up. And so now we both have whips and fight at the beginning. We have to be a bit careful. Then we throw the whips away and make love.

(Question: Do you enjoy doing it?)

Well . . . you have to keep your mind on the job, otherwise you get caught – which is nice for the audience, but you can't get rid of the bruise. When it really comes off, when you can hear the whip cracking just behind you and the audience gasping, then it's exciting.

Serena takes a professional pride in her job – which is to convey the idea of sexual frenzy, without actually letting the act get out of control. I am not, of course, suggesting that a strong element of instinctual pleasure does not emerge through dancing – that it is all coldly planned technique. That would be nonsense. But just as one has to decide initially to get high even on LSD, the element of prior planning cannot be eliminated entirely. Lulu as an earth spirit is an abstraction: pure intoxicated instinct does not exist.

But why do men like to see the self-intoxication of women? Why do they watch these rather dull strip acts where a girl rubs herself all over with a battery-operated dildo, pants and sighs to a climax and takes her bow with her right hand demurely protecting her vagina? Why do they want to see an act which has the effect of making them irrelevant? Perhaps men need to be reassured that women enjoy sex as well. At the turn of the century, when the "official" view was that women did not have any sexual pleasures at all and when Shaw stated that women's instincts were primarily maternal, Wedekind asserted the opposite – Lulu personified female erotic delight. The frenzied, abandoned style of dancing was an attempt to convey the impression that the body could do without the mind, and primarily because the mind was giving the wrong instructions. In a culture which pretended to ignore, or seemed exaggeratedly afraid of, its instinctual origins, Lulu was an attempt to reverse the process by ignoring the culture. From Wedekind's point of view, it is civilization which seems blind, arbitrary and violent. The repression of sexuality by the timid forces of custom is a brutality unparalleled in the world of instinct to which Lulu purported to belong. Lulu can appreciate the cruelty of Jack the Ripper, even admire it as an assertion of masculine will.

But she is lost before the coldness of Casti-Piani, the intellectual whoremonger – who offers her the choice of imprisonment or prostitution in the Middle East. Lulu lacks Casti-Piani's violence.

The confusion between Dionysus and Aphrodite presents a partial explanation of the Lulu theme: there is one element still missing. Why, for example, was abandoned frenzy usually expressed in terms of a ritual stabbing? Was sexual murder simply the most extreme image of uncontrollability which lay to hand? Perhaps – but in 1890, Sir James Frazer published *The Golden Bough*, a work which had great influence over the next thirty or forty years, since it presented a well-researched account of primitive fertility rites, of customs and taboos. A new dimension was therefore added to the Bacchic-erotic confusion, one involving human sacrifice: Elfrieda longs to be slaughtered on the sacrificial altar of sensual pleasure. After the drums have stopped beating and the dancers have sunk hypnotized to the ground, the priests would slowly lead the virgin to the ceremonial stone, where they would await the sinking (or rising) sun:

> She understood now that this was what the men were waiting for. Even those that held her down were bent and twisted round, their black eyes watching the sun with a glittering eagerness, and awe, and craving. The black eyes of the cacique were fixed like black mirrors on the sun, as if sightless, yet containing some terrible answer to the reddening winter planet. And all the eyes of the priests were fixed and glittering on the sinking orb, in the reddening, icy silence of the winter afternoon.
>
> They were anxious, terribly anxious, and fierce. Their ferocity wanted something, and they were waiting the moment. And their ferocity was ready to leap out into a mystic exultance, of triumph. But still they were anxious.
>
> Only the eyes of that oldest man were not anxious. Black and fixed, and as if sightless, they watched the sun, seeing beyond the sun. And in their black empty concentration there was power, power intensely abstract and remote, but deep, deep to the heart of the earth, and the heart of the sun. In absolute motionlessness he watched till the red sun should send his ray through the column of ice. Then the old man would strike, and strike home, accomplish the sacrifice and achieve the power.
>
> The mastery that Man must hold, and that passes from race to race.
> (D. H. Lawrence, *The Woman Who Rode Away*, 1928)

The Bacchic intoxication was therefore given an elemental purpose, and in Stravinsky's *The Rite of Spring* (1913), the climax of the

ballet is the ritual slaughter of the young flawless virgin couple, a rite which will propitiate the Gods and guarantee the crops. In 1971, when the Béjart ballet came to London in a new version of *The Rite of Spring*, the original scene of sacrifice was replaced by a *pas de deux* representing copulation, indicating that in a permissive society there is sometimes a return to more biologically appropriate images.

Jack the Ripper was not, of course, a High Priest, and the murder of Lulu owed more to Grand Guignol and melodrama than to Sir James Frazer. But the comparison reveals how various approaches within a society – the austere and academic, the popular and ribald, the private and pornographic – can sometimes seize on a common focal point, such as sexual murder, which then becomes inflated by too many associations. Lulu was a monster created to combat other monsters – the Hausfrau and Vivie. The problem with monsters is not how to construct them, but how to get rid of them. Sometimes the needs which animate those ponderous limbs are satisfied elsewhere, and the creature lumbers forward a pace or so, under a dying impetus, raises its head in a jerky, eye-rolling protest before slumping forward into its obvious fate as a mere hulk to be auctioned off in movie studios, to be climbed upon by children. But sometimes this ordinary decay is too long in coming and we have to drag up some Godzilla of the deep to tackle a King Kong on the rampage. When this happens, we watch the struggle full of anxiety, knowing that a victory for either side would be, in human terms, a disaster. We switch our allegiances to maintain the balance hoping for that rare outcome, a simultaneous knockout.

Unfortunately the bout of the century between the Hausfrau, Lulu, Nora, Laura and Vivie never took place – or not at least when it should have done. Censorship delayed the arrival of Lulu. Censorship – direct or indirect – interferes with the private enterprise of thought, and can sometimes have the effect of assisting the evils it intends to suppress. By delaying a production until the climate of opinion is right, censorship sometimes has the effect of releasing a simplified monster at a time when its rival is biting the dust. *Spring Awakening*, that passionate call for the sex education of the young, was not produced in Britain until after the principle of sex education in schools had been generally accepted – *after* its cause had been largely won. *Lulu* was not produced in Britain in a version approximating to the original until after Lulu had become the ad-man's cliché. But in the 1900s, this argument might have seemed unreal. Censorship was considered a form of benevolent

protection in which the rights of society as a whole were safe-guarded. Authoritarianism itself stood – or was presumed to stand – on firmer ideological ground. But gradually, as the assumptions of authority were challenged, notably in 1909, another image of human sexuality emerged, a compound of myths which few people, not even the censors themselves, could properly defend. And behind the controversies of censorship lay a deeper struggle. The battle for the rights of women is after all only one stage in our continuing fight to find a plausible image for humanity.

6

Essentially . . . a Man of the World

From 1895–1911 the Lord Chamberlain's Examiner of Plays was Mr G. A. Redford. He had an unenviable job. The sturdiest theatre critic would crumble before the avalanche of plays which rolled down the slope towards him every year – 519 in 1902, 538 in 1903, 468 in 1904 and so on. He read and censored 4,233 plays in eight years. Nor was he well paid. The post carried £400 a year "with perquisites" – presumably an office, expenses and free tickets to the theatre. He was expected to attend productions about which complaints had been made, and he added to his burden by inviting authors and managers to his office to discuss any difficult problems which might "crop up". It sounds like slave labour and one wonders what motives induced him in the first place to throw up his job as a bank manager to take the task on. Perhaps he was stage-struck – he had dabbled in writing plays. Or perhaps he was moved by a desire to maintain standards of thought and behaviour. Or perhaps he was simply doing a favour for a friend. Mr Redford's first taste of the job came when the previous censor, Mr Pigott, a personal friend, wanted to go away on holiday to Heligoland in 1875, and left Mr Redford (then approaching thirty) to mind the shop. In due course, when Mr Pigott retired in 1895, Mr Redford was appointed to succeed him. The word appointed is slightly misleading. It suggests an appointment board where the qualifications of other candidates as well were seriously considered. In fact there were no other candidates and the procedure was further simplified because Mr Redford had no particular qualifications. He was simply a nice man in whom Mr Pigott had every confidence.

Since the job was neither highly paid nor required special qualifications, we may be led to assume that the Lord Chamberlain's Examiner of Plays was a civil service post of minor status

where the rules were well laid down and required only tact to administer. In fact, the instructions were extremely vague, a mixture of precedent and general principles which could always be stretched and, in the last resort, the decision to pass or censor a play rested heavily on the personal judgement of Mr Redford. He could consult with his superior the Lord Chamberlain. However Mr Redford was mainly left on his own, to approve of disapprove, to act as judge and executioner.

Unfortunately he was censor at a time when the system came under attack. In 1909, seventy-one writers and theatre directors, including Shaw, Wells, Galsworthy and Granville Barker, wrote to the Prime Minister, Campbell-Bannerman, an open letter of protest which they afterwards published in *The Times*:

> They protest against the power lodged in the hands of a single official, who judges without public hearing, and against whose dictum there is no appeal – to cast a slur on the good name and destroy the means of livelihood of any member of an honourable calling. They assert that the censorship has not been exercised in the interests of morality, but has tended to lower the dramatic tone by appearing to relieve the public of the duty of moral judgement. They ask to be freed from the menace hanging over every dramatist of having his work and the proceeds of his work destroyed at a pen's stroke by the arbitrary action of a single official, neither responsible to Parliament nor amenable to law. They ask that their art be placed on the same footing as every other art. They ask that they themselves be placed in the position enjoyed under law by every other citizen. To these ends they claim that the licensing of plays should be abolished. The public is sufficiently assured against managerial misconduct by the present yearly licensing of theatres which remains untouched by the measure of justice here demanded.

These complaints require some explanation. The restrictions on the theatre were not limited to the censorship of plays. Mr Redford's duties did not extend to music halls or variety shows, which were not allowed to stage sketches longer than thirty minutes in length. Music halls were licensed every year by the local authorities and the police could oppose the renewal of licences. A spectacle which was held to be obviously obscene, could be charged under the various Vagrancy Acts which were interpreted differently around the country, but were generally held to apply to nakedness and copulation. These laws were very vague and local watch committees were there to interpret them. Some believed that

nakedness meant nakedness, no clothing whatsoever; others – that see-through and flesh-coloured tights were also banned; others still – that clinging and revealing clothing was also restricted.

The legal basis for Mr Redford's censorship rested on a direction in the Theatres Act (1843) which held that all stage plays had to be submitted to the Lord Chamberlain, who could refuse to license a play which contained material considered to be detrimental to "the preservation of good manners, decorum . . . or public peace". These criteria were wide-ranging enough, but by the 1880s they had been stretched even further. The words on the licences which Mr Redford issued (and had, he said, been in use for at least 27 years) had no parliamentary authority at all and certified that the licensed plays were not "immoral or otherwise improper for the stage". A university of lawyers and social scientists would have found the original criteria hard to interpret; a Vatican of theologians (assuming a Christian society) would have had problems with the extended form. The emphasis had therefore shifted from the social consequences of a stage production (which could have been observed and therefore provided a body of precedent) to something which was not observable – the "immorality" of a play. Mr Redford might have sought help from other legal definitions. If he did, he would have been unlucky. Obscenity was defined in 1868 like this: "an article shall be deemed to be obscene if its effect . . . is such as to tend to deprave and corrupt persons who are likely . . . to read, see or hear matter contained or embodied therein." But who admits that they have been depraved and corrupted by a play? We have to assume, if we are censors, that this corruption will take place. We have in a sense to punish a crime which has not yet been committed – for to prevent a play from being produced is a punishment to the dramatist as well as to the manager. It may destroy two years' work and take away a livelihood. It is the sort of decision which only the very blind or the very conceited are likely to take easily. But despite this, I am sure I would have made a good censor. I would have banned:

> (*i*) most society drama on the grounds that the plays perpetuated sexual apartheid, class consciousness and a stupid vindictiveness towards "fallen women";
> (*ii*) most melodrama for the same reasons, and for encouraging masculine sadism;
> (*iii*) most of Shaw's plays for fostering male sexual guilt and denying women sexual pleasures other than maternalism;

(*iv*) most plays from the French on the grounds that British aud-
iences were not yet ready for them.

Having done that, I would have looked around at the plays left and
probably banned those as well, for being Christian, or capitalistic,
or ill-written: and I would still not have strayed outside my defini-
tion of the phrase "to deprave and corrupt".

Fortunately perhaps, Mr Redford was not too worried about
the precise definition of this phrase. His office was not account-
able to the ordinary processes of law. He belonged to the Lord
Chamberlain's department and the Lord Chamberlain was paid
through the Civil List and was therefore a court official. He was
accountable only to the Sovereign. The Lord Chamberlain might
answer queries in the House of Lords if he chose to do so, but he
could not be compelled to give reasons why a play was banned or
for any other decision of his department. An author whose play was
banned by Mr Redford had no means of redress. He could not fight
his case through the courts. The theatre was subject to backroom
methods of censorship which in any other field would have been
considered tyrannical. The press faced ordinary libel and obscenity
laws, but copy did not have to be vetted in advance by someone
whose unqualified opinion could not be questioned. The system was
arbitrary, autocratic, discreet when it was not positively secretive,
and relied on the good sense of Mr Redford. As the result of
protests against the system in 1909, a Joint Select Committee of
both Houses of Parliament was appointed to consider the whole
procedure of the censorship of stage plays. Mr Redford was placed
in the unfortunate position of having to defend a system which
depended for its effectiveness on his merits as a man.

He was asked about his duties. "On what principles do you
proceed in licensing the plays which come up before you?" "I
simply bring to bear the official view and keep up the standard," he
replied with the impressive dignity of someone who refuses to
acknowledge the banana skins on the pavement. "It is really
impossible to define what the principle may be. There are no
principles that can be defined." His decisions were based on cus-
tom and precedent. But what was the custom? "Things," said Mr
Redford thoughtfully, "are always changing." Then what pre-
cedents? "Every case must be judged on its merits and every case is
looked at from its merits." "I should like you to elaborate," asked
Mr Alfred Mason determinedly, from the benches of the Joint
Select Committee, "on what you mean by its merits." "That is a

bad term perhaps – I mean on what it contains." "We are trying," said Alfred Mason patiently, "to get at what is the guiding principle." Mr Redford did not reply and his silence was duly recorded in *The Times* the following morning.

It is hard not to feel sympathy with him. Sixty years later, a working party was set up by the Arts Council to inquire into the obscenity laws, which had stayed in force after the office of Examiner of Plays was abolished in 1968. Their conclusions were generally that since obscenity was incapable of proper legal definition, the laws were unworkable and open to abuse. Mr Redford was being asked a more complicated question. He was expected to express a whole range of complicated Victorian and Edwardian taboos, although he may have called them principles. A principle may exist without being capable of legal definition. In a divorce case, for example, a magistrate may be asked to decide which parent should have the custody of the children. He may feel in principle that the guardian should be the parent offering the greater degree of love and security to the children. He may not be able to define love or security, nor even to possess the intimate knowledge of the family which will help him to make up his mind. He has to use his moral judgement – to decide, without full possession of the facts, a controversial and difficult question. Mr Redford, too, was being asked to use his moral judgement. In a sense (however stupid he may have seemed) his answers could scarcely have been bettered. His decisions were based on precedents, rather than definable general principles. Custom did guide him – although "things" were always changing. Moral opinions are like that. They are based on a complex amalgam of environmental impressions, on the organizing capacity of the mind which we call reason and on those stresses of selection and rejection which are subject to (for want of a better word) faith. The questions which the Joint Select Committee should have tried to answer were these. Is the theatre an activity which needs to be controlled by the moral judgements of a single man or of a committee? And if so, was Mr Redford the right man for the job? The matter of legal procedure was incidental. It would have been better, no doubt, for the censorship system to have been conducted in a more open way and for dramatists to have the right of appeal. But under any system the criteria for censorship would still rest on private value judgements, and the original questions would remain – whose judgements and were they needed?

The theatre profession itself was divided about the desirability of censorship. The dramatists (with several exceptions) were against it, whereas the theatre managers on the whole were for it and with good reason. A play passed by the censor was not likely to be prosecuted by the police either in London or on tour. A theatre manager presenting a licensed play was not likely to have his theatre licence affected by complaints of immorality. The reputation of the theatre was generally so bad that a licence provided a *Good Housekeeping* seal of approval. Managers also knew that the system of censorship was so shakily conceived that it needed their support to make it work at all. This gave them a power over the censor. "It may be confidently assumed," said Mr Smythe Pigott, the previous censor, in 1892, "that the mistakes of the Examiner of Plays in this country will always be in the direction of extreme indulgence for the simple reason that if the reins were tightened, they would snap in his hands." "It has always been my effort," said Mr Redford in 1909, "to take the broadest and most liberal view of every subject that came before me." The great merit of the censorship system for managers was that it protected the theatre from harassment. It limited extreme Puritanism to the Puritans. The report of the Joint Select Committee is full of the censor's indulgences. He passed French farces such as *My Giddy Goat* and *Dear Old Charlie* which shocked nearly all the theatre critics in London. "It was the custom," said Mr Redford, "to allow a wider latitude to foreign plays." He allowed violent scenes in melodramas, because the context was not serious and in any case they appealed mainly to the lower middle classes. It was just good fun and recognized as such. When the theatre pretended to be more than a game, when it put on airs of seriousness, then Mr Redford adjusted his standards accordingly. "Sometimes," said Sir Beerbohm Tree giving evidence, "it has been found that tragedies of great passion have been tabooed and frivolous French farces have been favourably regarded." W. L. Courtney, then critic of the *Daily Telegraph*, added that "the stalls and boxes have always favoured the lighter comedies and they do not much care for the deeper laws of life or of morality." Shaw saw the whole process as a conspiracy between the commercial managements and the establishment to exclude the serious-minded outsider. He could have cited the words of Mr Smythe Pigott: "I have studied Ibsen's plays pretty carefully and all the characters in Ibsen's plays appear to me morally degraded." Shaw considered it disgraceful that, in deference to the stalls and boxes, flippant studies of adultery and

promiscuity should be allowed, whereas serious plays on the subject, such as his own *Mrs Warren's Profession* or Granville Barker's *Waste* should be banned. Mr Redford could have retorted that in French farces there was no attack on the English way of life. They were not offered as serious polemic. But in *Mrs Warren's Profession* and *Waste*, not to mention the mild revue skit, *The Englishman's Home*, which he also banned, there were direct criticisms of the standards he was appointed to protect – of marriage and Propriety. He was not a theatre critic. He was not placed in his job to decide on subtle questions of literary merit. Nor was he a theologian. His job was to draw the line somewhere, just before the theatre called in question custom, honour, decency – all those attributes which he attached to the English way of life. Freedom within reason: an ideal which he assumed all would share.

And many theatre people, even those who had suffered from his blue pencil, did. The ideal censor, according to Sir George Alexander, was someone who had "a knowledge of literature and the drama" but was also "essentially . . . a man of the world". His job was to check the palpable indecencies, blasphemies and subversions, while assisting theatres which observed these limits by providing an atmosphere free from harassment. Sir George Alexander had little doubt that the plays not passed by the censor were not worth worrying about – and since these included plays by Shaw, Maeterlinck, Granville Barker and Ibsen, this remark by a very statesmanlike actor-manager (who afterwards confirmed his latent talents by entering politics) is in itself revealing. He conceded that a censor might make mistakes – but then so might a judge, and was this an argument for doing without courts? Within the terms expressed by Sir George Alexander, Mr Redford was the ideal censor, a mediant type, whose limited education had equipped him with a subtle, instinctive recognition for what was English and permissible, and what was not. Mr Redford was the son of a doctor, brought up in Windsor and educated at Clewer House School, within the shadow of Windsor Castle and Eton, but not within the walls. His professional experience, before he became censor, was acquired in banking. His hobbies were cricket, punting, sculling and golf. The ideal man: a man of the world indeed.

Mr Redford may not have been able to map out the boundaries of the permissible to the satisfaction of the Censorship Enquiry, but where in practice did this man of the world draw the line? This

question is more difficult to answer than it should be, for his correspondence with managers has been sent to the Public Records Office while the manuscripts to which they refer have been sent to the British Museum. Neither are easily accessible to the public and in any case the volume of work would require a computer to tackle, even without these obstacles. But we can piece together the opinions of Mr Redford from various other sources – from his remarks to the Joint Select Committee on Theatre Censorship and from his known decisions concerning particular plays. There is another important source. In 1912, Mr Redford was appointed the first chairman of the British Board of Film Censors. Unlike theatre censorship, which began sixty years before Mr Redford took office, the British Board of Film Censors was a new institution and therefore Mr Redford felt the need to explain his criteria each year to the film industry. The annual reports gave reasons for the banning of certain films, but without unfortunately giving the precise examples. They were banned for:

(a) Indelicate or suggestive sexual situations,
(b) Indecent dancing,
(c) Holding a Minister of Religion to ridicule,
(d) Cruelty to animals,
(e) Subjects depicting procuration, abduction and seduction,
(f) Excessive drunkenness,
(g) Judicial executions,
(h) Native customs in foreign lands abhorrent to British ideas,
(i) Indelicate accessories in staging,
(j) Impropriety in conduct and dress,
(k) Materialization of Christ or the Almighty.

Most of these criteria are questions of degree rather than taboos absolute. They depend upon the interpretation of words like "indelicate", "ridicule" and "excessive". Criteria which are not fixed and constant but which operate on a sliding scale are always open to challenge – from film producers who complain that a certain dance, say the can-can, was passed in this film, but not in theirs. Variable criteria place a tough burden on the censor and also on the producers, who are left in a state of doubt. But at the same time, these criteria may be the most useful ones, since they take account of the weight, degree and context of the emphasis. I am against censorship which has the effect of relieving the audience from the burden of moral choice. But at the same time, I have heard of films and stage shows (though I have not seen them)

which raise severe doubts in my mind. In the States apparently, there are blue films (secretly shown to audiences who pay highly for the privilege) which show US soldiers raping, torturing and finally slaughtering "Vietcong" women. These are seemingly documentary films smuggled from Vietnam. In Japan, there are stage shows in which girls are held under water until they're nearly drowned: briefly revived and plunged back again. I have seen whipping shows where the blows did not seem too severe, and have heard of others where, according to an enthusiastic tout, "they go all the way" (where? to what?). I have spoken to a girl recovering from such a whipping, who said she would do it again, because the money was good and the weals disappeared after a fortnight. These examples still do not provide a case for censorship, however, for it has not been proved that legal censorship does much good. In violent societies, we seek out violent images: our inclinations towards violence are established at an early age. One can sometimes produce violent images, accidentally on purpose – the burning ballet dancers of the nineteenth century – who were not well paid even for running the risks. Furthermore, the value of theatre in a violent society might well consist of presenting the audience with inhuman spectacles which in the hysteria of battle they might overlook as normal. And so the case for censorship is not to my mind proved: but at the same time I admire those reformers who seek to pull back the frontiers of cruelty in all directions – in schools, prisons, wars and the theatre. If censorship of entertainment were once more forcefully introduced in the West, perhaps we should begin by banning boxing.

The lines which Mr Redford drew formed a rough pentagon, whose sides were not equal. The longest side, the one with the most prohibitions, was composed of sexual indecencies (*a*), (*b*), (*e*), (*i*) and (*j*) in the list given above from the British Board of Film Censors. The second side dealt with blasphemies (*c*) amd (*k*); the third with cruelties (*d*) and (*g*); the fourth with Dionysian revelry (*e*), and the fifth with the preservation of the British way of life (*h*). The severest restrictions occurred when two of these lines – or more – crossed. In the theatre, *Mrs Warren's Profession* was banned, whereas Hall Caine's *The Christian* was licensed. Shaw's play was banned ostensibly because it dealt with prostitution, which was also a theme of *The Christian*. In neither play were there any brothel scenes. Indecency could not have been the complaint. *Mrs Warren's Profession* was about the economics of prostitution: "if

we get what we call vice," wrote Shaw in his Preface, "instead of what we call virtue, it is simply because we are paying more for it." Prostitution is thus shown as something which is built into the economic and social structure of British society. Therefore not only was the prostitute herself partly condoned but also the British way of life was attacked. Shaw commented on *The Christian* that "procuration and prostitution are dealt with in the good-natured puzzleheaded way in which the ordinary British citizen invariably thinks and speaks of these subjects." A third line also converged on *Mrs Warren's Profession*, in that a clergyman, the Reverend Samuel Gardner, is shown to have been one of Mrs Warren's former clients. Ministers of Religion were often held up to ridicule in Edwardian theatre – the comic parson was a stock character. But again there are degrees in ridicule, and Mr Redford evidently felt that the association of a priest with a prostitute was carrying things too far. Therefore the banning of a play might result from a combination of factors, none of which in itself would have provided a sufficient cause. Granville Barker's admirable play *Waste* was banned. The language and the action is decorous in the extreme, but the story concerned a politician whose affair with a demi-mondaine ruins his career and, by implication, damages the country, for he was the only one able to force a necessary law through Parliament. "Personally," Mr Redford said before the Joint Select Committee, "I do not think it a wholesome thing that politicians should be satirized on the stage."

The longest line concerned indecency: it was also the one which was subject to the most varied interpretations – and which drew the widest consensus of assent from the witnesses before the Joint Select Committee. They were all agreed that indecency should be banned from the theatre. But what was meant by indecency? W. S. Gilbert supplied a much-quoted example:

> In a novel one may read, "Eliza stripped off her dressing gown and stepped into her bath," without any harm: but I think that if that were presented on stage it would be very shocking.

Physical nakedness was one criterion, as it was later for film censorship. By 1915, the British Board of Film Censors, still under Mr Redford's chairmanship, were prepared to be more precise as to what constituted indecency: "nude female figures", "passionate love scenes", "men and women in bed together", "incidents suggestive of incestuous relations", together with the old taboos

against prostitution and procuration and the premeditated seduction of girls. But as Shaw pointed out, the Eliza example provided no case for censorship as such, because the ordinary vagrancy laws were enough – the actress could have been arrested for indecent exposure. Mr Redford extended this taboo to apply to those scenes where physical nakedness was hinted at in a serious context. Again the farces in which an actress might undress behind a screen were exempt. The music halls, where Maud Allan danced Salome and the Living Pictures stood and shivered, were outside his restrictions. Mr Redford only banned plays like Maeterlinck's *Monna Vanna*.

Maeterlinck was at the height of his European reputation. In 1911, he was awarded the Nobel Prize. *Monna Vanna* had been performed in Paris at the Théâtre de l'Oevre with great success. It was considered to represent a change in direction from the romantic symbolism of *Pelléas et Mélisande* towards high moral drama. *Monna Vanna* was first staged in 1902 and Philip Comyns-Carr tried to arrange a performance in London. When the play was banned by Mr Redford, Comyns-Carr arranged a private production at the Victoria Hall, Bayswater, in London (19 June 1902) which was attended by the critics. The performance caused no great disturbance and the censor's judgement was held in question. *Monna Vanna* proved to be a very moral, very romantic play in verse set in Pisa during the fifteenth century. An army from Florence, led by Prinzivalle, was besieging Pisa. Monna Vanna, the wife of the Pisan leader, Guido, was a famed beauty and Prinzivalle offers to spare Pisa if she will leave the town and come to his tent "naked beneath her cloak". There were rumours after the private production in London that Mr Redford had misread this key phrase or that his French was defective. Had he misread the stage direction, "Monna Vanna entrait nue sous un manteau" as ". . . sans un manteau"? At the inquiry, Mr Redford stuck to his decision, citing the whole tone of the work. This could have referred to the scene in the second act where Monna Vanna arrives, slightly wounded and naked beneath her cloak. Prinzivalle inquires after the wound and she lowers the cloak slightly to reveal – a wounded shoulder. He then asks her directly whether or not she is naked. She is about to throw the cloak aside – when he stops her, with a gesture. To this extent, Maeterlinck was clearly using Monna Vanna's nakedness to heighten the suspense. Was this the problem? Or was it, as some have suggested, the main theme – for Prinzivalle turns out to be a childhood friend of Monna

Vanna who has loved her from afar for many years. He will not allow her to "degrade" herself and she returns unviolated to her husband. But Guido refuses to believe that his wife has not been violated. He violently reproaches her for the dishonour which he has himself encouraged her to endure. Faced by the choice of living with a permanently jealous husband or of fleeing to the honourable arms of Prinzivalle, she runs back to the Florentine camp and her childhood lover. "The Beautiful," she says in the end, "is going to begin . . ."

"The whole plot of the play, to my mind," said Mr Redford, "was not proper for the stage; it does not come under the words which are, I think, in the licence itself, 'proper for the stage'." "Is not," asked Mr Hugh Law for the Joint Select Committee, "the whole idea of the play that love is not only not identical with, but the enemy of lust? Do you call that immoral?" "I certainly call the play immoral," replied Mr Redford with dignity, "from the point of view of the Examiner of Plays."

Mr Redford therefore interpreted the taboo on physical nakedness also to mean scenes where physical nakedness was implied, where the plots suggested that true love could over-ride formal marriage and where the physical language was too explicit. But the context was all-important. A scene similar to the second act in *Monna Vanna* occurred in the flamboyant melodrama, *The Devil*, where the actress was encouraged to lower the mantle much further. But since *The Devil* was a crudely flamboyant melodrama where the plot morality damned all sensuality, however much it may have catered to it, it was passed by the censor. Linked in an obscure way with nudity was a distrust of all physical details, particularly VD, seduction – from petting to copulation, and pregnancy. In eight years, Mr Redford banned twenty plays, not a high proportion, but they included *Monna Vanna, Mrs Warren's Profession, Ghosts, Waste*, Garnett's *The Breaking Point*, Shelley's *The Cenci*, and Brieux' *Maternity, The Three Daughters of M. Dupont* and *Damaged Goods*. None of these plays were pornographic, but they were all concerned with sexual customs and were intended to alter social attitudes towards sexual behaviour. This was why they were banned. Wedekind's plays would also have been banned, although nobody in Britain tried to stage them, believing with William Archer that they could never be produced.

Why were over half the banned plays basically serious studies of sexual behaviour? Why in 1915 did the British Board of Film Censors ban "scenes depicting the effect of venereal diseases,

inherited or acquired", when the authorities were trying to control VD among the troops? Later on in the war, the bans on *Damaged Goods* and *Ghosts* were lifted for precisely that reason – because they provided good education for the forces. It was because films and the theatre were considered improper places for this sort of debate to be conducted at all. Driven into a debating corner, Mr Redford would no doubt have agreed with Shaw – that it was morally better to show the dangerous consequences of loose behaviour than the pleasant ones: but he might also have protested that the theatre was not a fit place to consider these matters at all. Debates on political subjects should be left to Parliament. Debates on moral matters should be left to the Church. The theatre was a place for, well, entertainment, and biblical characters as well as Christ, politicians and representatives of foreign powers friendly to this country (*The Mikado* was banned during a visit of the Japanese Foreign Minister) were not suitable subjects for entertainment. Behind these taboos was a devaluation of the theatre as an activity. It was not a proper place to tackle either important subjects or nerve-tingling ones. His opinion was shared by other men of the world. The Speaker of the House of Commons was asked by the Joint Select Committee whether there was some way to bring stage censorship within the overall control of the House of Commons. Could not a Junior Minister be spared to answer, if not particular complaints of unfair treatment, at least general charges against censorship? He replied, "I think we have already got so much work to do ... of a serious and important character that I am not particularly partial to bringing in a great deal of additional labour, which is perhaps of a showy and flashy kind."

We should not accept this nonchalant dismissal of the theatre too much on its face value. If the theatre really were as trivial as Mr Redford and the Speaker (together with other witnesses) suggested on occasions, there would have been no need for censorship at all. Censorship was regarded as necessary only because the theatre was considered to be potentially dangerous – more threatening than the press, pulpit or public meetings, which were not subject to the same restrictions. We have already mentioned the two Edwardian fears which dominated the discussion on censorship – the fear of crowds and of sexual anarchy. The witnesses at the inquiry, from Shaw to Redford, were united on one matter – that there should not be a direct confrontation with the sexual act in the theatre, or any other stimuli which were considered too powerful for the public to handle. The debate in 1909 was about methods of control

– which in turn was basically a question about the rôle which the theatre should play in society. All societies develop and "invent" taboos, just as individuals do. It is a way of discovering a personal and social order. Jonathan Miller has put forward the view that censorship is the legal equivalent of personal modesty, whereby an individual protects himself from attack during moments of vulnerability by erecting commonly accepted barriers. We lock the door when we go to the lavatory. If we now condemn Mr Redford and the censorship system, we do so for various reasons: because he banned good, serious-minded plays and passed frivolous stuff, because the balance of his displeasure seemed loaded against the worthwhile, because the theatre in any case does not seem to require the special paternalistic treatment, because the standards of respectability which he protected now seem false and dangerous and because the system was administered in a manner both secretive and categorical. On his part, Mr Redford could have argued that the theatre was no place to consider questions of wide moral import, that the code (however vague) may have been hypocritical, even on occasions immoral, but it did provide some *felt* scheme within which the diverse city populations could discover order and protection, the social equivalent to modesty, and that the various prohibitions guarded the public from disruptive emotions which were likely to arouse crowds into anarchy and disorder.

It was basically a question as to what the theatre should be: was it a platform for mere games – which made no pretence at influencing behaviour – or for playing in a wider sense, whereby we try out situations in game form and afterwards relate these play experiences to daily life? Was it a place for "entertainment" or (as Shaw believed) a forum for discussion and social polemic? Or did it have yet another function – as a licensed play area, where everything could be attempted because nothing was "real", where the inverted commas of "Let's pretend" provided an inbuilt protection against the invasions of modesty. A confrontation between these contrasting attitudes should have taken place before the Joint Select Committee. It nearly did. It failed to do so, only because a bizarre incident intervened, a problem of procedure, which in itself revealed the formalism which dogs all paternalism, however benevolent, from school assemblies to the House of Commons, and from which so many other problems of communication stem.

The Joint Select Committee followed a well-established procedure for governmental investigations. Various witnesses were called

whose evidence was given and then they were cross-examined by the Committee. Unfortunately, this method prevented the arguments from emerging in their full clarity. The evidence was impromptu, discursive and anecdotal, relying largely on what the witnesses found personally to be distasteful. Shaw, anticipating this formlessness, prepared a long statement against censorship. This essay was afterwards printed separately and now provides the Preface to *The Shewing-up of Blanco Posnet*. But the Committee refused to debate the statement. It was returned to Shaw as "so much waste paper". This gesture was intended to be a dignified snub to someone who had a reputation as a trouble-maker, but the urbane solemnity of the moment was botched up by a committee member, Colonel Lockwood, who rose "with all his carnations blazing" to return his own two copies himself. It was as if at some difficult peace conference, with all the disagreements still unsolved, one ambassador had slapped another in the face. The human emotions suddenly erupted in a little scurry of eventfulness, hinting at the feelings which lay beneath the surface of the weighty impasse. Shaw retorted, by smiling sweetly and publicizing Colonel Lockwood's ridiculous gesture afterwards. The Committee's snub transformed a reasonable (but challengeable) essay into a manifesto, much discussed in *The Times*. It divided the Committee and its witnesses into two clear factions – the majority with its paternalism and presumptions of virtue, and the keen, embittered and articulate minority. The accompanying gesture from Colonel Lockwood revealed that the Establishment too had its emotional problems. It was unsure of itself.

Shaw's rejected statement accepted in effect many of the traditional Puritan arguments against the theatre, but turned them upside down to attack the censorship system, not to support it. The Puritans disliked the "falseness" of the theatre. It lured men away from "reality" and particularly the "reality of God". There were two ways in which the theatre could be considered acceptable: firstly, as a mild diversion from daily seriousness and secondly, as a spur to virtuous action. Plato, whose arguments against all art and drama in particular were often cited as an authority, allowed that drama could be of value if it inspired men towards deeds of valour in time of war or urged them towards right conduct in peace. It would have been better, no doubt, if the public could have responded in a proper way as the situations arose, but when they seemed sluggish, art could fire them with enthusiasm. Many Puritans and Non-conformists conceded as

much and, consequently, when, during the nineteenth century, dramatists and theatre managers sought to blunt the edge of prejudice against the theatre, they did so by filling their productions with worthy sentiments. Drama was nearly an indefensible form of self-indulgence: but it could be justified sometimes as a means towards good ends.

Shaw would not have disagreed with this attitude. Indeed he used all his vigour and intellectual ability to argue that this was precisely the rôle of the theatre, as a pulpit for telling invective. But he interpreted righteousness to mean not the conventional acceptance of existing codes, but a freethinking process in which codes were questioned and re-interpreted. When he defended the right of dramatists to be "immoral", he did so by defining "immorality" in a particular way.

> Whatever is contrary to established manners and custom is immoral. An immoral act or doctrine is not necessarily a sinful one: on the contrary, every advance in thought and conduct is by definition immoral until it has converted the majority. For this reason, it is of the most enormous importance that immorality should be protected jealously against the attacks of those who have no standard beyond the standards of custom and who regard any attack on custom – that is, on morals – as an attack on society, on religion and on virtue.

When Shaw urged the raising of bourgeois restrictions on the theatre, he did so to clear the path towards social enlightenment. He shared with the Puritans the belief that the theatre justified itself by social usefulness and that therefore a cause and effect existed between what people saw on the stage and what they did in life. Shaw however was an optimist. His arguments were based on the belief that by freeing the stage for proper discussion, mankind could evolve to better and more just societies. It was all part of the evolutionary process. But if we agree with him that the theatre can be socially useful in this way, we must concede as well that it can be destructive. When we raise the barriers in one direction, we raise them in another. Shaw appears to have recognized this dilemma by distinguishing between "sinful" and "immoral", which obviously implies a barrier to totally free discussion. The theatre can be "immoral" but not "sinful" – a highly question-begging remark. Brecht also saw this problem, arguing that freedom can only be seen within the context of an evolutionary situation which (bearing his Marxist vocabulary in mind) the rest of us might find restricting. If the Joint Select Committee had had

the wit to do so, it could have turned Shaw's arguments around again – to justify censorship, not to do away with it. It all depended on whether one was optimistic about the evolutionary process or pessimistic, and also on whether one believed that there were certain general standards against which a process could be measured as "evolutionary" or "regressive". Shaw's statement implied a considerable faith, for, without stating the means by which progress could be measured, he nevertheless asserted that progress would take place.

Shaw's arguments however were never seriously attacked. The Joint Select Committee decided that, for procedural reasons, they could not consider a lengthy thesis by any one witness, which left them open to the charge of running scared. And so the inquiry rambled on, a mixture of anecdotage and half-baked theory: and the findings were equally inconclusive – that the Lord Chamberlain should remain the Licenser of Plays, but that "it should be optional to submit a play for licence and legal to perform an unlicensed play". At the same time the Committee concluded that "theatrical performances should be regulated by special laws" – although they did not specify what the laws should be. It was a curious compromise much attacked in the press and not implemented in law. Shaw's rejected statement had a clarity and cogency which the official inquiry report could not match; it was also readable. And so despite its weaknesses, the statement became a manifesto for the liberals against the conservatives, for dramatists against the censor, for the theatre against all authority. This was sad for, hovering just to one side of the rejected statement, like a mystical emanation of the world to come, lay a much more urgent confrontation which still harasses our lives and which can best be described in those two old-fashioned philosophical words – essentialism versus existentialism.

If Shaw had been seriously cross-examined by the Joint Select Committee, if he had been asked to define the difference between "sinfulness" and "immorality" as it relates to the theatre, or asked to justify his sense of progressive optimism, how would that nervous, quick-witted intellectual dandy have replied? He might well have side-stepped the objections by suggesting that the free-thinking process in the theatre could be tolerated, not because it necessarily contributed towards the evolutionary process, but because there were no inevitable social consequences at all beyond those which the audience selected as within their consciences and

inclinations. The arguments of the Puritans, he might have asserted, were wrong because they mistook the nature of the game. If I say to someone, "There's a war on," when there is not, I am indeed lying, and trying to lure him away from reality. But if I say, "Let's pretend there's a war on," I am inviting him to take part in a game which may perhaps be a mental preparation for war, but bears no more relationship to military incitement than running round an athletics track has to running from the police. "The poet," wrote Sir Philip Sidney, "affirms nothing, therefore he cannot lie." What the audience morally does with the game of drama is its own affair. The theatre exists as a sort of gymnasium where we try out situations which we may (but by no means necessarily will) meet in everyday life. It is a way of keeping mentally fit and supple. If we accept this view, then the possible threat of the theatre is rather different – and so are its possible benefits. If we play only a few games, if the equipment in the gymnasium is limited, there is the danger that we will become muscle-bound in one direction – tremendously alert (say) to the dangers of war, but rather insensitive to the nuances of peace. This is an argument for freeing the theatre from as many restrictions as possible, for the dangers of limiting it particularly by law, far outweigh any possible gains. It is the sort of view which the former British film censor, John Trevelyan, would express with such admirable clarity and conviction. "My main qualification for being film censor," he once said, "is that I do not believe in censorship." His aim was to become a focal point for the industry, to be someone with whom to discuss the possible social effects of films. The question, as he saw it, was not, say, that "sex'n violence" should be banned from the screens, but that sex was rather too often linked with violence, that violent scenes were becoming too familiar and commonplace, that, in short, the variety of situations was becoming dangerously limited. It could equally have been limited by censorship – or by economic reasons. Theatres are expensive to run, films to make and distribute. Therefore theatre producers will (if they work on a commercial basis) look for themes which present an immediate chance of profit – and exploit a situation to death that catches the box-office. Therefore the *gymnasium* idea of the theatre is weakened by another form of censorship – that of profit and loss.

This is an attractive argument, but it does sidestep the Puritan and the Marxist case without providing a complete, crushing retort. If one believes that there is a pattern for right conduct in

man – or an observable line of evolution – then it is positively misleading to present individuals with alternatives, unless these choices are offered in such a way that they are not really alternatives at all, only obvious blind alleys. Most popular British nineteenth-century moral thought is *essentialist* in origin. A pattern or essence for man is assumed to be present in the mind of God, in relationship to which we human beings are just imperfect copies: replicas with the inbuilt choice to be faithful to the original or to deviate from it. Much twentieth-century thought starts from the opposite assumption – either that there is no such essence or that our lives are spent in discovering for ourselves what it could be. Existence precedes essence – the first premise of existentialism. If one is an essentialist, say, a Christian, then censorship is just common sense. The fewer roads leading away from the straight and narrow path the better. If one is an existentialist, then it is both useful and necessary to try out situations in the game form of drama before committing oneself to a course of action. If this game is to be of maximum value, there should be no *a priori* limitations. Behind the debates concerning censorship there are two conflicting world views, and the failure of the 1909 inquiry lay not in its inability to reconcile these views – which would have been impossible – but in its wilful blindness as to what the struggle was about.

Mr Redford was censor at a time when social attitudes towards sexuality in general, and particularly the rôle of women within sexual relationships, were changing rapidly but when the official sexual morality was still entrenched in Christian doctrine. His difficult task was to maintain a consensus in a situation where really no consensus was possible. I have already described the biological fallacies which Christian sexual teaching perpetuated, but the ideological problems which it caused were equally profound:

The ideological basis of the hostility of Christian ethics towards the sexual impulse, which has been and still is so disastrous in its consequences, is to be found in the New Testament. Jesus' teaching in the gospel was quite clear: "For when they rise from the dead, they neither marry nor are given in marriage, but are like angels in Heaven" (Mark xii, 25). Sexuality, in other words, belongs to a sinful world which is passing away. It is something to be overcome and left behind. In the Kingdom of God, where human life is ultimately fulfilled, sexual pleasures have no place, with the result that there are some believers who castrate themselves here on Earth for the sake of

the Kingdom of Heaven (Matt. xix, 12). Existing marriages have either to be given up for the sake of Christ (Matt. xix, 29) or according to the categorical evangelical prohibition against divorce (Mark x, 11f), they must be endured like lifelong imprisonment, with the result that even a desirous glance makes a person fit for Hell (Matt. v, 28f). . . . The defamation of sex inevitably leads to the defamation of women, who tend to be regarded as inferior beings. The New Testament provides plenty of evidence of this attitude. What is common to all its authors is a traditionally Jewish patriarchal view which was unable to concede equality to women. The gospels, for example, depicted Jesus as a man who treated women as second-class people, someone who certainly allowed himself to be served, looked after and supplied with money by them (Mark xiv, 3–9; Luke vii, 36–50, viii, 1–2, x, 38–42) but who did not accept any into the intimate circle of twelve, not even, as might well happen today, as an alibi. There are other indications too in the gospels that he was in no way concerned with the emancipation of women – for example, his use of the word "marry" for men and the phrase, "being given in marriage", for women (Mark xii, 25; Luke xvii, 27).

(Dr Joachim Kahl, *The Misery of Christianity*)

These extracts come from an avowedly anti-Christian book, written by a former pastor and theologian, but I do not believe that Kahl's conclusions on this matter can be effectively refuted. At a conference on Obscenity in London, organized by the British Young Publishers Association in 1971, the Bishop of Hereford stated blandly that Christianity is a non-censorious religion; but the history of Christianity is shot through with examples of censoriousness towards all forms of sexuality, except that which appears in the form of sexual hostility. The burning of attractive women who were thought to be "witches" was tolerated, adultery was not. The flogging of children in schools was accepted, masturbation was not. It is no coincidence that nearly all of the examples of turn-of-the-century drama which we have considered are either hostile to sex or applaud its demonic power, are either censorious towards female erotic emotions or deny that they exist, or assert that these feelings can only be expressed by human sacrifice by being slaughtered on the sacrificial altar. Although human sexual inclinations could not be destroyed by the repressive morality, they seem to have been drawn towards biologically inappropriate objects and behaviour: the penis became a dagger, the vagina a wound, an orgasm death. This phenomenon could be regarded as an imaginative way of reconciling human inclinations with the prevailing morality, but it had, of course, disastrous social, consequences. At

the turn of the century social attitudes were changing, and this had the effect of destroying the perverse reconciliation which had built up over the centuries.

Mr Redford was no hardened, essentialist, censorious Christian. He did not start from the assumption that man is a soul trapped in a carnal world – nor did he see the pressures of daily experience as a vale of tears through which one walked, waged war against temptation and was finally released into death. He may even have felt guilty at not being more of a fundamentalist. Since carnal pleasure according to prevailing Christian ideology was to be avoided in itself, Mr Redford might well have been stricter with the theatre than he was. In the States, Antony Comstock was on the rampage, seeking out "this cursed business of obscene literature" which "works beneath the surface and like a canker worm, secretly eats the moral life and purity of our youth". Mr Redford was not concerned with minor carnal pleasures, such as girls in tights playing principal boys. He was there to protect the public from pleasures which were considered irresistible. He was Ulysses listening to the sirens, while the less-disciplined members of the ship had their ears stopped. And there must have been times when he was puzzled by the feebleness of the lures, for the tentative descriptions of pleasurable sexual love, together with the horrific descriptions of sexual dangers, were the prevailing pattern of the age – the *reductio ad absurdum* of the belief that the body was the snare of the soul, to be controlled in the interests of higher spiritual concerns, but never to be valued in itself. Mr Redford did not invent these taboos, he administered them. They would have been a force without him; they would have changed without him. Censorship simply provided a strait-jacket for cripples, something which deterred them from even attempting to stand upright.

7

Back to Normal?

If Mr Redford had returned from the grave to conduct a grand tour of London and New York after the Second World War, what might his reactions have been? Gloom and despondency no doubt at the sheer impoverishment of Britain, although (since he died in 1916 in the dark days of the First World War) he might have been relieved that the nation had survived at all in a recognizable shape – with a King, a Parliament and an Examiner of Plays. He would have been appalled by the bomb damage, the austerity and bread rationing, the destruction of so many fine theatres (the Gaiety, Alhambra and Empire among them) and the reduced scale of the productions, the lack of opulence at the St James's – the chorus lines of only thirty girls. He would have been impressed by New York, now the theatre capital of the West, and particularly by the flourishing musicals, in the great tradition of *The Belle of New York*. In time (he might have reflected) these talented men, Cole Porter, Irving Berlin, Richard Rodgers and Oscar Hammerstein, could rival the great Gustave Kerker. As a former censor, he would have cast a wary eye towards Lee Strasberg's Actors' Studio and the writers and directors, among them Tennessee Williams and Elia Kazan, who were associated with it. These new Naturalists shared the habits of the old ones, of carrying "artistic integrity" to a point which offended Propriety. In Williams' *A Streetcar Named Desire*, a lavatory could be heard flushing off stage, and the husband, Stanley, strikes his wife Stella who is *enceinte*, although again the author goes all the way and states that she is pregnant. He might also have been disturbed by the prevalence of what can best be described perhaps as the Christian anti-ethic: a style which derived its impact from rubbing Christian assumptions up the wrong way:

In olden days a glimpse of stocking
Was look'd on as something shocking
Now – heaven knows – Anything goes!

Cole Porter wrote this song in 1934, but it was still popular in the
1940s and 1950s, and Mr Redford might have called it cynical.
But the dandies adopted much the same pose in the 1890s, and
they were usually married or confuted in the last act. And so too
were the sophisticates of musical comedy. He might have been
more dismayed by the cynical views of marriage itself, which
would have reminded him of turn-of-the-century French drama –
marriage as a means by which a pretty girl from the wrong side
of the tracks can get on in the world (*Gentlemen Prefer Blondes*,
1950) or, worse still, marriage as a jungle in which women painted
their nails "blood-red" to battle for their men (Clare Booth's *The
Women*, 1936). But he would have been comforted by the fact that
even in the States, which lacked the formal censorship of Britain,
there were powerful forces to prevent too severe a shock to the
prevailing sexual morality, which had remained Christian. In
Hollywood, the Motion Picture Production Code insisted that
overt sexuality be minimally displayed, and on Broadway the
productions were constantly vetted by organizations, such as the
National League of Decency, which had no formal power but much
influence: at one stage, the League listed 18 out of the 20 running
Broadway shows as wholly or partly objectionable, and in 1950,
only the combined efforts of the League of New York Theatre
Managers prevented a proposed morals bill which would have had
the effect of emasculating Broadway drama. The Chicago police
censored Sartre's *The Respectful Prostitute* (1946) off the boards,
mainly because it presented a tract against racism in the States.
Things, he might have concluded, were well under control,
even in the States: the delicate balance between changing
social attitudes, morality and inclinations, which he had done
so much to maintain, had not tilted disastrously one way or the
other.

To the eyes of an Edwardian playgoer, to Mr Redford or even
W. A. Macqueen-Pope who had seen it all, the theatre in London
and New York in the late 1940s and early 1950s presented a
familiar, though rather debased, pattern. The same organization
of the theatre had survived: commercial companies based in
London sending out productions on the Nos 1, 2 and 3 touring
circuits. There were one or two provincial reps whose names would

have been recognized – the Liverpool Playhouse and the Birmingham Rep – although Mr Redford might have been astonished at the prestige which Sir Barry Jackson's company at Birmingham had acquired. The same genre traditions had survived in the theatre Lilian Baylis (who died in 1937) had established a theatre for "classic" drama, mainly Shakespeare, at the Old Vic, which followed the example of Beerbohm Tree at Her Majesty's. Society drama, now in the hands of Rattigan, Coward and, on a loftier level, T. S. Eliot, was still recognizably concerned with the problems of Propriety and, while some of the hysteria attached to extra-marital sex had diminished, there remained a superciliousness towards the erotic which almost begged for the presence of Sir George Alexander. As Edward remarks in *The Cocktail Party* (1949) when two friends want to go to the cinema,

> A common interest in moving pictures
> Frequently brings young people together.

Eliot expressed a flat weariness with the world and a longing for the better life to come, which was both obviously Christian and, since his characters belonged to the successful and wealthy middle classes, did not derive from poverty and oppression. The disillusion was extreme, connected with guilt and the fear of discovery and expressed in images lengthened by fatigue and age:

> No, I've not the slightest longing for the life I've left –
> Only fear of the emptiness before me.
> If I had the energy to work myself to death
> How gladly would I face death! But waiting, simply waiting,
> With no desire to act, yet a loathing of inaction.
> A fear of the vacuum, and no desire to fill it.
> It's just like sitting in an empty waiting room
> In a railway station on a branch line,
> After the last train, after all the other passengers
> Have left, and the booking office is closed
> And the porters have gone. What am I waiting for
> In a cold and empty room before an empty grate?
> (*The Elder Statesman*, 1958)

The answer to Lord Claverton would be self-knowledge: but in Eliot's plays, self-knowledge brought with it an acceptance of human failings and an embracement of death. Among the human failings were sexual misdemeanours, the affairs as a young man, which cursed mature life; the actresses returning from the shadows

of the past. All this was familiar, even the names of actresses, Maisie Montjoy, Effie and Maude.

Nor had the popular stage changed fundamentally. Collins Music Hall had survived in Islington, and although the old panache of the music halls had waned with their huge audiences, some of the old troupers were hoofing and swashbuckling away – Hetty King and Marie Lloyd Jnr and, among the comedians, Will Fyffe and Suzette Tarri. Mr Redford would have admired the way in which the BBC toned down the bawdry of the music halls for the radio audiences of *Workers' Playtime* and *Music Hall*. They banned Max Miller from the radio for five years after he had told this story:

> Last night – no, wait for it! – I had a dream, see? I dreamt I was on this mountain ledge, very narrow, precipice one side, only room for one. I went round this corner, and there staring me in the face, was this beautiful girl, *naked*, not a stitch! Well – I didn't know whether to block her passageway or toss myself off . . .

The BBC were also cautious about what Mr Redford would have called *rosserie*: a style which now permeated popular songs and musicals, and had acquired two new influences since the days of Aristide Bruant and *Le Chat Noir*. One came from Germany and the cabarets of the 1920s and 1930s, from the songs of Brecht and Weill, the rugged severe beauty of Lotte Lenya and the presence of Marlene Dietrich, the archetypal night-club singer and demi-mondaine, wealthy, dangerous and infinitely seductive. The other from the States, the blues and the dreams of Bessie Smith. In Paris, Edith Piaf regretted nothing. But on the BBC, *rosserie* was kept within boundaries which Mr Redford would have recognized. Anguish was all right, sleaziness too, but one had to be careful with prostitution. The BBC passed Rodgers & Hammerstein's *Ten Cents a Dance* but not Cole Porter's *Love For Sale*:

> Love for sale,
> Appetising young love for sale,
> If you want to try my wares,
> Follow me and climb the stairs,
> Love for sale.

Pat Kirkwood's recording of *Love For Sale* was banned in 1953. Low-life melodramas in the style of Walter Melville (though without the spectacle) were also popular – *Wanton Lusts, Good*

Time Girl – but the set-piece torture scenes were replaced by the faster-flowing violent action of the tough-guy movies.

Nor would Mr Redford have been unduly dismayed by stage nakedness, which went somewhat further than the lengths to which he was accustomed. Paris was still the "erotic capital" of the West, as Paul Tabori described it, and nudes had appeared in spectacular revues at the Folies Bergère and Lido since 1917 – usually statu-esquely with elaborately designed non-clothes, feathers, G-strings and tiaras, but sometimes in Apache dances and acrobatic routines. The Windmill Theatre in London, which "never closed" during the war but did not survive competition from the strip-clubs of the 1960s, presented a tamer version of the Parisian revues. The naked girls were not allowed to move at all, and the fan dancers were not allowed to lower their fans until the very end of their acts when, feet placed firmly on the stage so that no flicker of movement would disturb the pose, they would lower the fans ceremonially, to show that the glimpses of bottom and breasts (so quickly concealed and revealed during the act) were what they seemed – that is, real flesh, not deceptive tights. Mr Redford would probably have agreed with the censor in the 1930s that static nudes were all right: he would have remembered the Living Pictures of his day and decided that skin, as opposed to flesh-coloured tights, did not make much difference to the morality of the spectacle. Mr Redford would also have seen the Salome dance of Renée la Staire, and felt that this too did not differ significantly from the Salome dance of Maud Allan. Maud Allan and Renée la Staire were both trained dancers and they shared the tradition that stripping was best placed within a historical or foreign context. Renée la Staire (and Teddy, her partner and husband) were trained like Maud Allan in classical ballet, an education which influenced their routines. Teddy had danced with the Markova and Dolin com-panies in the 1930s and, after a spell as a PT instructor during the war, joined the Windmill Company in 1946. Renée left ballet school and joined the Tiller Girls where she earned £5 a week, £3 of which had to be spent on board. She did not particularly want to become a stripper, but the wages were better (£8 a week and she could live at home), and also, in partnership with Teddy, they could develop strip acts which satisfied their balletic aspirations as well. They were both troupers, well able to adjust to the varying demands of the profession – an Apache dance one year, a fire dance the next, a whipping act the third – and they incorporated these routines into ballets which represented either scenes from the

classics, *The Hunchback of Notre Dame, The Tale of Two Cities,* or from history, *Samson and Delilah,* or from decadent places abroad such as Montmartre. In the 1950s as well as the 1890s, a veneer of culture and foreignness softened the impact of a nerve-tightening image. Renée la Staire was never a girl naked in London and apparently panting for it: that would have been crude. Instead, she danced to music by Borodin and Rimsky-Korsakov, the theme from *Exodus* and Edward German's *Country Dances,* and Teddy and Renée supplied the balletic equivalent of Tretchikoff's portraits and nudes, which were sold in W. H. Smith, the station booksellers. An audience who did not know much about ballet but knew what they liked, could lean back and say, "That's beautiful!" Mr Redford might have been more shocked by the strippers of New York with their heavy, exaggerated bumps and grinds, the slow deafening blueish beat of the music and the emphasis that money, lots of money, buys sex. The Republic, the Gaiety, the Eltinge and Minsky's might have emerged from a Brecht–Weill musical, complete with gangsters, diamonds and sudden death, and after the war they were all closed in an effort to clean up New York.

And so Mr Redford would not have been appalled by the changing sexual attitudes in the theatre after the Second World War. He might not even have been shocked. Everyone was saying, as they had done for hundreds of years, that permissiveness had gone too far – that eroticism in films and the theatre had reached the peak of decadence; but a man of the world would have known better. There were even some "improvements": the French farces of the 1900s had been replaced by silly-ass British farces, where the maids were less nubile and the men more timid than rakeish. And yet behind this lack of outrage, Mr Redford might have felt a certain unease, hard to define but also hard to suppress, and which appeared in several different genres at once, like the sudden rippling of small cracks on a plaster wall before the wall itself crumbles. He might have noticed that society drama in London was increasingly out of touch with the lives that middle-class audiences actually led. There were more tiaras on the stage (on first nights at St James's) than there were in the audience. Where were the demi-mondaines of London, the gilded butterflies who graced the promenade at the Alhambra? Probably waiting to be de-mobbed from the WAAF – or off to the States as GI brides. Where were the maids and servants who provided the leisure within which society drama could take place? In factories. The

theatre adjusted to this loss of wealth by providing stories about successful businessmen with nice families, one maid and a spare-time gardener – but the panache of society drama, its glittering wit and costumes, where had it gone? There is little point in maintaining the standards of Propriety if it is as comfortable to live in the suburbs as it is in Belgravia. The Anna Neagle/Michael Wilding films of the forties, *Maytime in Mayfair* and *Spring in Park Lane*, were nostalgic of glories which were past. The Vernon Sylvaine comedies, such as *Will Any Gentlemen?*, were set in the stockbroker belt around London, and the attractions to virtue were less marked. And was not the moral tone of society drama less relevant as well, with its emphasis on private benevolence, polite manners and sexual restraint? In a world of mass destruction – and of mass politics where, as Brecht pointed out, the good deeds of St Joan of the Stockyards were rubbed out by one bungled political act, a failure to deliver a message from one group of striking workers to another. Had the middle classes in Britain lost self-confidence and a feeling of success? Was not this reflected in the theatre?

The loss of London assurance could have been explained by the poverty resulting from the Second World War, or that the Empire was dead and the Commonwealth insecure. But was there not also a fundamental malaise afflicting the whole of Christendom? One symptom of this uneasiness lay in the changing Christian attitudes towards sex reflected in the progressively more liberal pronouncements of the Anglican Church during the Lambeth conferences. But the shifting emphases could no longer be concealed behind the decorum of an Anglican debate. The dandies of Edwardian drama may have challenged Christian sexual attitudes, but they were confounded in the last act. The disparities in the 1950s, however, between the ethic and the anti-ethic had become unavoidably marked. A man's sexual prowess was both a deplorable sign of his immorality – and a tribute to his virility. His affairs were matters for praise and blame. "The whole situation . . ." concluded Albert Ellis, researching into American sexual attitudes before the days of Kinsey, "is as confused, muddled and unhealthy as well, as almost every other sex situation in our society presently seems to be." The problem was not that different sexual attitudes existed, but that within the same play or indeed the same person different forms of self-approval and shame were at war. In Sidney Kingsley's *Detective Story* (1949), Mcleod, the tough-guy detective,

works throughout on the assumption that every goodlooking girl wants to go to bed with a screwing man, but when he discovers that his wife has had one brief affair with one man before her marriage, he laments hysterically, "I'd sooner go to jail for twenty years than find out this way that my wife is a whore." These split standards were of a kind which won Strindberg a reputation for insanity. Siri, according to Strindberg, was either a virgin mother or the whore of Babylon and he could never make up his mind which.

Mr Redford would have remembered attacks on Christian sexual customs (such as Shaw's *Getting Married*), but after the war sexual ethics seemed to be disintegrating from within – sometimes totally accepted, at others completely ignored. The naturalists of the 1890s attacked marriage for its unfair treatment of women. In the States during the 1940s and 1950s, the naturalistic dramatists were not just concerned with the social and economic injustices: the psychological problems caused by the nuclear family seemed equally important – perhaps more so. But these problems seemed almost without solution. The nuclear family was not directly attacked. On the contrary the system was regarded as biologically and socially necessary to mankind. In *The Misfits* (1960), Arthur Miller attributes the disintegration of society to the failure of marriages. But the portraits of nuclear families were depressingly claustrophobic. Emotions had to be suppressed to maintain the delicate balance between, say, the tyrannical father and the rebellious son – but sooner or later these passions would erupt in bitter quarrels. Men had to marry and raise families, but in doing so they caged themselves in with frustration and despair. How long could this gloomy vision of the Christian marriage survive without some attempt to find an alternative? If the prevailing ethic collapsed, what would happen? Would the anti-ethic take over?

In 1950, the official Christian attitudes in the States were as rigidly opposed to sexual pleasure as they had ever been. In Norman Vincent Peale's very popular and ironically named series, *Guide to Confident Living* (1949), Peale tells the story of one of his parishioners, a woman, who out of a sincere love for a man of her acquaintance "verged on the commission of a sex sin". But she read in the Bible that "whosoever looketh on a woman to lust after her hath committed adultery with her already in his heart." "So I saw at once my fault, I had not performed this act, but it had been my desire, therefore I was just as guilty as if I had done so. All

my life long I have lived a clean and righteous life, but in this I
have sinned and it has haunted me and I know that when I die, I
will be damned." Even non-Christian magazines, which con-
sidered sexual behaviour in the context of (say) popular psychology
or "true life" romances, supported Christian teaching by insisting
that Americans who indulged in pre-marital intercourse were
immature, neurotic, concealing latent homosexual tendencies or
were otherwise unsuited to marriage and the possession of a bank
account. Temptations abounded – but the strong resisted them.
The heroine in *Personal Romances* pushes away her fiercely kissing
lover who made "the blood rush through my veins . . . I knew that
if he kissed me again, I would be *lost*. I knew we were on the verge
of *disaster*." Mrs Arbuthnot could not have expressed the situation
better.

At the same time (and often in the same plays, books and films),
precisely the opposite view was expressed – that male virility was
to be measured in terms of sexual conquests and that women were
predators and gold-diggers, always on the look-out for the profit-
able lay. In *South Pacific*, the sailors sing "There is nothing like a
dame!" In *Kiss Me Kate* (1949), the hero lists his conquests
proudly in "Where was the life I led?" while the second girl lead
sings "I'm always true to you, darlin', in my fashion." In *Annie
Get Your Gun* (1946), Annie bemoans the fact that she cannot get
a man, any man, with a gun, and in *Oklahoma* (1943), the second
girl lead (who was usually faster and tartier than the heroine)
complains that:

> I'm just a girl who cain't say no,
> I'm in a turrible fix.
> I always say, C'mon let's go,
> Just when I oughter say nix.

The girls in *On The Town* (1949) want to rush their pick-ups to
their apartments, and in *Gentlemen Prefer Blondes*, the girls restrain
their eagerness for all men – or try to do so – until they have picked
out the wealthy ones. While many Christians were still insisting
that all sexual relationships outside marriage led straight to
damnation, the anti-ethic insisted that all sex was a sign of enviable
virility, even that which leaves a trail of unwanted children.
Ensign Pulver in *Mister Roberts* (1949) acquired a formidable
reputation for seducing girls and abandoning them:

It seems that on a certain cold and wintry night in November 1939
. . . he rendered pregnant three girls in Washington DC, caught the

11.45 train and an hour later performed the same service for a young
lady in Baltimore.

The contrast between the ethic and anti-ethic was also one of style
and class. The show-business musicals were light-heartedly "a-
moral", whereas the serious straight plays usually were not. The
word amoral is one to be used with caution, for the deliberate
avoidance of a conventional moral system amounts to a moral
judgement in itself. Show-business musicals were amoral in the
sense that there was no logical attempt to defend the anti-ethic.
Confronted by the strictures of the National League of Decency,
New York impresarios tended to use the argument – well, what
the hell, it is just entertainment! The class differences were also
observed. The heroine usually did not chase men – she found her
true-love accidentally and married him. But her friend and side-
kick, the second girl lead, was less well-educated and less restrained
in her behaviour: she would sometimes chide the heroine for her
primness. The ensigns in the navy can have a good time ashore,
their captains and lieutenants cannot.

Although the anti-ethic achieved its peculiar *frisson* by asserting
on every occasion the exact opposite of Christian sexual teaching,
it was not in fact an opposite but a derivative. The same taboos
were observed on both sides of the fence. Even in the musicals,
there is little description of sexual behaviour in bed (beyond the
odd "Whow-ee!") and few references to sexual deviation, mastur-
bation, VD, pregnancy, menstruation and so on. Intercourse is
mentioned with the bravado of someone picking up a live electric
wire with rubber gloves and dropping it suddenly. The anti-
ethic can be considered to derive from Christian teaching in
another way too, for the Christian distrust of sex led to a certain
determination in men and women to prevent sex from dominating
their lives. In the anti-ethic, this is expressed partly through the
male resolve to see women as just dames who could not be trusted
(like Eve), who were gold-diggers and whores, and who needed to
be bought as one buys anything else. Having purchased a woman's
beddable value either by hard cash or promises of marriage, it was
up to the man to drive the best possible bargain – to maintain his
sexual independence if he could, and if not, to teach his wife to be
obedient to his sexual pleasures. In the female anti-ethic, the
woman has to learn firstly to trap the man by tempting him
sexually, then to translate this power over him into hard currency
– "Diamonds are a Girl's Best Friend" – and finally to secure his

obedience and good behaviour in marriage, should she wish to marry him. "Why can't you behave?" sings the second girl lead in *Kiss Me Kate*:

> Won't you turn that new leaf over,
> So your baby can be your slave?
> Why can't you behave?

Kiss Me Kate, *Gentlemen Prefer Blondes*, *Born Yesterday*, *On The Town* and *South Pacific* are all apparently sexy plays, in that much time is spent talking about sex, whistling at legs and chatting about conquests. But nearly all this sexiness is rather hostile to eroticism in that sexual pleasure is shown to be something which has to be controlled, laughed at or used to strike a bargain. It is a world where men expect women to open their legs at the touch of a cheque-book, where women pray for a squad of rich oilmen to guarantee their future and where the only alternative to this cattletrading is supplied by the sudden arrival of true love – like a *deus ex machina* from the silver-lined clouds – which leads of course to marriage and the doll's house.

Both the ethic and the anti-ethic derived from Christian sexual teaching. But Christianity is not, of course, a single religion, but many religions which share a common vocabulary and a similar *point de départ*. Although many of the "official" and popular expressions of Christian sexual teaching remained hostile to sexual pleasure, a process of liberalization was taking place during the 1950s, which gathered momentum during the 1960s. In Britain, this tendency was reflected in the Lambeth Conferences of the Anglican Church, particularly in the discussions about birth control. In 1908, the Conference regarded contraception with "repugnance" – as "an evil which jeopardizes" the purity of family life. In 1930, the Conference took what was regarded as a courageously liberal step in declaring that there might be occasions when "a clearly felt moral obligation to limit or avoid parenthood', and "a morally sound reason for avoiding complete abstinence" would justify the use of contraceptives. By 1958, the emphasis had again changed. In the pamphlet, *The Family in Contemporary Society*, published after the Lambeth Conference, there was an attempt to re-formulate the principles which were regarded as essential to Christian marriage. "Full weight" was given to the personal value of coitus within a married relationship, and contraception by "methods admissible to the Christian conscience"

was approved. The pamphlet was described as heralding an age of "responsible freedom". This view was not accepted by the Roman Catholic Church, and in 1968 Paul VI in the famous encyclical, *Humanae Vitae*, reaffirmed with great vigour the traditional condemnation of all forms of contraception – except the "rhythm" method. Even within the Catholic Church, however, there was opposition to this encyclical if for no other reason than that the world seemed to be facing a population explosion. In 1971, the American publishers, Herder and Herder, whose lists contain many works specifically directed towards Catholic readers, brought out an encyclopaedia of sex, *The Sex Book*, whose definitions are notably liberal in outlook. Chastity, for example, is defined as "respect for the sexual partner as an individual, not as a sexual object": abstinence and celibacy are not implied.

This liberalization process sometimes had the effect of heightening the importance of sexual rôles. The key question ceased to be, "Are you enjoying sex for its own sake?" (which was considered bad) and became "Are you enjoying sex within a Christian marriage?" If you answered "Yes", you were all right – if "No", you were in trouble. Marriage was therefore the passport to sexual pleasure – or rather to the state of "responsible freedom" in which sexual pleasure could be admitted as a possible good. Pre-marital sexual intercourse was still condemned together with all forms of experimental sex, all forms of homosexuality, masturbation and, of course, adultery. The tone of the condemnation became less severe – thus giving support to the Bishop of Hereford's remark that Christianity is a non-censorious religion, but men and women were still expected to drop into marriage as untouched virgins and, from the background of conditioned ignorance and inexperience, to work out their lives in a state of responsible freedom. The humanist attacks on Christian sexual morality changed in the 1960s from deploring the hostility towards sex to denouncing the limited Christian conception of sexual rôles. In 1962, Alex Comfort summarized the two humanist sexual commandments:

1) Thou shalt not exploit another person's feelings and wantonly expose them to an experience of rejection.
2) Thou shalt not under any circumstances negligently risk producing an unwanted child.

From a Christian point of view, this shifting of emphasis in the debate struck an ominous note. The new-found sexual tolerance

was escalating towards "permissiveness' and beyond that – to what? Sexual anarchy? What was considered to matter was not "Are you married?" but "Are you faith-less and cruel within your sexual relationships – whatever they may be?" A sensible argument apparently, but what happens if a relationship deteriorates after a child has been born? With the abandonment of the concept of fixed sexual rôles, what else had to be left behind? Inheritance? Alimony? Maintenance of the wife during pregnancy and the early stages of child rearing? The humanists might insist that "thou shalt not wantonly expose (a partner) to an experience of rejection" – but how wanton is wanton? A husband or wife may have every reason to reject a partner, but if there are other considerations (such as the sheer dependence of that partner), how justified is he or she in doing so? Was not it possible only to postulate this freedom within a changed concept of society as a whole? The French post-war existentialists insisted that this was so, that freedom also meant a commitment to that sort of society where it was possible for a man to be free – which from their view meant a Marxist society. Had not the cause for a new sexual tolerance suddenly snowballed into a more threatening avalanche? The Christian assumption was being challenged that man lived in an essentialist universe with set patterns of behaviour from which he deviated at his peril. He was being asked to inhabit a world where there were no such signposts to virtue and sin. What was meant by *morality* in this new world? A free-flowing, free-thinking and totally unpredictable process of discovering for oneself what constitutes good and evil and acting in accordance with these private perceptions. Obedience to the Laws of God was out of fashion.

The naturalistic dramatists in the States (during the late 1940s and the early 1950s) and in Britain (during the late 1950s) shared the preoccupations with marriage and the problems of the nuclear family which their ancestors in 1890 had possessed, but their drama was written within a changed social (and ethical) climate. The Naturalists in the 1890s had not primarily attacked marriage but the unfair treatment of women within marriage, particularly their economic dependence. The Naturalists of the 1950s did not attack the nuclear family as such, but analysed instead the psychological pressures of the system. Among these pressures were the domestic consequences of capitalism where a man, the failed or fraudulent breadwinner, finds his failure reflected in his marriage. Arthur Miller's *All My Sons* (1947) showed how a man's domestic

life was progressively destroyed by a deceit which concealed his involvement in a war scandal, and his *Death of A Salesman* (1948) illustrated the ruin of a family because the father was a failure. Domestic happiness was shown to depend, not just on personal relationships, but on the way in which men and women coped with the injustices of society. This was a theme adopted by the "kitchen sink" dramatists in Britain during the late 1950s: Jimmy Porter's anger directed against his wife in *Look Back in Anger* derived from a boundless sense of social irrelevance. The new Naturalists were attracted, as the old ones were, to biological generalizations – man is a "pair-mating animal" and the formation of his mind is determined by the family situation of his childhood. The Oedipal stresses and strains within a family were shown to have a tragic inevitability to them so that if the delicate balance of hidden transactions was disturbed, an uncontrollable violence would ensue. When the new Naturalists analysed marriage, they did not stop at the front door: nor were they content to see the family as a small economic unit which reflected the structure of the rest of society. They went farther afield – in search of a new, more accurate image of man. And in this ambitious quest as well, they were following the tradition of naturalistic drama established in the 1890s.

But the ethical climate had changed. If the quest was familiar, the context was not. The fluidity of moral outlook had an effect on the new naturalistic movement which may seem almost paradoxical. Instead of becoming more ambitious and challenging in their attitudes, the Naturalists in Britain and America were cautious, responsible and disinclined to make bold assertions about the nature of society and of man. The images of marriage may have been claustrophobic ones, but marriage was still assumed to be the basic relationship binding a man and a woman. The nuclear family was biologically necessary to man. Joe McCarthy may have regarded Arthur Miller as a dangerous communist subversive, but in Europe he was considered to be amiably left wing. The British and the American dramatists after the war were drawn reluctantly if at all into the complicated political-social-ethical speculations of the French existentialists. They chipped away slowly at the known sexual taboos and prejudices, widening the areas of tolerance and extending the vocabulary of sex: but a direct confrontation between old attitudes and new ones was concealed behind appeals to good sense, reason and sincerity. The Naturalists of the 1890s had revolutionary pretensions but the new

Naturalists were less categoric in their approach. Was this because they felt themselves to be living within a revolutionary situation? Had revolutionary stances become commonplace and cliched? Whatever the reasons, the new Naturalists took no sides in the war between the sexes, were liberal rather than flamboyantly left-wing and on the side of cautious change. They presented however terrifying pictures of the tensions caused by incompatible out-looks. They called nobody to the barricades; they were content to watch the many cold wars of humanity with an impartial compassion.

The revolutionary fervour of a dramatic movement can sometimes be measured by the vigour of its opposition. The new Naturalists were not without opponents. In 1952, Arthur Miller wrote *The Crucible*, apparently about witch-hunting in seventeenth-century Salem but really an oblique commentary on Joe McCarthy and the congressional sub-committees investigating un-American activities. Jules Irving and Herbert Blau staged the play in San Francisco the following year and challenged the threats to freedom which loomed so thunderously over them. Within a few years, however, the sky had cleared. Joe McCarthy was dead, the various committees had been disbanded and *The Crucible* was included in school syllabuses as a modern classic. A political journalist might have summed up Arthur Miller's achievement like this: he had helped to rally the moderates against the forces of extreme right-wing reaction. But was this victory too easily won? The hysterical reactionaries were exposed for what they were – but what about the non-hysterical ones, the people who supported intervention in Vietnam? This political example provides a certain parallel with the moderation of the Naturalists concerning sexual ethics. For audiences in the 1950s, the American Naturalists were outspoken, even daring, on sexual matters. The British censor banned Arthur Miller's *A View From The Bridge* (1955) because Miller presented a father/daughter relationship which verged on the incestuous, and portrayed a homosexual. But *A View From The Bridge* was quickly produced in British theatre clubs, thus avoiding the censor. Despite this reputation for daring, the naturalists did not attack conventional sexual ethics. On the contrary, where their views on marriage seemed to be expressed at all, they supported the system and pointed out the horrors of the alternatives.

The plays of Arthur Miller, for example, constantly (though unobtrusively) stress the value of the nuclear family, the ties of

loyalty between husband and wife, and their protectiveness towards their children. Marriage can be destroyed by moral corruption (as in *All My Sons*), soured by nagging sexual guilt (as in *The Crucible*), or can settle into a bored acceptance of failure (as in *The Price*, 1969), but it nevertheless remains an emotional stronghold, the instinctive centre of people's lives, without which society itself falls into anarchy and self-destruction. The most terrible vision of this destruction occurred in Miller's filmscript for *The Misfits*, set in Reno, "the divorce capital of the world" – a town dumped down in the middle of a desert thriving on quick divorces. The camera calmly observes the telling juxtapositions – the elaborate wedding gowns in a shop beneath the office of a divorce lawyer, the pervasive decadence of gambling, drink and cheap sentimentality. At the railroad station, bored out-of-work cowboys linger around to pick up wealthy divorcées; at a casino, a solemn man crosses himself superstitiously before pulling the handle of a one-armed bandit. From these surroundings, Miller concentrates on a few anecdotes, often apparently unrelated, but which in their very lack of continuity reflect the aimlessness of the lives. Gay, an ageing gigolo cowboy, wants to impress the sensitive and tender divorcée Roslyn with a display of his manhood. He takes her out on an expedition to the hills to round up the rare mustang who still survive in small herds. The mustang are not valuable any longer, they cannot even be sold as ponies. Gay intends to slaughter them for cat-food. It is a purposeless display of energy which results in cruelty. Roslyn is appalled by what she sees and tries to release the wild horses after they've been lassooed and tied up. Gay is indignant because he has not managed to impress her but finally he agrees to let them go. With this small gesture of compassion, Gay and Roslyn are linked once more in a temporary friendship and drive back from the hills towards Reno. Surrounding this slender story are many small images, little anecdotes, all pointing to the same moral – that the destruction of the family leads to a terrible aimlessness in life. Gay is helped in his mustang expedition by a young man, Fred, whose life consists of touring around rodeos, getting tossed and gored and beaten up in a feverishly sustained quest for excitement. Why does Fred endure this hardship? Because his mother has married his step-father, a man he dislikes. He comes from a broken home. In another scene, Gay happens to meet the two children from his previous marriage. He wants to introduce them to Roslyn and goes to fetch her. But when he returns to the carpark where he has left his children, they have

gone – and Gay calls out for them hopelessly and despairingly across the lines of empty cars.

The new Naturalists shared the general assumption that broken marriages were responsible for much human misery – and they supported this premise with its corollary, that wayward sexual passions were an almost demonic force destroying marriages and societies and passing on this despair to the next generation. Their battles with the censor won them a reputation for outspokenness, even for writing sexy plays, but this fame concealed the fear-ridden conservatism of their approach. At one time Eugene O'Neill, that Jeremiah of the doss-house, was hauled on the bandwagon for supposed sexual freedom – O'Neill, whose sense of sexual guilt was so profound that he seemed unable at times to find a shameful enough story to match it; *O'Neill*, whose horror stories of marriage, drunken orgies over mothers' coffins, childish dependencies and weak-willed men are enough to put one off sex for life! – *he* was regarded as a liberating influence! His *Desire Under The Elms* (1924) was made into a film in the early 1950s and considered very daring. Tennessee Williams, whose vision of sexuality often seemed only marginally less panic-stricken than O'Neill's, was another dramatist whose prestige was borne aloft by this peculiar 1950s mixture of "outspokenness" and sexual shame. The heroines of his three early plays, *The Glass Menagerie* (1945), *A Streetcar Named Desire* (1947) and *Cat On A Hot Tin Roof* (1955), are all victims of a combination of social and sexual circumstances. One is the crippled daughter of a shabby genteel mother, doomed to live in nervous loneliness because the right man does not come along; Blanche Dubois in *A Streetcar Named Desire* is an ageing nymphomaniac, whose past – and the cruel treatment of her brother-in-law, the brutish Stanley Kowalski – destroys her last chance of a settled marriage; and Maggie (in *Cat on a Hot Tin Roof*) is married to a former athlete, Brick, who has retired into alcoholism to dull the after-effects of a suppressed homosexual love affair. In all these plays difficult problems are elevated into impossible ones. All possible courses of action are effectively barred. Maggie *could* leave Brick – but she loves him too passionately. Blanche *could* leave her sister's home, but where should she go and who would look after her? The outcomes can only be tragic – Blanche, raped by Stanley, goes mad, and within this world of claustrophobic oppression, madness seems an appropriate response. Sexuality is therefore shown to be a menacingly unstable force erupting both in vicious prudery and heady exotic pleasures,

and the world is a jungle – where menacing creatures lurk: rapists, baby dolls and deviants of all kinds. In Williams' *Suddenly Last Summer* (1958), this dangerous environment is given a tangible stage presence. The set is described like this:

> It represents part of a mansion of Victorian Gothic style in the Garden District of New Orleans on a late afternoon, between late summer and early fall. The interior is blended with a fantastic garden which is more like a tropical jungle or forest, in the prehistoric age of giant fern-forests when living creatures had flippers turning to limbs and scales to skin. The colours of this jungle-garden are violent, especially since it is steaming with heat after rain. There are massive tree-flowers that suggest organs of a body, torn out, still glistening with undried blood; there are harsh cries and sibilant hissings and thrashing sounds in the garden as if it were inhabited by beasts, serpents and birds, all of a savage nature . . .

Within this jungle, sex is represented at its most savage. A domineering mother, Mrs Venables, has effectively destroyed the normal life of her son, Sebastian, whom she has transformed through her misplaced adoration into a precious, homosexual aesthete. On a grand tour, Sebastian is accompanied by his cousin, Catherine, who is poor and dependent on her rich relations. But Catherine is also very beautiful, and Sebastian employs her to attract the boys to his quarter of the beach, whom he afterwards bribes and seduces. Sebastian is eventually torn to pieces by his victims and Catherine is the only family witness:

> CATHERINE: When we got back to where my cousin Sebastian had disappeared in the flock of featherless black sparrows (the children), he – he was lying naked as they had been naked against a white wall, and this you won't believe, *nobody* has believed it, nobody *could* believe it, nobody on earth could possibly believe it, and I don't *blame* them! – They had *devoured* parts of him.

Mrs Venables has blamed Catherine for the tragedy and she accuses her of spreading disgusting stories about Sebastian's sex life. But after her tormented account, the doctor employed by Mrs Venables reluctantly believes Catherine – and the blame for the death reverts back to the domineering mother.

With *Suddenly Last Summer*, the genre popularized by O'Neill and Williams stood revealed as erotic Grand Guignol. The whole image of a threatening world of sensuality, where sexual longings were tormented by guilt and then heated to boiling point by the

hot sun and the smell of flesh, toppled over very nearly into farce. In 1959, Arthur Kopit, still a student at Harvard University, wrote a brilliant skit, entitled *Oh Dad, Poor Dad, Mamma's hung you in the Closet and I feel so sad*. In this play, the domineering mother is Madame Rosepettle, whose favourite occupation (apart from collecting man-eating sundew plants and indoor piranha fish) is strolling down the beach, kicking sand in the faces of coupled lovers. Her son Jonathan is seventeen – but he is dressed as a child of ten. Jonathan lives with his mother in a succession of opulent hotels, and to complete the family party, Madame Rosepettle's dead husband is preserved and hung up in the closet with the rest of the clothes. One day, Jonathan happens to notice an attractive maid, Rosalie, who comes up to the bedroom and seduces him. Rosalie lures Jonathan into his mother's bedroom but he's terrified that his mother will return and catch them both. He tries to distract Rosalie by showing her his coin and stamp collection. But Rosalie still will not go and starts to undress, sitting on Madame Rosepettle's bed. Jonathan desperately smothers her with a pillow – and while she's still kicking, the door of the closet opens and his father's dead body slides across the bed. At this moment, Madame Rosepettle returns from the beach:

> MADAME ROSEPETTLE: Twenty-three couples. I annoyed twenty-three couples, all of them coupling in various positions, all equally distasteful. It's a record . . .

She goes into the bedroom, leaving Jonathan in the lounge, gazing apprehensively out of the window. Then she returns:

> . . I went to lie down and stepped on your father! I lay down and I lay on some girl! . . . There is a woman on my bed and I do believe she's stopped breathing. What is more, you've buried her under your fabulous collection of stamps, coins and books. I ask you . . . As a mother to a son, I ask you, *What is the meaning of this?*

The curtain falls. Arthur Kopit described *Oh Dad, Poor Dad* as a "pseudo-classical tragi-farce in a bastard French tradition" – a convincing literary invention which suits as a description of *Suddenly Last Summer*.

By 1960, many of the *subject* taboos (such as homosexuality and incest) which had constricted the theatre for so long had been defied successfully, mainly through the post-war naturalistic dramatists in the States. Elia Kazan once stated that the era of the Actors' Studio, the method and the naturalistic plays of Williams

18 A strip-tease at the Byker Fair, Newcastle upon Tyne (1971)

19 Renée La Staire at the Raymond Revuebar, London – with chandelier (1958)

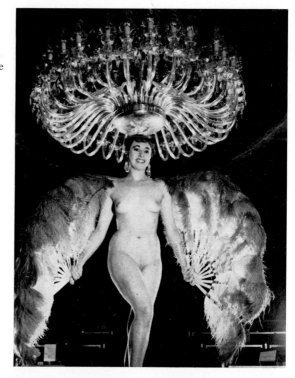

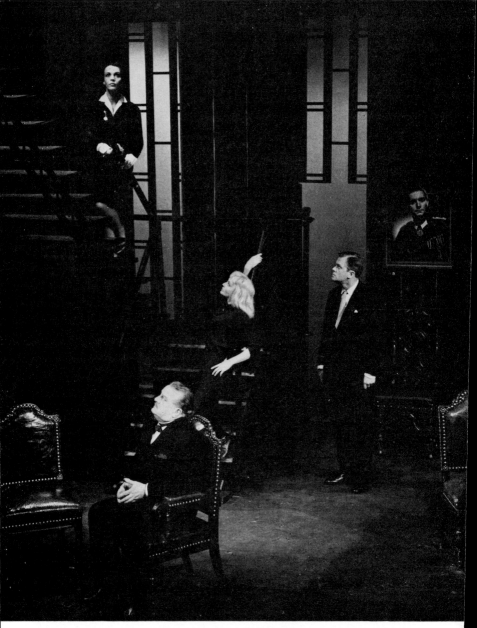

20 The Royal Court Theatre, London, production of *Altona* (1961) by
Jean-Paul Sartre, with Claire Bloom as Johanna, Diane Cilento as Leni,
Nigel Stock as Werner, and Basil Sidney as Herr von Gerlach

21 Jean Genet's *The Balcony*, from the Arts Theatre (London)
production (1957)

22 The Royal Shakespeare Company's 1971 production of *The Balcony* at the
Aldwych (directed by Terry Hands) with Hugh Keays Byrne as The Executioner,
Mary Rutherford as The Judge's Girl, and Clement McCullin as The Judge

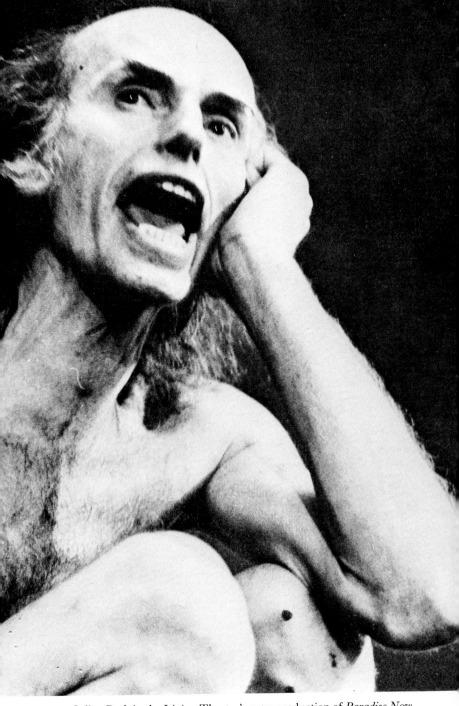

23 Julian Beck in the Living Theatre's 1971 production of *Paradise Now* at the Roundhouse

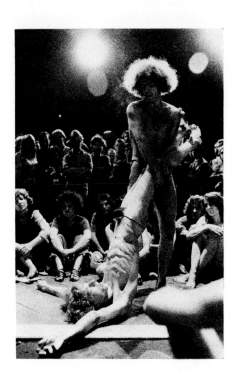

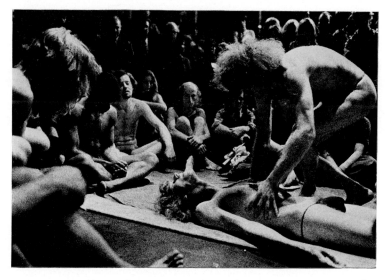

24 & 25 The Living Theatre in two scenes from *Paradise Now* at the
Roundhouse (1971)

26 Vietnam and the underground theatre. A scene from the Portable Theatre's 1971 production of Chris Wilkinson's *Five Plays for Rubber Go-Go Girls*, with Emma Williams and Paul Seed

27 "Treading through the audience" – Les Tréteaux Libres' *Requiem for Romeo and Juliet*

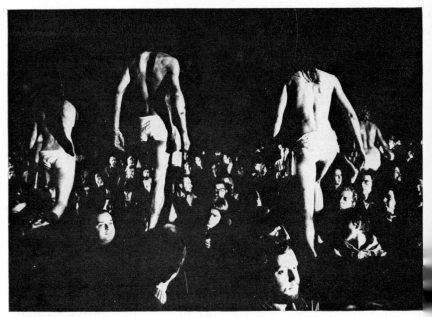

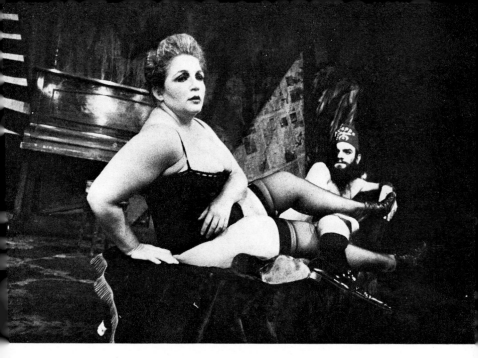

28　The Theatre of the Ridiculous' production of *Bluebeard* at the
Open Space Theatre, London

29　The Bread and Puppet Company parading outside the Royal Court
Theatre, London

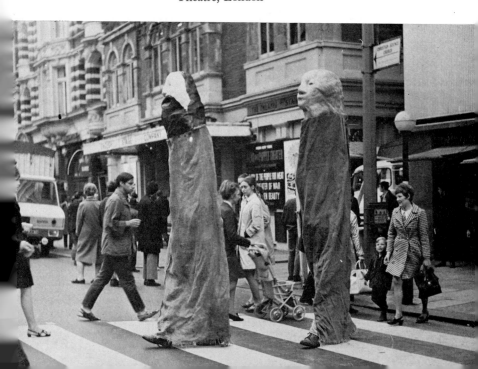

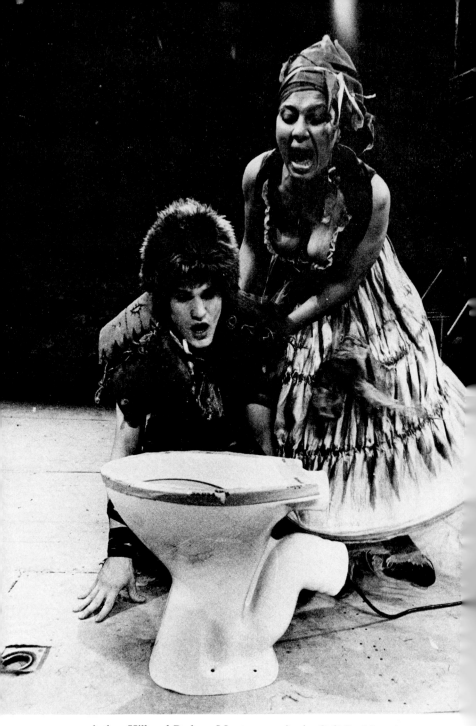

30 Arthur Hill and Barbara Montgomery in the Café La Mama's 1970
production of *Ubu* by Alfred Jarry at the Royal Court Theatre, London,
directed by Andrei Sherban

and Miller would be eventually regarded as one of the great dramatic epochs of all time, to rank with "Athens in the time of Aeschylus and London in the age of Shakespeare". Even in London, dramatists were prepared to state a homosexual theme without too much ambiguity: Rattigan's *Ross* (1960) hinges around the scene where Lawrence discovers his latent homosexual masochism at the hands of a Turkish Bey. With these taboos broken, what barriers remained to be crossed? Quite a few, although Mr Redford might not have thought so. The victories were as spurious as the taboos were arbitrary. The taboos largely derived from a Christian essentialist view of man, which regarded any deviation from a prescribed norm as sinful and leading to destruction. Many of the plays written by the new Naturalists might also have illustrated such a primer. There was a heavy Freudian gloss, which could not quite conceal the familiar outlines – that sex is a glamorous temptation which lures men and women to their destruction. Undue dependence on the mother leads to homosexuality, which in turn leads to decadence, drunkenness and drug addiction, and eventually to death. Suppressed incestuous instincts produce violent tensions and jealousies within a family which lead to death. Beautiful women can so easily arouse brutal instincts in the male which, if inflamed beyond endurance, result in violence and death. The post-war Naturalists, despite their outspokenness, were not ones to minimize the consequences of sin. Although the Naturalists went to considerable lengths to show all the temptations of lust, Mr Redford would have been pleased to observe that they did not go all the way and show its fulfilment and satisfaction. The taboos against bad language were also holding firm in the early 1960s, bearing in mind (as Mr Redford would have done) that Marlon Brando's diction, expressive though it was, might conceal almost any word behind the suppressed grunt – even the word f***.

Mr Redford was dead. But the unease, rather than outrage, which he might have felt was mirrored in the reactions of other men of the world as they watched the theatre in the 1950s slowly extending its boundaries of sexual expression. It was reflected in the remarks of theatre critics, who might preface their reviews with mild disclaimers: "Maybe I'm a prude but . . . I didn't find the spectacle of the gambler, Guy Masterson, seducing the girl from the Mission Hall very edifying," which was part of the reception given to Frank Loesser's *Guys and Dolls* (1950) when it arrived in London.

It was reflected by the general acceptance of private theatres and strip-clubs in the mid-1950s which were beyond the jurisdiction of the Lord Chamberlain and the local licensing authorities. It was reflected in the confusion (which still remains) about the legal interpretation of obscenity. Even those who watched the relaxation of formal controls with satisfaction, were a little dismayed by the presentation of sexual behaviour in the theatre – deviationary behaviour in particular.

In the 1950s, naturalistic drama tended to present sexual deviations in grotesque extremes, but by the early 1960s, this genre had become slightly ridiculous. In the early 1960s in London, however, cool sex comedies started to take up the banner of sexual freedom where these wet nightmares had left it. These farces also presented deviationary behaviour in extremes – but amusing extremes rather than horrific ones. By the mid-1960s in London, there were half a dozen good and prolific writers of sex farces, among them Frank Marcus, Joe Orton and Giles Cooper, who all possessed the knack of distancing sexual behaviour by sheer wit and an eye for the eccentric. At one time John Osborne's *A Patriot for Me*, perhaps his finest play, had to be shown in a theatre club because of its passionate and sympathetic treatment of homosexuality, while Frank Marcus's *The Killing of Sister George*, which deals with two lesbians, was playing publicly in the West End. Why were these two plays treated differently by the Lord Chamberlain? The answer lies in the fact that one was a tragedy and the other a cool sex comedy. Frank Marcus kept lesbianism at an emotional distance by making it seem ridiculous. The actress June Buckridge punished her girl friend by making her eat cigar butts. When drunk, June causes a scandal by attacking two nuns in a taxi outside Broadcasting House. Lesbianism was shown as a foible – something which civilized people could look and laugh at. Sexual situations were seen from afar, robbed of their danger and power to disturb: cut off, as Montherlant said, in "mid-idiocy".

But it was precisely this nonchalant handling of sexual situations which increased the sense of emotional unreality in the theatre: lesbianism, homosexuality, incest were all problems, "kinks" which other people cannot control. We were shown the consequences of lesbianism without feeling the attraction – the *effects*, but not the process. And so once a dramatist had stated that so-and-so was a homosexual (or a sado-masochist, or a transvestite) he often seemed unable to show how this character underwent emotional changes or fluctuations of feeling. A queer was a queer

was a queer. Sex became a mechanical force which obeyed non-human laws, and the characters who fell prey to these laws became rigidly non-human as well. In Giles Cooper's play, *Happy Family* (1966), Mark and his two sisters, Deborah and Susan, compulsively replay their childhood games. In Bill McIlwraith's *The Anniversary* (1966), Mum is continually struggling to keep her three sons to herself, while the sons are always struggling to break free. A good situation apparently – but one which failed because the mother was such an unvaried tyrant and the sons had chosen their destinies before the play began. Once their characters had been stated, there was no internal progress to them: they simply go from bad to worse. In *The Anniversary*, Mum starts by being openly rude to her youngest son's fiancée, "Do you mind not sitting next to me on the sofa? I don't like BO." She ends by taking out her glass eye and placing it on the pillow of her son's bed to stare up at them if they decide to go to bed together. The fiancée, who is pregnant, has a miscarriage when she sees the glass eye staring up at her and Mum feels that the battle is won. The girl will not stay after *that*. In *Happy Family*, Deborah starts by playing the "eye game" with her brother Mark. This is a game from their childhood, where they close their eyes, put their foreheads together and then open their eyes suddenly – after a count of three. Deborah's childishness is shown in more extreme forms as the play goes on. She is twenty-seven but she bursts into fits of laughter when she hears for the first time about the facts of life. She runs berserk with a machete when she discovers that there is no Santa Claus. Because the audience only saw the effects of their emotional inclinations, and had been alienated from the process behind these effects, they could not watch these characters changing without feeling that these alterations were somehow arbitrary and unconvincing. Therefore the characters were subjected to laws which made them seem as mechanical as robots. An ironic side-effect of the old prudery or the new permissiveness was that by trying to objectify sexual behaviour, by showing it as a distant foible, it seemed in fact more powerfully threatening – because it was inhuman.

Even the liberals therefore could not cheer too loudly as the skirmishes with the Lord Chamberlain about "fuck" and what constitutes an obscene gesture were fought and largely won, because we were then brought face to face with a harder rock – our own incoherence of feeling. Few plays in London during the mid-sixties portrayed in any depth sexual pleasure or, for that matter, sexual pain. We still preferred to strike attitudes about sex. We

were either marriage guidance counsellors or Falstaffs. We were
obsessed with trivia. "Many people" apparently wrote to remind
Kenneth Tynan that *Alfie* was not the first British film to mention
menstruation. I heard this conversation in the bar during the
interval of Edward Bond's *Saved*, one of the few plays of the period
to present in tragic and superb accuracy the loneliness which
leads to sexual violence:

> What's the fuss about? After all, a baby was beaten to death in
> *Infanticide in the House of Fred Ginger*.
> Was that the play about the sado-masochistic twins?
> No. Premature ejaculation.

The titles rolled out like family names at the battle of Flodden –
*Entertaining Mr Sloane, Under Plain Cover, Infanticide in the
House of Fred Ginger* – minor plays, all of them, but memorable
as standard-bearers in the battle against the Lord Chamberlain.

In other societies with different traditions, this obsession with
the "thing-ness" of sex was much less obvious. A dramatic char-
acter could be given a certain sexual inclination without every
detail of his behaviour illustrating and stressing this inclination.
In France there had been almost a tradition of plays set in brothels
– which were banned by the censor in Britain. Men visited prosti-
tutes, indulged in sexual fantasies and then went away to resume
their normal lives. In Simon Gantillon's *Maya* (1924), set in a
licensed Marseilles brothel, the central character is a prostitute,
Bella, whose sole purpose is to act out her clients' fantasies. She
was "the plastic matter of man's desire; the caterpillar whose
future wings are coloured by every man with hues of his longing".
But the longing was not the man. *Maya* was a popular play, but
considered superficial for the fantasies described were neither
related to society nor to the Pirandellian assumption of rôles,
which became so important a feature of French drama in the 1930s.
Henri-René Lenormand was more highly regarded, firstly for his
understanding and scepticism of Freudian analysis, and secondly
for the way in which he related sexual behaviour to social condi-
tions. Two of his early plays, *Le Mangeur de Rêves* (1922) and
L'Homme et ses Fantômes, concerned an analyst, Luc de Bronte,
"an eater of dreams, whose special function is to devour bad
dreams and so exorcize the dreamer". But this process, apparently
beneficial, had tragic results for the analyst brought images to the
conscious mind of his patient, which he was powerless to control.

De Bronte insists that the man in *L'Homme et ses Fantômes* is attempting to disguise his homosexual instincts under the façade of chasing women. The man accepts the interpretation of his analyst – and finds himself mysteriously transformed into someone who represents his bad dreams of himself – a homosexual transvestite. The man ends up in an asylum, surrounded by his phantoms which he cannot now control because he believes them to be an integral part of his nature.

Lenormand once described the duties of a writer in terms which seem peculiarly applicable to British and American theatre during the 1950s:

> We want to know what the creature we are afraid of becoming is like, what he thinks and what would be his limits of endurance ... A writer invents for himself the ghosts of the future and in this way communicates to the spectator very real and acute distress.
>
> (Preface to *Les Ratés*)

Were the post-war Naturalists inventing Nightmares of their own future? Was this what we feared to become once Christian sexual morality had weakened its hold on us? Lenormand in *La Maison Des Remparts* (1936) also shows the way in which brothel fantasies are related to apparently crumbling social institutions and, in doing so, he anticipated Genet's *Le Balcon* (1956).

Lenormand was not an *avant-garde* writer. He was influenced a little by the surrealists, but not by Artaud, and he could never have been linked with the writers of the Absurd. Like Billetdoux after the war, he represented a tradition of sensible middle-class drama, inclined to be over-literary, prone to be staid and logical. He did not go out of his way to shock anyone – although he too ran into trouble with censors both in France and Britain. In the early 1960s in London, we realized, particularly after seeing Billetdoux' *Chin-Chin* (1960) and Genet's *The Balcony* (1956), that the treatment of sexual behaviour in French theatre was not only different from ours (that had always been so) but contained insights and arguments which were fundamentally opposed to our own. British theatre treated sex as an innate compulsion which dominated people's lives and did not necessarily reflect the society to which the characters belonged; French theatre presented sexual fantasies as dreams which mirrored in a distorted form the needs and frustrations of daily life. A man indulged these fantasies as a form

of escape, although they were not an escape at all – just a variation
of the familiar in an erotic context. These are crude generaliza-
tions, but in their very crudity they reveal the sudden interest
with which British dramatists and critics snatched up the post-war
glories of the French theatre, having dropped with equal abrupt-
ness the American Naturalists.

8

Genet and the Sadistic Society

In the years immediately following the Second World War, the French existentialist movement acquired a bad reputation in London and New York. In popular films, the existentialists were portrayed as long-haired drop-outs, the fathers of the beat generation and the hippies. They were associated with drugs and promiscuity, dirty living and dirty talk, with attacks on religion which threatened to sweep away all values – the good with the bad – common sense with prejudice. Among the philosophy schools in Britain, the dialogue which gave existentialism its name – "Does essence precede existence?" "No, existence precedes essence" – was considered unworthy of debate because the terms themselves were so vague. It was considered an old-fashioned form of "philosophizing", rather than a philosophy, because it tried to handle so much, to question ethical and political systems, psycho-analysis, aesthetics, human custom and behaviour – the material which a self-respecting logical positivist would not dirty his hands with. In Britain, philosophers were particularly concerned with the meaning of meaning – to what extent it was possible to assign precise definitions to words and, by implication, what areas of experience were incommunicable, either through the inadequacy of our symbols or because of their inherent privateness. Existentialism was assumed to be part of the familiar attacks on Christian faith, which had continued for centuries. Marx wrote in 1843 that "for Germany, the critique of religion is essentially over"; why should Jean-Paul Sartre with his great intellectual gifts choose to waste his talents on old arguments?

The Roman Catholic Church in France wielded a power which even exceeded that of the Anglican Church in Britain. They succeeded in preventing a production of Lenormand's play, *La Maison des Remparts*, because one of the prostitutes, Lolita, was

portrayed almost as a saintly visionary; "the Church could not accept a prostitute's view of God". Lenormand commented in his *Confessions*:

> If the Church with a Popular Front Government in power threatens to take offensive action with out-of-date bodies like the Vigilance Committee (which is subsidiary to the Index Committee) it is feared that under a reactionary government, it will throw aside all restraint.

The existentialists feared the reactionary power of the Church, but they also recognized that much of the social system of France, from education to law to politics, rested ultimately on certain Christian attitudes and beliefs. Even Napoleon, who was a part-time agnostic, admired the Church as a force for social cohesion. Since the Church opposed nearly all left-wing political movements in France, the existentialists were eager to prove not only that the philosophy of Christianity was inherently self-contradictory, but also that the ethical and social systems which rested on Christianity were also misguided. Because they took on this huge task and seemed so plainly *committed* in a political sense, philosophers in Britain considered them not to be objective – hence, scarcely to be philosophers at all.

The existentialists started from fundamentals. Does not the order of the universe, the seasons, the rising of the sun, presume an ordering principle – hence, God? In a universe without God, would not everything be possible and nothing predictable? In *La Nausée* (1938) Sartre's first novel, the central character, Roquentin, has lost his belief in God but he wonders in a moment of horror, whether (since God does not exist) his tongue might not turn into a centipede. This obviously does not happen. Why does it not happen? Because of divine order? Roquentin concludes differently that the continuity of matter is ensured by another principle, of *contiguity*. One moment of existence influences what will happen to the next by its sheer proximity – by the fact that one split second flows into the next, which is both influenced by it and helps in its turn to define the next. On a material level this sounds an unprofitable line of reasoning, but on an ethical level its consequences are illuminating. Man, instead of being a creature which has been created to obey or disobey certain fixed moral laws, is instead constantly defining or influencing the creature he wants to become. His existence as a being precedes his *essence* –

the pattern of the man which he would like to become and towards which all his efforts are directed. He comes into the world with no prior rules to obey, and during the course of existence discovers for himself the values which are important to him, according to which he models his own behaviour. In one of Sartre's translucent phrases which nearly drove me to sea when I was sixteen, "the self is the hole in Being, the being through which nothingness enters the world." The self, in other words, has no recognition of its own separate thing-ness. We cannot point to any thing, neither our thoughts nor our dreams, and say "This is *me* – or us – or man." But we may have a clear picture of the people whom we would like or dislike to become; we know how we want to behave in this situation or that. This vision of ourselves-to-come is the essence: and in defining this essence – through our behaviour which aspires towards it – we are acting morally.

This view of morality – which stresses not man's obedience to fixed moral laws but rather his private moral perceptions – was unpopular in Britain, particularly with Christian theatre critics such as Harold Hobson. In Hobson's *The French Theatre of Today* (1953), he states that:

> Most Western people continue to believe in a standard of righteous-ness external to themselves: they consider that murder, treachery, dishonesty, are wrong absolutely and are not, in some cases, to become justified in relation to the nature of whoever happens to commit them.

And later:

> [Sartre] shrinks from that verse of St Paul's which exhorts us to act so that "we all come in the unity of the faith . . . unto a perfect man, unto the measure of the stature of the fulness of Christ." For this involves behaviour according to certain standards, in other words, the adoption of a system of ethics. And this leads to the idea of authority, of laws, all of which cripple men's freedom. Others may regard them as the compasses by which men guide themselves in the storm. But Sartre advises us that we should go out into the storm without a compass, manufacturing one for ourselves as the waves buffet and pound us.

But this reasoning is too simplistic. We may well consider murder to be wrong in all circumstances, just as cruelty is always wrong. This is because murder and cruelty are words with an inbuilt sense of wrong-doing. Murder is not just killing – otherwise

Harold Hobson (with the background of the Second World War, not to mention judicial executions) would have had difficulty in justifying his assertion that most people in the West consider it wrong. Murder means wrongful killing just as cruelty means inflicting pain wrongly. Therefore the statement, murder is wrong, is tautological. What we are basically asserting when we say murder is wrong, is that under certain circumstances killing can be murder and therefore wrong. The individual has to decide – and often the consensus of individuals within a society – what these circumstances are. Therefore these apparently absolute laws are not absolute at all but rest upon private perceptions, which is the point Sartre was making. Language itself is not capable of expressing absolute moral laws, since we learn to associate these sound symbols with different personal experiences. My understanding of the word love is different from anyone else's, although it may not be so different as to prevent all communication. Within a certain spectrum of meanings, my use of the word love can be understood by other people: it is not hate and it is not a tablecloth. The existentialists often over-emphasized the loneliness of individuals in the private worlds from which no accurate communication can be sent, but they did so partly to contradict what they regarded as the pernicious consequences of a belief in absolute moral laws. For what happens if we refuse to admit that these laws are not absolute? One consequence is that any person can claim to be acting in accordance with the laws of God when he is really trying to force his moral perceptions on to someone else who may not share them. The history of Europe is riddled with Holy Wars where both sides claim that they are doing God's bidding.

But Christian essentialism is not necessarily based on the concept of absolute laws. It could be a question of modelling one's behaviour upon a divine example, that of Christ. This, according to the existentialists, could be equally disastrous and for much the same reasons. Our images of Christ are infinitely variable, but we may delude ourselves into believing that we are in touch with a divine constant. Our moral behaviour is then governed by obedience and imitation rather than by our perception of circumstances. We are all aware of the priest who gives exactly the same look of kindliness and charity to everyone who crosses his path: he has decided in advance to be kind and charitable. He continues to do so whether or not there is an appropriate object for his kindness or charity. In his short essay, *Existentialism is a Humanism*, Sartre tells the story of one of his students who came to him during the

war to ask his advice: should he stay in France to look after and help his mother, who had left her husband, a collaborator, or should he escape to England to join the French forces? Sartre refused to help him. It was a moral question which ultimately depended on what he valued most – the personal value of family loyalty and affection, the protection of his mother, or his desire to defeat fascism and to secure a free France. No ethical system in the world could have helped the student to make up his mind, but in doing so he would inevitably also be deciding what sort of person he wanted to become and what sort of world he wanted to live in. The danger of Christianity lay precisely in its attempt to make up people's minds for them.

Christian society, according to the existentialists, is always trying to impose its own (imagined) absolute laws upon the perceptions of the individual, and by doing so not only paves the way for the despot, but also inhibits the process through which the individual decides for himself according to his perceptions the sort of person he wants to become. But without this ethical system, what would happen? Camus, in his play *Caligula*, presents a horrific picture of a man who continually needs to prove the limits of his freedom to himself by committing acts of atrocity. Sartre called Camus a pessimist, but the problem remained. Since there are no standards by which a person's actions can be judged wrong, how can laws be administered? How can we take concerted agreed action against a murderer? Why was Sartre a member of the French Resistance? Sartre answered these questions in several ways. If we assert our own personal freedom, we must also do so for other people since our only experience of mankind derives from our awareness of ourselves. To insist that we personally are free but to deny this freedom for others would be a form of what Sartre called *bad faith* – which becomes almost a blanket phrase in existentialism (similar to original sin in Christianity) to cover an illogic within the individual's reasoning, a self deception, a refusal to face facts and all forms of hypocrisy. For this reason, it is imperative for the individual to work for a society which will contain the maximum freedom for man. Sartre believed that the two great forms of authoritarian control over the individual were religion and capitalism. Just as the priest asserted that all forms of sexual relationship outside marriage were sinful, and in doing so perpetuated laws which discriminated against married and unmarried women, so the bourgeois asserted the importance and value of personal property which had the effect of discriminating

against those who had none. Both were in different ways defending
a system which gave them superior power over others. They were
both claiming the right to limit the freedom of other people's
behaviour. If the existentialist therefore was acting in good faith,
he should oppose the Roman Catholic Church with all his strength
and join the communist party.

What happens if we do not pursue this line of reasoning? What
if we believe that we are right and are therefore entitled to expect
the obedience of others? Then, according to the existentialists, we
are in danger of becoming sadists. In England we assume that
sadism is a form of sexual perversion, marked by the love of
cruelty; but in France the post-war existentialists gave the word
an altogether wider meaning, which included sex but was not
circumscribed by it. Sartre, in his play *Les Séquestres d'Altona*
(1959), described a relationship between two similar people:
Franz von Gerlach, a former Nazi officer whose cruelty during the
war earned him the title of the Butcher of Smolensk, and Johanna,
his sister-in-law, who was a film star before her beauty began to
wane. Why are they similar? Because they both imagine them-
selves as placed above the rest of mankind, he through his strength
and defiance, she through her beauty, and when the "real" world
(of other people) fails to notice their pretensions, they create a
fantasy world in which their nobility can have full sway. Franz's
cruelty, which is what we in Britain would call sadism, is just one
attitude in a far-reaching complex which also affects Johanna who
is not cruel, the von Gerlach family whose patriarchal head, Herr
von Gerlach, runs an industrial empire, and indeed the whole Nazi
society which they represent. The war has been over for ten
years, but the von Gerlach empire (like Krupps) has survived,
still in the hands of those who contributed to the Nazi war effort.
Though society has changed and Germany is now experiencing an
economic miracle, the psychological frame of mind remains.
Franz – hunted for his war crimes – is now hidden in the von
Gerlach home, seeing nobody, knowing nothing of the recon-
struction of Germany, endlessly defending his private guilt before
a tribunal of the future, for whom he records his descriptions of the
past.

The existentialist definition of sadism briefly is this. It is the
process by which one man tries to transform another into a mere
object of his will. The masochist is delighted by the spectacle of
himself as the object of another's will. The two forms of *bad faith*
are of course linked. When Johanna fails to dominate the cinema

audiences, she submits tamely and masochistically to the will of her husband, Werner von Gerlach, and she is only tempted to take control again, when Werner himself submits to the will of Herr von Gerlach, his father. The sadistic process cannot be completed because a man cannot become an object without ceasing to be human. A man becomes an object only in death – and so the sadist may feel drawn to kill his victim. But this satisfaction is an illusion, for the sadist is haunted by the presence of an independent life. It is the *life* he wants to control. But to dominate an independent life lies beyond the boundaries of human capacity. It is the one thing we cannot do. Or rather, if we *can*, it is proof that we are more than human. And so behind Franz's cruelty is not simply *folie de grandeur*, but that primordial pride in which men aspire to be God.

According to the existentialists, the sadist lives in a fantasy world, lured on by what he cannot attain. He beats his mistress not because she *is* an object of his will, but because she is not and never can be. Whether his sadism manifests itself in the cruelty of a Franz or the narcissism of a Johanna, the sadist experiences the same motivation. He is trying to convince himself of his divinity by committing "godlike" acts, and because he is never quite certain that his acts *are* godlike, he stands aside from what he does to examine his image anxiously for traces of superhumanity. He is Caligula, if we want to find a prototype, rather than de Sade. One of the ironic misunderstandings which bedevilled the British appreciation of post-war French theatre was that Camus' Caligula (1944) was regarded as the prototype existentialist, instead of being an example of what the existentialist most distrusted: the sadist.

Albert Camus perhaps assisted this misapprehension, for he did not share Sartre's all-embracing, total logic. He distrusted it. Others were sceptical that it was possible to avoid bad faith, or even that it was desirable to do so: we all from time to time become "objects of another's will", just as we also take command. The definition of sadism blurs the distinction between those limited transactions where we claim or acknowledge authority in certain fields of behaviour, and refuse to do so in others – and those unlimited ones, where somebody wants to be boss all the time. It also blurs the distinction between those perhaps mutually pleasurable sado-masochistic games – love-bites, bottom-slappings – and the more extreme forms of sexual cruelty. As children, our sexual inclinations are partially formed in a world which is run

by people who are much bigger than we are. We want to assert ourselves and are often, in various ways, bullied into submission. This assertion and bullying is often done in a loving way, and so it is not necessarily a horrific experience (although it can be). The effects of these experiences leave traces on our adult behaviour. In *Les Séquestres d'Altona*, Sartre shocks us into the idea that Johanna's narcissism and Franz's cruelty have similar emotional roots, but it is a puritanical insight, similar to those in the nineteenth century which linked dancing to promiscuity and eventually to well-deserved death.

Sartre believes that the sadist is the victim of his own fear and bad faith. Franz von Gerlach in *Les Séquestres d'Altona* felt guilty because a Polish rabbi whom he helped to escape during the early days of the war was betrayed by his father to save his son's life. The murder of the rabbi by ss men (which Franz witnessed) made him loathe and distrust human weakness, and this (coupled with his guilt) made him determined to be strong, strong at the expense of his humanity. This is a logical, almost classical, view of sadism. Because Franz loathes human weakness, he denies this weakness in himself and asserts his superhumanity. He beats his prisoners and bullies his subordinates always in an attempt to prove that he is not one of them. Because he feels that his will is tarnished with guilt, he attempts to assert his will on every possible occasion: to reassure himself that his will, despite the past and despite the fact that his good deeds have had terrible results, still exists.

But does this easy cause-and-effect logic exist between what we do and what we become? Is it true that we only long to be God when we have become ashamed to be human? And is it true that our shame is based on our personal guilt and fear? We must remember that it is almost an existential article of faith that we are individually responsible for what we become: and it is an article with which many people do not agree and which is impossible to prove. Jean Genet, for example, whose works and life provided the existentialists with an example of someone whose standards were totally opposed to bourgeois ones, but were also coherent in themselves (lacking in bad faith) and therefore admirable, believes that men are born with a sense of personal shame and are also innately god-inclined, even in a universe without a god. In *Le Journal du Voleur* (1948), Genet describes how, at the crucifixion, Christ delivers men from their sins, but punishes and humiliates them through the body. We cannot escape this pain and shame. Indeed

we should "embrace" it. But we must try to transform our degradation into "ritual" either of behaviour or art, which satisfies our "divine" aspirations. My body, Genet writes, is only a pretext, a pretext in his case for poetry: "ma victoire, c'est verbale". The man who has successfully transformed his bodily shame in this way has attained what Genet terms "sanctity". Sanctity means "union with God', but God is not a Christian god or a humanist "first cause". God is the god-in-man, "mon tribunal intime".

Genet, in other words, has described what the existentialist would regard as the essential pre-conditions for sadism: a loathing for human weakness, "divine" aspirations and a continual self-examination which attempts to discover in the weakness the seeds of the hoped-for strength. Whatever definition of sadism one accepts, I do not believe that the pre-occupation with sado-masochism in Genet's work can be ignored. Three of his five major plays, *Deathwatch* (1947), *The Maids* (1947) and *The Blacks* (1958), are concerned with the right and wrong ways of committing murder. In his play set in a brothel, *The Balcony* (1956), most of the fantasies acted out by the clients are overtly sado-masochistic: one acts a judge, ordering an executioner to flog the girl prisoner into confession; another plays the General, flogging his horse (a prostitute) into battle; another is a timid man, beaten by a girl. But if one adopts the existentialist definition of sadism, and remember what the implications of this definition were for Sartre in *Les Séquestres d'Altona*, the preoccupation becomes infinitely more marked. Nearly all of Genet's characters can be caught in the same giant web. They are all ashamed to be men. They act "divine" rôles to themselves, like Caligula, heightening what they believe themselves to be until they have transformed their human characteristics into totems. A black cannot simply be black: he must "negrify" himself by rubbing boot polish into his skin. When the banker visits the brothel, when the maids amuse themselves while their mistress is away, or when the blacks act out the downfall of the whites, their humanity is buried beneath ritual. They don masks, cothurni or elaborate clothes. They speak rhetorically in super-charged voices. They keep to a pre-determined script. They watch the ritual anxiously lest something goes wrong, and when it does, when the maids' alarm-clock rings or the banker hears the sound of a machine-gun, the wave of illusion breaks and the actors are left, stranded and panting on the sands of their own unavoidable humanity. The rhetoric which we associate with French

tragic drama is for Genet a psychological necessity. No man can resign himself to being human.

Genet, unlike Sartre, tends to assume that sadism is innate. This difference between them is of great importance. Sartre believes that sadism, in spite of its overwhelming presence in society and the behaviour of the individual, is a complex we can avoid. *Les Séquestres d'Altona* is an explanation as well as a portrait of the sadistic society, and there is no point in explaining anything unless it alters in some way our understanding and behaviour. But Genet does not explain. He takes sadism for granted. All that a moralist can do – for Genet like Sartre is a moralist – is to distinguish between types of sadism: between the successful and the unsuccessful, the sanctified and the abject. This is the theme of *Deathwatch* (Genet's first play), which is set in a prison cell and was loosely based on Genet's own experiences in jail with the murderer Pilorge, whom he loved. Both Green Eyes and Lefranc (in *Deathwatch*) are murderers, but Green Eyes kills in obedience to an inner necessity, a wave of compulsion which drowns his conscious resisting will, but which lifts him up to a higher plane of being – "Destiny takes control of his hands". Time moves faster. He murders elegantly with a flower between his teeth. The murder is like dancing. But when Lefranc, who envies the strength and detachment of Green Eyes, tries to imitate him by murdering Maurice, a fellow prisoner, he is pulled back by sheer human frailty. He killed in anger and to be admired. Green Eyes is naturally disgusted. Killing by itself means nothing. Only submission to superhuman destiny counts.

But neither Sartre nor Genet considers sadism primarily in terms of individual behaviour. Above all it is a complex which society expresses and exploits. As the individual sadist is not just a killer, so the sadistic society is characterized not just by cruelty but by the love of ritualistic detail: class-consciousness, status symbols, racialism, colonialism – anything which suggests that one man or group of men can be superior to the rest of mankind. Herr von Gerlach teaches his second son, Werner, how to dominate his subordinates: "Never look at them in the eyes. Always look at the bone in their foreheads." This domination is economically necessary to the von Gerlach family. Without it, they could not run the shipyards. And it is quite divorced from real merit. Herr von Gerlach is proud of the fact that he does nothing but sign letters. Other people know about his shipyards and they work for him. The "mistress" in Genet's play *The Maids* comforts herself

that she has much better taste than her servants. In his play, *The Blacks*, the "white colonialists" re-assure themselves that they do not have the nasty smell of the blacks. This is the sadistic society in action, where the individual is driven by a mixture of social, economic and private forces to prove his superiority, and because this superiority never can be proved, he is forced to magnify small details – class distinctions, taste, colour, smell – in order to convince himself that this superiority exists. These details in time become ritualistic partly because they are inflated beyond their real importance, and also because they become built into the customs and mythology of a society. A clear example of this process would be the way in which women have been treated from time to time in our society as inferior beings because (*a*) they menstruate, or (*b*) Eve succumbed to the blandishments of the serpent, or (*c*) they were created from the rib of Adam, or (*d*) they cannot work in the mines during advanced stages of pregnancy. Man also uses the small details to convince himself of his "divine" origins. The whites assume that God has a white face. Naturally. After all, he is their God. The "divinity", the "superhumanity" is what matters, the ritualistic details merely confirm an inner longing. In the sadistic society, one generation succeeds another by a revolution in miniature for nobody abandons his illusion of superiority except in defeat, and only victory gives an individual or class a temporary reassurance.

Because the socialist believes that the claims of the individual or the class must be subordinated to those of society as a whole, he must resolutely oppose the sadistic society. But to believe that socialism can exist, he must also believe that sadism is the result of bad faith and can be avoided – in other words, he must agree with Sartre. Genet, as we have seen, assumes that sadism is innate and so he admits that he cannot imagine what a socialist society would be like. Although Genet shares so many of the preoccupations of left-wing existentialists, and has been acclaimed by them, he is in fact an extreme right-wing reactionary. True, he sympathizes with the under-dog (the maids, the blacks, the rebels), but when the revolution's over, the rebels become the establishment, the blacks are the new whites, and society continues in the same pattern. Society, as we know it, is the mass projection of the sadistic impulse. When the corrupt feudal state in *The Balcony* is overthrown by revolution, the figureheads of the old order, the Queen, the Bishop and the General, are replaced by fantasy creations from the brothel. Private dreams become public institutions.

Nor is Genet simply shrugging away the possibility of change. He is stating a social philosophy which is the exact opposite of the Marxists. Whereas Marx believed that society is under constant pressure to adapt itself to its environment, to become, in other words, more useful, Genet assumes that men are always trying to free themselves from their environment and become useless. The man who acts the rôle of the Bishop (in *The Balcony*) stresses that a bishop should be without functions, without obligations to other men. When he hears a confession, he absolves, not to relieve the sinner of guilt, but to glorify in his powers of absolution. A man must not become a bishop through personal merit. This would pin down God's representative to human conditions. A bishop should exist "in solitude, for appearance alone". And once the appearance has been established, the man steers "a skilful vigorous course towards Absence. Death." The divine rituals we create become our tombs, and when they are built, gently we dissociate ourselves, shrink away and die. And so, society changes like the coral reef, in size and mutation, but not in kind. One generation of tombs simply piles upon another. In *The Balcony*, the only man to produce social change is not the revolutionary, Roger, but the Chief of Police, George. Roger, a socialist and presumably an existentialists as well, want to change the *kind* of society. He would like the rebels to be useful, rational men, and he disapproves of Armand, his fellow revolutionary, whom he finds posturing in front of a mirror. Armand enjoys revolution, the thrill, the ecstasy, the bravado, and it is this self-contemplating delight, urged on by the jingoistic songs of Chantal who left the brothel to assist the revolution, which enables the revolution to "succeed". The revolutionaries therefore are inspired by the fantasies which the old régime possessed and in time, when order has to be re-established, the old fantasy leaders have to be resurrected. Roger comes to a futile end, castrating himself in the brothel he swore to destroy. The Chief of Police who, through sheer terror, forces people to admire him, adds a new studio to the brothel. It is he who produces a mutation of the coral.

Expressed in these terms, Genet's vision of society seems only a more faded version of Spengler's cyclical history, which popularized the view that society did not really change at all, except in vast pendulum swings of fashion. Society, like the individual, aspires towards ritual, and we called this ritual "civilization" or "culture". We define "culture" only in non-useful terms. The art and literature of the Romans is their culture, their plumbing is not. And

we judge a culture not by the way in which it reflects their life, but by the way it shows their superhuman control of life – their "nobility", their "wisdom", their aesthetic pleasures. A wriggling worm is of no interest: a worm which wriggles gracefully and rhythmically, which has tried to transform its instinctive movements into some sort of dance, is aspiring towards ritual. It is a cultural worm. Once this social ritual has been established, men lack the incentive to develop it further. Civilization is an end in itself, and this is where human energy stops and dies away. The whites give way to the blacks, who give way to the yellows and the reds.

The difference between Spengler and Genet lies in the intensity with which Genet perceives this need for ritual and the degradation on which this need is based. When Genet writes, "my body is only a pretext" (for poetry), he is not only justifying his existence in terms of art. He is saying that without art, life is pointless and humiliating. The life cycle of a man or a society is like that of a plant. The thin malodorous stem which feeds on dying leaves and strangles its neighbour in the search for food has one aim: to produce a flower. And when the flower has been formed, the stem dies away and the blossom droops still glorious, until it rests on the ground. The flower – like the man – must be judged not by the morality of its growth, but by the beauty of its blossom. This is the central vision, intense, all-embracing, which floods through Genet's work. It is Lawrentian in its size and simplicity. It binds together all that multiplicity of subject matter which we find in his plays: the politics, the love-hate relationships, the social comment, the doubts about identity, the search for an acceptable god and for an honourable death. And it is also based on an extreme example, his own life, which has the effect of highlighting his arguments. When Genet writes about the degradation of man's life, he means not the comparatively commonplace bodily shame, whereby, say, a woman is ashamed of menstruation or a man of masturbation, but the state of being a foundling placed with an unfriendly family; of his early conviction as a thief at the age of ten; of escaping from the Foreign Legion, of being a homosexual prostitute in Nazi Germany because thieving (so familiar and blessed by the authorities) did not have the same honour of social defiance; of spending years on the run and in prison. When he talks of social ritual, he has in mind the rigid authoritarian structure of a prison, which he compares to a monastery. His masturbatory dreams do not prepare the way for ordinary sexual relationships.

He did not have that hope. They were pleasures to be treasured in themselves, erotic flowerings of the imagination whose delight lay in the extremities. His lovers (like Pilorge) could be snatched away from him at any time – by the guillotine or by the authorities who would transfer them to other cells, prisons or even set them free. His early novels, *Notre Dame des Fleurs* (1943), *Miracle de la Rose* (1943), *Pompes Funèbres* (1945) and *Querelle de Brest* (1946), celebrate the beauty and spiritual freedom (in contrast with the physical servitude) of the outcasts with whom he was in love. He is a poet of the underworld in the tradition of Villon, and his style often reflects the masturbatory fantasies about heroic criminals whose pictures he pinned above his bed – being both commandingly rich in imagination, and rather repetitive – ecstatic, finger-lickin' prose, which is suddenly and often wittily pulled back from floweriness by a deliberately placed fact, like the alarm bells which warn the maids of danger.

The Balcony was performed at the Arts Theatre Club in London in 1957, four years before its first production in Paris. Genet came to see the London production and apparently disliked it. The problem was a fundamental one. The production was staged semi-naturalistically, as if in a brothel. The girls were obviously prostitutes, their clients, middle-class business men whose fantasies were not confined to office hours. But Genet did not want the sexual rituals to seem ones which only had a place in the bedrooms of prostitutes. On the contrary, the tenor and argument of the play is that these rituals govern our social behaviour, and in the last speech, Irma, the madame of the brothel, dismisses the audience with these words:

> You must now go home, where everything – you can be quite sure – will be even falser than here . . . You must go now. You'll leave by the right, through the alley . . .

The first British production, it seems, was also conditioned by a British attitude towards brothels – that they are tawdry shame-faced places, full of cheap scent and tinsel. Genet emphasized during the course of the play how much effort was spent on getting the rituals exactly right, to the details of the costumes, the "Bishop's" lace "fashioned by a thousand little hands", the "General's" boots splashed with blood. The prostitutes have to

learn the scenes by heart, exactly what to do and when, and there is, to make the fantasies more credible, a weaving of fact and fiction together, one heightening the other. The "Bishop" must absolve "real" sins – not just invented ones. The "Judge" inquires anxiously at one stage of the girl "Thief" whom he is judging:

> – you're not lying about those thefts – you did commit them, didn't you?

and the "Executioner" who stands by with a whip, reassures him:

> Don't worry. She committed them, all right. She wouldn't have daren't not to.

The whipping is also real; Arthur, Irma's assistant, who plays the Executioner, sees to that:

> IRMA: You went easy, I hope? Last time, the poor girl was laid up for two days.
> ARTHUR: Don't pull that kind-hearted-whore stuff with me. Both last time and tonight she got what was coming to her: in dough and in wallops. Right on the line. The banker wants to see stripes on her back. So I stripe it.
> IRMA: At least you don't get any pleasure out of it?
> ARTHUR: Not with her. You're my only love. And a job's a job. I'm conscientious about my work.
> IRMA (sternly): I'm not jealous of the girl, but I wouldn't want you to disable the personnel. They're getting harder and harder to replace.
> ARTHUR: I tried a couple of times to draw marks on her back with purple paint, but it didn't work. The old guy inspects her when he arrives and insists that I deliver her in good shape.
> IRMA: Paint? Who gave you permission?
> ARTHUR: What's one illusion more or less! I thought I was doing the right thing. But don't worry! Now I whip, I flagellate, she screams and he crawls.

This too is in accordance with Genet's theme. The ritual of law in real life may have its origins in sexual fantasy, but it requires real crimes to feed upon. And the purpose of the ritual is something more than sexual satisfaction – it is rather the realization of a dream concerning the divinity of man. In *The Screens*, it is the inexperienced whore who undresses quickly, gets fucked and paid

cheaply, and wanders from client to client; the experienced whore
may not undress at all:

> WARDA: Twenty-four years! A whore's not something you can
> improvise. She has to ripen. It took me twenty-four years. And I'm
> gifted! A man, what's that? A man remains a man. In our presence,
> it is he who strips like a whore fron Cherbourg or Le Havre.

The first London production dissatisfied Genet, because it treated
sexual fantasy as a means of stimulating an orgasm, not as an end
in itself. The difference is crucial.

In 1971, *The Balcony* was staged again, this time by the Royal
Shakespeare Company at the Aldwych Theatre in London. The
production was magnificently faithful to Genet's intentions. The
fantasy creations – the Bishop (played by T. P. McKenna), the
Judge (Clement McCallin) and the General (Philip Locke) – were
splendidly dressed, and stood (as directed in the script) on coth-
urni. The speeches conveyed the intensity of the obsessions. Their
prostitutes – played by Helen Mirren, Frances de la Tour and
Mary Rutherford, together with a glamorously bored tough girl
(Laura Graham) – achieved exactly the right balance between
brothel fantasies and working girls. Brenda Bruce as Irma was
sensible, controlled, and yet also subject to fantasies (as The
Queen) and affections (for Carmen and the Chief of Police). It
would have been hard to fault either the direction (by Terry Hands)
or the performances. And yet this production, which had been so
eagerly anticipated, somehow misfired. And the trouble lay not
with the staging, but with the script – or rather with the changing
climate of opinion which made the script seem old-fashioned. In
1957, the juxtaposition of social authority with sexual fantasies
was still an unfamiliar one and the idea that one stemmed from
the other was a disturbing possibility. In 1971, these thoughts had
become clichés. When *The Balcony* opened at the Aldwych, the
film *W.R. Mysteries of the Organism*, directed by the Yugoslav
film director Makavejev, was running at the Academy Cinema and
heavily publicized by the "underground" entertainments guide,
Time Out, with a massive cover slogan, "To Touch the Truth is to
Touch Your Genitals". In the film, Makavejev made the now
familiar argument, linking social oppression (right-wing) with
sexual repression: and the slogan came from the sayings of
Wilhelm Reich, "the great radical psychotherapist", whose life
provided the subject for the film. For several years, "underground"
theatre had been hammering home the theme that war was just

pornography for the masses, that judges "were only in the legal racket for sadistic kicks" – a blind generalization if ever there was one, that obedience to authority was a form of masochism and that all politicians are emotionally unfit to run a Butlin's holiday camp. Within this context, the marginally less dogmatic (though more disturbing) arguments which Genet provided, were hopelessly buried beneath this stridency. The idea that the old rebels would become the new establishment was familiar as well – from Orwell's *Animal Farm*, Adamov's *Les Grandes et les Petites Manoeuvres*, and a dozen lesser works. The social comment in *The Balcony* was stale.

There was another problem. The rituals in the brothel seemed less convincing as sexual fantasies. They were too staid and literary. We had become alert to physical athleticism in the theatre – the La Mama productions where every line was underlined by a dramatic gesture – and after seeing *The Dirtiest Show in Town*, it seemed almost incongruous to watch sexual fantasies where the main emphasis lay with the words. But there was also something wrong with Genet's conception of sexual fantasy – as something which elaborately develops over years, carefully fostered until every detail is right. This seemed authentic in the 1950s, when other people's fantasies still came as a shock to us: but in the early 1970s when so many magazines were publishing letters from readers about their sexual games, the rituals seemed formal, very one-sided and even dull. The strip clubs of the 1950s were putting on similar shows – where a girl would be caged and growl for ten minutes (for those who liked caged girls), to be followed by the Baby Doll. By the late 1960s, stripping had become more professional. Each girl had a range of effects at her command, and would seem to enjoy herself more.

In *The Balcony*, the girls were not having fun. It seemed a boring amusement to force a girl to learn lines, and rehearse her part, when improvisation was more interesting. The fantasies in *The Balcony* belonged to a time when the woman supplied sexual pleasure to the man. Nowadays in brothels and strip clubs, a woman is expected to convey her own sexual enjoyment to her client. This, of course, could be another illusion – but it is one which differs from the scenes in *The Balcony*. With this awareness of mutual enjoyment, the one-sided fantasies in *The Balcony* seemed the pathetic longings of lonely men: abnormal rather than normal, staid and dull rather than interesting. They seemed moreover linked with an old-fashioned conception of culture, as something which has to be

brought to a static perfection, rather than as a living process which
alters as life changes.

This changed reaction was reflected in the remarks of theatre
critics who no longer commented upon the bizarre daring of the
brothel scenes, but rather on their longwindedness. As soon as the
sexual fantasies seemed less convincing, the social theorizing based
on them also lost credibility. Do people still wish to transform
others into mere objects of their own will? Probably they do, but
our theorizing about private sexual behaviour is full of the descrip-
tions of simultaneous orgasms. And (on a social level) the tenor of
our problems in Britain over recent years indicates the almost
impossible task of asserting authority over anyone at any time. The
difficulty seems to be to maintain co-operation between sections of
the community who inwardly feel themselves to be at war. Just as
voting patterns in Britain became exceptionally fluid during the
1960s, so the old class images of the employers and the workers
lost a certain validity. And the existentialists (in defining sadism as
they did) were really trying to explain why bosses wanted to be
bosses. At a time when authority is the world's whipping-boy, an
explanation which adds to the burden of reproof which the
establishment is expected to carry seems both trite and unneces-
sary. Should we be cruel to those whom we have already described
as sado-masochists?

In the late 1950s and early 1960s, however, Sartre and Genet
provided a necessary connecting link between our images of the
sexual behaviour of individuals and our understanding of social
structures. Their insights were not unique. Lenormand had said
much the same in the 1930s. But they were expressed with a
detailed logic and conviction, and came at an apt time – when the
descriptions of sexual behaviour by the American Naturalists
seemed neurotically far-fetched, and those by the British drama-
tists, lofty and alienated. But the attention given to the sexual-
political theories of Sartre and Genet took some of the critical
limelight away from other writers, who took the arguments of the
existentialists to heart, interpreted them critically and applied them
to gentle observations of people's actual, as opposed to theoretical,
behaviour. François Billetdoux' *Chin-Chin* caused much less of a
fuss in Paris and London, where it was produced in 1960. It ran
longer than either *The Balcony* or *Altona*, a fact which caused some
people to believe that it was a tame conformist play suitable for
bourgeois audiences. Those who made this mistake were under-

estimating both the play and the intelligence of the middle classes (whoever they may be), for *Chin-Chin* was selectively destructive of the old standards of Propriety and implied a re-assessment of our moral beliefs. The story is a simple one. A prim conscientious English housewife, Pamela, discovers that her French husband is having an affair with the wife of an Italian businessman, Cesario Grimaldi. She arranges to meet Cesario, ostensibly to discover ways of breaking up the affair. But Cesario does not have her practical approach. He is overcome with jealousy and self-pity, he wants just to sit down and pour out his grievances to someone and then to plot some awful revenge on his wife which he will not carry out. Pamela is impatient with him, but she sits down to have a drink with him (breaking a lifetime's abstinence). They meet fairly regularly, have a clumsy affair, fail to solve any of their problems and gradually drift into doing nothing in particular, just meeting, chatting, drinking. The downward path apparently – and yet Billetdoux manages to convey the impression that Pamela and Cesario have become better people. They have lost their old stock reactions; they are not so intolerant of those who have caused them harm; and they have discovered within themselves a freedom to explore, a freshness of response to the world which their previous lives excluded. Pamela has lost her sense of overbearing responsibility towards her grown-up son and Cesario has lost his compulsive wish to keep his business going at all costs. In the final scene, Pamela finds her son drunk in the gutter. He has been chucked out of his father's flat. She props him against the wall and discovers in his pocket a wallet full of money. She and Cesario are experiencing hard times and so she takes the wallet. "Where shall we go?" Cesario asks. "Anywhere you like," Pamela replies.

In *Chin-Chin*, Billetdoux reversed all our customary expectations of good behaviour. Pamela and Cesario were socially worthy in the first act, ruffians in the last. He did not glamorize their degradation, nor pretend that through discovery of freedom they were about to embark on the purposeful commitments of existentialism. But he does suggest that they have learnt to listen and talk to each other, to be sympathetic about other people's problems and practical (though not dogmatic) about their own. They have lost the moral prejudices which at one time provided a total barrier to their friendship and their appreciation of the world around them. One effect of existentialism which is sometimes overlooked was that in addition to attacking forcibly the old moral absolutes, it was also interpreted by some writers to mean a re-discovery of the

Christian virtues of charity and love. Billetdoux' influence on British theatre could never be considered a profound one, but did he perhaps lighten the tone of our rather rigid sexual reactions so that the plays of Charles Dyer, *The Rattle of a Simple Man* and *Staircase*, received a more sympathetic hearing?

9

Strip Clubs and Swingers

I am an Englishman, the beneficiary of a nineteenth-century education (in style, if not quite in date) and am therefore conditioned to regard sceptically the whole idea of substantial change. When I am confronted by an apparent change – even an extreme one, such as the contrast between the sexual reticence of the Edwardian theatre and, say, *Oh! Calcutta!* or Warhol's *Pork*, my instinct is to assert that there has not been a change at all, not really, that the difference is all a matter of style and emphasis. From the traumatic recesses of a third-form memory, the images of the Roundheads and Cavaliers arise, twin figures in a Swiss chalet barometer of sexual atmosphere. When one is out, the other must be in. "Plus ça change," as we used to say in our abominable Anglo-French, "plus c'est la même chose." It is a habit of mind which handicaps the reading of sexology. When Ira L. Reiss from the University of Iowa tells me that we are on the brink of "a sexual renaissance", my blood does not tingle with hope – nor does it chill when I read the warnings of Pitivin A. Sorokin from the University of Harvard that "our sex freedom is beginning to expand beyond the limits of safety. It is beginning to degenerate into anarchy." Nor do I find it easy to accept, even for the purposes of argument, the sort of cultural progression envisaged by Marshall McLuhan in *Understanding Media*:

> In the age of the bikini and of skin diving, we begin to understand the "castle of the skin" as a space and world of its own. Gone are the thrills of striptease. Nudity could be a naughty excitement only for a visual culture that had divorced itself from the audio-tactile values of less abstract societies . . . to a person using the whole sensorium, nudity is the richest possible expression of structural form. But to the highly visual and lopsided sensibility of industrial societies, the sudden confrontation with tactile flesh is heady music indeed.

Statements like this leave me with a warm glow of superciliousness, which others might recognize as typically British. Who really lives in an age of bikinis and skin-diving, apart from Lottie Haas, and is not McLuhan overestimating the changes which have happened even in style? In the 1900s, Annette Kellermann was giving public swimming lessons at the Hippodrome in what was regarded as a very daring swimsuit, and the manager of the theatre, Albee, stated succinctly, "We're selling backsides, aren't we? All right. If one backside is good, a hundred backsides are many times better. Go down to the cellar and bring up those mirrors." And so Annette Kellermann was surrounded on stage by mirrors. Edwardian men, even those who did not go to the music halls to see Living Pictures, were well aware of gorgeous girls in swimsuits (perhaps not *so* aware, but the difference is one of emphasis). And was Edwardian society, with its heavy perfumes, green orchids and deep décolletage, less "audio-tactile" than the island cultures it colonized in the Indian Ocean – where nakedness was the norm and dressing-up, sexual exhibitionism? I do not think I know anyone who uses the "whole sensorium", but perhaps I would not recognize anyone who did.

But – to move from McLuhan's general remarks to his specific observation – have the thrills of striptease gone? Paul Raymond, who owns the Raymond Revuebar, and Ray Jackson (who with Eric Lindsay stage the shows at the Casino de Paris in London) both dislike the word striptease, which they consider old-fashioned. Paul Raymond prefers "erotic entertainment" and the revue at the Casino de Paris in 1971, *Stand By For Take Off*, was described as "a great new avant garde naked spectacular". The word striptease, which ensured an audience in the 1950s, did not appear anywhere in the advertisements. The difference is not apparently just a verbal one. Striptease evokes an image of women stripping for men, whereas nowadays couples come to the shows as well. Neither Paul Raymond nor Ray Jackson can risk turning off the women in the audience while turning on the men. The last numbers in both the 1971 Revuebar Show and *Stand By For Take Off*, the climaxes of two evenings largely devoted to climaxes, are *pas de deux* in which the male dancer strips to a flourish of drums. And therefore striptease in the old meaning of the word may well be dying out. Furthermore there is a growing acceptance of nakedness on the stage, in films and TV. The witnesses at the 1909 Censorship Enquiry were united in the belief that the sight of Eliza stepping into her bath would be very shocking: nowadays in Britain such a scene could be included on

peak-hour television. Naked actors and actresses are a familiar sight on all our stages, from the Royal Shakespeare Company at Stratford to the Open Space and Criterion Theatres in London, from off-off Broadway to on. In Britain we have not quite reached that acceptance of stage nakedness whereby it fails to arouse comment. Actresses are still tempted to explain that they would not appear naked as a matter of course, only in certain scenes where it is necessary. Writers and directors are still insistent that the context of the play is all important, that they are not indulging in sex for its own sake; and the press still report these banal protestations of artistic virtue with a plonking flatness – as if they believed them, but thousands would not. When the Arts Council Working Party reported on the present working of the obscenity laws, they insisted that:

> custom and acceptance . . . are great anti-aphrodisiacs: barelegged girls are no longer erotic – nothing could be more antiseptic sexually than a nudist colony.

All these signs suggest that McLuhan could well be right, that the thrills of striptease are going, if they have not already gone, and that we are in an age when with a franker acceptance of the body, that stimulation which depends on the sudden sight of breast or bottom will dwindle away.

But striptease is not just a matter of undressing: it is the way in which people undress. It belongs to a signal system (recognized by society as a whole) in which lovers indicate their acceptance of each other. Custom provides men and women with certain formal obstacles towards each other – clothes, manners, taboos – which they can either harden into a thick, bomb-proof wall or knock down brick by brick to signify sexual interest and love. It is a process which goes on, with clothes or without, even while fucking, for we can withhold our affections, retain a certain psychological distance, play the coquette in the very act of making love. It seems to me very unlikely that teasing will end as stripping becomes commonplace. What may have changed is this. In the past, a fiction has been maintained that men are the aggressors who have to knock down the wall provided by women. If, as seems possible, women no longer feel on the defensive, partly because contraception relieves the fear of an unwanted pregnancy, these barriers may not be so substantial or only built by women. It may be that the situation expressed in one of Purcell's songs:

> Thus to a ripe consenting maid
> Poor old repenting Delia said:
> "Would you long preserve your lover?
> Would you still his goddess reign?
> Never, never let him all discover –
> Never, never let him much obtain"

has become old-fashioned, for it rests on a tenet of female chauvinism (almost as prevalent as the male) that man's sexual delight comes with conquest and that having conquered, men disdain. To keep one's lover, one prolongs the act of conquest, teasing rather than stripping. Without this implied acceptance of a man through striptease, the business of undressing is meaningless. In the 1900s, undressing before a man nearly always meant stripteasing; now it does not – or rather it is possible to imagine many situations where undressing does not mean a sexual invitation. Some cultures stress the act of conquest to an unnecessary extent and then heavy barriers have to be raised – veiled faces, secluded harems guarded by eunuchs – which can then be more brutally knocked down. If striptease has become less noticeable in our society, it might be a welcome sign that men no longer want to mount women simply because, like Everest, they are there. I do not believe that this has happened because the myth that the sexual act represents a male conquest of the female and proof of aggressive masculinity is still too engrained in our popular legends – of James Bond and Casanova – and while this is so, striptease will always be in danger of becoming a bad habit in which a woman is apprehensive of shedding the last veil for fear that she will have no further barriers to tempt the conquering man. There may be another difference in emphasis. More women today may have learnt to distinguish between the man who is so uncertain of himself that he has to keep proving his importance by conquest, and the one who is not. It still however seems inconceivable that the general process of teasing – woman of man, man of woman – will end with a readier acceptance of physical nakedness. It will simply transfer to another area of behaviour. It is possible that nakedness itself will become a bore and that present members of the Women's Lib will be shocked to find their daughters wearing seductive bras, long frilly *fin de siècle* knickers, petticoats forsooth, and this will neither indicate a return to modesty nor a decadent rejection of the body in favour of artifice. It will simply mean that the language of love, like any other language, is seeking renewal.

While the process of erecting barriers and knocking them down goes on in society the theatre will reflect the fact, and pornographic theatres, ones who aim almost exclusively to stimulate their audiences sexually, will use these teasing symbols to do so. The symbols may change, together with some sexual fantasies, for pornographic theatre can never be so divorced from the rest of society that it does not reflect the general compromise between social attitudes, moralities and sexual inclinations. Striptease has not disappeared: it has simply lost some of its dependence on undressing. And even this would be hard to prove, since most of the acts at the Casino de Paris and the Revuebar have the same pattern to them – a girl gorgeously dressed comes on stage and slowly takes off her clothes, dances for a moment or so naked before the lights switch off. The acts *have* changed, and also their presentation, but stripping in the old literal sense is still an important part of them. But if these acts have changed, how have they changed, and what do the variations signify? Why do the sexual fantasies in Genet's *The Balcony* now seem out of date? Why would Paul Raymond be unwilling to stage them? All the answers lie not simply in the strip clubs but in the changing patterns of social behaviour, of which the history of the clubs is just one manifestation.

A country has not only the government but also the strip clubs it deserves. And the strip clubs which sprouted up like mushrooms overnight in London during the late 1950s were as representative of a certain climate of feeling in Britain as football or the Cambridge Union. In making this assertion I am not indulging in chauvinism in reverse, nor am I trying to share John Osborne's attitude in *The Entertainer* (1957) that the tatty nude revues of the 1950s represented a nation in decline. There has never seemed to me anything particularly shameful about the Soho clubs: not "a national scandal" as one paper described them – nor even particularly decadent, except perhaps in the lack of talent. But there was something recognizably British about the way in which these clubs came into being, the type of product they present and their evolution over the past fifteen years – something which distinguishes them both from the old burlesques in New York and the spectacular revues in Paris, and from the newer strip clubs on the continent, in the Reeperbahn in Hamburg or Copenhagen. American burlesque (as its name implies) suggests a send-up of sex, reflected in the slow, bouncy, heavily suggestive music, the

athletic bumps and grinds, the infinitely prolonged strip starting with the glove and ending with the bra, but not the G-string. The strip clubs in London were more shamefaced, furtive and introvert. The girls went "a little further" than those in New York and apparently enjoyed themselves less. Tempest Storm, an American stripper, was disgusted that the girls at the Raymond Revuebar in 1960 wore no G-strings and walked out of the show. Paul Raymond had great difficulty in improving the image of stripping, even going the extent of banning rugger club outings and stopping matinées to which catered (profitably) to the macintosh brigade. London managers imitated but could not match the splendour of the Parisian revues, sequins like grains of sand, miles of synthetic fur, chorus lines of fifty girls or more. Nor have I seen in London the deliberately disgusting acts – women wrestling in mud, real whippings as opposed to rather badly mimed ones, or that act which was at one time apparently to be seen in Hamburg where a naked girl lies down on the stage and a pig is slaughtered over her. Audience-involvement acts, where men from the audience are invited up on the stage to be brought to orgasm by the showgirls, would be prosecuted by the police in London: the theatre manager would be accused of running a disorderly house. A correspondent to *Penthouse* wrote of her experiences in the Paderborn district (of Germany) where she was a showgirl in a club:

> The keynote of this particular club was audience participation. I was handcuffed to a chain that dangled from a low ceiling and my legs were then locked to another chain of similar length, so that I was strung up like an animal. I was wearing stockings, shoes, and a corselet that exposed my breasts, but between my legs I was entirely uncovered. The audience, once I was suspended in this manner, was then invited to lick me. Sometimes there were 40 or 50 men present, all types and ages – I had no choice in the matter. I can remember to this day the mixed feeling of intense sexual arousal and shame I felt as all those strange faces buried themselves in my pubic hair and those tongues that I had never even kissed squashed into my body.

Nor has London yet seen those twice-nightly copulations which are popular in Copenhagen. At the Vesterbro Club, huge profits and full houses have been reported because the couple who perform there are so remarkably expert – a skill acquired, so the publicity states, from their marriage. The stage manager explained:

They are more than just professional – they are really passionate. The whole thing is real, alive, not just an act like most other shows in this country. I've never seen such screwing. It may not go on as long as other couples in other clubs, but God while it lasts, they really fuck. My only job now as stage manager and general effects man is to put them in the right place in bed to start with. I don't have to fade the lights anymore when the couple don't climax or when the bloke simply doesn't manage an erection.

The strip clubs in Soho belonged to a different tradition altogether, one which could be traced back through the nude touring revues of the early 1950s, to the Windmill of the 1930s, to the "poses plastiques" – and was based on the precept that a girl could make a little money and her manager a lot by doing virtually nothing in a dark room.

The clubs were originally formed to explore not exactly a loop-hole in the law, but an area where two quite separate legal principles met but did not quite overlap. The touring revues were subject to various controls, particularly through the local authority of which the old London County Council was not a particularly broadminded example. The LCC byelaws forbade all forms of striptease "involving the removal of clothing while the performer (including a performer whose movements or a reflection of whose movements can be seen by the audience through or on a mirror, translucent screen or similar device) is within view of the audience". In Cambridge, the authorities were more lenient: strippers were allowed to undress to a G-string, or completely undress behind a translucent screen. The variable interpretations by local authorities set considerable problems for promoters of touring nude revues, such as Paul Raymond. What was acceptable in one town would be challenged in the next. There was a general understanding that a girl could pose naked (in the tradition of the Windmill), though with no pubic hair or sign of movement. One poor stripper saw a mouse, ran off stage and was prosecuted. In some towns, a girl could move with a G-string, in others a G-string and bra, in others still with strategic stars. Phyllis Dixey, who toured the halls as a stripper for years (until she was over fifty and cracking jokes on stage about her age) was prosecuted in 1956 in Northampton. She managed to secure an acquittal on the grounds that she was wearing a flesh-coloured G-string measuring 3 in. by 4 in. Others were not so lucky. Jane (Christabelle Leighton-Porter) was ordered to wear clothes in Wigan – which was a restriction for a stripper. Managers, fed up with these perverse regulations, looked for

alternatives. They found them in the concept of theatre clubs, which were "private" – that is, open only to members who had paid their subscriptions and been nominated. A club in law was considered a sort of home, and an Englishman's home is his castle. Two principles (unwritten) of law collided – the preservation of public decency and the protection of the privacy of the home, and in the shadowy area between them the theatre clubs thrived, subject only to the controls of liquor sales and restrictions against disorderly houses.

In any other genre of theatre during the 1950s, the obstacles placed before the public in attending strip clubs would have proved disastrous. The theatre was generally suffering from the challenge of television. The Arts Council gloomily reported in its annual surveys the decline of provincial theatre. At a time of general decline, when you could buy a seat at a West End musical for 5s or 7s 6d, the client at a strip club had to pay £1 for general membership and 15s for his ticket to a show. Nor could he simply buy a ticket at the box office. He had to wait for twenty-four hours before his membership was ratified. Club owners found ways round the restrictions – by admitting people as "guests", but then they ran into trouble if the "guests" tried to buy drinks at the bar. There was also a social ostracism which may have been a deterrent. It was reflected in the seediness of the environment, the touts and the photographs by the door. The very appearance of the clubs reeked of shame, as if conceding the Puritan case against them in advance. And clearly it was a struggle for some members of the audience to overcome their inhibitions to attend. "If a culture encourages or values a form of self-expression, be it homosexuality or excessive prudery – all those will show it who can: in a culture which discourages it, only those will show it who must." Official culture in Britain had set its face firmly against strip clubs and nude revues, but there were enough people who needed to defy the culture to make the enterprises commercially worth while. This palpable need had already been reflected in the commercial success of the touring nude revues. In 1951, Paul Raymond arrived in London with 1s 6d in his pocket. He borrowed a little money (£25) and started his first revue company. By 1956, he was running ten companies and on the road to his first million.

The first strip clubs in London – the Irving (1956), Raymond Revuebar (1958) and the Casino de Paris (1958) – followed the pattern of the nude revues, deviating only in the fact that the girls now moved. There would be a comedian-compère, such as Bob

Grey, a small band, patter-songs which the girls actually sang, usually daring words to well-known tunes, set ballet-type routines such as those performed by Renée and Teddy la Staire, and several striptease acts. Although the official culture may have been against them, the strip clubs did not lack good, high-minded advocates. It was felt that the moving nudes of strip clubs were an advance on the static nudes of revues. One feature common to most liberal and illiberal books about sex in the late 1950s (and perhaps deriving from the existentialist's definition of sadism) was that women should not be regarded as mere objects of the male will. The laws concerning static nakedness exactly illustrated the idea of "object-ness". The girls were there to be stared at. The leaden smiles and cold poses were a throwback in feeling to the time when Acton denied that decent women could have any pleasure from sex at all. To many people, static nudes were more objectionable than the moving kind – a point of view which neatly coincided with the interests of someone like Paul Raymond, who in his touring shows had to use all his ingenuity to invent situations in which nudes could look interesting: he put them in lions' dens, on revolving stages, under waterfalls, even *in* ice. The clubs secured more freedom for the promoters and won the qualified approval of Bamber Gascoigne and his fellow critics on the BBC's *The Critics*. But despite the movement, the girls still tended to be used like objects. Bob Grey at the Revuebar, a grey-haired tough-minded father figure, introduced an act in which the girls of the chorus would parade naked around the stage and then line up behind a screen with only their bottoms showing. The audience then had to guess which girl possessed which bottom. Or he would invite the audience to play strip dice, where the number of dots indicated the girl from the chorus who would have to strip, and another throw of the dice, her garment to discard. Paul Raymond also ran an Amateur Striptease Competition.

By the late 1960s the compère had gone – together with the competitions and games, the band, the patter songs and the chorus lines. Nothing was allowed to come between the stripper and her audience: she was in control.

The Revuebar and the Casino were, and are, well-run places. But in their wake were a number of less pretentious clubs, where the men would sidle hurriedly through doors hung with beads, hasten down a narrow corridor leading to a small room with a pocket-handkerchief stage. Most strip clubs were like dark cupboards through whose keyholes one peeped to see a girl undressing. One

club is actually called the Keyhole – another Peeporama. The clubs
not only provided an alternative to the restrictions of the world
outside – here girls were "naked" and they "danced" – but they
also exactly reflected the prejudices that a man could only witness
these intimacies through a crack in the curtain or an unmasked
window. All theatre audiences are voyeurs in the sense that they
are observers of a situation which is not of their creation, but strip-
club audiences were constantly being reminded that they were
voyeurs, which gave a different emphasis. The announcer over the
crackling loudspeaker would introduce the act: "And now the very
lovely Denise in her New York penthouse apartment dreams about
her lost lover and goes to bed only to be tormented by a frenzy of
sexual longing." And so the girl would slowly undress, put on a
baby-doll nightie, mime sexual frustration usually by massaging
her breasts and vagina, and finally writhe on the bed – before tepid
applause. The applause was half-hearted not just because the act
was abysmal, but because the audience was belatedly reminded
that they were known to be there. The pretence that they were
hidden observers had gone. Within this atmosphere it would have
been difficult for the best act to arouse extrovert enthusiasm, but in
any case, the nature of the product worked against any concept of
skill, intelligence or achievement. Most strip clubs simply provided
for men ignorant about the behaviour of women a peep behind the
scenes – male chauvinist versions of how women might behave
when they were not around. The very lovely Denise would be
followed by the adorable Giselle the Bride awaiting her groom
in the honeymoon suite and Cleopatra taking a bath in asses'
milk.

If the needs had been less strident, this combination of over-
selling, mock-history and tawdriness would have killed the clubs
from sheer ridiculousness. But they survived, and managements
learnt to bring some variety into a limited scene by ringing the
changes of fetishism. One girl would be dressed as a schoolgirl,
another in corsets and black boots, a third as a demi-mondaine
from La Belle Epoque. This fetishism rarely went beyond a
costume and a prop – the girl in jodhpurs and carrying a whip did
not act the termagant she was supposed to be. She would throw
the crop away, take off the jodhpurs and walk around like all the
other girls, bend over a bed to give the customers a good view of
her backside, writhe a bit and take her bow. Perhaps the real
decadence of these clubs lay not with the acts themselves or their
tentative deviations, but with their sheer half-heartedness: the

audiences who did not complain while they were being conned; the managements who were determined apparently to prick the bubble of sexual fantasy as it was about to soar; the girls who did their eight-minute strip, hurried off stage, packed their records in BOAC bags and hastened off to the next club and the next timid uncomplaining bunch of suckers.

This sleaziness mirrored social attitudes towards male sexual fantasies: that they were sordid, things to be kept to oneself, the product of dirty minds and dissatisfied bodies. The myth predominated that strip clubs were for lonely old men, who could not receive satisfaction any other way. The audiences in fact belonged to a wide cross-section of age and class groups, though nearly all men. But the legend was so forcibly maintained that people seemed almost physically to change as they sidled through the doorways. The young well-dressed man, full of self-confidence in Oxford Street, would hunch his shoulders, turn his collar up and seem physically smaller when he paid for his ticket to a strip club in Brewer Street. Some promoters, distinguished perhaps by a greater commercial aggression as well as sophistication, were aware that this surrounding atmosphere of shame boded ill for the genre. They took steps to alter the image. When Raymond opened his Revuebar in 1958, the doorway was almost a cartoon of all seedy stripclubs – flamboyantly sleazy, garish, in fairground colours like a small-time booth. But once inside, the visitor would find himself in an easy, rather opulent-looking interior with deep carpets, an impressive chandelier and well-stocked bars. The stage too was well-designed: proscenium-arch, with an extended forestage, good lighting, front and back projection, slick curtains – a model for small revue theatres. In 1960, Paul Raymond drastically changed the outside appearance of the club, confident that his public were now prepared to abandon their old furtiveness. He opened out the foyer giving the doorway glass panels, so that the public could be seen buying their tickets and leaving their coats in the cloakroom.

This was when, significantly enough, he first ran into major trouble with the police. There had been minor problems before. Scarcely had the Revuebar opened before a plain-clothes policeman had tried to buy a lager at the bar carrying only a temporary membership card to secure a conviction on the grounds of a breach of the licensing laws. But when Paul Raymond altered the outside appearance of the club the real trouble began. The police brought a prosecution against him for running a disorderly house, but they produced no evidence that the girls fraternized with the

clients and they conceded that the club was well run. Their evidence was provided by the acts themselves: Bonny Bell the Ding Dong Gel, who wore dangling bells on her breasts which she invited members of the audience to ring; Les Batix, an adagio whip act; an act with a snake. "Filthy – disgusting – beastly," declared the magistrate, R. E. Seaton, when he fined Paul Raymond £5,000. But it would have been hard to prove that these acts were significantly worse than those staged elsewhere. There were other clubs in London which were blatantly shop windows for brothels. Why did the police select a comparatively well-run club to provide a test case over two years after it had opened? My own opinion is that the Revuebar was the first club not to confess its guilt in advance by showing a proper sense of shame. "If we let this go through [the police must have thought] they'll all be doing it – quite openly!"

The police in a sense were right, not to bring the prosecution, but in their instinctive realization that the private world of the strip clubs had suddenly gone public. And if men no longer felt *ashamed* of their fantasies, what might the consequences be? Would all that masturbatory kinkiness start to permeate social life as well? Paul Raymond lost the immediate battle, but did he perhaps win the war? In the years immediately following the Revuebar prosecution (1961–2), strip clubs were marginally more restrained in their presentation of sexual fantasies. The audience participation numbers of the old Revuebar – Bonny Bell, Bob Grey and strip dice – were replaced by acts which were simply to be watched. Paul Raymond came to dislike audience-participation numbers in any case because they slow down a show. At the same time, the atmosphere in many strip clubs altered. Instead of rows of gloomy seats, dim light and long narrow corridors, clubs such as the Casino de Paris installed tables by the stage where men could sit and drink and be served by waitresses in brief leotards and long fish-net stockings, sometimes with bunny tails, like the girls in the Playboy restaurant. It was still a world for the male chauvinist, but it was a more comfortable one. As men lost some of their oppressive guilt, they started to bring along on occasions their girl-friends – perhaps to the late show at the Revuebar, where they would sit in an atmosphere of pleasant erotic stimulation, preparing for the night to come. The girls in the strip acts of the late 1950s – like the prostitutes in Genet's *The Balcony* – gave the appearance of doing what they were told. They paraded round the stage wearing fixed smiles and nothing else. The strippers of the late 1960s were prepared to

play with the expectations of their audiences, being coy one moment, severe the next so that one single fantasy was not hammed up for ten minutes, to be replaced by another girl and another fantasy. The acts contained greater variety of effects within them, and thus came somewhat closer to ordinary sexual behaviour where lovers may pretend to withhold, then to "submit", to kiss, to slap, to bite, to embrace. There were other differences as well. Teddy la Staire in the 1950s and early 1960s usually wore a flesh-coloured G-string, while Renée was naked. By the end of the 1960s, the male partners were as naked as the female ones. And, above all, the climaxes of the acts were usually presented as female orgasms, extreme ones, heightened by strobe lighting. Thus the possibilities of female sexual pleasure took their place as part of male sexual fantasies. Wedekind, the dramatist at the turn of the century who most championed the rights of women to sexual fulfilment, still seemed to regard female erotic pleasure in terms of sacrifice: they were longing to be "slaughtered on the sacrificial altar of sensual pleasure". It was a form of abandonment, of letting men have their own way, a simulated death whose guiding image was real death by stabbing. The orgasms in strip acts of the late 1960s were not stabbings, they were simulated orgasms. The women were not passive, they were apparently enjoying themselves. They were not abandoned, they were excited. There were of course stabbing acts, scenes of jealous quarrels between lovers which ended in violence. But the difference lay in that stabbing was no longer a synonym, a misguided euphemism, perhaps, for fucking. It belonged to a different emotion – of rage and hatred, rather than love.

Paul Raymond, when he altered the design of the Revuebar, challenged the assumption that the middle classes were expected to slum when they went to see strip. He was prosecuted for letting the middle-class side down. Stripping was no longer the profession for the layabout lower classes who would do anything for money. He changed the atmosphere of strip clubs and, by so doing, altered the style of the product – and also perhaps the sexual fantasies for which they catered. He also improved the standards of management, paying the girls good salaries, protecting them from harassment by over-eager clients and thus raising the level of self-esteem among strippers. In 1971, the show at the Revuebar presented a strange paradox: five of the twelve acts used, as part of the props, sleazy doorways with dangling beads. Slumming had come out of the streets and into the theatre where it belongs.

I am seeing life with a vengance he muttered to
himself as he paid his bill . . .
(Daisy Ashford: *The Young Visiters*

If Paul Raymond's main achievement during the 1960s was to
alter the class image of strip, his example was followed rapidly by
others. In 1968 the office of the Lord Chamberlain's Examiner of
Plays was formally abolished, and managements started to con-
sider the opportunities of the new freedom. One was that within the
limits of the infinitely interpretable laws on obscenity, public
productions could now present scenes involving naked actors and
actresses. The censor had paved the way for such a change by
allowing certain previously banned glimpses of nudity to be seen
in the plays of the early 1960s, such as the scene in the Murdoch/
Priestley play, *A Severed Head*, where the formidable doctor,
Honor Klein, is seen in bed with her brother, a psychiatrist, and
hastily covers her naked breasts. In 1968, the Royal Shakespeare
Company's production of Marlowe's *Dr Faustus* featured a naked
Helen of Troy, and in the same year *Fortune and Men's Eyes*, that
fierce and strident study of homosexuality in American prisons,
moved from the Open Space theatre club to the Comedy Theatre.
In general, West End managements treated this new-found freedom
with caution – the nakedness in *Abelard and Héloise* is concealed
by dim lighting. But there were two areas of theatre where this
restraint was intentionally lacking, where all the old taboos were
defied as openly as possible. They were the "underground"
theatre movement which quickly came to the surface in the mid-
sixties, and those productions which in some ways followed Paul
Raymond's example by providing erotic entertainment for swing-
ing middle-class couples. Middle class are awkward words. They
can still just be used sociologically to mean a certain income
group, life style or educational background. They have acquired
some pejorative meanings. I am middle class, but when I use
the expression I tend to think of someone like Mr Salteena
in *The Young Visiters*, who is determined to be well-spoken
and well thought of and to "see life with a vengeance". It is a
state of mind which everyone shares from time to time, even
Brecht, who so disliked the bourgeois tendencies of the East
German régime. Kenneth Tynan once described the origins of
Oh! Calcutta! in language which seems to me quintessentially
middle class:

Some time ago, it occurred to me that there was no place for a civilized
man to take a civilized woman to spend an evening of civilized erotic
stimulation.

<div align="right">(The Village Voice)</div>

The repetition of *civilized* has two effects: it reminds the reader
that erotic stimulation *can* be civilized but that Kenneth Tynan
does not have those scruffy little strip clubs in mind. But there is
also a trace of old-fashioned male chauvinism which trips the idea
up – for the civilized man *takes* the civilized woman. In other
words, he is not objecting to the scruffy strip clubs for their male
chauvinism, but for their scruffiness. Paul Raymond had a clear
idea of how to civilize strip clubs – he installed chandeliers, thick
carpets, glass windows and a décor reminiscent of the expensive
section in Lyons Corner House. What did Kenneth Tynan mean
by civilized?

Firstly, as befitted the dramaturg of the National Theatre, he
wanted *Oh! Calcutta!* to be well written, well designed and with
good light music. The dramatists who wrote sketches for *Oh!
Calcutta!* included Joe Orton and Sam Shepard. Johnny Dank-
worth was musical adviser and Allen Jones designed some cost-
umes. Clifford Williams was the director. Kenneth Tynan's first
achievement with *Oh! Calcutta!* was to bring together a very
talented and well-known team to write the revue. No revue in
London since the early 1950s has had such a team. It was also a
show which, both in its conception and intended impact, was
designed to appeal to audiences on both sides of the Atlantic. It
opened in New York in June, 1969, and transferred to the Royalty
in London the following year. It was therefore trans-Atlantically
civilized and deliberately not parochial. *Oh! Calcutta!* was also in
"good taste" – but this of course does not mean "proper". It was
filled with language and sketches which many would regard as in
the worst possible taste. But it was presented with style and pro-
fessionalism, with an eye for the telling effect – Madison Avenue
"good taste". And although its reception by the critics was
mixed, *Oh! Calcutta!* found the market which Kenneth Tynan
intended for it. After the initial *succès de scandale*, it settled down
in New York and London to long runs and coach-trade audiences.

To call a successful show a "disaster" always threatens a critic
with the charge of effeteness: and perhaps "disaster" is too absolute
a word for *Oh! Calcutta!*. It was comparatively better than the
shows at the Revuebar or the other pornographic plays in London,

Pyjama Tops and *The Council of Love*. But the expectations aroused by the names associated with *Oh! Calcutta!* mean that any other word seems too weak to convey the sense of complete disappointment, the knowledge that a good idea has somehow totally misfired. The problems partly lay in the unevenness of the script – the jumble of styles provided by the sketches, none of which lasted long enough for one to be aware of anything more than the idiosyncrasies of the author. One thoughtful mono- logue, "Who: Whom", about the difference between girls who are victims and those who passively submit to being victims and by their submission co-operate, was followed by a banal docu- mentary about knickers. Joe Orton's amusing sketch, "Until She Screams", about the terrible behaviour of a tea-bound family in the Home Counties, was ruined because his "shocking" lines, 'I couldn't come, Eliza – so I pee-ed up your yoni" – followed several other sketches, which also set out to shock and did so more crudely. The two lyrical numbers – the song "To His Mistress Going To Bed" and the *pas de deux* "One on One" – seemed within this context tritely sentimental. The revue formula also seemed a poor one, as if each writer had been set a holiday task, "Produce an erotic sketch of not more than ten minutes," and all the results had been packaged into one show. The revue was not "through-composed". But despite this mixture, there was an underlying sameness and lack of variety. How was this so? To begin with, all the writers seemed to have the same ideas as to what eroticism meant. It meant fellatio, cunnilingus, sado- masochism, groupies, fetishism, masturbation and the Anguish of Young Love. It was as if all the erotic ideas had been zealously culled from the correspondence columns of *Forum* magazine, *Playboy* and *Penthouse*, read with an innocent delight in other people's sexual problems. Chief among these problems were the male ones of coming too quickly or not coming at all. Three of the fourteen sketches were about men who wanted to, but could not at the proper time. The women were always willing. Despite the fact that *Oh! Calcutta!* was intended for enlightened couples, nearly all the fantasies, except perhaps the *pas de deux*, were male ones – chauvinist males at that. The show might have been designed to prove the Christian point that sex outside marriage is promiscuous, for in every sketch, eroticism was separate from relationships. Women were there to be fucked, men were around to fuck them if they could. It was almost as simple-minded as that. Covering over this catalogue of sexual technique was a bland good humour, which

had the effect of rubbing out all the emotions of sex and nearly all the wit. It was like being buttonholed by the Word Bird in Gavin Ewart's cycle of poems, *Eight Awful Animals*, who knows that everyone in Britain is frightened by words and so he flies up to a great height and drops them on people "like turds". The Word Bird is a condescending animal: he believes that everyone is more prudish than they have any right to be. And something of this condescension emerges in Kenneth Tynan's remarks about *Oh! Calcutta!*

> We're asking [the audience] to respond in public to things which they usually respond to in private. There is no theatrical consensus yet as to how to respond to sex; no one knows how he feels about watching people make love. So every night we have an experimental laboratory in people's reactions to sex on stage.

Unfortunately we do not see sex on stage in *Oh! Calcutta!*: we see sex through the eyes of a man's magazine on the stage, and even then, as Clive Barnes remarked, it is the sort of stuff "which gives pornography a bad name".

All these criticisms ultimately home on Kenneth Tynan's use of the word *civilized*. The question raised by the Raymond Revuebar, *Oh! Calcutta!* and, to a lesser extent, *Pyjama Tops*, the French farce currently running at the Whitehall Theatre where all the girls strip and dive into a swimming-bath, is this: is it possible to raise the class associations of pornographic theatre without radically altering its content? Why did the middle classes feel guilty when they visited strip clubs in the 1950s or brothels in the nineteenth century? Partly because they were prudes, no doubt – but also because the realization of their fantasies involved a certain class and sexual exploitation. Normally in the theatre, directors, writers, actors and actresses want to create something which both excites them and is likely to attract an audience. The unspoken dialogue in a theatre comes from two directions, from the stage and from the audience. Are you interested in this? Yes, we are – or No, we are not. There was no dialogue in the strip clubs of the 1950s, for in general the girls were not interested in what they were doing – they were simply around to realize as best they could the sexual fantasies of their clients. For this reason there was a feeling of exploitation – a two-way exploitation, for the girls were around to do what they were told and they did as little as they could to earn their wages and bring the audiences in. Male sexual fantasies

originally depended for their realization upon slumming because few men were inwardly convinced that girls could be found who might actually enjoy sharing their pleasures. This involved class exploitation, for you could only effectively buy someone whom you regarded as needing the money. But by trying to raise the class level of pornography, you effectively destroy the only reason why women should open their legs when you want them to – other than mutual pleasure, which implies a relationship. Pornography is intolerant of relationships, which it associates with the ennuis and responsibilities of marriage. And therefore in pornographic theatre, where there has been an attempt to alter the class associations, a myth has to be invented to replace the old economic submission of women to men in fucking. This myth is that all women crave to be fucked all the time, that they are always raring to go – although they may pretend to be coy – and that a man can therefore do what he likes with them. The old reason why some women would automatically submit to a man's pleasure had a basis in observable fact: women could be bought because the social conditions were such that they often needed the money. The new reason is an observable fiction. All women do not want to submit to a man when he says so. *Oh! Calcutta!* is old pornography in that it is designed mainly for one sex and has little to do with relationships. As such, it underlined the inherent contradictions of pornography in an age which frowns on class exploitation.

10

The Future Past

During the 1960s, it was not always easy to distinguish the "underground" theatre from the "*avant-garde*" or the "experimental". The problem was partly one of linguistics. Despairing of a polite adjective other than "hippy" (overworked) or "underground" (vague) to describe, say, the Living Theatre, journalists picked up the word *avant-garde*, twisted it into a helpful shape and from then on talked about the company as an "*avant-garde*, experimental theatre commune of underground hippies", or re-arrangements to that effect. This pioneering image was not resented by the companies themselves, for nobody dislikes being thought in the forefront of something. Pierre Biner, a member of the re-formed Living Theatre, wrote to *Time Out* from South America:

> [we] are on the verge of totally new aesthetics and language . . . The re-birth has started and we are led by poetry, visions, beauty and the belief that what we want to achieve is possible and Has to Be Done.

These conclusions were reached after a prolonged wordless demonstration in a village square against man's inhumanity to man. Peter Brook, writing about the Theatre of Cruelty evenings at LAMDA in 1964, described the shock caused by Glenda Jackson when (as Christine Keeler) she stripped, climbed into a bath and then (as Jackie Kennedy) re-emerged, the grief-stricken heroine:

> A new tension came into the evening, because the unexpected now might have no bounds . . .

The Theatre of Cruelty production was interesting, sometimes disturbing, and contained theatrical curiosities which we are unlikely to see again. It was also experimental in the sense that Peter Brook was trying out techniques which he afterwards used

in his splendid production of Peter Weiss's play, *The Persecution and Assassination of Marat as Performed by the Inmates of the Asylum of Charenton under the Direction of the Marquis de Sade*: hereafter called *Marat/Sade*. The one adjective which cannot be used to describe the Theatre of Cruelty evening is, however, *unexpected*. We in the audience came expecting shock tactics, and if the evening had been truly unexpected, we would not have come at all: we would not have known what to expect. The surrounding press publicity explained that the title derived from Artaud's stimulating theatre tract, *Le Théâtre et son Double* (1938), and those of us who knew a little of Artaud's writings, were curious to see what Peter Brook and Charles Marowitz would make of his theories. We were also offered an invaluable insight into production methods of a section of the Royal Shakespeare Company, the best ensemble in the country. If, after all this, we had seen *French without Tears*, that would have been unexpected. If the evening had not given us a passable imitation of the *avant-garde*, we would have demanded our money back.

For – even in the early 1960s – we had a clear picture as to what the *avant-garde* looked like. It was politically left wing, quick to shock all standards of sexual propriety, iconoclastic, determined to shatter our ideas about well-made plays, proscenium arches and stylized acting, fond of improvisation and "total theatre", distrustful of formal logic and its expression in logical plots and logical dialogue, and choosing instead the associative logic of dreams. It liked ritual of a primitive and oriental nature but not, of course, the ritual of the Catholic Mass, which was used only to point out its cannibalistic origins. If we examine this picture of the *avant-garde* closely, we must realize that these ideas have been with us for many years, though not perhaps finding their proper place in the West End or Broadway. Alfred Jarry, the father of Pataphysics and Dadaism, died in 1907 and Antonin Artaud in 1948. And it would be easy to trace many of their ideas back even farther, to the origins of the Romantic movement – in Britain, to William Blake. Anyone who found the Theatre of Cruelty evening at LAMDA unexpected had only himself to blame. What he might have found confusing, however, was the way in which so many different theories and technical possibilities (each of which had been with us for some time and had failed to develop into an interesting art form) had suddenly slid to the bottom of the crucible, where they melted and fused together, gold with the lead, in one hard lump of *avant-gardisme*.

The Theatre of Cruelty evening began with a short improvisation session, in which the actors were asked to make up short scenes on sentences suggested by the director and members of the audience. These sketches were imitative of the dialogue scenes in ordinary proscenium-arch drama and on television, and the only thing that was *avant-garde* about them was that they were made up on the spur of the moment. The company were apparently trying to prove that formally written scripts could be done away with: but they succeeded in proving the exact opposite – that actors trained in a literary tradition aimed for literary effects (gags and double-takes) when they tried to improvise. They brought no new insights to bear on the processes of drama. This session was then followed by a short lecture on the theories of Artaud, which particularly emphasized his distaste for verbal dialogue and his longing for another type of theatre altogether, one which relied on mime, ritual, shock images and non-verbal sounds to produce effects which by-passed the conscious interfering brain:

> The theatre will never find itself again – i.e. constitute a means of true illusion – except by furnishing the spectator with the truthful precipitates of dreams, in which his taste for crime, his erotic obsessions, his savagery, his chimeras, his utopian sense of life and matter, even his cannibalism, pour out on a level not counterfeit and illusory, but interior.

The company then illustrated his theories by performing his short play, *A Spurt of Blood*, where Artaud presents a prostitute beneath whose skirts lies a nest of scorpions – and a man who bites the Arm of God to fill the stage with a torrent of blood. Artaud was a particularly tormented man. He suffered from various nervous disorders which were exaggerated by drug-taking. His interior life was therefore charged with nightmares, and since our only images of other people's spiritual lives are conditioned by our own experiences, he assumed that the emotions of others were as overwrought as his own – that beneath the façade of social behaviour, there were teeming instincts of violence and anarchy. This may be so: but it is not an assumption which we should pass unchallenged. *Avant-garde* theatre, influenced by Artaud, often presents the human unconscious as if it were Artaud's unconscious and this in time feeds back into our images of normal human behaviour. An actress once explained to me with great sincerity that she thought she was singularly neurotic because she was not having the nightmares which Artaud talks about: she was so mixed-up that she

was suppressing them! Following *A Spurt of Blood* in the Theatre of Cruelty evening, there came a short polemical piece by John Arden about the ways in which fascist societies condition human behaviour, a short extract from a longer play, which involved farting and shitting, and several satirical sketches. One of these caused a minor scandal for it associated Christine Keeler, the call-girl in the John Profumo scandal, with Jackie Kennedy after the assassination of her husband. The point of the sketch was that both women were equally being crucified by the publicity given to their private tragedies – both were victims of public prurience and the confused standards of the times.

Should we have called that production (as we did) *avant-garde*? Obviously not. The word retains some of the jingoism of its military origins. The *avant-garde* artist seeks to attack establishment art and to be the forerunner of a movement which will replace the old standards with better ones. The *Lyrical Ballads*, *The Love Song of J. Alfred Prufrock* and *Les Demoiselles d' Avignon* were all in their times *avant-garde* works because Wordsworth, Eliot and Picasso were each attacking firmly held conventions and proclaimed alternative ones which in due course won an army of admirers. The Theatre of Cruelty evening was iconoclastic in stance, but the idols it was trying to shatter – the set text, the tyranny of reason, authoritarian government – had been bashed around systematically for at least sixty years. Nor did it express any coherent alternative beyond those theories expressed twenty-five years before by Artaud, which were vague enough in their original form. Peter Brook simplified these theories still more by interpreting them as shock tactics: "immediate and violent subjective experiences", not the "truthful precipitates of dreams". In his introduction to the English version of Peter Weiss's *Marat/ Sade*, he welcomes the way in which Weiss reconciled the intellectual detachment of Brecht with the physical sensationalism of Artaud:

> Everything about his play is designed to crack the spectator on the jaw, then douse him with ice-cold water, then force him intelligently to assess what has happened to him, then give him a kick in the balls, then bring him to his senses again.

It sounds like a particularly crude attempt at brainwashing. In welcoming this "reconciliation", Peter Brook pulled the tangle of incompatibles into a tighter knot and the confused result (though

less muddled in his own productions) became a model for other companies and directors whose idea of shock was genitals and shouting, of political theory – pretentious slogans, of intelligence – contrariness, and whose chief defence against criticism lay in the blind assertion that they were being "experimental" or "*avant-garde*"; that is, not to be judged by normal criteria (which were dismissed as irrelevant) or by any criteria other than those outlined in the surrounding bumph. It is possible to argue that we live in an age without an *avant-garde* at all, since there exists in the West no set of artistic, cultural or social standards so sacrosanct that they are not constantly under attack nor any standards readily at hand to replace them. This situation does not bother me, as much as it seems to bother others, for I see no reason why we should accept common standards. "One law for an ox and a lion is oppression." But it does question the importance – even the existence – of an *avant-garde*.

Underground theatre in general has been so valuable a feature of our recent culture that it was particularly sad to watch its merits slowly being buried beneath facile *avant-gardisme*, and as a first step towards disinterring them perhaps we should consider the use of a new tense: the Future Past. The Future Past can be used for all those theatrical events which are so *avant-garde* as to be positively old-fashioned. Thus: "the main feature at this year's — Festival *will been* the first all-queer production of *Romeo and Juliet*. Director — — shall conceived the tragedy as an allegory directly concerning the Gay Liberation movement, with the two houses of Montague and Capulet representing male and female chauvinism." The Future Past must obviously be distinguished from the Past Future, another useful and little known tense, which can be used for all productions so old-fashioned as to be positively *avant-garde*. Thus: "a production of Ibsen's controversial play *Ghosts* had be the last in a reason of contemporary plays presented at the — Rep." This solution would, I am sure, solve many problems at a time when the word *avant-garde* is used by the management at the Casino de Paris to mean men and women stripping together.

Central to the *avant-garde* confusion is an associative leap whose origins can be traced back two hundred years to the beginnings of the Romantic movement and to William Blake. Blake related the tyranny of authoritarian government (George III versus the colonies in America) with the tyranny of reason over the emotions,

custom over the liberating spirit of artistic and sexual creativity, formal art over the inspirational. This imaginative association of all he disliked – from the Industrial Revolution to the behaviour of nannies – gradually gathered admirers during the course of the century so that by the early 1900s there were many who would assert that, say, wars were caused by the suppression of the sexual instinct. As the teachings of Freud became popular in the 1920s and 1930s, these associations were given the confirmatory gloss of a science so that art was held to be the expression of the libido (which was composed mainly of sexual instincts) and bad art derived from the suppression of the libido. Equally, bad government, social customs and taboos, marriage, the Church, repressive laws, necessary but unpleasant laws, and ordinary self-discipline were all lumped together as forces hostile to the libido: until now there is an easy free-flowing, non-logic which cheerfully shifts from an attack on one area of custom to another. Judith Malina (the wife of Julian Beck and a founder-member of the Living Theatre) *will spoken* from the stage of the Brooklyn Academy in New York in 1968:

> I demand everything! Total love, an end to all forms of violence and cruelty such as money, hunger, prisons, people doing work they hate. We can have tractors and food and joy. I demand it now.

And she *shall led* the audience out into the streets, naked in protest.

This associative logic has become a bad habit. When Lenny Bruce confided to night-club audiences that Eleanor Roosevelt gave VD to Chiang Kai-shek (hence the leggings) – or when the actors in *Viet Rock* sang:

> I got syphilis today,
> Courtesy of LBJ.

or *Private Eye*, the British satirical magazine, asserted that if Lord Hailsham and Sir Alec Douglas-Home were laid side by side, they would be forced to resign, it seemed funny and we may still laugh. But it is an easy laugh because for many years we have associated authority with sexual problems. We are amused partly because this association of politicians with sex cuts them down to size. But why are we amused? Are our images of authority still so surrounded by cant that we secretly suppose them to be above "that sort of thing"? Are our reactions to sex still so puritanical that sex

automatically becomes a form of debasement? When Julian Beck
accused the audience during the Living Theatre's *Paradise Now*
for being "mother-fucking bourgeois intellectuals", his argument
was that the price of a theatre ticket would buy a meal for a starving
child. True enough – but why "mother-fucking"? Perhaps this
was the most insulting adjective that Julian Beck could think of on
the spur of the moment. He was, after all, improvising. Or was he
being subtler than we might suppose by suggesting that bourgeois
complacency derives from an undue attachment to the mother?
Whatever his reasons, there was a bewildering leap from the sexual
insult to the socio-political point: or, rather, it ought to be con-
fusing but we have somehow got used to it.

The underground theatre shared Blake's habit of linking every-
thing he disliked under the headline REPRESSION and everything
he liked under the banner FREEDOM, of which the chief symbol was
sexual freedom. Within this floppy framework much else could
be fitted: the theories of Artaud, political and social protests, Zen
Buddhism, the destruction of formal art, the interest in random
and chance events, the search for new ways of living together
(communes and extended family units as opposed to nuclear ones),
new relationships between the actor and audience, and so on.
Each of these elements contained their own confusions, which was
partly due to a poor appreciation of their historical origins. The
normal genealogy for the Theatre of the Absurd (of which the
Theatre of Cruelty is usually considered a part) runs something
like this:

> Alfred Jarry, eccentric Bohemian and Goon born out of his time,
> begat the Academy of Pataphysics, which begat Dadaism and the
> Anti-Art movement, which begat Surrealism, which begat the
> Theatre of the Absurd . . .

Unfortunately, not all these children faithfully reflected the habits
of their parents, and so the continuing tradition is really several
traditions, connected by a common attraction to nonsense. Jarry
was an irreverent anarchist, whose play, *Ubu Roi* (1896), shocked
Paris audiences with its anal good humour – the first word of the
play is "Shit!" – and burlesques of authority, particularly academic
authority. The Dadaists felt themselves to be in a graver situation
after the First World War, surrounded by symptoms of the col-
lapse of civilization. They rebelled against the tight mechanistic
logic of the nineteenth century – the logic which demanded a cause

for every effect and sometimes talked of God as the Great Watch-maker. Their form of nonsense not only reflected the breakdown of society, but also their desire to see that a rigid social system which could lead to such destruction would never be built again. They rejected scientific optimism. They enjoyed crashing in-compatibles together and listening to the shock. The exhibitions, poetry readings and cabarets staged by Tzara in Zurich and Berlin – where patterns of verbal logic were chopped up, where many events were staged at once and disparate images rammed side by side – exactly anticipated the Happenings movement in Britain and America during the 1950s and 1960s. The cup and saucer made of fur – a Dadaist image – foreshadowed Oldenburg's cloth type-writer. The Dadaists also launched an attack on classical art: a reproduction of Mona Lisa in Picabia's Review 391 had a mous-tache scrawled over it. They isolated single objects for contempla-tion – as Warhol did with Campbell's soup tins. In 1963, at a drama conference organized by the Edinburgh Festival, Charles Marowitz *will staged* a happening which was really a late Dadaist event. He went to the rostrum in all solemnity:

> ... I proposed an official interpretation of *Waiting for Godot* which when passed, would become standard and appear in the index of each printed edition. I suggested that the play – Christian and nihilistic interpretations notwithstanding – was in fact about the Negro problem in the Southern United States ... When the resolution became un-bearably preposterous, I was interrupted by a heckler planted in the audience. A bitter feud ensued. Gradually one became aware of the low throbbing sound of an organ and an electronic tape feeding back carefully edited excerpts from the week's discussion. Carroll Baker, who had been seated on the platform, took this as her cue to descend and began clambering over the seats ... Then a nude on a trolley was pulled across the balcony above the speaker's platform ... A group of strangers had appeared at the windows overhead hollering "Me: can you see me?" – and a mother ushered a baby across the stage pointing out the celebrities in the crowd. The final beat was when the curtain behind the speaker's platform suddenly tumbled to reveal rows of shelves containing over 100 sculpted heads, illuminated by footlights ...

Much was claimed for the Happenings movement. Peter Brook wrote that:

> A Happening can be anywhere, any time, of any duration: nothing is required, nothing is taboo. A Happening may be spontaneous, it may

be formal, it may be anarchistic, it can generate intoxicating energy. Behind the Happening is the shout Wake Up!

It could also of course generate the profound boredom in which anything can be done because nothing is worth doing. The weakness of both the early Dadaist exhibitions and the Happenings movement was that they were reactions against formal systems, undertaken at a time when the systems were also faced by more sophisticated attacks – hence, parasitical by nature and dependent on the logic they set out to destroy.

The Dadaists discovered that the apparently nonsensical association of ideas and objects might carry with it an emotional logic, similar to the correlations of dreams and nightmares. The Dadaist movement merged into surrealism, which concentrated on the associative logic of dreams. Dreams were considered to hold the key to the understanding of the unconscious. Despairing of human irrationality which led to such disasters as the First World War, artists in all the media – together with analysts, social scientists and teachers – came to believe that human behaviour was not governed by reason, but by the unconscious, whose mysterious processes could only be understood, and therefore anticipated, by an analysis of dreams.

It is, of course, impossible to be conscious of the unconscious. As soon as the unconscious becomes conscious, it ceases by definition to be unconscious. Sartre went to considerable lengths in *The Psychology of the Imagination* to disprove this fallacy: he distinguished between consciousness, and the consciousness of consciousness – thus doing away with the term unconscious altogether. The Surrealists sometimes failed to make the important distinction between the unconscious and the subconscious: and this in turn affected Artaud and the later interpretation of Artaud's theories. The unconscious was considered to be the formative processes of the mind, of which the individual must necessarily remain unaware because the mind which is attempting to understand the processes is also subject to these processes. It is like trying to see what makes you see. The subconscious is a term now rarely used by analysts, who consider it imprecise and unscientific. It was originally meant to refer to that area of the mind which contains suppressed longings and memories, feelings which the conscious mind refuses to acknowledge. The unconscious would include the sexual instinct as such; the subconscious, the suppressed desire to rape the Queen. The confusion between these terms

is important when we consider the theories of Artaud for the examples he gives would seem to belong to the subconscious: man's "taste for crime". Every individual, however, has a different subconscious in that his experience encourages him to suppress different experiences. But the unconscious lies beneath these environmental deviations. It is part of the processes of life itself. To confuse the unconscious with the subconscious is rather like confusing the river with the sunken boat. If we do make this confusion, we start to assume that the unconscious is composed of the longing for anti-social behaviour – that man's innermost processes are wicked, which is a suicidally gloomy idea. Artaud seemed to believe that all spectators are likely to have the same dreams, which might be true if the dreams came from the deep unconscious, but certainly would not apply to those images which were supposed to belong to the subconscious. The saddest confusion of all came when those influenced by Artaud tried to fill the theatre with violent and neurotic nightmares in the belief that all men deep down are like that. Perhaps Wilhelm Reich's most timely contribution to contemporary thought, apart from pointing out the latent Puritanism of the pre-war analysts, has been to assert the healthiness of innate instincts.

Within this single genealogy – Jarry to Artaud – there are therefore many important distinctions to be made. Dadaist nonsense is not the same as Surrealist nonsense, just as Artaud's nightmares were different from Jarry's. The trouble with the underground theatre of the 1950s and 1960s was that these distinctions were not made. Indeed the confusions were increased by relating Dadaist nonsense to Zen riddles as well, so that the delight in nonsense-iconoclasm became a form of mysticism. "I called my hippopotamus it's toasted" is a typical Dadaist non-sequitur. "You know the sound of two hands clapping? What is the sound of one hand clapping?" is a familiar Zen riddle. One statement makes sense as pure nonsense, the other as a bland enigma. Together they make no sense at all.

The early years of the underground theatre contained many such confusions. If the *avant-garde* had stayed on the level of the Theatre of Cruelty evenings, it would have stayed underground – a workshop beneath such theatrical events as *Marat/Sade*. The movement needed a focus. It is curious nowadays to reflect that the sketch in which Glenda Jackson played Jackie Kennedy made no reference to the American involvement in Vietnam. Two years later, such an omission would have been inconceivable. The

Vietnam war brought one benefit in its bomb-carriage of mass disasters. It gave the underground theatre a focal point for its confused dislike of authority and its longings for freedom. Freedom meant not being in Vietnam. Authority meant being sent there. Repression meant killing. Although the techniques of the underground theatre remained confused and heavy-handed, a purifying and single-minded emotion carried the genre to un-unexpected heights. Even the dreams – the attempts to shock propriety – the bitter sexuo-political gags were charged with the fervour of a generation with a grievance. Paradise *now*. It was not *avant-garde* or experimental, but it had a non-synthetic intensity which the American theatre had lacked since the days of the Actors' Studio.

"We are trying in our humble way," explained Rennie Davis, who founded the San Francisco Mime Troupe, one of the many underground theatre groups flourishing in the States during the mid-1960s, "to destroy the United States." The remark illustrates the difference between the political aspirations of the new underground theatre and those of Naturalists after the Second World War. When Jules Irving and Herbert Blau staged *The Crucible* in 1952, the production was directed against a specific political target – not the destruction of America, but the anti-communist hysteria of Joe McCarthy and his supporters. There was a similar target in the mid-1960s, the Vietnam war, but the consequences of the war could not be limited to the battlefield. Joe McCarthy's influence, vast and threatening though it was at one time, did not affect the social life in every small town. His decisions did not hang as an immediate threat over every male high-school graduate. He might hound worthy citizens, but the papers every morning did not carry accounts of hideous new weapons which the forces of freedom were using to contain communism. The people who opposed Joe McCarthy most effectively were men with some power and influence – middle-class intellectuals, highly regarded in their professions, men like Arthur Miller. But the people who were most threatened by the Vietnam war were the students who lacked middle-class means of bringing pressure to bear on the authorities. The first task was to find a way of bringing their anger to the attention of the public. High-school magazines overnight became underground magazines. Since few high-school graduates could expect the luck of Arthur Kopit who saw *Oh Dad Poor Dad* taken up by commercial managements in New York and London, new

forms of theatre had to be found. The San Francisco Mime Troupe and the Bread and Puppet Company took drama into the streets, using masks and costumes and developing simple legends, like fairy stories but with a sharper polemical edge. Inter-Action, the company formed in London by the American Ed Berman, staged similar events in playgrounds and community centres. One scenario for a street theatre production involved the construction of a model village with puppet people. The passing public was to be encouraged to play with these puppets, as children do with dolls in a doll's house. When the public was fully involved, four actors would come along, zooming like bombers, to knock the houses down and spatter the puppets with red paint – blood. The street productions owed much to the Happenings movement, but in place of Dadaist randomness, there was an attack on the war in Vietnam.

Street theatre was one form of expression. At the same time, a new "poor people's" theatre found homes in cafés, lofts and garages off-off Broadway in New York. The surroundings were restricted – often just a place beside the bar – and so the theatrical effects associated with proscenium-arch theatre could not be attempted. Other forms of spectacle, relying less on staging and lighting, had to be found – grotesque masks and costumes, the physical athleticism of the actors, the use of voices, hummings and cries, to convey a sense of atmosphere. Among the most useful of these improvised effects were physical nakedness and the shock confrontation of the audience with erotic images in the style of Antonin Artaud. The value of such moments was twofold. They attracted publicity and perhaps some voyeuristic trade but, more significantly, nakedness symbolized a rejection of middle-class standards – the system which dragged American boys across the seas to Vietnam. Nakedness was part of a common cause – which (with true Romantic diffusion) could either be seen as the super-ego suppressing the libido, or as the whites oppressing the blacks, or as male chauvinists enslaving women, or as young men dying in old men's wars. Nakedness meant freedom: clothes and respectability – tyranny.

No other genre in Western drama has ever pursued the bizarre with such relentless intensity or from such lofty motives. In *Futz*, for example, which was once described as a pornographic *Under Milk Wood*, an innocent country lad, Cy, is persecuted by society because of his erotic love for his sow, Amanda. The language is

tender, even idyllic, and provides a shock contrast with the subject
matter, bestiality:

> O the cow's tits are bigger and I know it's wrong, but young uns
> never know the difference between an animal's or a woman's hip
> bones, so soft like my socks, fresh-washed like new kids· hoofs . . .
> (Rochelle Owens, *Futz*, 1967)

Michael McClure's *The Beard* concerned a seduction (but in
whose direction?) of those two all-American stars, "Jean Harlow"
and "Billy the Kid": the play ends with Billy, head buried beneath
Jean's skirts, licking her to an orgasm. The sheer exuberance of
these erotic dreams – together with the confused call to freedom
which they represented – spread to other countries. In 1969, for
example, a Japanese play, *Narcolepsy*, was produced at the Little
Theatre Club in London. The story concerned a man's longing for
his mother, which is expressed through his naked miming of an
oral sex act. In the same year, at the Mercury Theatre in London,
there was a production of *The Labyrinth*, a play by the Spanish
dramatist Fernando Arrabal, where a naked man swings across
the heads of the audience on a rope, exhorting the actors to molest
the public. The Living Theatre's production of *Frankenstein*
surrounded the audience with images of man's inhumanity to man
– a gruesome carnival of torture chambers, guillotines, blood and
horror. Some theatre companies were less intense in their approach.
The Theatre of the Ridiculous presented Tavel's *Gorilla Queen*
(1967), which starts with a wonderful revue sketch idea – a queer
King Kong – which is then extended into a burlesque of bad
horror movies with a parade of camp deviations:

> If it's militant, jump it.
> If it hymen has, rump it.
> But if it's got a hole, hump it!

The Theatre of the Ridiculous specialized in sending up bad films.
Their leader, Charles Ludlam, once wrote, directed and starred
in a burlesque of an old Charles Laughton movie, *Bluebeard*, in
which Ludlam made explicit some of the sexual implications of the
original story and added some ideas of his own. One amusing scene
featured Ludlam as a small, skinny, mad scientist trying to fuck an
unusually fat woman on a chaise-longue and eventually getting his
head caught between her thighs. In Britain, the small talented
theatre group, the People Show, combined various similar erotic

images with ones of greater lyricism. In one production, a shy
man sitting by himself and apparently masturbating starts to
disgorge pounds of raw meat from his stomach – which he then
eats. But this powerfully disgusting moment is set beside a scene
where a girl wanders thoughtfully among balloons. Jane Arden's
Holocaust Theatre Company, a women's company dedicated to
the cause of Women's Lib, presented *A New Communion for
freaks, prophets and witches* at the Open Space Theatre in London,
which illustrated the variety of psychological deformities caused
by the male tyranny of women. Chris Wilkinson's *I Was
Hitler's Maid* provided a collage of sado-masochistic scenes culled
from men's magazines. And so on. From 1965 to 1970 each
month seemed to offer fresh examples of the quest for the sexually
bizarre.

The trend shocked many people. "Let a collection of yahoos but
take off their clothes, cavort about the stage and yell obscenities,"
denounced Malcolm Muggeridge, the British journalist and former
leader writer for the *Guardian*, "and a great breakthrough in
dramatic art is announced and applauded." Quite untrue of
course. Underground theatre was never uncritically praised: on the
contrary, it derived a certain strength from the relentless attacks
of the establishment critics, with the notable exception in the
States of Robert Brustein, who was sympathetically critical. Nor
were the underground theatre companies simply to be dismissed as
yahoos. My impression was of many infant Christs doing their
best to harrow various unconvincing hells. Criticism of society in
general was an integral part of the erotic nightmares. In the States,
this criticism always homed in on one ledge, Vietnam, the porno-
graphy of war which derived from the corruption of politicians.
Even those plays which did not overtly mention Vietnam acquired
a force for the social criticism from this over-riding common
cause. The President in underground theatre is always presented as
a diabolic father figure who will contemplate any human atrocity
to maintain his prestige. He is shown in 1984-ish surroundings –
on a huge TV screen which dominates a living-room, as in Jan
Quackenbush's *Talking of Michelangelo*:

> My fellow . . . Americans. Now let no man underestimate the urgency
> of this report. For at this moment, America stands on the brink . . .

a warning which precedes the announcement that the mutual
nuclear deterrents of the United States and the Soviet Union

have got out of hand. Barbara Garson's *Macbird* (1967), that literate, funny and savage attack on President Johnson through the guise of a modern Macbeth, implied an overwhelming rottenness in the political state of America. Nor were the attacks limited to the complicity of politicians. In the Open Theatre production of *America Hurrah* (1966), the attack extends to TV, with its endless exploitations of violence, and to a motel, where a homely proprietor (in the figure of an enormous aproned doll) lets a room to two jerky puppet lovers, whose sterilized cardboard embraces lead to an increasing violence in which everything in the room is destroyed.

Like William Blake, the underground theatre had a particular political target which it chose to generalize into an attack on society. Following the example of William Blake, it chose to express this total polemic in sexual terms – as the suppression, distortion or liberation of the sexual instinct. Unlike Blake, however, the underground theatre was quickly taken up by commercial managements, by the very establishment it was attacking so vigorously. But when underground theatre turned commercial, another transmutation happened. The polemic against society understandably diminished, and instead the movement became permeated with a youth cult: psychedelic lighting, strident pop music, long hair and energy. The force became the fashion. The liberation of the mind meant the intoxication of drugs. *Hair*, for example, was originally a conventional musical with a strong story and a definite cause – evasion of the draft. But when the production moved to Broadway, under the direction of Tom O'Horgan, the point of the plot was buried under a new show-business style – "love-rock". The theatre was filled with clean-limbed hippies with wild hair and beads; the rhythm of the music throbbed through the bodies, like a nightly Woodstock. But the dilemma of the young man who does not want to go to Vietnam but does not dare burn his draft card was buried, and the lyrics of the songs acquired an unfortunately sentimental edge. "Don't you care about *anything*?" a girl plaintively inquires at one stage, "Not *me* – not Vietnam?" Coupled with the domestic gushing – "It's Easy to be Hard" – is a sentimental mysticism: "What a piece of work is man!" The company seemed to teeter on the edge of asserting that love is a many-splendoured thing. The music by Galt McDermot was exciting, but it was really a sort of compromise between pop and Puccini: conventional enough to send the coach audiences away humming, but providing a fair imitation of pop

groups. And the occasional scenes of nakedness were presented "tastefully" under dim lighting.

The magazine *Time* once pointed out the dangers of what it termed "Modcom":

> Modcom is the commercial exploitation of modernity without regard for dramatic art. Modcom peddles the youth cult as a product. It is replete with cynical counterfeits of innocence, freedom and dissent.

In 1970 there were several commercial productions which seemed to be cashing in on the underground theatre genre. They were popular in London and New York, and acquired a religious orientation. In the *New York Times* (16 August 1970), Judy Klemesrud asked a very unnecessary question:

> What kind of man would write a two-hour show, without inter-missions, chock full of scenes of what people apparently *want* to see today (nudity, fornication, homosexuality, lesbianism, switch-hittin, group gropes) interspersed with scenes of what people think they *should* see today (blasts against the war in Vietnam, air pollution, water pollution, urban blight, computerized conformity), call it *The Dirtiest Show in Town*, direct it himself, open it off-off Broadway at the Astor Palace Theatre, and suddenly find himself with the hottest show in town with a top ticket of 10 dollars?

The kind of man is obvious: the specific man is impossible to guess, unless one knew already who wrote *The Dirtiest Show in Town*. From Judy Klemesrud's description, a dozen names spring to mind. When Tom Eyen (who wrote *The Dirtiest Show*) was asked whether he would ever consider writing a Broadway show, he answered "thoughtfully":

> Broadway *is* the next logical step. There's a lot of money to be made there . . . and I really like the glamour. Whenever I see something like *Hello Dolly* I say, "Wow! This is what show business is all about!"

But by 1970 the underground revolution had, in Genet's words, "begun to congeal".

The effect of Modcom was to make underground theatre both more fashionable and less so. The style was exploited commercially, but when this happened many underground theatres which

retained their sense of moral purpose lost public support. The Living Theatre, partly through its own excesses, alienated even its student audiences and broke up into several separate groups. The theatre communes, formed partly in imitation of the Living Theatre, experienced hard times. The merit of the communes however was that they tended to resist commercialization. Les Tréteaux Libres, for example, was formed in 1968 – shortly after the *événements de mai* in Paris in which the Living Theatre took an active part. Les Tréteaux Libres is one of the most rewarding communes, unpretentious, thoughtful and (within their philosophy) skilled. On their second visit to London in 1971 they offered a production, *Requiem for Romeo and Juliet*, which summarized both the positive sexual morality of the underground theatre and the techniques of group production associated with the communes.

Requiem for Romeo and Juliet had, as a whole, a bad reception in London. "The girls weren't even pretty," complained one actor of the nakedness, "and you can't say they were acting." Another critic wrote:

> *Requiem for Romeo and Juliet* is based on the naïve notion that in modern society love is doomed. With such advocates it could hardly help it. Artaud, you should be living at this hour! See your scantily clad followers hell-bent on expressing themselves but unacquainted with the ways of self-expression; endlessly miming clichéd sentiments and pawing girls in the audience. No really, being grabbed doesn't grab me. Simple-minded it all was, and nasty and brutish, but not short, oh no, it wasn't short.

These remarks were a little unfair. The actor expected the girls to be pretty because he associated nakedness with the cult of the body beautiful. The girls were not particularly ugly either, just normal. And normalness was the key to the production. It was like watching an acted family prayers, a simple theme and simple devotions in which the audience was invited to take part. It was not a *performance* in the ordinary sense of the word, it was a ritual expression of a communal faith. The faith, in my summary, was this:

> In the beginning, sexual love was innocent and unselfconscious: but in his search for power, man has sought to destroy the relationships on which human happiness depends. Men and women have been torn apart, sexually and spiritually, by priests (who preach abstinence,

celibacy and the rejection of the body), by warlords (who exploit sexual frustration to military ends) and by a commercially aggressive society, eager to snatch income from unhappy lives. Mankind in general has become both frustrated and exploited: but two lovers, Romeo and Juliet, survive. Their happiness attracts the destructive longings of the deprived. The lovers are physically torn apart, kept from one another by halters tied to their necks and then released so that their copulation may provide masturbatory pleasure, to those who cannot any longer experience love. But Romeo and Juliet become anxious and dismayed by this scrutiny. When they try to dress, the onlookers stop them from doing so: and when they cannot perform, they are slaughtered. In a feast of blood and flesh, which mocks the Christian mass, their bodies are shared among the onlookers. Love has now been ritually slaughtered: and the deprived humans, now scarcely human, are changed into blind automatons, endlessly self-seeking, but moved by lusts for money and power, transmutations of the instinct for love.

Expressed in these terms the theme sounds a little naïve perhaps, but nevertheless plausible. Alex Comfort put forward similar views in the early 1960s. It is possible to discuss the ideas, agree or disagree with them, and reach some conclusions. But the impact of *Requiem for Romeo and Juliet* was deliberately not on the level of rational debate. The production was largely non-verbal – in keeping with the views of Julian Beck, who once said:

> Words have become a barrier, an alibi. It is so easy to justify a war in words, but if you are there on the battlefield, confronted with an appalling bloodshed and horror, how can you? We are not rejecting the use of a text in the theatre, so much as a use of words to create an alibi.

Requiem for Romeo and Juliet was intended to sidetrack a verbal culture, and in place of argumentative logic there was a different sort of appeal – to the senses and by upsetting the normal codes of conduct between actor and audience. But if we use the phrase, "appeal to the senses", we may bring to mind *mise en scène*, formal music and dancing. These skills did not exist. The production was full of musical impressions, sung choruses and chants, but ones whose technical origins derived from Morton Feldman, the American composer, or John Cage, from aleotoric and improvisatory music, where the chance effect assumes an equal importance with the intentional one. The visual impact of the production also relied on the random in that various incidents happened

around the room which depended not on organized staging or carefully planned movements, but on chance groupings of people in the audience. The scenes which were planned in advance – birth, copulation, death, order versus anarchy, love versus frustration – were group improvisations which allowed each member of the company considerable freedom of interpretation. An unsympathetic observer – and there were many of them – might have concluded that Les Tréteaux Libres were a bunch of amateurs doing their own thing and conning the public into taking part, for all of us (the actors who hated the lack of formal skills, the agnostics who rebelled against the naïve self-righteousness, the Christians who were disgusted by the parody of the Mass), were touched or trampled upon, challenged or caressed, and these moments took place within a polemic against a society to which we all belong. It was like being asked to hold a candle at a Black Mass. Nor could we walk out without this gesture, too, belonging to the ritual; nor could we escape mentally by scanning our programmes – there were none and the houselights were on. We were trapped, by a bunch of people who made no pretence to possess ordinary dramatic techniques – such as beauty, eloquence, mimicry – and compelled not only to watch them but each other with a silent distrust which suddenly, almost arbitrarily on occasions, blossomed into an amused friendship, very nearly a temporary love. We were being belaboured into togetherness – like passers-by confronted by a Salvation Army band, joining in the tuneless choruses half-heartedly at first and then with a reluctant enjoyment.

But it would be a mistake to assume that, because the familiar skills were lacking, there were no skills at all. On the contrary, the evening had been carefully planned to convey, rather like a mystery play, a familiar parable using, not working against, the informal atmosphere and deliberately selecting those methods for producing chance effects which were most suitable to the theme and the occasion. I saw *Requiem for Romeo and Juliet* at the small church hall theatre, the Mercury, Notting Hill Gate. The company chose not to perform on the proscenium-arch stage, but against the exit doors and staircase at the opposite end of the room. The place was overcrowded. People were sitting on the floor. The performance stuttered to a beginning when (with latecomers still walking across the cleared stage area) nine members of the company – four women and five men, dressed in loin cloths – walked slowly and separately through the audience and sat cross-legged on the floor. They began to hum softly, holding long single notes in the middle

registers of their natural voices, to the endurance of their breaths, then gradually opened out their mouths and throats until their full voices blurred into one soft, confused but not unpleasant dischord. It is an effect familiar from the music of Morton Feldman, but on this occasion we were made aware of the distinctive character of each voice, as if the physical rhythms of breathing and the different naturalnesses of pitch provided a sudden close link with them as people. On their fingers, they wore emblems – long candles, joss-sticks, sponges, ears of wheat – irritatingly symbolic of something. Of what? Of the birth of life perhaps, or of primitive religion.

The first "scene" mimed birth. The candles on the first man were lit. He stood up, altering his voice from a single note to an improvised *obbligato* rising above the general hum, and the others, one by one, crawled through his legs, rising up afterwards and joining in the improvised tune, until the company flowered into tall, rising bodies and free-flowing clashing melodies. The movements were as freely improvised as the singing, but the company kept to the idea of a tightly knit, pulsating orgiastic group which gradually unfolded until separate members broke away from the group, and started to touch and fondle members of the audience. It was a scene which might have filled Paul Raymond with horror – which (if staged at the Revuebar) would have risked prosecution on the grounds that the place was becoming a disorderly house – for the girls wore nothing but loin cloths and were not only caressing men in the audience but also were caressed by them. After this group petting had continued for a while and we were all aware of the shape of each other's breasts and lips, a girl (seated in the audience) walked to the doors at the back of the stage area. Her head was shaven and she wore a long robe, which she took off, and then sat down completely naked on the entrance steps, viewing the audience with cold detachment. She began very softly to hiss, to repeat familiar phrases evoking sexual guilt. Gradually the caressing became more violent and despairing. Patches of blood appeared on the loin cloths – symbolizing castration or brutal circumcision. Certain members of the group, the men, responded more promptly, tearing the girls away from their partners in the audience. The girls began to quarrel and fight until only one couple, Romeo and Juliet, was left ardently embracing, oblivious to the sounds of hysteria circulating around them. These lovers then became the object of hostility. They were torn apart, tied to the walls with halters around their necks, just out of reach of each

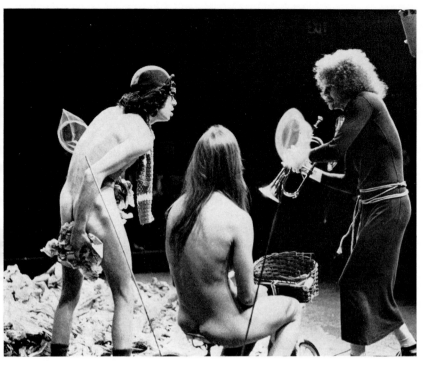

31 *The People Show* – Mike Figgis, Laura Gilbert and Mark Long

32 Renée and Teddy La Staire in *The Tomb and the Mummy* at the
Raymond Revuebar, London (1959)

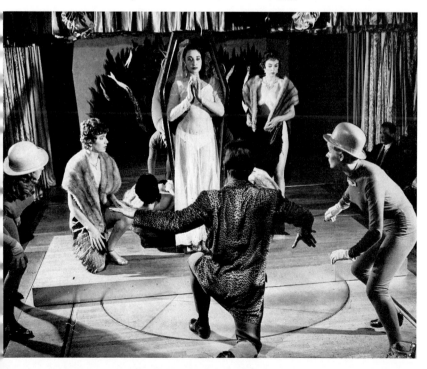

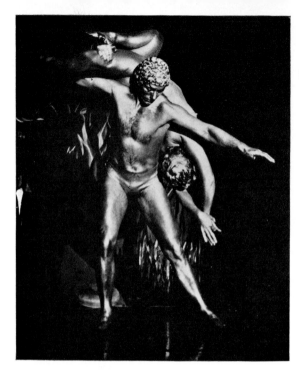

33 Renée and Teddy La Staire in *Goldfinger* at the Raymond Revuebar, London (1962)

34 Milovan and Serena (1971)

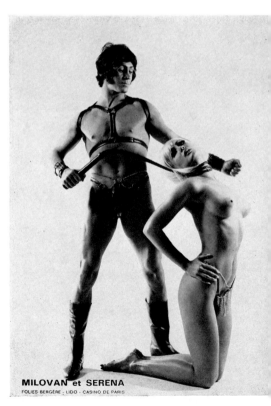

MILOVAN et SERENA
FOLIES BERGÈRE · LIDO · CASINO DE PARIS

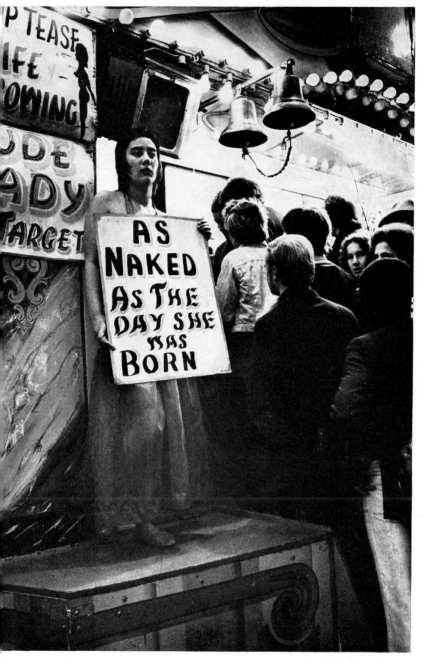

35 The exterior of a strip booth at the Byker Fair, Newcastle upon Tyne

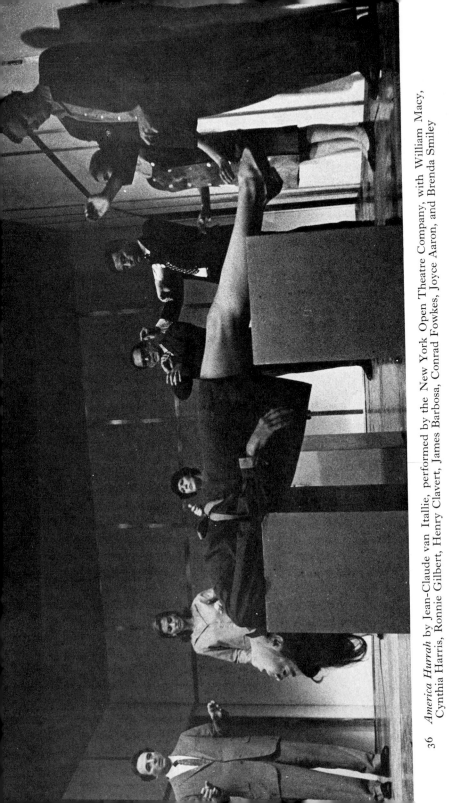

36 *America Hurrah* by Jean-Claude van Itallie, performed by the New York Open Theatre Company, with William Macy, Cynthia Harris, Ronnie Gilbert, Henry Clavert, James Barbosa, Conrad Fowkes, Joyce Aaron, and Brenda Smiley

37 The New York Open Theatre Company in a scene from *America Hurrah*

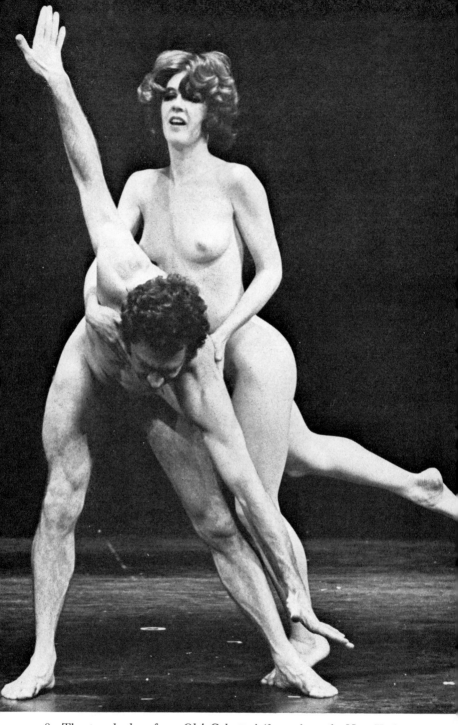

38 The *pas de deux* from *Oh! Calcutta!* (from the 1969 New York production)

39 The Royal Shakespeare Company's 1971 production of Harold
Pinter's *Old Times* at the Aldwych. Dorothy Tutin as Kate, Colin
Blakely as Deeley, Vivien Merchant as Anna.

40 Edward Albee's *All Over* (RSC, Aldwych, 1972). Dame Peggy
Ashcroft as The Mother, David Waller as The Son, Angela Lansbury
as The Mistress, Patience Collier as The Nurse

41 Michael Williams as Troilus and Helen Mirren as Cressida in the RSC's 1969 production of *Troilus and Cressida*, directed by John Barton

other. Then they were released to fuck, while the rest of the group cheered them on. They tried to escape, to dress, but were forced back into the ring of hysterical, jeering lunatics, forced to fuck again and to degrade each other, until they dropped from despair and exhaustion. When they were no longer able to perform, they were sacrifically slaughtered and (to the words of the Christian mass) bread and water, their body and blood, were handed to members of the company and the audience. Then the woman with the shaven head barked a command, and the company lined up, military style, and following an order marched straight ahead, blind as robots, through the audience – treading on laps, chairs and handbags in the lemming march to nowhere in particular. In this state of mechanical blindness, they left the theatre.

The great merit of *Requiem for Romeo and Juliet* – and of the company who devised it – lay in its simple realization of an allegory, almost a mystery play, with a newly interpreted story about the fall from innocence. We, audience and actors, took part in a family game, whose loose framework and simple rules enabled us all to contribute something – if only our sense of indignation. The process of the drama was perhaps more important than the final effect. The success of the theatre communes lay in their general reminder that the process itself has a value. Alas, the authorities did not always agree. Shortly after their appearance in London, Les Tréteaux Libres were arrested in France for staging an obscene and blasphemous spectacle. Sometimes society, through its appointed guardians, seems to have a habit of persecuting those well-intentioned rebels whose support they should be trying to enlist.

Two productions at the Roundhouse in London (November 1969) finally convinced me that the efforts of underground theatre had not been largely in vain. They presented a fascinating contrast One came to this "womb of student London" (which on this occasion actually had a baby in a carry-cot by the bar) from BBC television and the Phoenix Theatre, Leicester – two prim and respectable nannies. The other, washed up late at night on the sand-coloured sharply tilted penny of a stage, surrounded by a Brighton beach of stackable chairs, came from God knows where – from a backroom somewhere (according to the *Guardian*), from the Edinburgh Combination and other casual warehouses, where the landlords are arbitrary and the police inquisitive, where the smell of dust and onion soup provides a more pervasive *mise en*

scène than any set mounted, no expense spared, at Drury Lane. Side
by side, in this dosshouse for TV directors and other cultural drop-
outs, Dennis Potter's *Son of Man* and the Freehold's *Antigone*
proved to anyone still in doubt (and the Arts Council in particular)
that the best pegs are not always hung with the best coats, that
schools with a high output of cabinet ministers may be low on
other forms of productivity, that an environment can provide
everything except talent. It can provide all the necessary material,
from language rich in attitude and nuance to a sixty-two-way
lighting board, but not the drive to seize hold of an idea and to
transform it into something less parochial, into something which
has (to use two unfashionable words) beauty and truthfulness.

Both plays were versions of old stories revised to illustrate their
contemporary significance, but one came from the "over-ground"
and the other from the "underground" theatre. Both were in
favour of love (of man, not of power or money), against authority
(personified by Pontius Pilate and Creon), for peace and against
war, for good (it may be supposed) and against evil. They had
therefore something, if only sanctimony, in common. But a
comparison between them cannot be kicked around too much
without disintegrating, for these abstractions were so differently
interpreted, had been filtered through such diverse windows that
the light of one became fire in the other, a shadow became a mass,
an object became an image, became an idea, to be discarded in
distrust. *Son of Man* was a British establishment view of Christ, if
you believe (as I do) that the establishment is liberal and humanist
rather than right-wing and Christian. The opening scenes give a
rough documentary account of the circumstances in which Christ
emerged as a spiritual leader: a colonized country; Romans ruling
by bluff, cruelty and an unshakeable faith in their own superiority;
the Jews looking for divine intervention; Messiahs emerging all
round and being slaughtered one by one; Christ in the desert
wrestling with his conscience and finally deciding, against all his
human wishes apparently, that he is the Messiah. "You have
opened up the top of my head," he says to God. The first act ended
with a sermon in which Christ exhorted his followers to love their
enemies. This brief summary may suggest what seemed to me the
case: that Dennis Potter fell into every ditch in this crevassed terrain,
struggled and yelled his way out, apparently mistaking the effort
for literary creation. He made a familiar story seem more so. What
did Romans do when they were not conquering? They watched
wrestling matches and had their backs rubbed by nubile slaves.

Was Christ divine? No – but his inspiration was so *profoundly* inspired that it might have come from God.

"I really do sympathize with you agnostics," said the chaplain while we in the fifth form lined up alphabetically to take confirmation classes, "but you must be careful not to throw out the baby with the bathwater." My problem has always been that with Christianity I cannot distinguish between the two. Dennis Potter apparently could. The bathwater is all that muddle of mysticism which the Christians (totally lacking in historical perspective) take literally. The baby comes with the philosophy of love. In *Antigone*, there are many images of love, but the word itself is treated cautiously – with irony. Creon denies Polyneices a proper burial – for *love* of his country. He had rebelled against custom and the state: he did not *deserve* burial. Denis Potter had no such reservations. If everyone loved one another, the world would be a happier place. You will have noticed that he kept the end of the first act for Christ's sermon on love, a climactic point, where he experiments with some audience participation. Christ, having addressed the audience as "you cosy, cosy people" and again as "you sweet, cosy, smug people", invites them to touch one another and then exhorts them to extend this loving contact even to their enemies. The established theatre was borrowing some lessons from the underground, but not assimilating them successfully. For at least one member of the audience, this advice was counter-productive. How can you possibly love someone who calls you a cosy person? I merely added two more names to my list of unloved enemies. I felt inclined to touch my neighbour until Frank Finlay as Christ impertinently told me to do so. Instead, I scribbled on my programme, partly to relieve my feelings, partly to indicate to the row that, as a critic, I was above that sort of thing.

One image of love in *Antigone* was that each member of the company took turns to be the dead body of Polyneices, quietly, at the end of the scene as a matter of course. And so Antigone's instinctive love for her brother extends by implication to all men. Polyneices is all dead men. Creon was not like Pontius Pilate, a barbarian in disguise. He had good reason for doing what he did, dishonouring the body of a traitor. Love in *Antigone* had a different weight and emphasis than in *Son of Man*: really a different meaning. In *Son of Man*, love is a good resolution, a gesture of forgiveness towards a cruel enemy. In *Antigone*, love is a state of mind in which men acknowledge their common humanity, and Creon seems inhuman when he attempts to confine a purely instinctive

process within the lines of good government. Hence the vision of love which, in *Son of Man*, is achieved by much wrestling in the desert and then argued with soap-box oratory, is accepted as *normal* in *Antigone*, and the success of the Freehold Company's production could be measured simply by this: that they persuaded us in the audience to accept this vision as well. Some critics felt that the references to Biafra and Vietnam, which occurred during the descriptions of war, were tactless and out of place, jarring anachronisms. To me, they seemed sensible illustrations – not dragged in to pin down the contemporary significance, a little obvious perhaps, but was there anyone in the audience who was not, while watching *Antigone*, remembering Pinkville as well? Sometimes to omit what is in everyone's mind is more obtrusive than to state it. There was one remarkable moment of near-audience participation, so different from the naïve and clumsy example in *Son of Man*. At the end of *Antigone*, the cast scatter confetti or regret over the body of Polyneices before leaving the auditorium. At one performance apparently, the audience filing past the body on the stage laid their programmes gently beside Polyneices, following Antigone's example and those of the demonstrators outside the American Embassy who fed the names of dead soldiers into a coffin. When I saw *Antigone* this did not happen, but I felt the urge to do so, and in a smaller more intimate environment such an expression of audience involvement might have been hard to resist. Nobody on stage told the audience to take part, but the atmosphere generated by the production was so compelling that participation came of its own accord – whether or not it was accompanied by a physical gesture.

Clearly the *idea*, love of mankind, is pretty banal, just as the *experience* is medium rare. The Freehold Company ignored the one and concentrated on the other. This contrast between the two productions could be attributed perhaps to different insights, but the technical differences between the two cannot be dismissed as superficial – nor, more importantly, the ways in which the two productions had *evolved*. Dennis Potter and Robin Midgley, his director, spoke the language of the theatre not just with an accent which distinguished them from the Freehold Company, but with different words and syntax as well – a different language, in fact. One example, picked almost at random, lay in the way in which the two stories were told. Whereas Dennis Potter told the story of Christ in a schools' documentary way, illustrating each event with a scene which leads logically to the next, the narrator in

Antigone told the story in a précis form at the beginning, not to dabble in Brechtian alienation, but to leave the company free to represent the main facets of the theme almost in an abstract form without feeling that the audience had to be kept informed. *Son of Man* was, I would imagine, conceived in a conventional way – that is, Dennis Potter the writer had an idea which he wrote out firstly as a TV script and then adapted for the stage. The director, Robin Midgley, then cast the script, choosing Frank Finlay and Joseph O'Conor for the main parts, and then tried to realize the rest of the production through the facilities afforded by his repertory company at the Phoenix. *Antigone* on the other hand "emerged" from the improvisations of a group of actors (and possibly writers and musicians as well) who felt bound by a common cause, and chose this theme to give some clarity and focal point to their activities. They were prepared to allow a director, Nancy Meckler, to organize and simplify their experiments. The merit of the first approach is that it leads to a straightforward, efficient and logical production, a little one-dimensional perhaps and stilted, but one which has proved to work sensibly. The merit of the second is that it should provide a rich fusion of outlooks, a more spontaneous and vital performance which develops and changes from day to day, though always at the risk of diffusion, of clumsiness and obscurity.

The two productions might have been chosen to illustrate the weaknesses of the first approach and the strengths of the second. Because Dennis Potter was not working directly with the actors, he was not exactly certain what they could convey and so he had to make everything explicit. There must have been subtler ways of pointing out that the Jews were looking for a Messiah other than having a crowd of them wandering around the stage, whispering, then shouting "The Messiah is coming!" He was giving generalized "crowd effects" which he knew Robin Midgley would block out with his usual efficiency. And this was how it took place, with all the wailings, rags, ailments, haughtiness of the soldiers – and so forth. But Dennis Potter did not know what each actor could contribute as an individual to the scene, hence, he only expected broad and rather crude effects, he only asked for them and so these were what Robin Midgley delivered. Again, because Dennis Potter was stuck behind his typewriter in his study, he became bogged down by the problems of dialogue – how to include those Christian mottoes, naturalism versus stylization – without apparently realizing that actors only require those lines which make things happen

on stage and that the success of their lines has little to do with
"good writing" as such. Generally speaking, Dennis Potter opted
for the "naturalistic" solution. Hence Peter to Judas: "Stuff your
bloody warnings!" or (descriptively) "The streets of the city are
thick with rumour," or Pontius Pilate (loftily) "Now perhaps we
can exorcize this tedious ghost." What was wrong with the lines
was not that they were naturalistic – or, as some complained, they
contained swearwords – but that they were banal in any case and
gave the actor little opportunity to develop what he had to say,
either ironically by acting against the line or by placing the line
within a specific context to give it greater depth.

When the underground theatre companies reacted against the
tyranny of the text, they might have done so for Julian Beck's
reason – because words gave a false alibi – but they also succeeded
in avoiding one of the pitfalls of British theatre, an awful, straight-
faced literariness. The actors in *Son of Man*, faced by this pedantic
simplicity, had to fight their way through. Frank Finlay tried to
absorb the dialogue in a performance of tormented passion
in which there were moments of sweetness; Joseph O'Conor
under-played with tight control. But really they could do nothing.
Around each humanist corner a Lloyd C. Douglas lurked. In
one scene, notable for its lack of humour, a female slave, struck
by Pontius Pilate, turned the other cheek. It was that sort of
play.

The demarcation of duty in a production – the writer at the top
handing the blueprint for the production to his director and design-
er, who in turn pass it on to the actors – provides an almost feudal
structure with some of the weaknesses of feudalism: lack of com-
munication down and up the ladder; incipient revolt among the
spear-bearers, who feel that their talents should be better used;
the man at the top isolated by his eminence, waiting for that
inspiration to strike which could justify his position. It is this
feudalism that the underground theatres have helped to make old-
fashioned with their emphasis on improvisation, group therapy,
"total theatre", avoidance of set texts and words which create an
alibi. No such demarcation existed (I would have thought) in the
Freehold Company. Their problem must have been to prevent the
democracy from turning sour and confused. Someone in each scene
had to take control – but who? And did the director, Nancy
Meckler, limit herself merely to the selection of ideas? The
inspiration for their work came from a now familiar combination of

traditions – Artaud and the Living Theatre, Grotowsky and La Mama. They moved athletically but without the discipline of strict choreography, sang simple modal songs of their own composition, mimed vigorously and distrusted words. The snatches of dialogue were either from news-cuttings or satirical comments or statuesque utterances: "Man is the wonder of the age," intoned rhythmically and illustrated by movement. All of these activities taken separately were somewhat amateur. The actors in a mime would lose balance slightly on the raked stage. The singing was slightly out of tune. And there was also the La Mama rhetoric in which every verbal idea has to be illustrated, often with an extreme contortion, by the movement. But taken together, these different elements provided a rich and complex "folk theatre", a term which might please them more than it does me, conjuring up those spectres of anti-intellectualism and that sincere simplicity which is supposed to come straight from the heart. But it was not a primitive theatre, it was not comparable to the family approach in *Requiem for Romeo and Juliet*. It was an actor's production, with some of the weaknesses which that implies. I doubt whether a production stemming from a writer's or director's vision would have spent so much time on the slapstick scene (the soldiers guarding the body of Polyneices). To compensate, some scenes were unexpectedly rich and magnificent, involving a fusion of ideas which one would not expect from a single mind – the much-praised messenger scene or the song in praise of man, or the dialogue between Antigone and her sister Ismene, cautious and doubtful, where the two sisters seemed at first like Siamese twins, then like mirror images.

A final point: would this state of apparent group co-operation have been possible without a certain freedom from conventional sexual restraints? In a production so athletic, which depended so much on group discussion and the development of group mimes, could the company have worked together so successfully without the feeling that they could say anything to each other, behave roughly as they liked without causing offence? Was not the success of the production partly that it conveyed the impression that the members of the company were doing their own things, but together? I am not suggesting of course that the Freehold are a sexually promiscuous company, but rather that if the actresses had been obsessively concerned with preserving their distance and dignity, or the actors bent of proving their masculine prowess, would co-operation on this level have been possible? Perhaps the value of the erotic nightmare play of the mid-sixties was not that it

shocked the audience's prejudices, but that it relieved the underground theatre of a self fear – the hidden belief that if the taboos they wanted to defy were actually broken, all hell would break loose. The underground theatre opened Pandora's Box and found inside a little wind and several pornographic pictures of Lulu in different positions, all ungainly.

11

Up Propriety

Mr Redford's ghost might have survived alarmed but not appalled by a tour of the post-war theatre in London and New York: but if he returned today, he would probably die of shock. He would not necessarily have been hastened to a premature re-burial either by middle-class striptease or by the underground theatre. He could have comforted himself with the thought that neither genre had exactly conquered the West End. What might finally drive the stake through his heart would be – as he would see it – the total inversion of all the standards of Propriety. He would have considered the political satire – from *MacBird* in the States to *Mrs Wilson's Diary* in London – thoroughly unwholesome. He would have been distressed by the portrait of Christ the Poof in *The Council of Love* (1970), whose father, God, was shown to be a dirty, vicious old man conspiring with Satan (a humble shopkeeper) to bring a lecherous Papacy back to celibacy with the whip of VD. He might have been dismayed by the spectacle of two British national companies presenting plays about the behaviour of queers, and by all the bad language, on Arts Council grants. None of these isolated examples, however, fully illustrate the reversal of the standards which Mr Redford held dear and protected through his office as censor. It was a profounder matter still, about the nature of marriage. The fallen woman in his day dragged a ball and chain like a guilty thing. Nowadays the married couples do so – such as George and Martha in Edward Albee's *Who's Afraid of Virginia Woolf?*, or Frank and Norma in E. A. Whitehead's *Alpha Beta*. The nymphomaniacs and demi-mondaines are not the only ones nowadays demanding contraceptives; the harassed, loving wife is also doing so as in Kevin Laffan's *It's A Two-Foot-Six-Inches-Above-The-Ground World*. There were plenty of plays about unhappy marriages in the old days, usually handing out blame in

one direction or other, and plays too which questioned the legal rights of women in marriage. But few plays, not even by Strindberg, went so far as to portray marriage itself as a disease, the *Huis Clos* of two hapless people, bound by memories, vindictiveness and a common fear of the outside world. Marriage can no longer be likened to a ship setting sail in stormy seas which may be buffeted and perhaps sink, but which nevertheless offers a prospect of survival. In the theatre the more popular image seems to be that of two leaky boards strung together by fraying ropes in a calm sea – and the survivors who cling to it (alternately trying to hang on to each other and push each other off) are fools who should learn to swim. Nor are the writers who express these perverse views well-known eccentrics, as Frank Wedekind was, but award-winning dramatists in main-stream, middle-class theatres, which in his day would have presented society drama. Nor are they foreigners, like the French, whose hedonistic opinions the British had learnt to disregard – but British and American writers who are attacking their national forms of Propriety. It is the British aristocracy, in Peter Barnes' play *The Ruling Class*, who are shown to be mad. Propriety, once an oasis in a world of disruptive passions and other ailments, is now a ghost town. Surrounded by all these assaults on standards which were once taken for granted, the shade of Mr Redford might well conclude that life is no longer worth living. He might as well be dead.

I have no wish to resurrect him further, but would like him to rest in peace. That he may do so, I would offer the comforting suggestion that the assault on the *forms* of Propriety could be an oblique affirmation of its content. What sounds like a rugger cry, "Up Propriety!" could be re-punctuated "Up! Propriety!" Propriety in the nineteenth century was a response to social circumstances – the equivalent in custom and behaviour to those rows of battlemented, terraced houses in the suburbs of London. The purpose was to preserve the basic pair-mating situation of marriage in a society which had lost shape and cohesion. The extended family structure of small country communities was broken up as people left to seek jobs in the new industrial towns. Within these towns, where great poverty and comparative affluence existed side by side, it was of particular importance not only to preserve the last stronghold of emotional security, the nuclear family, but also its comparative status in society. The taboos against behaviour which might threaten a marriage – or against language and deeds which might reflect a lowly origin – were therefore

preserved with an intensity which implied that life itself was at stake. There may have been better systems. Several were tried out. But none succeeded in reconciling so completely the prevailing morality, Christianity, with the changing social circumstances. The theatre reflected the importance of this reconciliation.

Propriety was therefore a system for preserving (and achieving) a basic quality of life in circumstances both unfamiliar and threatening. The attacks on Propriety today derive partly from an awareness of changed circumstances, partly from a decline in Christian faith – but also from precisely the same instincts towards betterment which once formulated the standards. The attacks on Christianity have been sufficiently stressed. The changed social circumstances are almost too obvious to require comment and too complicated to admit space for the description. The population explosion in nineteenth-century Britain has been curbed. Contraception in the West has proved an effective retort to the warnings of Malthus. In the West, disparities of wealth still exist, but are less obvious in terms of human misery. The class system survives but, with increasing wealth, has lost some of its original purpose and defiant rigidity. With smaller families, an increased life expectancy and an improved school system, the economic reasons for preserving marriage at all costs are no longer so strident. Women are not tied to their homes for most of their lives and they can earn their livings. The attacks on Propriety may be premature, they may be misconceived, but just as the terraced houses of nineteenth-century London no longer seem quite such an appropriate environment for civilized living, so Propriety no longer provides an appropriate code of conduct.

There is no exact equivalent in modern British theatre to society drama at the St James's. The plays of Wilde, Pinero, Lonsdale and Rattigan are still performed often enough but do not command the same instant assent. At the turn of the century, well-dressed men looked like Sir George Alexander. Their behaviour followed his example of good manners and decorum. No actor now sets the fashion so completely, and no theatre in the West End carries the social prestige of the old St James's. But we do have society theatres and society dramatists – it is a question of identifying them. The modern parallel to Wilde and Pinero would not be, say, William Douglas-Home, whose plays seem to belong to the society drama tradition. Wilde and Pinero were both considered to be daring dramatists in their day, intellectually stimulating and broadminded. Home is thought to be a little old-fashioned. Who then are our new

society dramatists? I would suggest Edward Albee and Harold Pinter. For what reasons? Firstly, because both these dramatists manage to combine intellectual prestige with popularity. The nearest equivalent to a George Alexander première would be the opening night of a new Albee or Pinter play, perhaps directed by Peter Hall, performed by the Royal Shakespeare Company at the Aldwych Theatre. Secondly, because they both share the Edwardian preoccupation with good dialogue – spoken and unspoken. This delight in language concentrates the attention on the relationship between the stage characters, for neither Pinter nor Albee subscribe to the old myth that good dialogue can exist simply on a level of verbal felicity. Good dialogue is not a sequence of fine phrases; it is something which reveals the hidden intentions and hopes of their characters. Neither are polemicists in the sense that they are, say, trying to convince the public of the iniquities of the class system – nor are they naturalists in that they do not believe that mere imitation of life is good enough. They would not defend their plays on the grounds that "life's like that". Drama is a distillation of feeling, and both dramatists use symbolism if it suits their purpose. Both have acquired a self-assured style – if the public does not immediately follow what they are trying to convey, they do not feel the need to explain. Albee and Pinter are cultural leaders: it is the public's duty to follow them if they can and if not, to take them on trust. Sometimes the sheer assurance makes their plays and productions seem a little too stately. The pauses, the dimming of the lights, the ironic nuances are so exactly calculated as to seem almost formalistic. If there are two dramatists today who carry a weight of fashion to match that of the old society playwrights they would be Albee and Pinter. If therefore my contention is a correct one – that the old standards of Propriety are attacked from precisely the same instincts towards betterment that once formulated the standards – we would look to their plays for confirmation.

Albee and Pinter, of course, come from very different social environments. Albee was the adopted son of a family of theatrical impresarios in the States. His training, however, was not in the theatre – but in a variety of jobs which all contributed to his experience as writer. Pinter was born into a Jewish family in East London, an area where anti-Semitism was commonplace. Both started with sympathies towards the outsider – particularly the man who was excluded by the existing structure of middle-class society. Albee's early play, *The American Dream* (1961), attacked

"the cruelty and complacency of American life" and the archetypal victim of this society was either Jerry, the agonized hippy in *The Zoo Story* (1958) or the blues singer, Bessie Smith, who was refused admittance into a white hospital when she was dying. In Pinter's early play, *A Slight Ache* (1959), a fairly wealthy British middle-class couple are alternately terrorized and fascinated by a tramp who stands at the gate of their comfortable house in the country. These plays share a common hostility to the standards of middle-class life in both countries. Gradually however the emphasis changes in the work of both dramatists – and in a similar direction. Instead of hostility to the conventions, the standards are shown to be a response to an inward lack of certainty and fulfilment. They are maintained out of fear – but fear of what? Not of a class revolution, but of an inward anarchy, a lack of balance which destroys the delicate, often absurd, transactions within which human relationships operate. Both dramatists are concerned with relationships, particularly within a family situation. The nuclear family is as important for Albee as it was for Pinero. But the emphasis is now not on the preservation of marriage at all costs – but on the avoidance of loneliness within a relationship; not on the terrible destructiveness of the world outside, but the bitter alienation from the world within; not on the half-hearted avoidance of sexual temptation, but the frustrated search for sexual fulfilment. If the word Propriety can be used at all in the context of their plays, the meaning has to be re-considered. Instead of an external code of behaviour superimposed upon a family, it is, rather, an internal, acquired order which provides a framework for family relationships. Albee's plays affirm the importance of domestic good conduct – but they do not underestimate the sacrifices which have to be made to preserve the "delicate balance". Albee and Pinter celebrate the tenacity for companionship which survives intolerable strains. They re-define Propriety rather than do away with it altogether.

After the first production of *Who's Afraid of Virginia Woolf?* (1962), a journalist with much the same eye for a phrase as for accuracy wrote, "Albee begins where Tennessee Williams left off." Quite untrue, of course. Albee begins exactly where Tennessee Williams began, only louder and consciously funnier: in the family circle, where big Daddy morosely broods in his study, Sister plays with her dolls, Mummy washes her 16-year-old son and adds to his castration problems. The characters in Albee's

plays, like those in Tennessee Williams', are all at an awkward age, suspended between a "secure" childhood (which is rapidly becoming a myth) and another myth, the wide threatening world, where, as C. P. Snow puts it, "they die alone". Mathematically though, they're not adolescents. Martha (in *Who's Afraid of Virginia Woolf?*) is 52, "looking somewhat younger" and her husband George is 46. Nor do their Oedipal frustrations explode in tragedy as those in a Williams play would have done. Albee called *Virginia Woolf* a love story, despite the endless bitching between George and Martha, and George and Martha invite their young friends, Nick and Honey, to join an evening of fun and games. Unlike Williams therefore, Albee presents the passions and recriminations not as a genuine cry for emotional freedom, but as emotional habits without which George and Martha would have difficulty in making contact or indeed living together at all. The games are cathartic – they help George and Martha to get rid of excess emotions – and they are also a form of therapy.

A similar situation occurs in his later play, *A Delicate Balance* (1966). Agnes and Tobias maintain a calm, ordered family life and they do so through the preservation of good form and dignity. But behind this surface lies a morass of "unsublimated" Oedipal emotions. Their daughter, Julia, is 36 when she returns home after her fourth broken marriage, but she expects to find her old nursery bedroom waiting for her, untouched by visitors. Her aunt Claire – drunken, goodnatured – fights off the memory of her affair many years before with her brother-in-law, Tobias. In an adult gloom, they re-play their nursery games, putting off the moment of independence with alcohol and rhetoric. They are all rebels who cannot quite pluck up enough courage. But do they inwardly want to disturb the balance? Can they do so?

Douglas, Julia's latest boyfriend, is an open revolutionary – he is "against everything". He wants to blow up bourgeois society and right in the centre of that glowing, innocent mushroom are Agnes and Tobias. And, indeed, the family seems to be such a strait-jacket, tightly constricting violence and inspiration alike, that such a solution would seem to be more than desirable and almost inevitable from the slow accumulation of internal pressures. A bomb actually dropped would miss the mark, because the *family* in the plays of Albee and Williams is not a socio-economic unit, a bundle of hire-purchase agreements, a house delicately balanced somewhere between the wild woods and the grey streets. The *family* is the map of the mind, crudely sketched by Freud after

Ptolemy, "here be monsters", earth mothers and father-figures, and the whole supported by a flabby red pillar on the swollen rump of a tortoise. You can be adopted at birth (as Albee was), sent to a stream of boarding schools (as Albee was), bum around the world (meaning the States and Europe) with a handful of part-time jobs from Western Union messenger to unemployed novelist (as Albee did), and still not be free from the family in this sense for it purports to be the biological framework of the mind, and if this framework is also a strait-jacket, nothing can be done about it. When human aspirations totally exceed the frail chemical machine assigned to the species, resignation to the structure of the family or self-destruction are the only wan alternatives. Jerry in *The Zoo Story* impales himself on a knife. Albee's other characters whittle away their lives more slowly – in insults, drugs and liquor. The freedom from the family – is (within this context) impossible.

Since the family cannot be avoided it has to be endured. And so a system of mutual transactions grows up – which often amounts to little more than a recognition of territory. Claire will not attempt to rival Agnes in her own house. Agnes will not draw attention to Claire's drunkenness. Unfortunately, the system breaks down in *A Delicate Balance* because two close friends of the family, Harry and Edna, seek asylum with Agnes and Tobias from an inexplicable, unnamed terror. Tobias offers them a home in his household – but unfortunately Harry and Edna remain still visitors. They are not members of the family and therefore their arrival disturbs the delicate balance of transactions. They come at an awkward time, for Julia is expected back and the only free bedroom is hers, the child's room, where the door is always ajar to catch the light from the hallway. Julia kicks up a fuss, Edna is not tactful and the bickering between Agnes and Claire, which always goes on, comes to involve all the women, with tears, hysteria and acid recrimination. Finally the family unite against Harry and Edna, regarding them as "intruders" who have brought the "plague" with them. Even Tobias wishes them away – although he is appalled that the long friendship should mean so little.

Propriety then in *A Delicate Balance* could be regarded as the proper division of rights within a family. The balance has to be maintained, and the hidden transactions are a way of doing so. The weakness of this view of Propriety lies in its initial premise that the mind is totally structured by family relationships. Albee and Tennessee Williams speak the language of analysis with the careful insistence of someone who has learnt it too recently. They

want to be correct. The easy subjective flowing from metaphor into fact and back, the conversational freedom of a doctor, who has never had to punch an abstract idea across the footlights, merely confuses them. When an analyst talks about father figures, if any of them still do, he probably means the daily problem of transference – the way in which our attitudes towards teachers, doctors and older friends are modified by our memories of childhood. When Albee and Williams create a father-figure, he is the big daddy of all daddies. He has fabulous wealth and authority (as in *Cat On A Hot Tin Roof*); he builds up a university from nothing (as in *Who's Afraid of Virginia Woolf?*); and doles out marriages, jobs, pleasures, punishments and the whole ethical system of society. There is a confusion between the extreme emotional tendency and the more moderate commonplace variety. George and Martha are childless: they want a son and look around for a substitute. A common enough occurrence – but not quite in the way which Albee portrays – for they invent, as a pure fantasy, a son with a history, an education, blue eyes and eventually a death. Son substitutes are not usually like this: a garden would be more plausible. George and Martha are not mad, they are sane people trying to adjust to intolerable circumstances. Nor does it help when Albee points out that George and Martha are really playing a game, with rules which can be broken or kept, but living tears. But is it a game which distracts them from "reality" – in this case from George's impotence – or does it help them to focus their attention on "reality"? And is George's impotence a failure to erect or to fertilize? Or does it not matter? Is it merely the outward symbol of his castration fears so carefully mentioned in the first act? Combined with this very literal treatment of Freudian ideology is a certain inner sloppiness. We know what Albee wants to say. He tells us. If we have missed the point that George and Martha enjoy sado-masochistically a good quarrel, Martha reminds us: "my arm has gotten tired whipping you". If we have missed – though how is this possible? – the sub-text in *A Delicate Balance*, Agnes points out that "it's one of those days when everything is underneath". We know what he wants to say – but not what he means. This is left vague.

The vagueness is not always disastrous. Sometimes (as in *Virginia Woolf*) it passes for a teasing ambiguity, but not in *A Delicate Balance* and not in the central girder of the story, the terror which drives Harry and Edna from their own home to seek refuge with their friends. What is this terror? We are not told, of

course, nor do we expect to be. At the end of the first act, when Harry and Edna arrive, silent, lost and shaking, we guess that they have had some early intimation of death perhaps, or isolation, or the sense "of solving emptiness that lies just under all we do". But in the last act, when they decide to go away, the fear is not so metaphysical. They can apparently sell their old house and escape from the fear by living in a hotel. So: the terror was attached to the house, like a ghost, not to their lives. Immediately the story becomes less convincing – for a fear which can be exorcized by going away on holiday is not fear as you, I or Kipling know it – or as we were led to expect. The point of the play is also weakened. *A Delicate Balance* is about the texture of family life which is so strong that it defeats the intrusion of outsiders. But there is a difference between outsiders who have no real reason to prolong their stay – and those who do. By making the terror less convincing Albee made the exclusiveness of the family seem more reasonable.

There is another consequence of this misplaced vagueness: it makes us doubt the whole validity of his apparent theme. In *A Delicate Balance*, the casual insights about the nature of family life, so elegantly spun to parcel up the story, are very conventional and seem to be imposed on an emotional situation which cries out for a different interpretation. Apparently the theme is concerned with the strength of the family and the limitations of friendship. Julia has nothing in common with her parents, she always quarels with them. But she belongs to them. She can claim her bedroom as of right – "I want what is *mine*" – just as she can always claim the affection of her parents. Harry and Edna get on well enough with Agnes and Tobias, but they can make no such claim. The ties of friendship, the plot concludes, are weaker than those of blood: "The only skin you've known," Edna says, "is your own." This is one interpretation, but it is not quite appropriate for Harry and Tobias remain close friends. If they were sharing the house, there would be no problem. It is the women who drive them apart with their rivalry for the home. Tobias to the end refuses to admit that his love for Harry has been found wanting. He begs him to stay, but they both know that the arrangement will not work because the women resent each other. But what else do they resent? The close attachment between the men. The interpretation in the script – that blood is thicker than water – smacks of rationalization. The women really seem to be pulling their husbands back from a friendship which threatens to cut them out. If this friendship excludes women, it would also provide them with an excuse to be

bitchy and demanding. In *Who's Afraid of Virginia Woolf?*,
Martha is also hungry and George is unable to give her food.
Hovering to one side of the "official" interpretation is a totally
different one – that women resent the homosexual attachments
between men. Indeed the relationship between George and
Martha in *Who's Afraid of Virginia Woolf?* seems more akin to a
homosexual relationship, and this would have given a sharper edge
to the invention of a son. Was Albee a victim in the 1960s of the old
standards of Propriety – the ones which preferred not to discuss
homosexual marriages but favoured the orthodox ones?

Although he presents family life as something to be endured
rather than enjoyed, Albee constantly affirms the codes of dom-
esticity, even at the expense sometimes of the story. The affirma-
tion is supported by the carefully controlled, almost pedantically
class-conscious language. The dialogue in *Who's Afraid of Virginia
Woolf?* is rich with tirades, jokes and cool literacy, but in *A
Delicate Balance*, Albee went colonial. The language is distinctly
Edwardian, blown by the trade winds across the Atlantic but still
evoking the land of starch and ceremony. "All of you," cries
Tobias when the girls bicker, "be *still*." "That will give her occa-
sion for another paragraph," says Claire of the talkative Agnes.
When Harry and Edna have gone and the morning sun seeps into
the drawing-room, Agnes remarks, "Come now, we can begin the
day." Final curtain – of course. The emphasis on stately dialogue
continues in his later plays. In *All Over*, the situation is reminiscent
of French society drama at the turn of the century – a family
grouped around the bedside of a dying man, the wife and his
mistress swopping bitter memories. The real difference between
Albee's Propriety and (say) Pinero's is that Albee is more inclined
to ascribe to man an innate need to preserve the family and its
conventions, whereas in Pinero Propriety is custom, an environ-
mentally acquired set of rules which are based ultimately on the
laws of God.

Harold Pinter rarely emphasizes to such an extent the innate
importance of the family. Aston and Mick in *The Caretaker* (1960)
share the intimacy of brothers, which excludes Davis the tramp,
but they are not similar people, nor do they gang up against Davis
until Davis makes himself obnoxious. His characters are isolated,
lonely individuals, and ties of blood do not break down this
isolation. The moments of close contact between them are rare
and fraught with passion, desire, pleasure and suspicion. A com-
mon family background assists these moments of contact without

guaranteeing them. Nor are these family contacts necessarily ones involving loyalty or brotherhood. They are simply part of the environment from which the individuals derive – not a language exactly – but those fragmentary symbols which assist the hidden and inner communications. Pinter makes no case for the preservation of form and good conduct, as Albee does. Ted, the husband in *The Homecoming* (1965), leaves his wife Ruth surrounded by the aggressive male fantasies of his father and brothers to return to America. And yet Pinter does not so much attack Propriety or ignore it, as to invest it with a new meaning.

Propriety in Pinter's plays provides a pattern of normal conduct, a grid of expectancy, and deviations from this grid are the result of sudden emotional pressures. Propriety becomes rather like a radar beam constantly scanning the horizon, flaring into a ragged star when it hits an unfamiliar object. Every relationship, not just family ones, has this normal pattern to it, but Pinter prefers to concentrate on the stars rather than the beam. We are clearly using the word Propriety in yet another sense. It does not mean codes of behaviour which everybody is supposed to observe nor is it man's innate need for family security. It is closer to the examples given in Eric Berne's *Games People Play*. Dr Berne describes how two people may see each other habitually on the way to the station: they do not formally know each other, they are not friends, but they acknowledge each other with a "Good morning". These acknowledgements set up a formal rhythm. But then – for some reason or other – a fortnight passes without this regular contact. And so when they see each other again, they stop to have a short chat – to make up the "Good mornings" they have missed. It is a way of returning to normal – to reassure each other that the familiar relationship, involving no fear or challenge, still exists. But what if, without any absence, one man apparently broke the rhythm, and stopped to chat? What would the second man think? "What does he want? Is he trying to be friendly? Does he want to borrow anything?" If this habit relationship involved a man and a girl, would not the girl believe that the man wanted to make a pass at her? Would not she probably be right? In a Pinter play, the habitual "Good mornings" would probably be left unspoken – but the sense of an emotional break from routine would be conveyed by a sudden isolated line – "How's the *job*?" – spoken with an unusual intensity.

When *The Homecoming* opened in London, many critics considered the play to be shocking in a rather heavy-handed way,

unintentionally funny in places. The story is apparently simple. Teddy, a British-born don in the States, decides to re-visit his family in North London and introduce to them his wife Ruth, who also comes from London. His mother died several years before, and his family is now an all-male-*ménage* consisting of his father Max, his two brothers Lenny and Joey and his uncle Sam. But the homecoming implies more than just a return to London. It also means a return to class origins. Teddy and Ruth are now middle-class, affluent and in a good environment, but they came from sleazy homes and poverty. Teddy's occupation as a don is a cerebral one. His manners are prim and controlled, and so the homecoming also means a return to the well of emotion in his character which has been covered up for years by the old academic boards. Somewhere at the bottom of this well is his dead mother. Max (since his wife's death) has taken over the maternal duties with a singular relish. The all-male household has adjusted to the loss of the mother by excluding, rejecting and degrading women in the imagination. All women are tarts: "falling apart with the pox", "a filthy scrubber off the streets", "a disease". It is Max who provides the motherly love:

> MAX: Teddy, why don't we have a nice cuddle and kiss, eh? Like the old days? What about a nice cuddle and kiss, eh?
> TEDDY: Come on then.
> MAX: You want to kiss your old father? Want a cuddle with your old father?
> TEDDY: Come on then. (Teddy moves a step towards him.) Come on. (Pause.)
> MAX: You still love your old Dad, eh?
> (They face each other.)
> TEDDY: Come on, Dad. I'm ready for the cuddle.
> (Max begins to chuckle, gurgling. He turns to the family and addresses them.)
> MAX: He still loves his father!

At the end of the play, Sam, Max's brother, who drives a taxi, reveals the possibility that Max's children may not be his: "Mac-Gregor had Jessie in the back of my cab as I drove them along." Sam might not be telling the truth – but if he were, it would suggest that Max, a latent homosexual, had never overcome his fear of women, had found pederastic pleasure in rearing his children and had instilled into them his own loathing. It is characteristic of Pinter that we never know whether this is the case.

All we do know is that Ruth has entered a household, seething with frustrated sexual longings and aggressions, and that she discovers here an emotional home. The wilder the male sexual fantasies become, the more she revels in them until (in the final scene) she is offered a flat in Greek Street, a life as a whore – which she *accepts*. She does not want to go back to the tidy campus and her neat children. Teddy does. Teddy decides to leave her behind – not in an anguished quarrel, but a flat recognition of their different needs. Ruth turns to him as he's about to go:

> RUTH: Eddie. (Teddy turns.) (Pause.) Don't become a stranger.
> (Teddy goes, shuts the front door.)

It was this moment in particular which shocked audiences in 1965 – apparently a flat rejection of the family in favour of whoredom? Why does not Teddy assert himself? Why does not Ruth realize how awful her life will be?

There are several possible interpretations of this last scene, all equally valid, all equally mistaken. One could be that Ruth is simply fed up with the over-civilized life on the campus and (like the woman who rode away in D. H. Lawrence's story) she longs for exotic sexual pleasures, even to be slaughtered perhaps on the sacrificial altar. Another – that she does not take the wild fantasies seriously but, like a good teacher surrounded by the baroque imagination of children, she plays the game well enough to calm the hysteria. She wants to prove to men that she is unshakeable. Whatever the interpretation, the total effect is that the male household has at last found a mother-bride to complete its social pattern. The homecoming in this context also means the coming of home. Max the maternal father collapses before this threat to his paternal matriarchy:

> (Max falls to his knees, whimpers, begins to moan and sob. He stops sobbing, crawls past Sam's body round her chair, to the other side of her.)
> MAX: I'm not an old man. (He looks up at her.) Do you hear me? (He raises his face to her.) Kiss me.
> (She continues to touch Joey's head, lightly. Lenny stands watching.)
> *Curtain*

The arrival of Ruth transforms a collection of warring individuals into something which corresponds to a family. The establishment of feminine authority is not a bloodless battle – Teddy is driven

away, Max has to forget his carefully acquired rôle and Sam dies of a heart-attack having rebelled against Max. But Ruth has provided a calm centre to the household and from this new mediterranean, civilization begins.

Despite this final scene which shocked London audiences in 1965 and was dismissed by Robert Brustein as the "mere exploitation of the bizarre", Pinter seems to be affirming a homely truth: that men left to their masturbatory fantasies are arbitrary creatures. They require women to absorb their imaginings and to give their lives some unifying purpose. It is again a question of balance; not the carefully acquired family conventions which restrain the Oedipal rebellions in Albee's plays, but rather the re-establishment of a rhythm to relationships. Women in Pinter's plays are usually the ones to dictate this rhythm – not all women, but the emotionally strong and self-sufficient ones. In *Old Times* (1971) Pinter is concerned with a subtle emotional triangle – a husband and wife living in an isolated country house, who are visited by the wife's former room-mate. The wife is calm and reserved, content with her surroundings and inexplicably remote both from her husband and from her girl friend. The husband and the friend are drawn into rivalry. They try at different times to isolate the wife, to make her jealous and to force her into an emotional dependence. They appeal to her memories of the past, to a sense of nostalgia which cripples their love with sentiment. But the wife remains unmoved and, at the end of the play, it is the husband who cannot stand the strain of competition. Because the wife does not inwardly need either the husband or the girl friend, all the normal attempts to establish a rhythm of relationship are in vain. All the appeals to the past, all the evocations of friendship and marriage, and therefore the moments of sexual passion, the sensuousness when the wife takes a bath, the water on the hair, the exchanged glances of longing between the husband and the girl, longing which is directed towards the wife, are all doomed to frustration.

How then could the word Propriety be used in connection with Pinter's plays? It could mean a recognition of a certain completeness in the balance between the sexes. Men by themselves are frustrated, lonely, aggressive beings. But affection and sexual contact are not enough. Affection is expressed through a normality of behaviour, a grid of expectancy, whose purpose is partly to provide re-assurance and partly to express, through distortions of the grid, the moments of sudden fear and panic. There are no rules which externally can provide this grid, no laws of good con-

duct. Aston and Mick are certain of each other, despite their different personalities; the husband and wife in *Old Times* are not. Propriety is the personal discovery of a working relationship. It is the search for stability in friendships.

I don't know whether these new definitions of the word Propriety would comfort Mr Redford, but they certainly comfort me for I do not believe that one can live without conventions, but too often our conventions in the past have proved unduly rigid and limiting. As Oscar Wilde pointed out, a society which includes Lord Illingworth and excludes Mrs Arburthnot has acquired the wrong customs. We might perhaps add nowadays that a society which provides men and women with fixed sexual rôles which they can neither escape from nor accept, has misunderstood the nature of sexuality. "You're not the mistress type," a doctor once remarked to a friend of mine, who, although she wasn't married, dared to ask for the Pill. What is the mistress type? Pinero would know but Pinter would not – and this I take to be not a degeneration of standards, but an improvement, or rather that in a less hostile world we can afford to be less blindly censorious. If Mr Redford is still not satisfied, I would have to treat him (I am afraid) not as a ghost of the world, but with the condescension traditionally given to maiden aunts and take him along to see William Douglas-Home's *The Secretary Bird* where adultery is still (as in Sardou) a game of marriage, or to Agatha Christie's *The Mousetrap* which is more interested in murder than sex, or to the American musical, *Company*, which reveals that Christian anti-ethic is still alive and well and living in New York.

These exceptions apart, few plays in London over the past few years have started from the premise of society drama – that marriage is a good thing in itself and to be preserved. There is no automatic assumption that love affairs and comedies end in a church or that the fallen woman will have difficulty in recovering her balance. The marriage of Frank and Norma in E. A. Whitehead's *Alpha Beta* is a disaster; they ought to separate if they can pluck up courage to do so. Traditional Propriety is dead. It survives only as a memory of a standard which we should try to improve. But to replace this old insistence on the external code is an equally prevalent emphasis on the importance of stable relationships. This stability is something which has to be acquired through the stresses of experience and trial.

The four lovers in Leonard Webb's *So What About Love?* (1970)

teeter towards marriage in the last act, but only after they have tried out all the permutations of the impossible. Among the obstacles to settled relationships is class. Dickie, an impoverished writer, is conducting an enjoyable affair with Maggie, a cockney teacher living in a small flat in Battersea. But he aspires towards marriage with Jennifer, an upper-middle-class girl living in a comfortable flat paid for by her parents. Jennifer lives with Dickie, fostering his genius, but her parents want her to marry a promising but rather hidebound barrister, Robert. Eventually, class backgrounds assert themselves: Dickie settles down with Maggie and Jennifer marries Robert. A traditional story apparently – but there is no condemnation of the sexual experimentation which precedes the settled relationships, nor is there the suggestion that class as such is an obstacle to an affair: it is just inconvenient to have disparities of wealth and social background within a relationship. Maggie, when she tries have an affair with Robert, tries to cope with the French cooking he expects – but cannot do so. And so class itself – once a major obstacle to unplanned love affairs – has been reduced to bickering about inessentials. Robert would not be de-classed by a marriage to Maggie: his career and social standing would not suffer. He would simply find difficulty in sustaining the relationship.

Class too has become a matter for fun. It surprised some people that Christopher Hampton's play, *The Philanthropist*, should be subtitled a "bourgeois comedy", when it opened at the Royal Court in 1970. We do not normally associate the Royal Court in London, the theatre of Osborne, Wesker and Edward Bond, with conversation pieces around a settee, with gin-and-tonic sessions where somebody dies and another is bedded, where everybody is frightfully nice, or rich, or sinister. Christopher Hampton had been the Royal Court's resident dramatist for three years – long enough to be influenced by the anti-bourgeois traditions of the place. He defines bourgeois as a style which one has wilfully assumed – not as a series of lax habits which are maintained simply because one is apathetic towards change. One has to *want* to be bourgeois, or rather, while striving to be elegant, "amusing and intelligent and attractive", one effortlessly becomes bourgeois. You will have noticed that I have used the pronoun "one" rather too often. One is trying to stay in style. "I" sounds too conceited – "you" is too aggressive – "thou" too biblical. "One" blurs the distinction between people. It protects one's vulnerabilities. Furthermore one can imply with a judicious use of the word that the

"yous" and "mes" of this world are excluded from some special social order: "one doesn't *do* things like that" – you may and probably have.

But am I reading too much significance into a verbal habit? If so, we have much in common – Philip, the hero of *The Philanthropist*, and I. Philip is a philologist, fascinated by the games language plays. His advice to budding writers is to "make the real shapes" – an anagram of Shakespeare and Hamlet. In a society where the form of a statement is as important as the content, Philip is the hidden, unacknowledged and rather timid legislator. Many bourgeois comedies contain authors who are either brilliantly witty scoundrels or solidly sensible detectives. There is one in *The Philanthropist*: Braham Head – once left wing, now right wing, rich and outrageous – hence a cad. Philip rather diffidently in conversation analyses the structure of his wit: "Your use of paradox. You've got it down to a fine art. You've digested that it's an extremely simple and extremely effective technique." It's a sensible comment but Braham is naturally offended: "I think there's nothing cruder than an excess of subtlety" – thus precisely illustrating Philip's point. With the deflation of Braham Head, the tradition of the elegant cad, which reached its peak with the dandies of Oscar Wilde, finally fell from grace. The dandy was being attacked – not for his supposed "immorality" – but for being unspontaneous, unstylish and rigid in his following of fashion. His "wit" is just an extremely simple technique. *The Philanthropist* is a double-edged play: it is both the best recent example of a bourgeois comedy and an acute analysis of the whole genre. And Philip? Is he merely the author's *alter ego*? Is he there just to expose the vanities of bourgeois wit? By no means. Philip is so obsessed with language that he is often tongue-tied himself and the cause of dumbness in others. He is like the hostess who, concerned for the cleanness of her table napkins, blunders into one *faux-pas* after another. And, unfortunately, since he is an amiable, lonely man, his gentle observations cause offence; they have the ring of honesty because he is not deceived by the impressions people wish to convey through the style of their language.

Bourgeois conventions, in short, even that which masquerades as a dandy-like disregard for normal propriety, are regarded as mere mechanics, a style to be acquired and thrown aside at will. Indeed the dandy has become an almost pathetic figure. Butley in Simon Gray's comedy is, despite his untidiness in dress, almost a dandy. He's brilliant, witty and outrageous – an English don with a

broken marriage behind him and a broken love affair with one of his former (male) students still .causing anguish. The student is beginning to find his attitudinizing ridiculous and swops to another lover – the solemn businessman Reg Nuttall. Butley, at the end of the play, considers the prospect of choosing someone else: but decides not to. He will settle down to his job and try to re-build his life sensibly. *Butley* (1971) also illustrates another change in emphasis in modern British comedy. In the 1960s, homosexuality tended to be treated either circumspectly or with a bland statement of the apparently outrageous, a comic effect in which Joe Orton excelled. In *Butley*, the homosexual relationships are stated with the sympathy and insight previously accorded mainly to normal love relationships. Butley and Joseph Keyston, his lover, are both likeable: but they cannot discover a poise or balance to their relationship. Joseph cannot forget that he once was Butley's pupil – hence placed in a dependent situation. Leaving Butley is also a gesture of rebellion: he has found new standards and (to his mind) better ones. The defeat of Butley is a moral defeat, but the morality has nothing to do with a return to normal sexuality. Butley recognizes that he has let himself run to seed: he has grown old without growing up. He resolves to do better in future.

Propriety, therefore, means today the search for what is proper – rather than the obedience to external standards. But there is a further sense in which the word can be used in connection with the theatre. In Mr Redford's day, the theatre, despite all its efforts to the contrary, remained an improper medium – "the unholy mistress", "flashy" in the word of the Speaker of the House of Commons. Nowadays (despite all its efforts to the contrary) the theatre has become respectable. It may still not be a profession which would arouse the enthusiasm of a middle-class parent, but for economic reasons rather than moral ones. If someone states that he or she wants to go to drama school, we no longer assume that sexual promiscuity is really the attraction. The student could be destined for theatre in education – a very worthy activity. This new acceptability is reflected in various ways. Would Equity, the Actors' Union in Britain, tolerate the backstage conditions which once contributed to the burning of ballet dancers? Why was the Arts Council formed in Britain? Not initially to provide grants for the money was not available. At first the aim was to preserve traditional drama, so that we could relate our current values to those of the past. Then this purpose was generalized – so that the theatre

was considered to provide a game area in society, where alternative ways of living can be experienced by proxy – at no greater cost to one's normal life than the price of a ticket. It has been suggested that the stage should become a forum for the community, a place where different class groups, generations and perhaps cultures can meet, express their differences peaceably, quarrel and perhaps marry. The very nature of our theatre today reflects our social efforts towards peaceful understanding, tolerance and desire for social justice: these were the high aims which helped to establish the repertory movement so successfully in Britain and the popular arts centres in France and Germany.

We may not of course possess any of these qualities, but our morality esteems them sufficiently highly to try to consecrate the theatre to this purpose. This again reflects our changing standards of Propriety. I would consider it vaguely improper if a theatre existed (as they still do) showing solely society drama, while another down the road presented a totally different world of drama. It would represent to my mind the sharp social distinctions which have already caused so much trouble. On the whole I admire the off-off Broadway movement of the 1960s, but the disparity between off-off Broadway and Broadway itself seems thoroughly disturbing. A theatre in a sense is like a library in that it can present many different experiences: a library which stocks Smiles' *Self Help* but not Marx, Richardson's *Pamela* but not *The Female Eunuch*, is a poor library.

If with all these aims in mind, old-fashioned Propriety had not been challenged, if our "normal" habits of mind were merely reflected on the stage, then the theatre would not be fulfilling the purpose which we have planned for it. The theatre can afford to attack both prejudices and our sensible opinions, not because it has become subversive, but because it has become respectable. It does not feel that its very existence is threatened by opposition – just as a girl with a lover no longer suffers from quite the same vulnerability as a "kept woman". Who does not really rather prefer an equal companion to the heady, furtive delights of an "unholy mistress" and does not this preference reveal a change in what we consider to be proper?

12

The Exhilarating Descent

. . . The exhilarating descent into the pornographic maelstrom can be
more aptly regarded as but one more insidious form of distraction
added to the many that already blind the fast-scurrying members
of the affluent society to the impending holocaust of the human
species.

I have chosen this quotation as the title for my last chapter to
encourage those readers who already consider this book too per-
missive, to read on. It comes from an article in *Encounter* (March
1972) by Edward J. Mishan, which has earned a privileged place
on my bookshelves beside *The Obscenity Report* (mentioned in the
first chapter) – although its humour could be considered perhaps a
trifle less subtle by being, as it were, *fractionally* less intended. Mr
Mishan is dismayed not so much by the existence of pornography
(which he concedes has always been with us) but by the fact that it
is so publicly on display:

> What is significant is the scale and the "publicness' of the phenome-
> non: the fact that obscenity now struts openly in the market place.

This phenomenon, he believes, is unique to our civilization:

> Again the idea that public orgies or spectacular displays of sexual
> practices were commonplace in Antiquity bears no relation to the
> known facts. Although sexual conventions differed from those in the
> West today, there was in Islam at least, apparently no pornographic
> literature. As for ancient Greece, the sexually obscene went little
> beyond the familiar bawdy matter such as that of Aristophanes. And
> if there was something like a pornographic literature during the
> various periods of the Roman Empire, its circulation was rather
> limited and never such as to cause much stir.

This assertion may rest on his definition of widely-circulating pornography. To prevent anyone mentioning Apuleius or Ovid, or pointing out that the *deikteriades, auletriades* and *hetairai* combined the twin functions of show- and call-girls, or harping on about the *lupercalias* of Rome where loinclothed priests celebrated the arrival of spring (and the founding of Rome) by beating every woman in the vicinity with leather straps, or going on about the comparative merits of *Lysistrata* and Warhol's *Pork* as pornography, or happening to mention that the sexual ethics of Islam were singularly disgusting by current standards, Mr Mishan clarifies his assertion in a footnote:

> I am not, however, denying for a moment the existence of homosexual conventions in ancient Greece or Rome, nor of the occurrence of private orgies, private lascivious displays, or other obscene activities not only in the Ancient World but in other civilizations. We are not comparing private practices, or sexual conventions, throughout the ages. The issue is the prevalence of wanton sexual performances as a legitimate form of *public* entertainment.

Again one could quibble about the word *public*, for the only people barred from hiring *deikteriades* for an evening's entertainment were those who could not afford to pay for them: and Solon himself prescribed the first state-run brothels to protect Athenians from homosexuality. The suspicion unfairly enters my mind that Mr Mishan may really be objecting to the invention of printing, or affluence – or both. But this really is unfair because, as Mr Mishan makes quite clear elsewhere in the article, he is really trying to protect the lower middle classes, notably civil servants, from their own notoriously bad taste:

> . . . there are also a number of emotional attitudes tending to favour the permissive revolution. One of them is commonly to be found among the lower middle-class and young middle-aged group, in particular among social workers, civil servants, semi-professionals, including some educationalists. What appears to be common to such a group is a deep, almost desperate, desire to be associated with things 'progressive'. Any doubts about the value of a new cultural departure are deemed absurd, if not reactionary. "The future" is itself a beacon, while the "past" is seen as a long struggle upwards through the darkness towards the present. For this group, the highest virtue is tolerance – tolerance of any kind of social deviancy – You name it – they'll tolerate it.

He goes on to make the point that while illiteracy at one time
limited the public for pornography to those who could read, now
"today's cinema and television can bring its quota of sadism and
prurience right into the home of every humble hamlet in the land".
He then links this social situation with that of Nazi Germany:

> In the unrelenting search for the uttermost in orgiastic experience,
> cruel passions might be unleashed, impelling humanity into regions
> beyond barbarism. One has only to recall the fantastic sadistic
> barbarities of the Nazi era . . .

and again:

> . . . art will encompass the uttermost in what is sick and sordid. For
> who denies that scenes of homosexual copulation, scenes of sadism
> and physical torture, the crucifixion of squealing girls, scenes of
> unhinged bestiality do not pluck at the raw ends of the nerves? On
> this criterion, the concentration camp at Auschwitz during the last
> world war would have to be accounted as a veritable power house of
> artistic achievement.

My flesh is prevented from creeping because I cannot quite accept
some of Mr Mishan's associative leaps. I do not automatically
associate homosexual copulation with the crucifixion of young
girls – nor with Auschwitz. Nazi society was not tolerant towards
pornography in art; it was puritanical – even repressive. Nor can I
call to mind anyone who rates homosexual copulation very highly
as an artistic achievement. I am sustained in my scepticism by
another remark of Mr Mishan's, which seems to have a bearing on
the subject. He is speculating about the honest libertarian who,
confronted by the spectacle of sex shops, blue films and strip
shows, asks himself this question:

> Are these the sort of people for whose society he must stand ready to
> make sacrifices? Do they comprise a nation in whose defence he
> should be willing, if necessary, to take up arms?

Well, either pornography did lead to Auschwitz (in which case it
did not deter the German people from taking up arms) or it did
not – in which case one may seriously question Mr Mishan's logic
in associating pornography with Auschwitz.

It may seem that I have spent too much space on Mr Mishan's
article – although the words of a Professor of Economics at the
American University, Washington DC, should never be lightly
dismissed, even on a subject so far from his own. I have done so

because the article exactly illustrates the common confusions which afterwards seemed to be incorporated into the Longford *Report on Pornography*. There is an understandable assumption that because sex is a function of the body, it is also the first concealed or unconcealed cause of certain social phenomena: unbridled lechery caused the moral disintegration which led to the downfall of Rome – that sort of reasoning. Pornography, by unnaturally stimulating sexual excitement, contributes to unnatural and undesirable social practices. This logic is too simplistic. Our genders may be determined physically – and to this extent cause the attraction to take part in any form of sexual behaviour. But the sexual behaviour itself is a reconciliation of our biological needs with the prevailing social attitudes. Pornography demonstrates this reconciliation. If it were possible to stimulate sexual excitement without reference to prevailing social attitudes, then a pornographer would only have to present physiologically appropriate objects to men and women – and stimulation would follow automatically. But pornography provides a curious mixture of the appropriate and inappropriate, and some forms of pornography seem positively anti-sex. Why is this so? Basically because our various social attitudes have diverted our sexual instincts away from the biologically appropriate, and towards substitutes. If an adolescent has been told habitually that sex is sordid, he will not stop fantasizing about sex, he will merely fantasize about its sordidity. If a society offers a particular type of pornography – say, a prevalence of stories about spanking – this phenomenon tells us a little about the biological needs but much more about the cultural climate which gave these needs this particular form. There is no such thing as pornography plain and simple: it is always a reconciliation of various social and physiological needs. For this reason the pornography of one generation may seem boring to the next: the Windmill Theatre has closed. It is not a simple escalation process, from bad to worse, which changes the fashion in pornography; it is the search for an erotic image which is suitable on many levels – which may assuage masculine guilt and feminine shame, which reflects certain class relationships and which is sexually stimulating at the same time. But is it possible to avoid the course of substitution whereby man's sexual instincts are diverted from the appropriate to the inappropriate? Not entirely – for substitution is an important method of controlling the sexual instinct. Just as a young girl may learn how to look after a baby from playing with dolls, so a boy may learn

about the extent and nature of his sexual needs through the invention of fantasy situations. There is in fact a basic human dilemma which the substitution process reflects: man's physiological capacity for sex exceeds his social capacity for looking after children. What is appropriate biologically is inappropriate socially. While this dilemma remains, ways of controlling the sexual instinct will still be needed, while the search for appropriate social circumstances goes on. Among these methods is the encouragement of sexual prudery and the use of substitutes. It is not a contradiction in terms to say that pornography can be prudish: it is an observable fact. Who are among the most popular characters in pornography? Stern governesses and nuns. What situations are among the most popular? The sexual humiliation of men and women.

I have defined pornography in a fairly limited way – as the presentation of an image or situation which is intended to stimulate an orgasm. This definition would exclude most underground theatre, which Mr Mishan might consider pornographic. But pornography also serves another purpose – of indicating situations where sexual stimulation is permitted or cannot be avoided. If this is so, why does so much pornography concentrate on the remote and the unlikely? The escapades of the fabulously wealthy – deeds in Gothic castles or in the harems of Sultans? There are two complementary answers: one is that the social indoctrination of children begins at an early age – long before puberty. When the Arts Council in Britain reported on the workings of the obscenity laws (and advocated their abolition), it was stated that: "it is commonly known in medical science that sexual leanings are fixed at an early age, probably around five to six years old." Pornography reflects the childish acquisition of sexual habits – habits which may seem to be beyond rational control because they have become so integral a part of the personality. "Obscenity," stated a witness to the Arts Council Working Party, "does not corrupt, although it may appeal to the corrupted." Pornography is out of touch with reality because it appeals to a phase in the training of sexual instincts when it was impossible to test the acquired habits within the realities of sexual experience. For this reason, pornography often seems to be socially out of date. In Britain, it harks back to a time of maids and governesses, of extreme religious repression. This explanation of the implausibility of pornography does not supply the complete answer – for pornography often stresses the absurdities, as if to remind the reader or audience that they *are* in a fantasy

situation. The public who watched the harem ballets at the Alhambra during the 1890s, knew perfectly well that they could not buy or sell concubines in Kensington High Street. They were enjoying a fantasy which stressed its remoteness from real life through its choice of an exotic setting. If the fantasy had strayed too close to normal living, the audience would have rejected it violently. This sharp distinction in the public mind between the pleasurable fantasy and the daily caution is something which theatre managers always have to take into account. Many rep managers in the late 1960s told me that Ann Jellicoe's *The Knack* shocked their audiences, whereas the farce *Boeing Boeing* did not. *The Knack* was considered immoral and sexually suggestive. But both plays are comedies about seducers and seductions. The girls are prettier in *Boeing Boeing* and wear less. The tone in *Boeing Boeing* is more cynical and the girls are handed from man to man more freely. By any *conscious* standard, *Boeing Boeing* is the more "immoral" play – but the real problem is not on this level. *Boeing Boeing* is set in a luxury Paris flat and the girls are air-hostesses. Thus, an unreal glamour hangs over the proceedings. *The Knack* however is set in a dingy bed-sitter and the girl is on her way to the YMCA. The closer a sexual fantasy comes to reality, the harder it is for an audience to avoid its social implications: and so *The Knack* was condemned as "filth", whereas *Boeing Boeing* was accepted without question. In the 1890s, behaviour was tolerated in French farces which would have been considered shocking in society drama. The same pattern is revealed in pornography. By stressing its remoteness from "real life", the pornographer prevents the carping and critical adult mind from interfering with the experience of a childish sexual fantasy.

The bizarre extremities of pornographic literature may not therefore be a trumpet sounding reveille to bizarre practices in everyday life. It may have the opposite effect of reminding an audience that a substitute is just a substitute, not to be confused with ordinary behaviour. But some people may refuse to make this distinction between fantasy and reality: and what sort of effect would pornography have on them? The history of certain types of killing in the West – from Jack the Ripper to Charles Manson and Ian Brady – suggest an uncomfortable link between the behaviour of murderers and the fantasies presented by some pornography.

Does pornography provide a do-it-yourself handbook on perversions? The medical witnesses to the Arts Council Working Party were divided on this question: they were not sure as to the

effect which pornography had on the mentally sick. They all agreed that when somebody was unable to distinguish between fantasy and reality, this lack of discrimination revealed a personality disturbance which pornography neither cause nor controlled. If a person cannot cope with life nor relate to other people, he may retreat into a private fantasy very similar to those supplied by some forms of pornography. He will also select from the outside world only those details which support his inner fantasies and may therefore rely upon pornographic literature to supply these details. Would the suppression of pornography (if this were possible) assist such a man to adjust to the outside world? Probably not – for it is impossible to control the environment so completely that somebody's fantasies are starved into submission. The attempt to do so through the withdrawal of pornography could be counter-productive. It could discourage the person who is unable to cope with the outside world from trying to do so – for the knowledge that someone else shares his fantasies nurtures an embryo sense of togetherness. But does pornography encourage the mentally sick in the belief that their fantasies exist in the outside world – thus tempting them to try out their dreams in practice? Or does it relieve the frenzy of loneliness whereby a person may try to force the outside world to conform to his fantasies simply because his solitary self-confinement has become unbearable? Is pornography a stimulant or a sedative to the mentally sick? Some medical witnesses to the Arts Council Working Party were convinced that pornography had a useful cathartic effect, mainly by relieving the pressures of loneliness. Others were less optimistic. The question is one which goes to the heart of the problems of treating the mentally sick. If we knew how to prevent people from withdrawing into worlds of their own, if we knew how to encourage them to relate to the outside world, the problems of analysis would be solved. The failure to distinguish between fantasy and reality is one which characterizes mental sickness: but how we treat this lack of discrimination is a hard question indeed and one which offers no single answer. To one patient pornography could be helpful – to another dangerous.

The treatment of the sick and psychotic raises a still more general question – do the mentally sick lie at one extreme of a scale which includes all the other degrees of the reality/fantasy confusion, a scale which can be extended to apply to all of us? Do not all men suffer from the dilemma of young Marlowe in *She Stoops to Conquer* of cutting their fantasies to suit their cloth? And do not women follow the example of Miss Hardcastle of manipulat-

ing these fantasies until their own psychological needs are satisfied?
How does pornography relate to the general process in which we
learn to select those circumstances from real life which satisfy both
our internal dreams and our adult recognition of the possible?
Does pornography have the effect of blurring the distinction
between fantasy and reality simply by presenting our wet dreams as
observable objects external to ourselves? Or do we realize the
ludicrousness of our dreams by examining them in this external
form? At this point the whole debate concerning pornography
sinks dangerously low in a swamp of speculation, for what applies
to pornography could also relate to every other form of literature.
We are all involved – creators of fantasy and audiences alike – in a
constant process of selecting the real from the unreal, the appro-
priate from the inappropriate: and the main feature which dis-
tinguishes pornography from other forms of literature is that it has
a limited usefulness. It draws together those images which are
helpful to stimulate an orgasm, and ignores those which are not.
The most habitual masturbator quickly becomes bored even with
the pornography he hoards – for once the orgasm has come, the
stimulant has no further value for him. The book, magazine or
theatrical memory is left aside until the next time he feels frustrated.

Pornography therefore reflects those social attitudes which are
manifest in the conscious or unconscious sexual training of chil-
dren, and it does so in such a way that adult suspicions are lulled
and not distracted by images irrelevant to the stimulation. Adults
who do not respond to a particular type of pornography may well
find it juvenile, disgusting or just stupid; and they may also miss
the many indications that this fantasy is just a fantasy, useful to
stimulate an orgasm but with no other pretensions. For these
reasons I am inclined to turn Mr Mishan's argument inside out –
to assert that pornography merely reflects social attitudes towards
sex which it does not cause and has a negative impact on society in
that it draws together sexual fantasies into one masturbatory
image which is clearly labelled "fiction – not to be taken literally".
The question posed by Mr Mishan's article also has to be reversed.
Instead of asking "What impact will all this pornography have on
our society?", we should inquire "What impact has our society
had on our pornography?"

How can we assess this impact in terms of pornographic theatre?
Pornographic theatre, as we have seen, occupies a comparatively
small section of the general treatment of sex in our theatre and an

even smaller section of pornographic literature as a whole. These limitations have their advantages and handicaps for anyone who is foolish enough to try to generalize about the decadence or otherwise of a society from the examples offered by the theatre. The main handicap is that the theatre may not provide a representative cross-section of pornography. Pornographic theatre is always a public activity; even when it takes place in a theatre club with restricted membership, other people are always present. The advantages to offset this difficulty are these: the theatre nearly always provides a consensus view of pornography in that the producer offers to the public something which will stimulate a large enough group to keep his theatre going and he often has to veil this pornography against the ridicule and antagonism of those who do not experience the attraction; the producer has therefore selected or rejected pornographic images according to their general appeal and the amount of opposition which they are likely to arouse, and he has done so in a public way. It is impossible to tell how many people read a circulated manuscript in the 1890s or what their reactions would have been: to consider the pornographic theatre of the times is an easier task. Pornographic theatre by being a fairly limited genre has a certain coherence for the researcher.

One comparatively simple method of describing the impact which changing social attitudes have had on our pornographic theatre is to consider the way in which "fantasy" is kept apart from "reality". If the taboos and customs surrounding "normal" sexual behaviour are very strong, the pornographer will not wish to confront them too directly in the presentation of a fantasy lest he awake the critical sense of his audience. He must avoid giving sexual advice to his audience because they may forget to be stimulated and start to answer him back, "I couldn't do *that* to my *wife/ sister/dog*." If the norm of sexual behaviour is considered to be "intercourse – for the purposes of procreation – within marriage", then the pornographer will present images which have nothing to do with marriage, nothing to do with procreation, and perhaps nothing to do with intercourse. If the taboos weaken, if the "norm" of sexual behaviour admits more variety, the pornographer has less to fear from giving offence. The fantasies can be less remote and closer to home: and the public will neither be shocked nor quick to criticize. The wildness of a fantasy is therefore related to the rigidity whereby a norm is preserved.

This last statement sounds so much like a scientific law that I

am anxious not to lose this impression of authority. Can the wildness of a fantasy be measured? Can statistics be compiled to illustrate the comparative wildnesses of different pornographic cultures? Obviously not – and yet the temptation remains to dare the impossible. We might, for example, gauge the remoteness of a fantasy by its setting. For Edwardian audiences, London was the norm and nothing sexually abnormal ever happened in London. But Paris, well, that was a thoroughly improper city, whereas the Middle East was harem country and the Far East was where the Orientals terrorized nuns with fiendish tortures. We could express geographical remoteness by a simple ascending numerical scale thus:

Paris/Hamburg=1; Middle East=2; Far East/Africa=3.

History is another way of distancing a fantasy. The norm is always today: and nowadays we know that the Victorians exploited factory girls and whipped children at school. The Romans indulged in all manner of perversions, whereas the Vikings and the Goths sacked and pillaged and raped. The idea of historical remoteness may be expressed similarly:

between 50 and 100 years=1; well-documented history=2; badly documented history=3.

There are subtler methods of achieving the same object: one is to ensure that the relationship between the partners in a sexual fantasy bears no resemblance to any plausible pairing in everyday life. The relationship is not like a relationship at all: there is no communication, adjustment or compromise between the partners. One is totally at the mercy of the other. Thus, disparity between partners would be:

master/servant=1; sultan/slave=2; gaoler/prisoner=3.

Class, racial colour and age heighten the disparities:

(a) boss/working girl=1; count/maid=2; king/peasant=3.
(b) WASP (White Anglo–Saxon Protestant)/educated Indian=1; WASP/educated black=2; WASP/primitive savage=3.
(c) One generation=1; two generations=2; three generations or more=3.

When "normal" sexual relationships seem unlikely to develop, sexual "fantasy" can reign supreme. Nowadays in male pornography, lesbians aspire to heights unclimbed by conventional mountaineers. There are of course many other explanations of these disparities. I do not have to stress the obvious sado-masochistic content – nor to emphasize that the disparity between partners also reflects the child/parent relationship during the period when sexual inclinations are formed. But sometimes an equally obvious interpretation is ignored – that the disparities heighten the "unreality" of pornography and prevent its confusion with everyday life.

The deliberate isolation of pornography from life is sometimes achieved by methods which have nothing to do with the fantasies themselves. It may be achieved by structuring the relationship between the audience and the performers. If a predominantly male audience watches a company of female strippers, the disparity between the sexes is stressed by the other disparity between the watchers and the watched. This too can be heightened by suggesting that the male audience is in command and that the girls are passive objects of the male will. We can therefore suggest two further criteria based on the stage/audience relationship. The first might be concerned with sexual disparities:

mixed audiences/mixed sex acts=1; predominantly male audiences= 2; male audiences/female cast=3.

Secondly, power disparities:

girls stripping for enjoyment=1; girls passively accepting male voyeurism=2; girls bought as well as observed=3.

Lastly, the isolation of pornography within society assists the promotion of its unreality. Pornographers may have been driven by law to seek out the dark alleys of towns; but this social ostracism does not deter pornography. There is some evidence to suggest that the ostracism assists it. When pornography was legalized in Denmark, moralists feared an uncontrolled boom of pornographic books. There was a temporary boom – which lasted for about two months. Then pornographers faced a severe and unaccountable loss in trade. They, as it were, saved their skins by exporting illegally to countries where the restrictions on pornography still exist – such as Britain. The booming strip clubs in Britain during the late 1950s exploited the age of their own

furtiveness. Inside this cellar, so the fantasy ran, sexual dreams are fulfilled: outside the cellar, we have to conform. Social ostracism heightens the separation from life which is implicit in pornography, and this can be illustrated as follows:

considered low class or demeaning=1; barely tolerated by law=2; suppressed by law=3.

We have invented some criteria by which the isolation of pornographic fantasies can be measured. During the course of this book we have mentioned various forms of pornographic theatre: the brothel theatres of the eighteenth and nineteenth century, "poses plastiques" in the music halls and supper rooms, the abandoned dances which Lulu might have danced, the touring nude revues during the 1950s in Britain, the strip clubs and swinging erotic spectaculars such as *Oh! Calcutta!* or *Pyjama Tops*. If we take examples of these genres and relate them to our criteria, we will notice an interesting trend – that pornography has become less extreme in recent years, not more so. The permissive society, in other words, does not encourage the pursuit of the bizarre, or at least not on the level of pornography. I have interpreted my criteria with imagination: John the Baptist is a White Anglo–Saxon Protestant and Salome (for the purposes of this chart) was an educated Indian. At least three of my criteria could be challenged on

| *Examples of genre* | *Criteria* | | | | | | | | |
	Geog-raphy	Hist-ory	Disparity between partners	Class	Race	Age	Stage/Audience A	B	Social ostracism
Feast of Otahiti (Brothel Theatre)	3	3	1		3	1	3	3	2
Diana the Huntress ("Poses Plastiques")	1	3	3	3			2	2	1
Maud Allan's Salome dance	2	3	3		1	1	2	1	1
Phyllis Dixey (Nude Revues)	2	2					2	2	1
Renée and Teddy La Staire (Strip clubs – early 1960s)	2	2	2				2	1	2
Serena and Milovan (Strip clubs – 1970)		1					1	1	1
Pyjama Tops		1					1	1	

the grounds that they were no longer so applicable today as they were a hundred years ago: class, race and social ostracism. But the comparative irrelevance of these criteria helps to prove my general point, that it is no longer so necessary to isolate the pornographic fantasy from the texture of normal living, that a greater variety of social and other partnerships are tolerated as normal and that the quest for bizarre partnerships is no longer so strident in pornography.

This trend against the bizarre is also noticeable in pornographic literature. Modern versions of *Justine* and *Histoire d'O* are still written and marketed – but they are hopelessly outsold by soft-core correspondence magazines, where letter-writers (real or imaginary) swop anecdotes about sexual experiences and techniques. It could be argued that this tendency is a dangerous one, for it blurs the distinction between fantasy and reality. Anyone who has tried to defend pornography in a public debate will be familiar with the argumentative impasse provided by his opponents. If pornography is extremely bizarre, then it encourages its readers towards bizarre practices; if it is mild, plausible and concerned with sexual techniques, then it has escaped from its protection as fiction and is advising its readers towards deviationary practices. It is really a question of the cultural climate one prefers. Do we want to live in a society where there is a rigid division between "normal" sexual practices – where normality is defined not merely according to the biologically appropriate but also according to the prevailing religious and social faiths – and fantasy? Or do we wish to live in a society where "normality" is largely a question of personal choice and where pornography can provide a useful guide to sexual technique?

My conclusion that there has been a trend against the bizarre in pornography could be challenged for another reason, that I have defined pornography too narrowly to exclude underground theatre and such plays as Warhol's *Pork*. Nobody denies that there are bizarre sexual fantasies in underground theatre: the dispute concerns whether these fantasies are used for the pornographic purpose – to stimulate orgasms. My impression is that they are not. In American underground theatre of the mid-1960s, the presentation of a bizarre sexual image was usually part of a general attack on American society – as in *America Hurrah!* or McClure's *The Beard*. Sometimes though it was offered up in fun – as in *Bluebeard* or *Gorilla Queen*; and sometimes as part of a call for sexual freedom – as in *Futz*. Very rarely though was the fantasy presented

for its own stimulatory pleasure. Even if we consider a play which is a collage of pornographic images drawn from male magazines, *I was Hitler's Maid*, by the young British writer, Chris Wilkinson, we are almost too forcibly aware of the way in which the author breaks up the images, transposing them from place to place, drawing fun and social comment from the fantasies and never allowing them to take control. In Warhol's *Pork*, there is a parade of sexual eccentrics, but again the fantasies are treated with a cool non-stimulating humour. The central character, modelled after Warhol himself, chats with the eccentrics while they are masturbating, rubbing each other or trying out new techniques and, at the end of the play, he confides to the audience, "You know, I'm really quite tired!" It is the *reductio ad absurdum* of sexual conversation. In one scene, where a queen revels in the idea of hot shit and piss streaming down from his squatting lover into a glass bowl covering his face, the Warhol character says conversationally, "I suppose you use Pyrex to prevent the heat cracking the bowl."

The real contribution of underground theatre seems to me the reverse of pornographic – in that it has proved that bizarre sexual images need not be handled in a stimulating way and that they can be used successfully within a didactic context. It is a discovery which mainstream middle-class theatre has slowly begun to exploit. Victor Garcia's astonishing production of Lorca's *Yerma*, presented in London during the World Theatre Seasons of 1972 and 1973, could not have been seen publicly in Britain during the years of theatre censorship, since there were scenes of total nudity, but, more importantly, the vision of Eros denied could not have been adequately expressed in an age of inhibited reticence. Yerma is a barren and frustrated woman tortured by the codes of the Spanish village society to which she belongs, codes which deny her any fulfilment other than motherhood. In this situation, her thoughts turn obsessively towards childbearing and erotic fantasies. Garcia's achievement was assisted partly by the physically alert playing of the Nuria Espert Company led by the incomparable Nuria Espert herself, and partly by his *coup de théâtre*, a huge trampoline stage which altered shape and dimensions according to the meaning of the play: but his most powerful unseen ally was a change in the climate of opinion which has affected the whole Western World, from Spain to New York, Berlin to London, and which now accepts that sexual longings cannot be controlled by mere repression.

There are other milder examples. In Trevor Griffith's play,

Occupations, staged by the Royal Shakespeare Company at The Place theatre in London in 1971, there is one startling moment which would have been impossible to present a few years ago. *Occupations* is a debate-play concerning different methods of conducting a socialist revolution, and is set in Italy during the 1930s. A communist revolutionary leader comes from Russia ostensibly to assist the striking workers in Italy against their capitalist bosses. In fact he sells out callously to these bosses. His betrayal on a political level is also shown to derive from an inhuman lack of concern for people. This crudity is revealed both in his treatment of his dying wife and in his sexual demands on his wife's maid. The maid is ordered to strip and she does so – with bitter resentment. She is neither pretty nor prepared to make any concessions of spurious affection to the man who is exploiting her. This thin tow-haired angular woman with the patchy yellow fur around her cunt just stands there, waiting on him, and all the cant about rape, all the male chauvinistic propaganda that women really like to be forced, falls away before this single image. Some women may be able to lie back and enjoy it – but not this woman and not with this man. A shocking scene – but relevant to the purpose of the play, necessary and totally non-pornographic. For the moment one was tempted to believe that the age of sexual enlightenment had come and we would have to endure no more horror stories about sex nor the distorting sentiment, but could watch a sexual situation for what it was, painful on this occasion, pleasurable at other times. But alas, there are too few writers of Trevor Griffiths' ability, too few companies of the Royal Shakespeare Company's stature – and our society is still not one which positively encourages sexual maturity.

The theatre is a place where we can experiment with situations without becoming too deeply involved – where we can rehearse those actions which, if they happened in everyday life, might well be disruptive. This function is of particular importance with regard to our sexual emotions. We can feel in game form what it is like to have mistresses without actually being unfaithful to our wives. We can imagine what it is like to be a transvestite without becoming one. And we can also learn to appreciate an exciting sexual relationship which we may never have had the opportunity to experience. The purpose of erotic theatre is not simply to gratify instincts which we should have learnt (if this is possible) to "sublimate" – but also to discover new aspects of our

emotions and to assist the process of adjustment whereby we try to reconcile our inner fantasy longings with the practical needs of everyday life.

Perhaps, too, the persistent Puritan attacks on the lasciviousness of the theatre are also part of an adjustment process, handicapped only by the fact that they generally take place outside the theatre – in pamphlets and sermons, parliamentary speeches and the courts. These attacks may have diminished in recent years, but they have not died away nor lost their strange virulence. Even as recently as 1972, two promoters of a strip revue in Manchester, having misguidedly pleaded guilty to staging an obscene show, were sentenced to eighteen months imprisonment. What conclusions can we draw from these repetitive attacks? One might be that the Devil always finds servants to do his work for him; another – that the middle-aged are always jealous of the sexual enjoyments of the young and this envy expresses itself in disapproval. A further possible interpretation is more complex. Dr Comfort has put forward the view that Oedipal tensions in a family have instinctual origins. He provides a parallel from the behaviour of birds:

> In general the existence of long-term pair-mating family situations involves two requirements: that other sexually active individuals should be driven away (usually by the male who defends his territory) and that the accepted mate should not.

As young male birds grow up in the nest, they are protected from the territorial aggression of the father by adolescent plumage which only changes into recognizably male plumage when they are about to leave the nest. Animals without this plumage but in similar family situations (such as human beings) rely on certain psychological taboos – for example, the castration fears of adolescents – to prevent a direct clash between the father and his children. As young men grow up, they wish to flaunt their freedom from these taboos, to demonstrate their adulthood. In some societies this freedom is represented by initiation ceremonies – but not in ours. We have to demonstrate our freedom and adulthood in other ways, among them by providing a certain shock often on sexual matters to our parents. And as parents, we respond with a growl of aggression – "Don't go too far!" "Don't be irresponsible!" In the wider world of society, this taunting of our parents and the assertion of our authority as parents is reflected in the various conflicts over "per-

missiveness" – an interesting word since it does not specify who is entitled to permit what. Do our various conflicts derive from an instinctive need to defend our territories?

My own view places a different emphasis. The circularity of our sexual debates often seems to derive from a failure to distinguish between *sexual inclinations* (the predisposition towards certain, forms of sexual behaviour, deriving from our childhood training), *social sexual attitudes* (the pragmatic realization of the practical difficulties which certain types of sexual behaviour cause) and *sexual moralities* (the values which we attach to certain sexual relationships). When the laws concerning homosexuality were changed in Britain, many MPs naïvely assumed that there would be an increase in homosexuality – or that our sexual morality as a society (if there is such a thing) was changing its system of values. But nobody becomes a homosexual simply because the law has been changed. The law expresses a social attitude – it can neither enforce a morality nor a biological predisposition. This sort of confusion becomes difficult to handle in discussion. In debates concerning the permissive society, a formal pattern has developed in which one side (advocating stiffer laws against pornography) accuses the other of harbouring secret desires which only the restrictions of the law hold in check, whereas the other side (calling for the abolition of all laws against pornography) insists that censorship is in itself a form of sexual perversion deriving from a deepset fear of sex. And so the fur flies. Our sexual discussions move quickly from the general comment to the personal insult. The Earl of Arran (who sponsored the Bill concerning homosexuality) was accused of being a poof. But why do we make these assumptions? I believe that it is because we are looking for a certain general coherence between what a person advocates and what he is. We do so with such eagerness that we overlook the complexities of the human personality. We are looking for ways to trust the other person, not to convert him but to see him for what he is. And while we are doing so, we jump to conclusions, which are converted into insults, which provoke retorts, which are intended to make us re-consider our conclusions.

The study of erotic theatre over the past century should teach us at least one lesson: that vast disparities exist between our declared attitudes and our private gratifications. But we do not feel that these disparities ought to exist. And so we become involved in constant minor adjustments – adapting our inclinations to suit our

moralities, altering our moralities to suit our inclinations, and disguising both our moralities and our inclinations behind bland, question-begging public attitudes. It is a sort of battle, and one which has for various historical reasons become almost the central pre-occupation of the theatre, affecting both tatty revues and splendid *haute-couture* productions alike. But it is an unpleasant struggle, endless and self-distorting and somehow out of touch with the lives we actually lead. There are hundreds of plays and films giving intelligent and sensitive accounts of the behaviour of men in war: very few even today offer comparable studies of the sexual relationships between men and women. The distinctive feature of our erotic theatre is not its extent, nor its outspokenness, nor its survival despite the legal restrictions – but its rather poor quality. We deluded ourselves in the early 1960s that those plays where it was revealed (usually to a hushed silence at the end of the second act) that somebody was a HOMOSEXUAL, were being outspoken; we have pretended that those films where the beautiful girl scientist decides to abandon her brilliant career to marry an astronaut, were saying something sensible about Women's Lib. We have endured marriage guidance counsellor plays, full of sincerity and good advice, and Falstaffian plays, brimming with blue jokes and bonhomie. We have watched the very lovely Denise portraying Cleopatra in a nude revue and clasping her asp. Very few plays have managed to break through this barrage of attitudinizing. Perhaps only recently have social circumstances been right for us to do so, for there are signs that our theatre is becoming less pretentious on this subject and more enlightened. Was this enlightenment possible in Britain before the abolition of stage censorship in 1968?

Has the poor quality of our erotic theatre done much harm? Perhaps, for gaucheness breeds gaucheness. But the theatre corrupts nobody who does not inwardly need to be corrupted – who does not discover in the fantasies presented some temporary solution to the problems which are causing him concern. Very rarely do we find a stage fantasy which comes "as they say love comes" with a single "Yes". Usually we are confronted by a situation which is not quite right, an image which does not work, a world which dissatisfies. Even when in pornographic theatre we are confronted by an image which almost exactly corresponds to one of our wet dreams, we are nevertheless distrustful of it. It is too neat, the girl is wrong, the atmosphere is too sordid or tranquil. The great merit of the theatre as an activity is that when it presents a

familiar image before us, we suddenly realize that it is wrong after all and much has been omitted. It stimulates our scepticism more than it comforts our complacency. Nor does the value of the theatre end when the curtain comes down and the lights are switched off – for even its darkened presence reminds us that an area still exists for experiment and that life is not so rigidly determined that experiments are unnecessary.

Index

Index: People

Index: Productions, Events and Sources